prints and printmakers

Edgar Degas, *Self-portrait*, 1855

Contents

Foreword . VII

INTRODUCTION

I Original prints . 3
II Printmaking techniques . 7
III Complementary terminology . 29

Part I
A SHORT ANATOMY OF PRINTMAKING

I Paper . 37
II Watermarks . 43
III States . 51
IV Monograms and signatures . 63
V Collectors' marks . 71
VI Copies and forgeries . 77
VII Early prints . 83
VIII Posthumous impressions . 95
IX Modern prints . 117
X Quality . 127
XI Rarity . 139
XII Condition . 151
XIII Restoration and conservation . 153
XIV Catalogues raisonnés . 157
XV Terminology used in sale catalogues 165

Part II
THE WORLD OF PRINTS

I Early appraisals of graphic artists and their prints 175
II Changing monetary values and the fluctuating fortunes of prints 207
III Drawings: a brief survey of values 257
IV The last of the great collectors 263
V The big auctions . 269
VI Notes and digressions . 273

Select bibliography . 287

Index of illustrations . 289

Index of names . 299

Dedication

Fulfilling a promise made to my parents a long time ago,
I should like to dedicate this book to the dear memory
of my brother Silverio, medical student, born in 1920 at Pola,
who in Turin in 1940 went ' to meet the Lord '

(I Thess. 4:17)

Foreword

Je dy vray, non pas tout mon saoul,
mais autant que je l'ose dire;
et l'ose un peu plus en vieillissant.

Montaigne, *Essais*, III, 2

Since I last had the pleasure of writing about prints, the number of people interested in engravings has grown enormously, and I therefore felt that it would be worth while for me to take up again the inexhaustible theme of prints and print collecting. My enthusiasm remains the same, but I shall be writing with the detachment that is essential for an objective and balanced treatment of the subject.

I have tried to be equally painstaking in dealing with early and modern prints, although naturally I have dwelt at greater length on the past than on the present. The reason for this is not so much that fifty or a hundred years is a short time compared with many centuries, as that prints of recent date, while they are in many cases far from being as easy to document as they should be, nevertheless have a history which can eventually be traced, in spite of occasional blank or hazy patches. Old prints on the other hand are a bit like an old library full of volumes with missing pages, and with lettering which has become faded and difficult to read, sometimes to the point of being indecipherable. This means that the scholar must carry out patient research and consider his findings at length: the conclusions he draws must be cautious, and never hasty.

Since my text is perhaps somewhat unorthodox, a few preliminary words of explanation are required in order for it to be read to advantage. I did not intend writing a history of prints, which has already been done by many others, nor did I wish to revive the old type of collector's manual: I had to find a way of interesting the reader by writing on a theme which I feel is demanding and which does present a number of difficulties. After the introductory chapters, I propose to begin with a number of examples – descriptions of prints, taken from catalogues raisonnés or, more often, from catalogues of important sales; not from gallery catalogues where the prints are in any case discussed in great detail. These examples lend themselves well to examination and discussion, and also give me the opportunity of reporting new and interesting pieces of information about various prints.

Having decided on the best presentation for my theme, the only difficulty being that of choosing the best examples, I then had to decide which artists I should discuss, and the choice was certainly wide, for over the centuries thousands of engravers have been active. Among the early artists, I have concentrated to a certain degree, though of course not exclusively, on Rembrandt. I did this

with good reason and in any case, had I given equal space to all the artists I dealt with, I could have achieved no more than a useless list of facts and figures. What I have done is, in a sense, to use Rembrandt's graphic works as models for the purpose of demonstrating my methods. But I have often turned also to Dürer, the only printmaker of the past who can be placed on a level with Rembrandt. I have then given various examples of prints by the most important graphic artists from the fifteenth to the twentieth century, from Mantegna to Picasso. Naturally, the criteria used in dealing with nineteenth- and, especially, twentieth-century prints are different from those used in dealing with early prints.

The second part of the book deals with the long, fascinating and sometimes dramatic history of a number of individual impressions. I have written about the popularity of a particular print during the artist's lifetime, about how the public's appraisal of it has changed over the years; about the greater or lesser regard which cultured men have had for various prints through the centuries. This kind of regard, in other words the attraction or indifference felt for a work of art, can be measured fairly accurately with a monetary yardstick, by looking at the value which a print has had at any given moment over the years, and this is in fact a method adopted by scholars. In doing this I have not attempted to translate currencies, to give the pound or dollar equivalent of an old florin, for instance, or to explain complex problems by trying to reduce them to easy formulae. What I have done is to set down facts, co-ordinate them and add some informative notes. If any of this part of the book is of interest to collectors, this is not thanks to my research alone, but also, and indeed to a great extent, to the late Frits Lugt, who with his characteristic generosity allowed me to draw on his important and incomparable work on collectors' marks.

Finally, the reader should remember that the various topics I deal with are difficult to isolate and to confine within a single chapter, so there is a certain amount of overlapping of subjects, particularly in the footnotes. My text has had to be kept within fairly restricted limits, and does not pretend to be a learned work or a study in depth: often it has to range over centuries in the space of a few notes, and sometimes it has to deal with subjects which have not been documented; it is therefore, I am sure, not without inaccuracies, and it could certainly be improved upon. But however that may be, I should have been unable to write it without the advice of a number of scholars for whom I have great esteem; and whose friendship and patience I have often tried. I should therefore like to record my gratitude to the following, among many: the directors and keepers of the prints and drawings rooms of the Rijksmuseum (the Rijksprentenkabinet) in Amsterdam, the Bibliothèque Nationale and the Louvre (Cabinet Rothschild) in Paris, the British Museum in London, the Staatliche Museen in Berlin, the Staatliche Graphische Sammlung in Munich, the Staatliche Kunstsammlungen in Dresden, the Bibliothèque Royale in Brussels, the Museum of Fine Arts in Boston, Mass., the National Gallery of Art in Washington, D.C., the Baltimore Museum of Art, the Art Institute of Chicago, the Uffizi Gallery in Florence, the Pinacoteca Nazionale in Bologna, the Biblioteca Classense in Ravenna; to the directors and experts of the firms Sotheby & Co., P. & D. Colnaghi & Co., Craddock & Barnard, Christie, Manson & Woods, all of London; C. G. Boerner of Düsseldorf; Paul Prouté and R. G. Michel of Paris; Kornfeld und Klipstein of Berne; William H. Schab of New York; to the Gabinetto delle Stampe of Milan; and to friends and collectors in France, Italy, Sweden and the United States.

FERDINANDO SALAMON

INTRODUCTION

I Original prints

It is only during the past few decades that the need has been felt to regard prints as 'original' and to qualify them as such. In the past they were called engravings, and later the term lithograph was also used; or else, more generically, they were referred to as prints, but the word had a different, more distinguished meaning than it has today. It was not until the nineteenth century that a distinction began to be made between creative graphic art, such as that of Albrecht Dürer (1471-1528),[1] Rembrandt Harmenszoon van Rijn (1606-1669) and Canaletto (1697-1768), and the kind of reproductions done for example by Marcantonio Raimondi (c.1480-c.1530), who copied Dürer and reproduced on copper works of the Renaissance masters, even though he was himself an engraver of undisputed talent. But both kinds of print were considered original and genuine: the creative kind, that is, produced by artists doing original work on copper (judged on a level with paintings, hence perhaps the term *peintre-graveur*[2]), and reproductions, that is, where an already existing model was copied on to a plate. Eventually, it was the work of the *peintre-graveur* which became the more highly prized, although the old-established practice of making reproductions has never entirely died out, even if it is now understood in a rather different way.[3]

The concept of an original print is therefore quite recent, and is partly a consequence of the great technical progress which has been made in the production of prints. Behind the concept lies a certain ambiguity, spotlighted by an incident which took place in Paris after the last war. Several artists of renown – among them Georges Braque (1881-1963) – had rather rashly authorized certain publishers and dealers to reproduce their paintings and engravings by photo-mechanical means, in black and white and in colour. They also agreed to a meticulous system of numbering which was in many cases absent in the original, and they signed the sheets in their own hand. These, which came to be called

[1] Artists' dates and bibliographical references for prints are given only when they are first mentioned.

[2] Adam Bartsch, *Le Peintre-graveur*, 21 vols. (Vienna 1803-21). In the first volume, p. IV, the famous scholar and cataloguer made a clear distinction between 'prints by painters... which are always sought after, by true connoisseurs and by artists themselves' and prints made by 'engravers' or copyists.

[3] It is common practice among painters, not only among those who make prints as an end in themselves, to transfer their work on to copper or stone. In this connection, Jean Adhémar writes in *L'Estampe* by Jean Laran (Paris, 1959), vol. I, p. 328: 'Many artists have produced engraved reproductions of their own paintings or drawings which are no more than straight copies, and do not contribute anything new to the art of printmaking. To make an "original", in every sense of the word, an artist must think and work as an engraver.'

'false' impressions, indeed had nothing original about them except the signature. However, there was a particular case which was rather different since the prints in question really were originals, at least from a technical point of view. Certain famous artists, including Joan Miró (b. 1919) and Marc Chagall (b. 1887), arranged for limited editions of some of their colour lithographs, which they signed. The French periodical *Verve* then printed by offset lithography, using the same matrices, a large edition of the prints which were sold bound in with the magazines. The artists' original stones had been used: all that was missing from the prints, which were naturally called 'original', was the artist's signature on the lower margin. This double edition inevitably gave rise to many misunderstandings.[4] The first signs of reaction against these and various other practices appeared in France, where in fact such abuse was most common. An attempt was made to distinguish between a *gravure* (engraving), and an *estampe* (print). Lithographs had to be included among the *gravures*. A number of dealers preferred to call themselves *marchands de gravures* rather than *marchands d'estampes*, and well known writers like Claude Roger-Marx and Jean Adhémar, in their books about prints, stressed the word *gravure*.

But all this was no more than a useless palliative. The most it achieved was to inform the layman that the word *gravure* implied something more genuine than *estampe*, which was a highly inflated term. In England and America the word 'fine' placed before the generic word 'print' means an original print. In German, *Kunstdruck* or *Kunstgraphik* are distinct from *Druck* or *Graphik*, which mean nothing more than prints, in the widest and sometimes ambiguous sense of the word.

Over the years, museum curators, artists and others with a special interest in prints have met together to try and draw up once and for all some precise definition of an original print, acceptable to every one and at the same time providing the printmaker with specific rules to follow.[5]

I The first outline proposal was drawn up in five paragraphs at the Third International Congress of Plastic Arts held in 1960 in Vienna:

ORIGINAL PRINTS

1 It is the exclusive right of the artist-printmaker to fix the definitive number of each of his graphic works in the different techniques: engraving, lithography, etc.
2 Each print, in order to be considered an original, must bear not only the signature of the artist, but also an indication of the total edition and the serial number of the print.

The artist may also indicate that he himself is the printer.
3 Once the edition has been made, it is desirable that the original plate, stone, woodblock, or whatever material was used in pulling the print edition, should be defaced or should bear a distinctive mark indicating that the edition has been completed.
4 The above principles apply to graphic works which can be considered originals, that is to say to prints for which the artist made the original plate, cut the woodblock, worked on the stone or on any other material. Works which do not fulfill these conditions must be considered 'reproductions'.
5 For reproductions no regulations are possible. However, it is desirable that

[4] Carl Zigrosser and Christa M. Gaehde, *A Guide to the Collecting and Care of Original Prints* (New York 1966), p. 17. See also Joshua Binion Cahn, *What is an Original Print?* (New York 1967), pp. 10-11. This incident is very well known. The American writers are probably referring to Chagall's *Bible*, published by *Verve* in 1956-60 in two volumes containing many lithographs in colour and in black and white.
[5] I have followed the cogent account of Zigrosser, op. cit., pp. 83-9.

Abraham Bosse, *Printing a line engraving*, 1642

reproductions should be acknowledged as such, and so distinguished beyond question from original graphic work. This is particularly so when reproductions are of such outstanding quality that the artist, wishing to acknowledge the work materially executed by the printer, feels justified in signing them.

The Viennese proposal contains unexceptionable recommendations which any young engraver would readily accept and which would reassure even the most demanding collector. Yet they are really very rigid and therefore one may suppose that not all artists and, on their behalf, publishers, would welcome them.

II The Print Council of America, whose headquarters are in New York, subsequently modified the terms of the Vienna definition and at the same time widened its scope, with typical Anglo-Saxon pragmatism, allowing the printmaker much greater freedom.

An original print is a work of art, the general requirements of which are:

1 The artist alone has created the master image in or upon the plate, stone, wood block or other material, for the purpose of creating the print.

2 The print is made from the said material, by the artist or pursuant to his directions.

3 The finished print is approved by the artist.

These requirements define the original print of today and do not in all cases apply to prints made before 1930.

Zigrosser has made a few important remarks in this connection, making the American definition more flexible,[6] even though it ought anyway to be understood more as a principle than as an absolute norm:

1 The use of technical innovations is allowed in the making of a print (so that it could conceivably become three dimensional), although engravers do not like the idea of photo-mechanical methods;

2 The aid of a professional printer or a pupil is allowed (as it was in the past), provided that the artist supervises the work. If it is the artist who is personally in charge of the printing, the word *imp* (ressit) should be added after the signature in pencil;

3 Trial proofs (in other words, the first attempts before arriving at the perfect original) ought to be marked as such;

4 So-called artist's proofs should be limited;

5 The edition does not necessarily have to be limited, just as it was not limited in the past, when more copies were printed than nowadays. But if it is limited it must really be so, and therefore each print should bear an indication as to the total number of copies printed;

6 It is advisable for the engraver to cancel or obliterate the master image once the edition has ended;

7 An indication as to the date of the engraving is a useful requirement.

III Last in chronological order is the definition of originality given in December 1964, in a truly Cartesian spirit, by the Comité National de la Gravure. It was subsequently accepted by the Chambre Syndicale de l'Estampe et du Dessin and then published in *Nouvelles de l'Estampe* in February 1965:

The following are to be regarded as original engravings, prints and lithographs: impressions printed in black and white or in colour, from one or more matrices, conceived and executed entirely by the artist himself, whatever the technique employed, and excluding the use of all mechanical or photo-mechanical processes.

Only those prints which correspond to this definition have the right to be called *original prints*.

The various definitions and guidelines put forward between 1960 and 1965, even if they are in some cases rather vague, do not entirely contradict one another: essentially, the final decision is left to the judgment of the engraver.

Lastly, I should like to dwell for a moment on an attractive theory which at one time appealed to me: that prints should be seen as a democratic form of art. And so they must have been at one time, when engravings were circulated among a great many people, always at a reasonable price, the only limitations on their circulation being technical ones. But this practice, which was common up to fairly recent times, seems to be at an end now, just when the democratic ideal is perhaps most widely understood and valued. In fact, the modern print, especially if it is by a great artist, is, because of conditions imposed by the market, reserved for a relatively small and wealthy minority. Whether this is a good or a bad thing, it is not my intention to discuss here. At any rate the reasons for this state of affairs are not technical, for modern innovations could allow excellent printing in almost unlimited numbers, which would have been inconceivable, for example, in Dürer's time. The latter, who even in his lifetime was considered the greatest engraver of his age, sold his work for very little money to artisan or gentleman.

[6] Ibid., especially pp. 84-7.
[7] Carl Zigrosser, *The Book of Fine Prints* (London 1956), p. 9.

II Printmaking techniques

Today the practice of classifying prints according to the kind of matrix used, whether of wood, metal or stone, is no longer common.[1] Instead, a more systematic classification is used, based on whether the ink is transferred on to the parts of the printing surface which have been left standing up, or on to those cut away, or on to a flat surface.

Relief prints

First in chronological order is the *relief print* (*gravure en relief*, *Hochdruck*, *incisione in rilievo*), already in existence towards the end of the fourteenth century. The ink which the engraver uses does not penetrate the cut away parts of the block but adheres only to those parts left standing up, i.e. in relief, which appear on the finished print as lines or marks. The printing block is made of wood, and today, often of linoleum, which is more easily cut. For a short period, a long time ago, metal was also used. In printing, fairly gentle pressure is brought to bear: this can be done manually, with the palm of the hand, vertically from top to bottom, or with the aid of rollers and dabbers; or mechanically, with a printing press of the kind used for printing type.

Prints obtained by this method are the woodcut, wood engraving, metal cut or dotted print, colour and chiaroscuro woodcuts, and so-called relief etching. The matrix leaves no mark in the margins of the print.

Woodcuts (*gravure sur bois*, *Holzschnitt*, *silografia*). This process had a precedent in the medieval *Zeugdruck*, the use of woodblocks to print fabrics. The engraver uses a plank which at one time could have been nearly an inch thick, carved out of wood such as apple, pear, beech or even from harder woods, like oak, and cut along the grain. The wood used must naturally be well seasoned, in order to avoid subsequent cracking or splitting caused by changes of temperature. The plank, solid and absolutely smooth, is first of all smoked in order to make the marks more visible, and then it is covered with a drying powder.

In the fifteenth century the engraver himself cut away the parts which were to appear white in the print (hence the term *taille d'épargne*, since the empty spaces thus made 'saved' lines), so that only the parts to be inked remained in relief, and

Relief print: inked block

Intaglio print: plate (bottom), and ink adhering to the paper (top)

Planographic print: bed of the printing press (bottom), stone, paper and blanket

[1] See Carlo Alberto Petrucci, 'Engravings and other print media', in *Encyclopedia of World Art* (New York and London 1961), vol. IV, p. 748 ff.

it was these which would be reproduced. But by the end of the century, when the art of engraving was becoming more and more refined, the drawing was usually executed by the artist directly on to the block with sharp points or, more often, traced on paper which was then pasted on to the wood, and the material execution was left to skilful engravers: these *Formschneider* defined the drawing with knives and 'V' tools or gravers and cleared waste areas with chisels and gouges. It was a difficult process and was always carried out in the direction of the grain in order not to split the parts in relief while engraving the dense parallel lines. Dürer, though he had learnt to cut wood himself, used professional engravers who included Hieronymus Andreä and Wolfgang Resch, two of the most skilful craftsmen of their time. Some of the small *Dance of Death* woodcuts by Hans Holbein the Younger (*c*.1497-*c*.1543) were engraved by Hans Lützelberger, in about 1525.

The technique fell into disuse, but several centuries later great artists began again to use woodcut and often carried out the cutting and printing as well: notable examples are Paul Gauguin (1848-1903) and Ernst Ludwig Kirchner (1880-1938).

Colour woodcuts (gravure en couleurs, Farbholzschnitt, silografia a colori). This is another ancient printmaking technique, which originated in Germany at the

Abraham Bosse, *The Engravers*, 1642

Hans Holbein, *Death and the Prince*, from the *Dance of Death, c.* 1523-6

Line engraving (top) and drypoint

Etching

Cross-hatching done with a burin

beginning of the sixteenth century: in it, the image is reproduced in various gradations of the same colour. The first, basic block of wood, known as the 'key' block, bears the black outlines. Various shades of the chosen colour, usually green, brown or grey, are used on successive blocks – one, two or at the most three. Registration marks must be very precisely made with pins in the corners of each block of wood so that the blocks may be positioned exactly during the printing, which usually starts with the lightest and finishes with the darkest shade.

The earliest dated German colour woodcuts are *The Emperor Maximilian on Horseback* (B. 32) of 1508, by Hans Burgkmair (1473-1531), *St Christopher* (B. 58), dated 1506, although it was really done three years later, by Lucas Cranach the Elder (1471-1553),[2] *The Witches* (B. 55) of 1510 by Hans Baldung Grien (*c.*1485-1545). Some think that the inventor of the colour woodcut technique was the master of these three artists, Jost de Negker of Antwerp, at one time in the service of Maximilian I, and active at Augsburg between 1508 and 1544.[3] An outstanding colour woodcut is *The Beautiful Virgin of Ratisbon* by Albrecht Altdorfer (*c.* 1480-1538), illustrated on p. 245.

The Italian chiaroscuro woodcut (*clair-obscur, camaïeu*) is much more widespread. It was used mainly for the reproduction of paintings, including those of Parmigianino. In 1516 Ugo da Carpi (*c.*1480-1532) obtained from the Signoria of Venice the 'privilege' – what we could call today the patent – for this technique which he claimed to have invented, even though none of his woodcuts is dated earlier than 1518. The Italian process, although of North European origin, differs from the German. In the latter method, the key block, that is, the block bearing the black lines, could be used on its own to produce a print, while the only function of the subsequent blocks was to improve or strengthen the image made by the first one, with various gradations of the same colour. In the Italian technique, however, the 'black' block was not intended to produce the complete print, and the others were indispensably complementary to it.

In Japan, where Europeans did not establish real contacts until after 1854, the technique of making colour woodcuts was brought to perfection by Suzuki Harunobu (1724-70). It seems that at the beginning of the nineteenth century, up to twelve different blocks were used, superimposed with the help of *encoches en équerre*, set-squares placed at opposite corners of the blocks. Key drawings marked with the different colours required from each successive block were glued to the surface before cutting. It can therefore be said that the two methods, the Japanese and the older European one, even though they had developed independently of one another, were substantially the same in that they were based on the principle of the use of several blocks. The main difference was that the colouring used by the Japanese was more refined, with more delicate tonal effects, since they used water soluble colours, not oil inks.

Wood engraving (gravure sur bois debout, Holzstich, nuova silografia). In the eighteenth century the practice of using end-grain blocks, of wood cut across the grain, became widespread. This had sometimes been done in earlier times, but its new popularity was due mainly to the influence of the English artist Thomas Bewick (1753-1828). To increase the block size a number of small blocks of wood such as

[2] See *L'Incisione europea dal XV al XX secolo*, catalogue of an exhibition at Turin, April-June 1968, no. 108, p. 216.
[3] For an exhaustive study of these early techniques see Arthur M. Hind, *An Introduction to a History of Woodcut*, 2 vols. (London 1935), vol. I, pp. 1-63. See also Philip Hofer, 'Book Illustrations in the Intaglio Medium', in *Print Collector's Quarterly*, vol. XXI, nos. 3 and 4 (July and October 1934).

boxwood and maple were joined together in a mosaic. The end grain enabled the engraver to use a burin instead of a knife and thus to draw more freely and to achieve a fine, soft line. Wood engraving, which allowed a large number of impressions to be taken, all of them of good quality, was often used for book illustrations. The blocks therefore had to be of the same, standardized thickness, just over 20 mm (about an inch), so that they could be used in printing presses.

Metal cut (gravure sur métal, Metallschnitt, incisione su metallo). This was a method of engraving on copper in use during the third quarter of the fifteenth century. The technique used, laborious because of the hardness of the metal surface, was the same as that used in woodcuts, except for a few special expedients which were necessary. Printing was probably carried out with a screw press; at any rate it is certain that the metal plate was mounted in some way for the printing. Of particular interest among these metal cuts is the *dotted print (manière criblée, Schrotschnitt, a fondo punteggiato).* The copper in this case was cut with goldsmith's punches, toothed wheels, etc. so that parts of the background of the print had the appearance of a sieve. The dotted background and the white line (*taille blanche,*

Above:
Domenico Beccafumi, *St Peter,*
*c.*1520-40

Above right:
Hans Baldung Grien,
St Christopher, c. 1511

Opposite:
Hans Burgkmair, *The Emperor*
Maximilian on horseback, 1508

IMP·CAES·MAXIMIL·AVG

Iost de Negker.

H·BVRGKMAIR

Weisslinie, linea bianca), which meant that the drawing came out white on a black ground, were peculiar to this kind of print. The technique was also used on wood by a few artists, such as the Swiss Urs Graf (*c*.1458-*c*.1528).

In the *paste print (Teigedruck)* the design also appears in white on a black ground. In this case the design was worked on a sticky paste, upon which the sheet of paper, often gilded, was then laid. Several other colours could be added. Prints of this type have become extremely rare, partly because of the difficulty of preserving them; and so have dotted prints, which are almost always known in single sheets only. One of the very few known examples in Italy of this technique is the superb *St Roch* (Schr. 2722) by an anonymous master of Cologne (*c*.1470), preserved in the Biblioteca Classense at Ravenna.

Relief etching (acquaforte in rilievo). The first artist to use this very rare technique of etching away the negative part of a drawing on copper was William Blake (1753-1828). He in fact wanted to write on copper, to engrave his long poems with illustrations around them, as for example his *Songs of Innocence and Experience* (1789-94). For years it was thought that engraving so many thousands of words must have cost him immense effort and that they must have been written back to front for them to be legible when printed. However, eventually it was realized that he must have used some ingenious expedient, such as writing the words on a sheet of paper which, while it was still wet with ink, would be placed face down on the heated copper before it was etched. Thus, by going from the right way round to the wrong way round and then back again, he would have been able to achieve his purpose. The technical feasibility of this process (Blake said it had been dictated to him in a dream by his dead brother, but never revealed the secret of how it was done), was demonstrated by Hayter.[4]

Towards the end of the first third of the fifteenth century, still to the north of the Alps, the type of print known as *intaglio print (gravure en creux, Tiefdruck, incisione in cavo)* was born. Here the ink, less dense and viscous than that used in relief printing, is pressed with dabbers into the lines which have been incised in the plate, which is usually of copper, and then cleaned off the surface with tarlatan, so that the mark which is transferred on to the paper comes not from the surface of the copper plate but from the cut-away parts. The plate, heated to a suitable temperature, is then placed, together with the blankets and the dampened paper, on the bed of the roller press. The latter is heavier than the screw press used for woodcuts, and at one time was worked only by hand. Two rollers, which up to the beginning of the eighteenth century were made of wood, exert a very strong pressure which naturally has to be constant, in order to avoid irregularities in inking, and the ink is transferred from the plate on to the paper receiving the impression.

In the intaglio print, special tonal effects can be given to the engraving in order to harmonize or soften the incised lines, or certain tones can be brought out, by applying the process called *retroussage*, which consists in wiping the inked plate with muslin or gauze so as to remove traces of ink from the grooves. This procedure is used in line engravings but much more in etchings: a very skilful artist can create really astonishing effects.

All intaglio prints bear a plate mark caused by the action of the press on the paper. This direct technique – that is, where the metal is engraved by manual

[4] William Hayter, *About Prints*, 2nd ed. (London 1962), p. 132.

The engraver's tools:
gouge
needle
scraper
burin
rocker
roulette
burnisher

Intaglio prints

Opposite:
Anonymous Master from Cologne,
St Roch, *c*.1460-70. Dotted print

13

action – is used for *line engravings, niello engravings, drypoint prints and mezzotints.* The indirect process, in which the plate is bitten by a chemical substance, produces *etchings, soft-ground prints, aquatints, stipple engravings and colour engravings.*

Line engraving (gravure en taille-douce, Kupferstich, incisione al bulino). The engraved mark is made with a tool called a burin, a rectangular steel pen with a sharpened lozenge-shaped tip. Its wooden handle allows the engraver to exert strong pressure with the palm of his hand. The copperplate, which is generally little more than one millimetre thick, is placed on a small cushion or piece of felt so that it can be easily moved around during the engraving process. The action of the burin on the plate produces a groove, and in front of and at the edges of this groove shavings of metal called 'burr' are raised. This burr is easily seen through a magnifying glass and it is removed with a scraper, thus leaving a very clean line, which is characteristic of this type of engraving. If the burr were not removed the pressure exerted by the printing press on the plate would produce stains which would be transferred on to the print. The scraper is also used for correcting and smoothing out the engraved lines, and, if these are not too deep, it can if necessary be used to obliterate them altogether. The burnisher is a tool with an oval-shaped handle and a smooth rounded end, which is also useful for removing marks that are not too deeply engraved. Finally, a hammer can be used to beat the back of the plate in order to smooth the surface. These tools serve for

Above left:
Kitagawa Utamaro, *Utamaro painting a Screen in a Green House,* *c.*1800. Colour woodcut

Above:
Suzuki Harunobu, *Girls reading a Poem, c.*1750. Colour woodcut

all kinds of engraving on metal. The most illustrious exponent of this technique, in which German engravers excelled from 1450 onwards, was Albrecht Dürer.

Niello. This form of burin engraving was widely used by Italian goldsmiths in the second half of the fifteenth century. The invention of the technique was formerly attributed to Maso Finiguerra (1426-64), but it probably had precedents in Germany. The engraving was made on a small plate, usually of silver, and was filled in with a mixture of lead, silver, copper and sulphur – *nigellum* – which when heated to a high temperature melted into the grooves. This produced a black drawing on a white background. The chief object of the *niello* technique was not to obtain a print, but a proof was often taken as a record of work carried out. For this reason these early proofs are extremely rare and most of the existing ones are in the British Museum and in the Edmond de Rothschild collection in the Louvre. Naturally *niello* engravings do not involve the use of a printing press.

Drypoint (pointe-sèche, Kaltnadelradierung, puntasecca). In this technique, the line is engraved on metal, more freely than in the burin method, for a very sharp steel needle is used, almost in the same way as a pencil. It produces, at the sides of the grooves, a very thin layer of shavings known as *burr (barbe, Grat, barba)*. This is not taken away with the scraper as it is in line engravings and therefore it retains the ink, so that when printing takes place, if slight pressure is exerted – not enough to crush the burr immediately – very delicate velvety shading can be seen around the engraved lines. But the printing press soon squashes the burr, and the number of prints obtainable with these characteristics is very limited.

The first drypoint engravings known in the history of prints are those of the Master of the Housebook, active in Germany between 1465 and 1500. The technique was also used, though rarely, by Dürer, for example in his *St Jerome by a Pollard Willow* (M. 58) of 1512; the Dalmatian Andrea Meldolla, known as Schiavone (1533-63) combined it with etching. But the unsurpassed master was to be Rembrandt, who used drypoint on its own, or with etching.

Mezzotint (manière noire, Schabkunst, mezzotinto). The surface of the plate is first of all roughened with a very fine-toothed tool called a rocker, so that if the plate were to be inked straight away, it would print an entirely black sheet of paper. Mezzotint is a negative process: the engraver does his drawing starting with a black ground, making white lines and marks. The burr, which is very abundant, is removed with a special scraper with very dense serration (up to forty teeth per centimetre), to produce lighter areas in the print. To obtain white areas, a burnisher is used, to erase the pitted holes and smooth the plate. Only a few really good, velvety prints can be obtained from each plate.

The technique seems to have been invented by a German soldier, Ludwig von Siegen (1609-c.1680); the earliest known mezzotint is *The Grand Executioner* (A. 6), done in about 1660 by Prince Rupert, the Palatine Prince Ruprecht von der Pfalz (1619-82). *The Colossus* (H. 29) by Francisco Goya (1746-1828), engraved in about 1815, was produced entirely by this technique, which was later taken up by others, notably by Edvard Munch (1863-1944).

Etching (eau-forte, Radierung, acquaforte). This is the oldest of the indirect *intaglio* techniques, in which the plate is indented by acid and not by the action of the engraver. The heated plate, as usual well cleaned, is covered by means of a roller or dabber with a thin varnish, normally a mixture of resins and waxes, which is resistant to acid. The engraver, having blackened the surface with smoke so as to

make his marks more visible, traces his drawing with a wooden-handled needle. Then, having protected the margins and back of the plate with a special wax resist, he immerses it in a dish containing a biting solution, such as diluted nitric acid. The acid attacks – that is, bites – the marks which have been uncovered by the needle, thus achieving with much less effort what is achieved by the engraver working directly on the metal with his burin. The lines in an etching are more free, resembling those in a drawing, since they can easily be traced in whichever direction the artist desires. The depth of the cut does not here depend on the pressure exerted by the hand, but on the duration of the immersion, the concentration of the acid used, etc. The engraver, having taken the copperplate out of the first bath, is able to examine the effects of the biting; if some marks seem to him to be too faint, all he has to do is protect the satisfactorily bitten cuts with wax and then re-immerse the plate in the solution. He continues in this way until he is satisfied with his work.

One of the many advantages of the indirect method of intaglio engraving, compared with the burin technique, is that errors are more easily corrected. It

Anonymous Bavarian master, *The Martyrdom of St Sebastian*, c.1410-20

does, in fact, allow for second thoughts which in the case of woodcuts would mean resorting to the laborious remedy of inserting a new piece of wood into the block.

The earliest known etchings are by Daniel Hopfer, active at Augsburg between 1493 and 1536, the Swiss Urs Graf, and Dürer, who did five etchings on iron, among then *The Agony in the Garden* (M. 19) and *The Cannon* (M. 96); Lucas van Leyden (1489-1533) also used this technique on a few rare occasions. The earliest Italian etching is by Parmigianino (1503-40), whose prints are more sketchy and spontaneous than those of the Northern artists.

Etching is above all the medium of Rembrandt: with it he reached a depth and universality of expression never equalled in the history of prints.

Soft-ground etching (vernis mou, Weichgrundradierung, vernice molle). In this process, a stiff, sticky paste made of tallow, added to the hard ground used for making an ordinary etching, is spread on the plate. A thin sheet of paper is placed over it and on this the engraver makes a very free drawing with a sharp pencil. When

the paper is removed and the varnish is exposed, it can be seen that only those parts on which the lines have been traced have adhered to the ground. The process is continued as for an etching. The resulting print is softer and more delicate than an ordinary etching, and resembles a pencil drawing or a lithograph. The texture of the paper and the kind of pencil used for the drawing have a determining influence on the final effect. Soft-ground etching, much used in the seventeenth century, has in recent times been taken up again.

Aquatint (*aquatinte*, *Aquatinta*, *acquatinta*). In this technique the surface of the plate is protected by a porous ground, through which the acid penetrates and bites the metal. The plate is placed in a special box and is then spread with a resin dust (generally colophony, a turpentine derivative), which adheres to the plate, when it is heated. Those parts of the drawing which are to appear white in the print are covered with a varnish (of bitumin or pitch). The plate, when immersed in the acid solution, will be attacked in its unprotected parts, i.e. those not covered by resin or varnish. These processes of protection and biting are repeated until the desired light and dark tones are achieved. The plate can also be treated with resin dissolved in a solution of alcohol which when it evaporates also leaves a granulated covering; or it can be roughened by rubbing it with sandpaper or scattering sulphurous powder over it.

Aquatints (in which other technical devices, one of which will be discussed below, can also be used) are sometimes confused with mezzotints because of their similar effects of tone.

BENEDECTO
MONTAGNA

The process was invented by Jean-Baptiste Le Prince (1734-84). François Janinet (1752-1813) was the first to employ it for colour prints, by using several plates. Francisco Goya made great use of it, often combining it with line engraving, etching and also drypoint. In more recent times it has been one of the favourite techniques of Georges Rouault (1871-1958) and Pablo Picasso (b. 1881).

Stipple etching is built up as a system of minute dots, applied on a grounded plate with needles, a roulette (spur wheel) or moulette (drum roulette).[5] The plate is then bitten in acid in the usual way. *Crayon manner* (*gravure en manière de crayon, maniera a lapis*) entails similar tools supplemented by needles and burins, and creates an effect similar to a chalk or pastel drawing. *Stipple engraving*, or flick engraving (*gravure au pointillé, Punktierstich, incisione in cavo a fondo punteggiato*), is performed direct on an ungrounded plate with a special stippling burin.

[5] The technique was used almost exclusively in the eighteenth century. Unfortunately, even the most authoritative books on prints which have appeared recently use a terminology which often leads to confusion. As Hind points out, even when the names of the technical processes differ, the final effect is practically the same, apart from a few details.

Albrecht Dürer, *St Jerome by a Pollard Willow*, 1512: Dürer's rare drypoint

The two techniques, often used in combination, served especially for the reproduction in monochrome or in colour of oil paintings and watercolours. Giulio Campagnola (*c*.1482-*c*.1515) was an early exponent of the stippling technique.[6] Among the major users of this technique were the French artists Gilles Demarteau (1729-76) and Louis-Marin Bonnet (1743-93), and, in England, the Italian Francesco Bartolozzi (1727-1815).

Colour prints (gravure en couleurs, Farbstich, incisione a colori). The German Jakob Christof Le Blon (1667-1741) was the first to produce an engraving in several colours. He took as his starting point Newton's theory, published in 1702, which stated that all the colours in the spectrum are composed of the three primary colours – blue, yellow and red. In practice, however, in order to obtain a satisfactory impression, a fourth plate had to be added, bearing black lines.

[6] The term *interrasile*, used at the beginning of the twelfth century by the Benedictine monk Theophilus, as in *opus interrasile* in his *Diversarum artium Schedula*, was at one time used for the *manière criblée* and also, incorrectly, for Giulio Campagnola's engravings.

Giulio Campagnola, *Christ and the Woman of Samaria*, *c.*1505 : the rare first state, before the top of the plate was damaged

Right:
Giovanni Benedetto Castiglione,
Old Man with a Long Beard, *c.*1650

Opposite:
Prince Rupert (Ruprecht von der Pfalz), *The Grand Executioner*, after Spagnoletto, 1658. Mezzotint

Colour prints, both aquatint and mezzotint, were made by two different methods. With the French method several plates were used, each one covered with a different coloured ink. These were then run one at a time through the roller press and the impression was taken with the help of registration marks (*repères*) in order to avoid the risk of inaccurate positioning of the plates, which would ruin the print. The English method, however, uses only a single plate, the incised areas being coloured with various inks applied by means of dabbers (*à la poupée*), almost painting the plate in one operation, before each impression is taken. The print was often retouched by hand. This procedure saved time, in that the print did not have to be registered for successive plates, and it also saved the not inconsiderable expense of the extra metal. However, the end result was inferior to that produced by several plates.[7]

In the *planographic print* (*impression lithographique, Flachdruck, stampa in piano*), the line is neither in relief nor incised, but one with the surface. The technique is based on the incompatibility of grease and water, and on the ability of limestone to absorb both. The lithographic press, which is even heavier than the roller press, is today often mechanically operated. The drawing is done on the stone, or on a metal plate, which is then covered with the paper to be printed (protected on the back by wet papers) and placed on a carriage which runs under a scraper covered in leather. Strong, uniform pressure is applied, transferring the image on to the paper.

Lithography (*lithographie, Lithographie, litografia*). The best kind of limestone is Bavarian. Light-coloured and perfectly smooth, it is porous and absorbs both water and greasy substances equally well. The stone used is about six inches thick and is fairly big, up to 90×65 cm (35×25 inches), and can weigh up to 150 or 175 pounds.[8]

The stone is ground smooth. The drawing is made on it with a greasy lithographic pencil or crayon, and then fixed by rinsing the stone with a very weak solution of nitric acid and gum arabic (not sufficiently strong to attack it). The stone is wiped with water before each impression is taken and, for each print, it is inked by means of a leather-covered roller. During this operation, the porous limestone retains the grease of the crayon where the drawing has been made, and the parts which are not drawn upon become impregnated with water. The ink, which is greasy, is repelled by the water-wet areas and adheres only to the areas marked by the crayon.

Instead of a lithographic crayon, a pen or brush can be used, according to the final effects desired, dipped in a greasy mixture composed of waxes, soaps and lampblack. Thin plates of zinc or aluminium can be used instead of a stone; they are usually larger and are suitable for printing posters. However, retouching and corrections are more difficult to carry out on a metal plate, and special care is required in maintenance.

The stone can be used for many years, sometimes for the whole of the artist's lifetime, since it can be ground down and re-used. Today, instead of making the drawing directly on to the stone, some artists prefer to make it on lithographic paper or *transfer paper* (*lithographie sur papier* or *papier report, Papierlithographie,*

[7] Recently an entirely new method of colour engraving, using one plate only, was tried out by William Hayter at Atelier 17. The artist engraves the plate at various depths and then inks it with colours of different degrees of viscosity. (This information was kindly given to me by Lia Rondelli.)

[8] H. van Kruiningen, *The Techniques of Graphic Art* (London 1969). On p. 59 the author discusses the disappearance of the old, heavy lithographic stone and the now widespread use of offset printing.

Georges Rouault, *Qui ne se grime pas?*, 1923. Aquatint

carta litografica or *carta di riporto*). In this way there is no need for the artist to reverse the drawing as it will be reproduced in the same way as he draws it.

Lithographs, the result of a planographic process, do not show platemarks.

The technique was invented by the Prague playwright Alois Senefelder (1771-1834). After noticing the acceptance by limestone of both water and grease, and the fact that water and grease do not mix, he made his first successful experiments in 1798 and during the next twenty years greatly improved the method.

Lithography was in use by the early nineteenth century, and was raised to the level of great art by Goya who in 1825, as an old man, made his four *Toros de Burdeos* or *Bulls of Bordeaux* lithographs (H. 283-286). Honoré Daumier (1808-79) also excelled in this technique, and produced four thousand prints, among which were many masterpieces. Later still came the unrivalled colour prints of Henri de Toulouse-Lautrec (1864-1901).

Today lithography, together with etching which was revived by the Société des Aquafortistes of Paris in 1861, is the most widely used printmaking technique.

Chromolithography (*chromolithographie*, *Farblithographie*, *litografia a colori*). Chromolithographs from one or more stones are obtained by processes similar to those I have already described in connection with colour engravings. On some late nineteenth-century prints the registration marks can be seen in the margins.

Many artists from earliest times have used different techniques in combination. Jacques Callot (1593-1635) frequently added some engraving with a burin to his

Combined techniques, or mixed media

Hercules Seghers, *Mountainous Landscape with a Track*, *c*.1620. Combined techniques

etchings. Rembrandt, by about 1640, was increasingly making use of drypoint together with etching, and in some of his work drypoint predominates. He also used line engraving together with etching. Before him Hercules Seghers (*c*.1590-*c*.1640) used aquatint – otherwise unknown at the time – together with etching in his experimental proofs.[9] The most notable experimenter in the combination of totally different techniques was Edvard Munch, who for a single print employed relief, intaglio and lithographic processes together, frequently in colour.

New techniques

Sugar aquatint or *lift-ground etching (réservage, Aussprengverfahren, acquatinta allo zucchero)*. The basic principle of this technique has long been known, but its popularity is new. The drawing is done on copper with a pen or brush dipped in a solution of ink and sugar. When the drawing is dry the entire surface of the plate is covered with a liquid varnish. The plate is then immersed in hot water: the sugary solution in which the lines have been drawn melts and lifts the varnish so that the drawing shows through. The process then continues as for an ordinary aquatint. Sugar aquatint has been much used by Rouault and Picasso.

Silkscreen (sérigraphie, Siebdruck, serigrafia). This technique was common in China centuries ago; after the First World War it was imported, via Japan, into the United States, where it was improved and subsequently it became known in Europe. A fabric screen with a fairly open weave, possibly nylon, is stretched

[9] More details and precise information on the complex techniques of the great Dutch master will be found in E. Haverkamp, K.G. Boon and J. Verbeek, *The Graphic Work of Hercules Seghers, The Complete Etchings* (Amsterdam 1971).

Pablo Picasso, *The Wasp*, 1941.
Sugar aquatint

over a wooden frame, and the parts which are not to be printed through are covered with a varnish. The paper to be printed is placed under the frame and receives the colour when it is drawn across the *screen* (*pochoir*, *Sieb*, *setaccio*) with a rubber blade called a squeegee. The white areas in the print correspond to those parts of the fabric protected by the varnish. This process differs completely from the classic ones we have described. It does not require the use of a printing press, and with the aid of a few technical devices it can give an almost unlimited number of impressions and is therefore particularly good for commercial use. The French *pochoir* or stencil method (*Schablone*), used for colouring popular prints in France in the fifteenth century, is very similar.

III Complementary terminology

In addition to the terms used in connection with engraving techniques there exist a number of others which are complementary and which one must know in order to be able to read and understand catalogues.

Bevelling (*biseautage, Unfacettierung, bisellatura*). The edges of the metal place are blunted by rounding them off with a file, in order to prevent the paper from being torn while the press is operating.

Biting, rebiting (*morsure, remorsure*; *Ätzung, Nachätzung*; *morsura, rimorsura*). We have seen how the acid bites the plate where the varnish has been uncovered by the etcher's needle. The depth of the mark depends on various things: the concentration of the biting agent in the liquid used, the duration of immersion, which can be from a few minutes to several days, the way in which the bath is prepared, the temperature, etc. The repeated biting processes which the artist uses in order to reinforce the lines on his plate, to achieve the effects he wants, have nothing to do with the 'rebiting' practised by owners of old, worn copperplates which they want to re-use, perhaps retouching them and reprinting numerous impressions. It is naturally more difficult to achieve good biting on iron, which is harder than copper; on zinc it is easier, though prolonged biting tends to widen the engraved lines.

Broadsheet (*Flugblatt, volantino*). Popular woodcut of the fifteenth and early sixteenth century.

Cliché-verre. This is really an engraving technique, discovered in about 1850. A piece of glass is covered with a black emulsion, and then scratched with a needle as in an etching. The printing process is exactly like a photographic procedure, starting with a negative: the drawing is in fact transferred on to paper which is sensitive to light. Jean-Baptiste-Camille Corot (1796-1875), who was gifted with a high degree of graphic sensitivity and yet not at all expert in the art of engraving, produced at least sixty-six *clichés-verre* between 1853 and 1874. Brunner rightly points out that if this technique were practised today it would no longer be recognized as 'original'.

Coloured print (stampa colorata). Different from 'colour print' in that the colouring is added by hand.

Counterproof (contre-épreuve, Gegendruck, controprova). If pressure is applied to a print while the ink on it is still wet, it will produce an impression, in reverse and a little fainter. This impression can be used by the artist when he wants to alter or correct any marks, for they are reproduced on the counterproof in the same way, i.e. back to front, as they appear on the engraved plate.

Fine manner, broad manner (manière fine, manière large; feine Manier, breite Manier; maniera fine, maniera larga). Fine manner is a burin technique which must have originated in that used by Italian goldsmiths especially between 1460 and 1480. Short parallel lines, close together and sometimes crossing, give the print the appearance of a tonal drawing. Broad manner, developed after fine manner, can be distinguished from it by the fact that the lines are further apart, so that the engraving looks more like a pen-drawing.

Among fine manner prints are those known as the Otto prints (*c.* 1465-80), which are mostly circular, and the first states of the *Prophets* and *Sibyls* series (*c.*1470), the latter by an anonymous Florentine master. The burin engravings of Andrea Mantegna (1431-1506) are in the broad manner.

Heliogravure (héliogravure, Heliogravure, eliografia). This old French process, based on the aquatint, was very slow, although it gave good results in reproduction. Today it is done with rotary presses with galvano-plasticized cylinders, on which the engraving to be printed is transferred photo-mechanically.[1]

Incunabulum (incunable, Inkunabel or Wiegendruck, incunabolo). This term covers printed books before 1501, and documents relating to the very early history of anything. In printmaking, it is the generic term for any relief or intaglio print made in the fifteenth century. A woodcut incunabulum may be a leaf from one of the early book of woodcuts (blockbooks), which often had illustrations and text printed on the same page. The text was printed from characters cut in the block, not from the movable type whose invention in about 1450 is attributed to Johann Gutenberg. (It is certain that the Chinese had some form of movable type earlier than this, although their invention had no sequel, for their technique must have remained at a rudimentary level.)

Considerable critical and scientific work has been done on the dating of most of the woodcut books:[2] here it is enough to recall that books like the *Biblia pauperum*, the *Canticum canticorum* and the *Ars moriendi*, at one time thought to have been first printed in the years 1440-50, have recently been postdated, to 1465 for the former and about 1466 for the other two, on the basis of a radiographic examination of the watermarks and dating of the paper by means of Carbon 14 tests.

Maculature (stampa maculata). In normal printing, the master must be inked after each impression. A print taken accidentally without re-inking is called a maculature.

[1] Felix Brunner, *A Handbook of Graphic Processes*, 3rd ed. (Teufen, Switzerland, 1968), p. 162 ff.
[2] Hind, *Woodcut*, op. cit., vol. I, pp. 207-64; vol. II, pp. 273-362. Also Allan Stevenson, *The Quincentennial of Netherland Blockbooks* (catalogue of an exhibition at the British Museum, London, October 1966).

Master of the Ravenna Last Supper, *The Last Supper, c.*1470. Woodcut incunabulum

Monotype (*monotype, Monotypie, monotipo*). This is usually, but not always, a single print obtained from an inked plate. The first person to adopt this practice was probably Giovanni Benedetto Castiglione, called Grechetto (1616-70). William Blake's colour monotypes are famous; subsequently Edgar Degas (1834-1917), Paul Gauguin and others distinguished themselves in this technique, in black and white.

Offset. This is an indirect lithographic procedure, and therefore cannot be considered as original. A zinc plate is bent round the cylinder of a printing press and the impression is transferred on to another cylinder, of rubber, and then from this on to the paper. Machining is very rapid and thousands of sheets per hour can be run off; offset should be used only for commercial purposes. It is difficult, as Brunner notes, to distinguish an offset lithograph – now often called 'original' – from a lithograph produced by an ordinary press. A strong magnifying glass and long practice are needed to discern that the film of ink is thinner and less shiny than in a traditional lithograph.[3]

Plate cancelled (*cuivre rayé, Platte zerstört, biffatura*). Present-day engravers normally score through their plate with engraved crosses, once printing has been completed, or at any rate with some engraved sign to indicate that, as far as the artist

Enea Vico, *The Rhinoceros*, 1640. Line engraving: the plate was copied from Dürer's broadsheet, and the impression therefore appears in reverse from the original

[3] Brunner, op. cit., pp. 191-2.

Anonymous Venetian master, *St Anthony of Padua*, *c*.1460-70

Anonymous Florentine engraver,
Gentleman, Lady and Musician,
c. 1470-80, one of the so-called
Otto prints. Fine manner engraving

is concerned, the edition is terminated. [4] In lithography, the surface of the stone can be reclaimed, destroying the previous image.

Platemark (témoin du cuivre, Plattenkante, impronta del rame). This is a depression in the paper surrounding the printed area: it is visible in intaglio prints, especially if they have been taken from plates which are not too worn. It is not to be seen on relief or surface prints, unless it has been artificially produced.

Popular print (image populaire, stampa popolare). A type of print dating back to the fifteenth century, made by a craftsman rather than by an artist; frequently a reproduction of a religious painting. Such prints are very rare today and are sought after by some collectors.

Poster (affiche, Plakat, manifesto). Posters were in widespread use in France during the second half of the nineteenth century. Sometimes of real artistic value, these posters, which are often in colour, were, because of their large dimensions, frequently printed as lithographs from zinc plates.

Signed in the plate or stone (firma rovesciata). The artist's signature appears back to front on the original when the artist, having engraved the plate in reverse, has absent-mindedly written his signature the right way. The appearance of this error

[4] Giorgio Morandi, before depositing his copperplates at the Calcografia Nazionale in Rome, used to mark them with serial numbers in roman.

is particularly valuable when the matrix used was metal, since it would then be logical to suppose that the artist himself engraved the signature.

Steelfacing (aciérage, Verstählung, acciaiatura). In this process, which is used to give plate a uniform hardness, a thin coating of iron (now more usually chrome or nickel) is deposited on the surface of the copper plate by electrolysis, a principle discovered in England in 1800 and perfected in 1832 by the physicist Michael Faraday. The outstanding example of steelfacing in the history of prints is found in the graphic work of Goya: the first edition of the *Desastres de la Guerra* (H. 121-200) appeared in steelfaced form in 1863, published by the Calcografía de la Real Academia de Madrid, followed in 1864 by the first edition the *Disparates* or *Proverbios* (H. 248-265); the *Tauromaquia* was steelfaced in its third edition, Paris 1876, by E. Loizelet; the copperplates for the *Caprichos* (H. 36-115), which had deteriorated because of the number of impressions taken, as had the copperplates for the *Tauromaquia*, were steelfaced for the fourth edition, published by the Calcografía of Madrid in 1878.

Today steelfacing is commonly used both for large and small editions, especially where the printing is carried out in a large establishment. The reasons for employing it are obvious: the copper in use today is perhaps more fragile than that used in the past, making the printer's task difficult; and, what is more important, steelfacing allows for very easy and rapid printing. Engravers who cling to the old methods point out, not altogether incorrectly, that the impression taken from a steelfaced plate is colder, less soft than that taken from a plate which does not have the thin protective film of steel. Steelfacing is today also used for drypoint and gives a print of uniform quality, avoiding the rapid deterioration of the velvety parts. Should the engraver discover some imperfection in the print he is still able to correct the plate by removing the metal film, using the reverse electrolysis process, and then having it steelfaced again.

Trial proof (épreuve d'essai, Zustanddruck, prova di stato). This refers to a print – sometimes more than one – which the engraver produces so that he can check one or more impressions before normal printing. These trial proofs were and still are much sought after. Sometimes they are inferior in quality to subsequent or definitive states, but trial proofs by some old master engravers fetch exceptionally high prices.

Xylography. A term no longer in current use, applied by some to early woodcuts and by others to any print made with wood.

Part I

A SHORT ANATOMY OF ENGRAVING

I Paper

Jost Amman, *The Papermaker,*
c.1565

Paper (papier, Papier, carta). Man's need to communicate to his contemporaries and to posterity those things which he thought should be known and preserved spurred him into seeking the most suitable means of achieving this objective. The first real pictures he made are found scratched on the walls of prehistoric caves. It is not known how many millennia passed between these already refined graffiti of the Palaeolithic age, when Aurignacian art was flourishing in the Dordogne, and the papyrus which was certainly in use in Egypt around 3000 BC, under the First Dynasty. Papyrus (from the Greek *papyros,* hence the word *paper*)[1] was made by placing together and then steeping reeds of *cyperus papyrus,* which grew wild along the banks of the Nile and the Euphrates. The use of papyrus quickly spread among the most advanced neighbouring peoples: it reached the height of its splendour at Alexandria which, after the death of Alexander the Great, became the most important centre of ancient civilization. Here, in 300 BC, Ptolemy Soter had founded a famous library. Two hundred and fifty years later, at the time of Julius Caesar's conquest of Egypt, the entire library was burnt: the loss of its five hundred thousand scrolls of papyrus, which contained all the knowledge which had accumulated in the Mediterranean over the centuries, was an irreparable disaster. Gradually papyrus became less and less common, and in the early Middle Ages it was replaced by a more practical means of transmission, *parchment (parchemin, Pergament, pergamena).* The name comes from Pergamum, the city in Asia Minor where it was first made in the second century BC. Parchment is made from the skin of a lamb or a sheep, ironed out until it is a thin, smooth membrane. Unlike papyrus, it could be used on both sides. It was in use in Europe up to the fifteenth century.[2] *Vellum (vélin, Velin, velina),* made from the skins of young animals, continued in use longer and was employed – though rarely – by Rembrandt and a few other artists.

In Central America the Aztecs and Mayas, even before the Spanish Conquest, were making paper out of the inside of the bark of fig trees, and using it for writing their ideograms, for drawing on, and even for making garments.[3]

[1] Writing on papyrus was called *biblos,* hence the word Bible.
[2] Parchment made from chemically treated paper is totally unlike that made from animal skin.
[3] George Biörklund and Osbert H. Barnard, *Rembrandt's Etchings, True and False,* 2nd ed. (Stockholm 1968). The chapter on 'Old Paper' by Biörklund, pp. 165-73, is in spite of its brevity an original contribution to the study of ancient paper, and of oriental paper in particular.

In ancient China, silk was used, or bamboo canes tied tightly together. In AD 105 the first paper was made, by an important official whose duties corresponded to those of a modern minister of agriculture, one Ts'ai Lung, mentioned in the history of the Han dynasty. That the invention of this 'divine art' – as it was called in 1693 by the French Jesuit Father Imberdis – dates back to the beginning of the second century is proved by the existence of several written pages, today preserved in London, which were discovered just over fifty years ago in some old towers on the Great Wall.[4] The raw material used by Ts'ai Lung must have been of different kinds of bark mixed with other organic substances, such as pulped fishing-net. We can only guess at the earliest manufacturing processes, but presumably by the end of the second century the raw material, in particular the bark of the mulberry tree, was pulped in tubs full of water. The paste thus obtained must then have been spread over a porous fabric which acted as a sieve, and which was stretched over a frame of bamboo canes. The paste was then pressed and finally left to dry in the sun. The paper thus obtained, though somewhat coarse, must have been similar to our *wove paper (papier vélin, Velinpapier, carta velino)*, which was first manufactured in Europe towards the end of the eighteenth century and which when held against the light does not show any lines. Subsequently, the Chinese improved their invention, replacing the early kind of frame with a square 'mould' to which was fixed a trellis of bamboo canes tied tightly together with silk thread, camelhair or horsehair. The pulp itself was rendered more solid by the use of starch. The result of this improved process was similar to the paper later used in Europe, called *laid paper (papier vergé, geripptes Papier or Büttenpapier, carta vergata)*, which has equidistant parallel lines across it, called *laid lines* or *wire lines (vergeures, Längsrippen)* which themselves are crossed by others, also equidistant but much closer together, called *chain lines (pontuseaux, Querrippen)*. (In Italian, both types of line are called *vergelle*.)

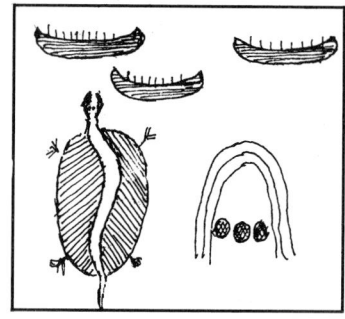

American Indian pictographs of the late eighteenth century, representing an expedition by an Indian tribe across a lake in three canoes. The upright lines on each of these indicate the crew; the three circles, that the journey lasted three days; the turtle symbolizes successful landfall

The Chinese kept this invention of theirs a secret for more than five centuries, until it was imported into Japan, via Korea. However, some people maintain that already a century earlier, at the beginning of the seventeenth century, a Buddhist monk called Doncho had introduced it there from Formosa. It is in any case certain that the art of paper-making did not come west by way of the 'silk route' which had linked China and Persia since the second century BC. It was not until later, following an armed conflict between Persians and Chinese, which took place in the year 751 in the province of Khurasan, on the farthest frontiers of the ancient Chinese empire, that the capture of some prisoners who happened to be papermakers by trade enabled the first paper mill to be built at Samarkand. A few years later, when another paper mill was built at Baghdad, the Abbasid Caliph Haroun al Raschid was able to order the use of paper for all official documents that were issued in his empire. Shortly after that, Egypt began to import paper and by the year 900 it was already manufacturing its own. There was a paper mill in operation at Fez by AD 1100; 51 years later the Arabs built the first one in Europe, at Játiva near Valencia in Spain. This paper was so highly prized that when, a century later, the Catholic kings drove the Moors out of that region, the Muslim papermakers were offered special privileges, provided they agreed not to abandon their mill. Paper had already been imported into Sicily for perhaps two centuries when in 1276 a papermill was founded in Italy at Fabriano: it was to become the most important in Europe. In 1391 papermills were established at Troyes, and shortly afterward Nuremberg had a mill, built

[4] Adolfo Annesi, *La nobile arte di fabbricare la carta* (Tivoli 1969), p. 13.

probably in part by Italian workers.[5] In the Americas the first mill was in Mexico
in the sixteenth century; 150 years later another was built on the banks of the
Potomac, a few miles from the site of the future city of Washington was later
constructed.

The paper manufacturing process in Europe was much the same as it had been
in ancient China. However, the Arabs made an important improvement at Játiva
with the introduction of a mill to break down the fibres used. Later, special
chemical washes were introduced to remove impurities, and also felts which, placed
between one sheet and another, prevented them sticking together and thus
speeded up the work. It was not until the seventeenth century that these felts
were made from special materials which did not leave hairs pressed into the
paper. The illustration of *The Papermaker* (B. 381,8) by Jost Amman (1539-91)
shows in synthesis the manufacturing process after the rags, of vegetable origin,
which have first been fermented in water for several weeks and then reduced to a
pulp, are immersed in vats. The mould which can be seen consists of a rectan-
gular frame protected at the sides by a rim which prevents the still soft pulp from
spilling over the edges. Thin metal wires are attached to the mould, arranged
vertically and horizontally, forming a mesh.

Up to quite recent times, supplies of raw material were a serious problem and
lack of them often brought about closures and bankruptcies in the industry.
Therefore for centuries, and still in the nineteenth century, trade in rags and
organic materials of all kinds, including ship's hawsers and rope soles, flourished
on a large scale, side by side with the papermaking industry. The paper I have so

[5] Ibid, p. 63 ff.

39

far described was made by hand, with processes which remained practically unchanged until 1800. Today these methods are used only in a few establishments making special papers which are of high quality and of course expensive, intended for limited use, for de luxe editions, and for prints and drawings. With the invention of the 'continuous machine' in 1798 by the Frenchman Louis Robert, production increased enormously – more than thousandfold in the space of a few decades – in particular to meet the demand created by the increasing circulation of newspapers. Consequently, even for the cheaper qualities of paper there was a sharp drop in costs, which had also occurred many centuries earlier when paper, instead of being imported from North Africa, began to be manufactured in Europe.

Paper for printing must be structurally homogeneous and solid. As well as being free from impurities, it must be sufficiently porous to absorb the printing ink, and yet dense enough so as not to give rise to stains when it is subjected to pressure by the printing press. The best kind used in Europe was the old laid paper. First the Italians and then the French excelled in its manufacture. The high quality paper once known, incorrectly, as Dutch paper, which was prized in all countries, was not produced in the Netherlands until towards the end of the seventeenth century. Before that it had been imported there in large quantities from France where, according to Biörklund, 'Dutch paper importers owned or controlled not less than 175 papermills, ... mainly in Champagne, Auvergne and Angoumois.' These Dutchmen were mostly Protestants of French origin, who had emigrated in the wake of the wars of religion. The French laid paper, used in Holland and also re-exported, was then called *papier de Hollande* in France and *holländisches Büttenpapier* in Germany, as a definite mark of superiority.

At this point I must mention Japanese paper (at one time incorrectly called 'Chinese' by the French), of interest above all because it was used by the best European engravers over six hundred years. While the art of papermaking was slowly declining in China towards the year AD 1000, in Japan a golden age was beginning. The cultivation of the mulberry tree was intensified, and joined by that of other plants such as *gampi (wikstroemia canescens)*. By processing the fibres taken from the inside of the bark, the Japanese produced the 'queen of papers', which remained for many centuries without rival in the whole world for its toughness, density and glaze.

After the expulsion from Japan of the Portuguese and Spanish in 1639, only the Dutch were allowed to stay, on the small island of Deshima in Nagasaki harbour. Trade was limited until the ultimatum by Commodore Perry, Commander of the American fleet in the Far East, opened up the empire's ports to Europeans after 1854. The documents of the Dutch East India Company, which had been kept at Deshima, were taken in the nineteenth century to Batavia on the island of Java, and then sent to Holland where in 1909 they were placed in the archives of the Algemeen Rijksarkief at The Hague. Among the papers, which concern the Company's trade in Asia and to a lesser extent in Holland, was found a single invoice dated 1 October 1643, which mentions a shipment – never repeated, it seems – via the sailing-ship *De Swaen*, of two cases carrying 3,000 sheets of Japanese paper, destined for the Indies and Holland. Then for another two centuries no more Japanese paper arrived in Europe.[6]

It is certain that Rembrandt bought a large quantity of this paper, perhaps all of it. It was used practically only by him, then by his pupils and a few others after him. The paper, without lines or watermark, is fairly thick and of a warm colour, somewhere between white and amber. Rembrandt used it for the first, experimental proofs of those print states which were most important to him. Other kinds of paper that he used, with astonishing results, include parchment but also a coarse paper known incorrectly as oatmeal paper, India paper, whose fibres are yellowish (this he used less often), and yet another kind, very thin, called Chinese, which must also have come from the East. For the first two states of the portrait of the painter *Jan Asselijn* (B. 277), of c.1647, the artist for the first time used four different papers – Japan, oatmeal, India, and French laid – and also vellum.[7]

Types of paper similar to Japanese, and called Japanese, were subsequently manufactured in Europe, particularly in France in the nineteenth century. A thin China paper was also manufactured, and often used for pasting on to another, thicker paper.

Meanwhile, towards the end of the eighteenth century, wove paper without lines was being made in Europe in increasing quantities. The moulds employed in its manufacture were of course solid. In the same papermills they were also making a soft, absorbent laid paper, used especially for large colour or black and white prints, as can be seen in some Parisian editions of Piranesi's works. In about 1830 wove paper also began to have lines and watermarks. In fact it quickly became a good substitute for the old laid paper. Around the middle of the century the raw material, which had formerly been pure fibre, was steadily being replaced by cellulose.

[6] As well as the information supplied by Biörklund, op. cit., see the interesting notes on oriental paper by Sue W. Reed, in particular on the possible arrival in Amsterdam, after the cargo of the *De Swaen*, of another small quantity of Japanese paper, in *Rembrandt: Experimental Etcher* (catalogue of an exhibition held in Boston and New York, October 1969-January 1970), pp. 178-80.
[7] D. de Hoop Scheffer, *Rembrandt's Etchings* (Amsterdam 1969).

The formats used by paper-makers through the centuries, standardized at various times in the different regions of Europe, are not of particular concern here. One of the largest sizes is *imperial*, about 74×50 cm (30×22 inches) – Piranesi's famous 'Atlantic' sheet. The surface area of the *royal* is almost two-thirds of that of the imperial; and there are also smaller sizes, such as *demy, crown* and *medium*.

An expert can determine the age of a piece of paper if he has long practice and sometimes the gift of special sensitivity. The American Gustav Mayer possessed this sensitivity to a superlative degree: however impossible it may seem, he was able to judge, approximately at any rate, the age of a sheet of paper from its vibration. Chemical analysis or examination under a microscope, carried out in a fully equipped laboratory, makes it possible to discern the presence of traces of cotton fibres, which are found in paper made from 1800 onwards; it also allows ancient oriental papers to be distinguished from similar ones manufactured at a later date in Europe.[8] But even with these scientific methods it is difficult enough to detect the almost imperceptible differences which exist between linen and hemp fibres, both present in old papers; and it is almost impossible to ascertain the age of papers made during the centuries in which the composition of paper remained almost unchanged.

[8] Biörklund and Barnard, op. cit., 'Paper Analysis', pp. 175-80.

II Watermarks

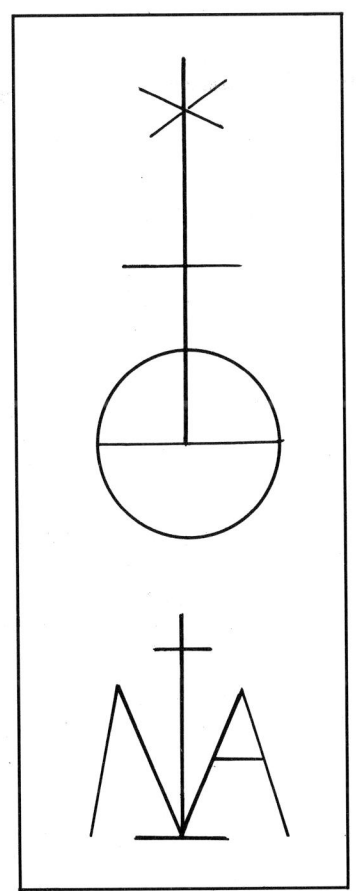

Imperial orb with line and star watermark (D. 4.4 cm: 1³/₄ inches), characteristic of the paper on which Dürer's engravings were printed c.1520-25
Name of Mary watermark (H. 4.8 cm: 1⁷/₈ inches), found in the paper of various woodcuts from the 1511 edition of Dürer's three great books

Watermarks (filigranes, Wasserzeichen, filigrane) are an important characteristic of European paper. At one time they were produced by a very fine wire shape, sewn with horsehair to the mould used in making the paper. Since the introduction of the 'continuous' machine in the nineteenth century, the wire has been welded to the dandy roller, so that the design is still impressed in the paper. When older paper, made when manufacturing processes were less refined than they are now, is held up to the light, it is seen to be very slightly thinner and more transparent in the vicinity of the watermark and the laid lines.

The Italian papermakers of Fabriano were the first to use watermarks. When Briquet[1] was examining some Italian paper in the State Archives in Bologna, he found a watermark in the shape of a rough Greek cross which he dated at about 1282 and reproduced as no. 5410 in the second volume of his famous dictionary of watermarks. It was, he considered, the oldest watermark he had found in thirty years of research in the major archives of Europe.[2]

There have been many theories about the possible significance of these designs that appear in paper, including the suggestion that the designs might have been of a symbolic or secret nature. Finally it was concluded that the sign had probably originally served as a protective trademark, as an indication of the provenance of the paper, or perhaps as a tribute to some important personage, since many watermarks depict regional designs, initials, arms or emblems. Each papermill tended to use special watermarks which were sometimes peculiar to the town or region where it was situated. Among early Italian marks, in addition to the Greek cross already mentioned, are the bow and arrow, the hammer and

[1] C.M. Briquet, *Les Filigranes*, 4 vols. (Leipzig 1923). In this monumental work the author reproduces in facsimile, comments upon and assigns a date to 16,112 watermarks examined by him on paper manufactured in Europe between 1282 and 1600.
[2] See Carlo E. Rusconi, *Carta* (Turin 1955), p. 38, for the recent rediscovery by the librarian Meroni of three sheets dated 1271, in a codex kept in the archives of the Cremona hospital. These sheets bear a watermark similar to one which Briquet includes in a group of watermarks under nos. 8145 and 8148, and which dates back to between 1314 and 1322-35. Meroni's watermark, which has an extra F, points to the probable existence in Italy of other papermills unknown to us, which were built before the one established at Fabriano in 1276, since the sheets in question are of an earlier date.

anvil, the spoked wheel and the scales. In the eighteenth century in central Italy the fleur-de-lys in a single or double circle was widely used and was a variation of a device which had been in use centuries earlier.[3] In the Veneto in the same century the three crescent moons, the letter R and various other watermarks were common and are found for example in papers used by the two Tiepolos and by Canaletto. Other recurring watermarks are the sixteenth-century lion and shield from Zurich, and the cross from Basle; the ox-head and the high crown, both from Germany; and in France the cogwheel and the double C entwined round a cross of Lorraine. In French seventeenth-century papers, particularly those sent to Holland which was then the centre of European engraving, the foolscap *(folie, giullare)* watermark frequently appears, as does the arms of Amsterdam mark. Later, a watermark from Auvergne became common: T followed by a drawing of a bell and FIN/DUPUY/AUVERGNE 1742. The figures refer to the date when the paper was first manufactured, but the watermark must have been in use for a very long time, the original wire shape having been replaced when it wore out. Sometimes it appears without FIN (which refers to the quality), as in the rather soft laid paper used for the first Parisian edition of the works of Piranesi, before the copperplates were sold to the publisher Firmin-Didot, father of the famous collector.

It is obvious, therefore, that watermarks can be helpful in determining the age of a sheet of paper, and consequently of a print, provided that careful judgment is exercised when examining them. However, a few cautionary remarks ought to be made here.

Since watermarks are impressed in the paper at regular intervals they may appear whole on the engraving, but on the other hand only part of a watermark may be visible, if it occurs near the edge of the print, or it could be missing altogether in the case of a small print.

The metal wire sewn to the mould eventually wore out: it was then often remade in exactly, or nearly exactly, the same way, thus giving a watermark which, being practically identical with the preceding one, could easily deceive anyone trying to date a sheet of paper.[4]

Some watermarks have hundreds of known variants: for example, for over two hundred years, from the end of the fourteenth century to the beginning of the seventeenth, the Gothic p was used in various designs, all of which can be dated approximately. Briquet writes that in 925 documents he has found at least 325 crown with diadem designs. He describes 200 of them, dating them between 1474 and the end of the following century. He also describes and reproduces 1,391 ox-head watermarks.

Ox-head with line and cross watermark (H. 4.5 cm: 1³/₄ inches – Briquet no. 15035), *c.*1495-1510

Other watermarks, such as those in the seventeenth-century French paper sent to Holland, are sometimes found in conjunction with another design, or with the addition of apparently insignificant details: each one must have been in use during a particular short period. The foolscap watermark already mentioned (Churchill 335-64)[5] was current during the whole of the seventeenth century, while the arms of Amsterdam mark, which is found far more frequently (78

[3] Andrew Robinson, *Giovanni Battista Piranesi: Prolegomena to the Princeton Collections* (New Haven 1970). The author, who over a long period has carried out a detailed study of the watermarks used by Piranesi, writes that instead of the eight watermarks (three contemporary, three posthumous from Rome, two from Paris) reproduced by Arthur M. Hind in *Giovanni Battista Piranesi. A Critical Study* (London 1922), p. 34, he himself has so far found over fifty, presumably all similar.
[4] Briquet, op. cit., vol. I, p. XIX
[5] W.A. Churchill, *Watermarks in Paper in Holland, England, France, etc., in the XVII and XVIII Centuries* (Amsterdam 1935). A useful book with interesting information, though not as up to date as the more recent *Watermarks, mainly of the 17th and 18th centuries*, by Edward Heawood (Hilversum, 1950), which reproduces and catalogues systematically over 4,000 watermarks.

Enlargement of the upper part of Dürer's engraving *St Jerome in Penitence* (reversed, to show the watermark). The laid lines of the paper are clearly visible, as is the watermark of a Gothic p with flower and knot, which is a feature of the fine proofs (Meder quality B) of this print. Early sixteenth century

Watermark with double C intersecting the cross of Lorraine (H. 7 cm: 2³/₄ inches). Early seventeenth century

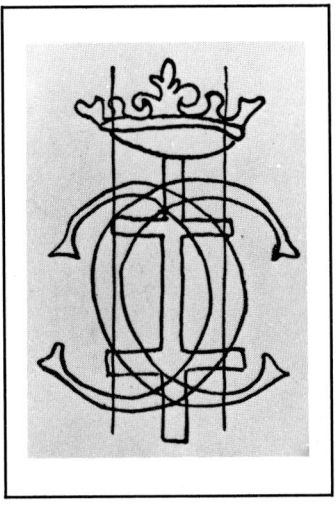

examples are known), was in use between 1635 and 1781, and the 'Seven Provinces' mark occurs in paper produced between 1656 and the beginning of the nineteenth century.[6]

Although in the past papermakers almost always produced paper to order, there were nevertheless occasional cases of speculative buying and accumulation of stocks, and this has sometimes led to the rediscovery of considerable quantities of sheets which, if not actually antique, are certainly very old.[7]

These remarks on the difficulties arising out of an over-hasty examination of watermarks are not intended to discourage the amateur but should persuade him of the importance of making a careful and thorough examination of the paper in question. It is clear that a reference in a catalogue to a Gothic p watermark in an engraving is of scarcely any value at all in determining the age of the print unless a reference is also made to the relevant number in Briquet or another manual. A specific reference, for example to Churchill no. 355, which is a particular variant of the foolscap mark found in a manuscript of 1656, is of real use.

Lehrs and Hind in their encyclopaedic catalogues of Northern and Italian primitives reproduced the early watermarks which occur most frequently in prints, referring back whenever possible to Briquet's work. Research into the earliest watermarks, of the fifteenth and sixteenth centuries, has tended to be more thorough and therefore it is possible to date papers from this period more accurately than those from the following century when, with the increased number of papermills, there was greater likelihood of identical or similar watermarks being produced by different manufactures, possibly at different times.

When it comes to the seventeenth century, in addition to the work by Churchill and Heawood research has also been done by the authors of catalogues

[6] G. Biörklund, op. cit., 'Watermarks', pp. 181-2.
[7] A few years ago two volumes were sold at Sotheby's containing many sheets of blank paper bearing the characteristic watermark of the fleur-de-lys in a double circle used by Piranesi.

46

Albrecht Dürer, *St Eustace, c.* 1501.
The lines in a burin engraving are
much finer and more varied and
produce greater contrast than those
in a woodcut: this is visible even in
a reproduction

raisonnés of the graphic work of individual artists. For example, Lieure made a study of the watermarks in paper used by Callot, although on some points he is not entirely convincing; Marie Mauquoy-Hendrickx made an exhaustive study of the paper used in the various states of the *Iconography* of Anthony van Dyck (1599-1641); and Godefroy reproduced some of the watermarks found in the etchings of Adriaen van Ostade (1610-84). Eighteenth-century paper has perhaps been a little more neglected, but on the other hand it has not presented insoluble or even very difficult problems, since the period is so much closer to the present day.

In England, from about 1794 onwards, some papermills, such as Whatman's, used as a watermark their own trade name followed by the year of manufacture, thus making it possible to determine fairly accurately the date when an impression was taken, since engravers or publishers did not normally keep stocks of paper but bought sheets as they needed them.

Finally, another important clue in dating a sheet of paper is to be found in the laid lines already mentioned, which are impressed into the paper in a similar way to the watermark. Although there is a clear difference between the types of paper and laid lines in use during the fifteenth and sixteenth centuries and those produced in the eighteenth, it is difficult to give any precise rules which will always hold good with regard to the width of the laid lines, for example, or the spacing between them, or the thickness of the paper. Once again, as in the case of other characteristics of prints, direct knowledge of the various kinds of paper is valuable, since the differences are of tactile more than morphological nature.

Examples [8]

ALBRECHT DÜRER

Joseph Meder describes, reproduces in facsimile and assigns a date to at least 356 watermarks noted by him in contemporary and posthumous impressions of Dürer's line engravings and woodcuts.[9] However, on page 293, he agrees with an observation made earlier by Hausmann, that Dürer himself did not use paper with more than twenty-one different watermarks. This observation was based mainly on a study of the paper used for the artist's drawings, as has been done in the case of seventeenth-century Dutch engravers, especially Rembrandt. At the beginning of the sixteenth century, paper used for line engravings was thinner and more opaque than that used for woodcuts.

St Eustace (B. 57, M., Holl. 60)
'Engraving, a very fine impression, rich in contrast and clear, a Meder D impression, on paper with the little jug watermark (M. 158).'[10] There follows a detailed description of damage to the engraving and of its provenance. It had been sold by Christie's in London on 25 June 1919 as having come from the collection

[8] Where examples are taken from sale catalogues, the city where the sale took place will indicate the firm: thus Berne for Kornfeld und Klipstein; Paris for Hôtel Drouot or Palais Galliera; New York for Parke-Bernet; but Sotheby's and Christie's of London will be mentioned individually, as will some other firms which are less frequently quoted. Prices referred to will be given in the original currency, if recent, with the equivalent value in dollars. (Sterling prices are given in pre-decimal form, i.e. pounds, shillings and pence.) It should be borne in mind that on the continent of Europe a variable amount of commission has to be added to the price: this is explained below in the chapter on 'The big auctions'.
[9] Joseph Meder, *Dürere Katalog* (Vienna 1932). This is a classic, exemplary model of a catalogue raisonné, complete and detailed in all the information it gives. Unfortunately, Meder's important and basic study, forty years after its publication, does seem in slight need of revision. In the same period five authors have added at least three new catalogues to the fourteen which already existed on Rembrandt's graphic work. Karel G. Boon pointed this out in the foreword to *Albrecht und Hans Dürer* (1960) vol. VII in the Hollstein series, which in particular updates certain information on the artist's woodcuts. The massive works *Kronen Wasserzeichen* (Stuttgart 1961) and *Ochsenkopf Wasserzeichen* (Stuttgart 1966) are more detailed studies on watermarks in old German paper. The latter work, in three volumes, contains illustrations of a thousand ox-head watermarks, all dated and subdivided into sixteen different types.
[10] Sotheby's 8 April 1970, £6,200 ($14,800). In *Print Prices Current* by F.L. Wilder and E.L. Wilder (London 1919), vol. I, p. 55, we read that £375 was paid for the engraving at Christie's in 1919.

47

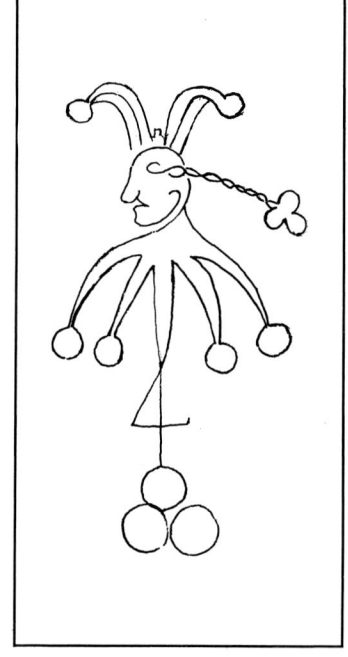

Canaletto, *Town on a Riverbank*, c.1743

formed in the eighteenth century by the Spencer family (Lugt 1532). Meder's no. 158 refers to variant 'd' of the watermark, which he dates at about 1525. This information has helped the cataloguer to give a very clear description of the engraving.

The example gives rise to several considerations:

That it is possible to find Dürer line engravings (this one was engraved c.1501) of excellent quality, good enough to satisfy the most demanding collector, which were nevertheless printed several years after the date when the engraving was actually made, or is presumed to have been made.[11]

That the lack of a watermark in early versions of certain line engravings, such as *The Knight, Death and the Devil* (M. 74), could lead to the possibility of B, C and D quality impressions, which Meder records as being without a mark, being upgraded to A. The difference in quality in these cases is discernible only by someone with a profound knowledge of Dürer's graphic work (see also below, p. 60).

That the price realized by this sheet, a sale record for a Dürer print in June 1971, could have been at least two or three times higher if it had been A instead of D and moreover in perfect condition.

JACQUES CALLOT

Many of Lieure's watermarks require critical revision. However, I shall limit myself to recalling the hunting horn mark,[12] which is often cited in catalogues as

Foolscap watermark (H. c.10 cm: $3^{15}/_{16}$ inches), similar to Churchill 355. From a manuscript of 1656

[11] The case of *St Eustace*, where a long period elapsed between engraving and printing, is of course unusual, for Dürer's prints or for any others.
[12] J. Lieure, *Callot, la vie artistique. Catalogue de l'œuvre gravé* (Paris 1924-27), 4 vols. See watermark no. 44.

Hans Baldung Grien, *The Witches,* 1510

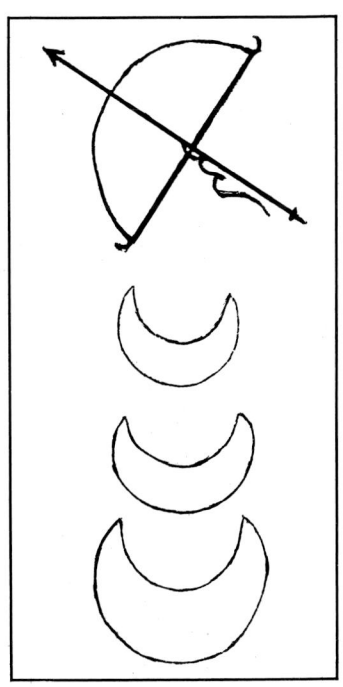

Veduta di Campo Vaccino

Giovanni Battista Piranesi, *View of the Campo Vaccino*, 1772

Below:
Aimed bow and arrow watermark (L. of arrow 4.2 cm: $1^5/_8$ inches) typical of Venetian paper of the mid-eighteenth century; and the three crescent moons watermark (L. 4.5 cm: $1^3/_4$ inches) typical of the paper used by Canaletto

die für die frühesten Drucke Verwendung fand (found in only the earliest impressions), although in fact it is common in the normal editions of the *Grandes misères de la guerre* (L. 1339 III, 1340-55 II/III, 1356 III). Callot etched his famous series in 1633, just before he was stricken with the fever that caused his death, and he entrusted the printing of the etchings to his old friend from Lorraine, the publisher and dealer Israël Henriet (1590-1661). After the artist's death, Henriet took charge of most of his copperplates, which were later inherited by his nephew Israël Silvestre (1621-91).[13] One cannot but presume that after Callot's death numerous other etchings were printed from his plates, with the same paper and watermarks.

REMBRANDT

The following case is of interest. Christopher White, on examining an impression of *Christ healing the Sick*, usually known as *The Hundred Guilder Print* (B. 74),[14] noticed a watermark similar to the one reproduced by Heawood under nos. 1780-85 and dated by him at 1670-80.[15] The print was described in a catalogue as follows: 'Etching, in the second state, with diagonal lines on the ass's back. A rather worn impression with touches of rework, but before Baillie's reworking.'[16] A note follows on damage and tears in the paper, and on Pierre Mariette's signature and the date, 1690, on the back of the print.[17]

[13] Jean Laran, op. cit., vol. 1, pp. 86, 94, 332, 394.
[14] The traditional, but unsatisfactory, explanation of the name *The Hundred Guilder Print* is that this etching was exchanged during the artist's lifetime for several engravings by Marcantonio Raimondi priced at 100 guilders.
[15] Christopher White and Karel G. Boon, *Rembrandt's Etchings. A New Critical Catalogue*, 2 vols. (Amsterdam 1970), text pp. 39-40.
[16] In the eighteenth century an Englishman, Captain William Baillie (1723-1810), came into possession of the original used plate, scraped most of the worn marks, and then re-engraved (not just retouched) the composition.
[17] Sotheby's, 21 March 1968, £750 ($1,800).

The watermark and the date written by Mariette on this sheet show that already in the seventeenth century the plate must have been badly worn. By comparing a photograph of this etching with the impression on silk kept in the Teylers Stichting Museum in Haarlem it might be possible to assign an approximate date to the latter, or at any rate to answer some of the questions raised by these impressions on silk, surely of posthumous date.

ANTONIO CANAL called CANALETTO

The three crescent moons, frequently referred to as being characteristic of the best contemporary impressions, also appear in the large second state etchings which were probably printed posthumously. Another watermark, not described by Pallucchini and Guarnati,[18] was found in the very fine early states in the Theobald collection (L. 1375), the complete album of which was auctioned in 1910 by Gutekunst in Stuttgart. The same collection reappeared in a sale at the Hôtel Drouot in Paris in 1962; unfortunately the purchaser broke up the volume in order to sell the individual etchings at a higher price.

GIOVANNI BATTISTA PIRANESI

Hind's watermark no. 3,[19] the fleur-de-lys in a double circle surmounted by a small design which looks like a letter B, is typical not only of the contemporary edition printed on thick paper but also of the edition printed by the artist's son Francesco, as can be observed in several sheets among the complete works housed in the Accademia di San Luca in Rome and which correspond to the general catalogue printed in French in 1792.

FRANCISCO GOYA

In the first edition of the *Caprichos*, 1799, the engravings were printed on laid paper without a watermark. From the second edition of 1855 to the ninth, 1908-12, wove paper without watermark is used, and after that various types of paper. All seven editions of the *Tauromaquia*, 1816-1937, are on laid paper, but it is only the first – the only one of artistic value – which has in several but not all of its prints the watermark MORATO or SERRA, and sometimes NOLO. The first edition of the *Desastres de la Guerra*, 1863, is on wove paper bearing the watermark J G O with palmette; the other six editions, all of inferior quality, are printed on either laid or wove paper. The first edition of the *Disparates* or *Proverbios*, 1864, is also on wove paper bearing the J G O and palmette watermark, and so is the second, numbered, edition of 1875. The six subsequent editions, of very poor quality, were printed between 1891 and 1937 on laid paper.[20]

Often an artist or his publisher will order expensive paper with a watermark which is partly to serve as a protective 'trademark' for the original edition: watermarked paper has in any case become traditional over the centuries. The 'Ambroise Vollard' and 'Picasso' watermarks are among the best known today.

Fleur-de-lys in a circle watermark (D. 4 cm: $1^9/_{16}$ inches) typical of paper used by Piranesi before about 1760. After this date the artist used paper with the double circle watermark

Modern watermarks

[18] R. Pallucchini and G.F. Guarnati, *Le acqueforti del Canaletto* (Venice 1944). For watermarks see pp. 40-41. It is well known that the unsigned *Vedute* etchings do not belong to the rare first states but to the late editions printed after the artist's name had been scraped off the copper.
[19] Hind, *Piranesi*, op. cit., p. 34.
[20] Tomás Harris, *Goya, Engravings and Lithographs*, 2 vols. (London 1964). See vol. II, pp. 63-71, 173-6, 307-12, 367-71. Examples of the first edition of the *Caprichos* are of such varying quality that some people think that a second edition (which Harris does not mention) was printed a few years after 1799, using paper identical to that used for the first edition. It is however probable that the first edition was slightly larger than is generally supposed and that after a certain number of impressions had been pulled the prints began to show the wear suffered by the copperplate.

III States

State (état, Zustand, stato). This refers to variations in the same design, engraved or drawn on the matrix by the artist or occasionally by someone else. After a print is completed, if it is not retouched in any way it is considered to exist in one state only; if various alterations have been made to the plate, several states are said to exist. In the fifteenth century it was fairly rare to produce more than one state of the same engraving, although there are examples by Martin Schongauer (*c*.1445-91), Israhel van Meckenem (*c*.1450-1503) and one or two others. It may be, however, that in those times it was not always the artist himself who retouched his plates, producing new states: they may in fact have been the result of an accident, or of alterations to the plate carried out by another hand.

Different states occur more frequently in the works of Dürer, particularly in his line engravings. Meder, in cataloguing Dürer's engravings and woodcuts, makes a clear distinction between the states that were deliberately produced by the artist and those which came about merely as a result of wearing of the plate. He prefers to call the latter variants, rather than states, and identifies them in alphabetical order. This is perhaps even more obvious in the case of woodcuts where, as we have seen when discussing printmaking techniques, any variation the artist might have wanted to make would have necessitated the laborious 'patching' of the matrix with a new block of wood. Therefore in Meder's system of alphabetical classification, the letters refer not only to the state but also to the quality, from A, meaning perfect, down through B, C, D, and so on.

However, by the seventeenth century it had become almost common practice to produce engravings in several states, partly because the technique of etching, which by then was widespread, makes alterations easy to carry out. The etcher can change his mind, cancel some lines, add others, and sometimes add entirely new figures to the plate, before arriving at the definitive state, which he judges to be the best one. Changes made to a composition are sometimes of such a radical nature that they seem to represent different plates rather than different states. One of the best known examples of this is Rembrandt's *Three Crosses* (B. 78): in the eighteenth century it was still believed that the artist had used a different plate for what is now known as the fourth state. Another example is the second version of Piranesi's *Carceri d'Invenzione* or *Prisons* (H. 1-16) which the artist produced in 1760 by making extraordinary changes to his first, brilliant designs of 1750.

In the seventeenth century and to an even greater extent in the eighteenth, engravers were sometimes persuaded to make alterations, in order to produce several states to satisfy the whim of a collector. Even in those days, when prints were not as highly valued as they are today, collectors were anxious to obtain the most rare state of an engraving. (Catalogues always indicate the existence of several states. For the classification of states by roman numerals see the chapter on 'Catalogues Raisonnés', below, p. 158, n. 5.) Thus it often happened that several states were produced which involved not so much variations in the design as details which were artistically irrelevant, such as the various inscriptions which are normally placed at the bottom of the print, within the platemark. In the very first state, the *proof before letters (avant la lettre, vor der Schrift, antilettera)*, the bottom margin – which is usually decorative in character and bears the title of the work and the names of the designer, engraver and publisher – is completely blank. The gradual addition of the description or title of the engraving, and of one or more names, produced different states (four, five, six or more) without any changes at all having been made to the picture area. So great was the desire in the eighteenth century to possess certain very early states that the practice of producing so-called masked proofs arose. This consisted in covering, during printing, any lettering which was not to appear on the proof, thus producing a spurious 'proof before letters' state.

It is essential for anyone studying graphic art to have some knowledge of states, to be able to tell whether these were the work of the artist or whether they were produced by another hand at some later date. Sometimes rarity and quality, the paper used or the collector's mark on the back of a print are important factors

Giovanni Battista Piranesi, *View of Paestum*, 1778. Trial proof before letters

Perspective du Pont de Dresde sur l'Elbe, ... tirée de la veue du Palais de S. M., dit
d'hollande avec la part. laterale ... de l'Eglise catolique et batimens contigüs.
Peint, desiné, et grav. par Bernard Bellotto dit Canalletto ~ 1749.

Bernard Bellotto, *View of the Bridge at Dresden on the Elbe*, 1748. First state out of four

in this connection; at other times they are not enough and the question mark remains. It is known for example that various etchings by Rembrandt exist in one state only, even if the plate was subsequently used again; others however are known to exist in several states. Some of these, which I shall discuss later, were done in the seventeenth century either by the artist himself or by others, while others date from the eighteenth century. The French collector Claude Henri Watelet (1718-86) owned about fifty of Rembrandt's original plates which had been bought at the Pieter de Haan sale in Amsterdam in 1767,[1] where apparently he had charged a certain Fouquet to acquire for him the plates which interested him most. It is certain that Watelet retouched several plates,[2] probably in some cases with drypoint, and he frequently printed versions with surface tone so as to make them seem like early prints, even on fairly close examination.[3] After Watelet's death, Pierre-François Basan (1723-97) bought many of his plates which he too retouched and etched again, as did his successors in the nineteenth century, with predictable results.

[1] A very rare copy of the catalogue of the Pieter de Haan sale (Amsterdam, March 1767), with many prices marked on it, can be seen at the Rijksprentenkabinet in Amsterdam. On pp. 231-4 are listed 76 *Kopere Konst-Platen door Rembrandt geetet*, with corresponding prints, sometimes as many as 80 per plate. After Rembrandt comes a list of plates and prints by the Dutch artist Jan van Vliet, a pupil of Rembrandt, by Cornelis Dusart, Nicolaes Berchem, Adam Elsheimer, Bloemaert, etc.
[2] Jean de Cayeux, 'Watelet et Rembrandt', in *Bulletin de la Société de l'art français* (Paris, June 1965), pp. 131-46, and 12 comparative plates.
[3] Christopher White, *Rembrandt as an Etcher*, 2 vols. (London 1969). See text p. 19, n. 28. White's study, exemplary for its clarity and depth of technical, historical and critical analysis, is indispensable for anyone wishing to have a clear understanding of the artist's graphic work.

Rembrandt, *The Three Crosses*, 1653. First state

The practice of producing various states, frequently by way of experiment, is also very common in the case of modern engravings. The etching and aquatint *Au Louvre: La peinture (Mary Cassatt)* (D. 29) by Edgar Degas is known in twenty different states. The drypoint by Muirhead Bone (1876-1953), *Spanish Good Friday*, must still hold the record at twenty-nine states – almost as many as the total number of prints taken – with the burr renewed in some parts. A change in the colour of the printing, as frequently happens in the case of combined techniques, also constitutes a new state. One of the most recent and most interesting examples of technical virtuosity is the lithograph *Le Taureau* (M..17) of 1945-6 by Picasso, of which eleven proofs exist, each one different from the others.[4]

Inscriptions. These as we have seen can determine a state. They are relevant to graphic art of the seventeenth century, and even more so to that of the eighteenth. *f., fec., fecit,* or *inc., incidit* or *inv(enit), delin(eavit)*, followed by a name indicates the author of the engraving or the artist who made the original design, even if it was in a different medium, such as a painting or a drawing

Opposite, above:
Rembrandt, *The Three Crosses*, *c.*1660. Fourth state

Below left:
Rembrandt, *The Three Crosses*, *c.*1660. Fourth state, detail

Below right:
Rembrandt, *The Three Crosses*, 1653. First state, detail

[4] Brunner, op. cit., pp. 19-21.

Above:
Rembrandt, *Ecce Homo*
(horizontal), 1655. First state
out of eight, detail

Right:
Rembrandt, *Ecce Homo*
(horizontal), 1655. First state
out of eight

Opposite:
Rembrandt, *The Three Crosses*,
c.1660. Fourth state, detail

Andrea Mantegna, *Battle of the Sea Gods*, left part of the frieze, 1493

exc(udit), *imp(ressit)*, *div(ulgavit)* followed by a name indicates the publisher
lith(ographavit) plus a name can refer to the artist who made the lithograph, or sometimes to the printer
cum privilegio regis or of some other authority (the Emperor in Germany, the Pope in Rome, Parliament in England) indicates a kind of 'copyright' protecting the publisher and the artist against plagiarism.

ANDREA MANTEGNA

Examples

The Battle of the Sea Gods, left hand part of the frieze (H. 5). A print sold at Berne[5] was described as being of 'outstanding quality', and important because it was complete and in good condition, which is rather rare for one of Mantegna's large prints. Eighteen months later the same engraving was up for sale at an important graphic art gallery in London, with a note to the effect that this was a hitherto unknown first state, before the addition of extra shading in the bottom right hand corner, a fact which neither Hind nor the later Swiss cataloguer had noticed, and which had probably been missed by the experts as well.

ALBRECHT DÜRER

Examples

The Knight, Death and the Devil
'Engraving, a very fine Meder A or B impression, trimmed to the platemark, with three horizontal foldmarks.' Collector's mark L. 1529 d.[6]

[5] Berne, 12 June 1968, 25,000 Swiss francs ($5,780).
[6] Sotheby's, 29 June 1965, £2,600 ($7,280).

Opposite:
Albrecht Dürer, *The Knight, Death and the Devil*, 1513

59

Variants A and B are here used again to connote quality. The uncertainty of the cataloguer, who was aware of Meder's description, is evident. In such cases, anyone reading a catalogue, regardless of how scrupulous the expert has shown himself, will definitely take the inferior state or quality as the one to go by – in this case B. A well-known cataloguer recently described an impression of *St Jerome in his Study* (M. 59) as being between Meder A and E, that is, between the date when the engraving was done, 1514, and 'after 1550'. To be precise, according to Meder's accurate and meticulous classification (M. 260, p. 316), it should have been between 1514 and 'about 1560', a very approximate date at which certain plates of Dürer were still giving *kräftige Abdrucke* (strong impressions), that is to say clear and with good contrast.

REMBRANDT

The Three Crosses

'Hind's fifth state of five, a very good impression of this state, with very considerable burr... From the Collections of J. Peoli (L. 2020) and A. Firmin-Didot, with two unidentified collectors' marks, Alexander J. Godby, sale, Sotheby's, 29-30 January 1935, lot 75.'[7]

The fifth state bears the name and address of Frans Carelse, who may have been active in Rembrandt's lifetime. The mention of burr ought to leave us somewhat perplexed, considering that several impressions exist of the fourth state, which was the last to be done by the artist. However, another sheet of the same state, in the Kupferstichkabinett in Dresden, is also described as being very rich in burr.[8] The Carelse state is not common, but it is not more rare than the others, as was formerly believed. In 1960 an example which had previously been in the Duke of Buckingham's collection (1834) was sold in Berne; several others can be found listed in various old catalogues, such as John Barnard's (1798), no. 110. Other fifth state impressions are in the Uffizi in Florence, the British Museum, etc.[9]

GIOVANNI BATTISTA TIEPOLO (1696-1770)

The Adoration of the Magi (V. 1)

'Etching, first state before numbers, a fine early impression on paper with wire lines but without watermark, with wide margins.'[10]

The fine quality of this impression, and above all the mention of the last owner, Wolfgang Gorter, great grandson of Count Andrea Tiepolo of Fiume, a direct descendant of Giovanni Battista, brought the price up to two or three times the amount that would have been paid a year earlier for a not particularly rare etching of similar quality. Sheets of the second, third and fourth states of this etching, referred to by de Vesme,[11] must be fairly rare as they are seldom seen.

Examples

Examples

[7] New York, Nowell-Usticke sale, 30 April-1 May 1968, $20,000. The print had been bought for £122 (about $500) at the A.J. Godby sale in 1935. See *Print Prices Current*, vol. XVII, p. 223.
[8] Christian Dittrich, ed., *Rembrandt: Die Radierungen im Dresdener Kupferstichkabinett* (Dresden 1969), no. 280, p. 92.
[9] On 21 June 1971, I saw three impressions of this drypoint in London: one, the John Barnard sheet, at Christie's; another, which I have already mentioned (Parke-Bernet 1968), at a London dealer's; and finally a third, at the British Museum, the only one of the three with clearly visible burr.
[10] Sotheby's, 12 December 1968, £4,600 ($11,040).
[11] Alexander de Vesme, *Le Peintre-graveur italien* (Milan 1906), pp. 381-2.

Giovanni Battista Tiepolo, *The Adoration of the Magi*, c.1755. First state

IV Monograms and signatures

Master P.W., *The Columbine Foot-soldier*, *c*.1500

Up to about the last quarter of the fifteenth century engravings did not normally bear any sign identifying the author. It was not until the last century that any of these early prints, whose artistic level was roughly that of a modest or talented craftsman, were attributed to individual artists and even then the attributions were sometimes ingenuous. The unknown artist was sometimes given a name which was based on the recurrence of a certain theme, as for example the Master of the Gardens of Love, active before 1450. In other cases the attribution derived from the place where the print was kept, for example the Master of the Vienna Passion and the Master of the Berlin Passion (the latter has been identified as the father of Israhel van Meckenem), both active in the middle of the fifteenth century. There was also a Master of the year 1446, after the date engraved on the only print attributed to him. The most important of these early line engravers was the Master of the Playing Cards who in about 1450 engraved a famous pack of playing cards which inspired others after him. In Italy there was, among others, the so-called Ferrarese Master of the *Tarocchi*, active around 1465 (he was not in fact from Ferrara, and the cards that he engraved, though similar, are not tarots). But the most notable of the engravers who left no precise means of identification was undoubtedly the Master of the Housebook, active at Mainz between 1465 and 1500, who took his name from a *Hausbuch* belonging to a German prince, in which he had drawn sixty-three sheets. He was also called the Master of the Amsterdam Cabinet, because the Amsterdam Print Room contains the largest collection of his engravings, almost all of which are known in single impressions only.

So far I have been referring to engravers on metal, not to the early anonymous woodcutters, some of whom were possibly active at the end of the fourteenth century. These are identified by the places where they worked.

Those artists who engraved on copper symbols, or more often letters, which were probably their own initials, are called 'monogrammists'. Among the earliest of these was an artist who lived towards the end of the fifteenth century and was in the habit of marking his line engravings with his initials, I.A. or I.A.M., the device of a goldsmith's tool or weaver's shuttle, and with the word *Zwott*, for Zwolle, the place in the Netherlands where he apparently came from: he is known as the Master of Zwolle. Jacopo de' Barbari (*c*.1450-*c*.1515) was also called the

Above left:
Master of the Playing Cards, *King of the Wild Men*, *c*.1450

Above:
Master E.S., *Two Men* (from the Large Playing Cards), 1463

Master of the Caduceus, because he engraved this symbol on his copperplates. The best known of all was the Master E.S., also called the Master of the year 1467: of the 300 or so prints attributed to him, 18 bear the initials E.S. and some also bear the dates 1466 and 1467, the year in which he apparently died. We known much more about other, later engravers: their Christian name and surname, various dates and their nationality. MS, for instance, stands for Martin Schongauer, and AD of course for Albrecht Dürer, so that monogrammists are not always unknown artists.

Later, in the sixteenth and more commonly in the seventeenth century, artists tended to sign their plates, sometimes abbreviating their name as Rembrandt did at first, signing first *Remb*, and later *Remb* followed by *fecit*.

However a signature, engraved and later handwritten, is not something which gives authenticity and greater value to a print, as is still widely believed in the case of modern engravings. The custom of signing prints by hand goes back to about 1880 when the American James Abbott McNeill Whistler (1834-1903) began to draw an emblem in the shape of a butterfly at the bottom of his etchings, and his brother-in-law, the English surgeon, collector and printmaker Sir Francis Seymour Haden (1818-1910), signed his in full. The name to be found very occasionally on some engravings by Charles Meryon (1821-68) is not to be considered a signature as such. Other artists, such as Edgar Degas, sometimes added a signature afterwards, at the request of the owner of the print. From the end of the last century, artists, adapting themselves at first extremely slowly to the new practice, began adding their handwritten signature to their prints.

Overleaf:
Master I.A.M. of Zwolle,
The Adoration of the Magi, *c*. 1485-90

Albrecht Dürer: *Lion lying down* (enlarged), 1521. Silverpoint drawing

'Then I saw the lions, and sketched one with a needle' – Ghent, 10 April 1521
(from the diary of Dürer's journey to the Netherlands)

William Blake, *The House of Death*, c.1810

Device of a goldsmith's tool or weaver's shuttle, from the Master I.A.M. of Zwolle's engraving – probably a reference to his original trade

The signature is generally placed at the bottom of the sheet on the right hand side, usually on the white margin, on a level with the serial number which may be given on the left hand side. Some artists always sign, others sign more rarely, especially in the case of a set of engravings where the artist might sign only the first or last page where information on the edition is given. Signatures are greatly prized by collectors, sometimes to a greater extent than is justified. However, it is true that it can be somewhat confusing to discover that a signature is missing from a print by an artist who normally signs, as did Edvard Munch and, in general, all the German Expressionists. Moreover, a collector may feel understandably bitter when he discovers that while a print he owns has no signature, another sheet of the same print has been signed by the artist to please someone, or even for money. In some special cases an artist will categorically refuse to sign certain of his prints, as Picasso did in the case of the etchings from his first great graphic work *The Acrobats* (G. 2-7, 9-15, 17, 18), particularly in

Rembrandt's etched signature

66

Jacopo de' Barbari, *Victory and Fame*, c.1500

Jacopo de' Barbari is also known as the Master of the Caduceus, from this symbol which appears in his engravings

Heinrich Aldegrever, *Spoons with ornamental handles* (enlarged), c.1540

Jusepe Ribera, *Bacchus*, 1628

the steelfaced edition of 1913 published by Fort, on Van Gelder Zonen water-marked paper or on Japan.

The question of signatures, already referred to in the chapter on 'Original Prints', needs settling once and for all, in a manner which will satisfy the collector and protect his interests; for after all it is he more than any other who contributes to the success of an engraver. On the subject of signatures, it is worth recalling a saying which has been common in Paris for years, and is not altogether a joke: 'after the artist's death, everything will be signed.' There is also the question of forged signatures, but I shall not go into that here.

Examples

PABLO PICASSO
'*Peintre chauve devant son Chevalet,* from "Le Chef-d'Œuvre inconnu" (B. 87; G. 128 b), etching, on Japan...'
'*Peintre ramassant son Pinceau,* from "Le Chef-d'Œuvre inconnu" (B. 88; G. 129/ii/b), etching, on Van Gelder, signed in brushpoint, numbered 42/99.'[1]

Opposite:
Lucas Cranach the Elder, *The Temptation of St Anthony,* 1506

[1] Sotheby's, 24 March 1970, nos. 184 and 185, £104 ($240) and £400 ($960).

69

Both etchings are part of a series of thirteen done by Picasso in 1927 for Ambroise Vollard and printed by Fort in 1931. This series can serve to illustrate how an edition might be made up.[2]

65 impressions on Imperial Japan plus another set on Rives paper (65+65)	130
175 impressions on Rives paper	175
99 numbered and signed impressions	99
35 impressions *hors commerce* numbered in roman	35
total number of impressions	439

To these can be added a few proofs pulled before the plate was steelfaced, and an unspecified number of artist's proofs. One therefore arrives at a total of 480 to 500 sheets of each individual etching. If we take it that the plates were in fact cancelled after the declared edition was printed, that all the prints which were on sale were steelfaced and that in this particular case there is no substantial difference in value between one title and another, it seems quite absurd – and a number of people are of this opinion – that there can be a four hundred per cent difference in price between one impression which is signed and another which is unsigned, and all the more so when the unsigned sheet is printed on better quality paper. It goes without saying that the artist has absolutely no control over the capriciousness of the art market or of collectors.

Pablo Picasso, *The Sculptor modelling, on the right two of his works,* 1927, from *Le Chef-d'œuvre inconnu*

Below:
Edvard Munch's handwritten signature
Giorgio Morandi's handwritten signature
Pablo Picasso's handwritten signature
Marc Chagall's handwritten signature

[2] Bernhard Geiser, *Picasso, Peintre-graveur, 1899-1931* (Berne 1955), page not numbered. See also *The Artist and the Book, 1860-1960* (catalogue of an exhibition at the Boston Museum of Fine Arts, 1962), no. 225; and also Georges Bloch, *Picasso, Catalogue de l'œuvre gravé et lithographié, 1904-67* (Berne 1968), pp. 42-5.

V Collectors' marks

Two collectors' marks:
Left, the mark of the Earl of
Aylesford (1786-1859), Lugt 58.
Right, the mark of Henry Studdy
Theobald (1847-1934), Lugt 1375

Collector's mark (marque de collection, Sammlungstempel, sigillo di collezione). This is
the stamp – or at one time merely a signature – which is imprinted by the
collector generally on the back of the print or drawing, partly as a mark of
ownership. With the passing of years and in some cases of centuries, a collector's
mark can assume special significance, depending on the period when it was
added, the person it belonged to and the engraving it was attached to. The
fascinating history of collectors' marks has been recounted by Frits Lugt who,
through years of careful study, has been able to follow the life of a particular
sheet sometimes from the latter part of the sixteenth century up to the present
day. For example, under no. 1227 on page 217 of the first volume of his work,[1]
Lugt (after having provided some interesting information about Seymour Haden,
Whistler's brother-in-law, and his activities as art critic, collector and engraver),
gives the following appraisal of Haden's flair: 'as a collector Seymour Haden is
thought to be one of the best judges of the quality of an impression; so discerning
is he in his purchases that the value of a print is increased just because it once
belonged to him. It is even said in the trade that prints bearing his mark are
valued at twice as much as they would be otherwise.' Lugt cites various auctions
where prints from Haden's collection were sold.

Lugt's work reveals an interesting gallery of personalities, whom one comes
to admire and almost to regard as friends. Indeed, when the curator of a print
room is able to show an important Rembrandt etching which, say, was owned in
the seventeenth century by the Burgomaster of Amsterdam, Jan Six, and then by
the Earl of Aylesford and the Duke of Buccleugh, he speaks of this with a kind
of respect and pride.

Lugt's scholarly, informative and enthusiastic work also contains a number of
interesting anecdotes, such as the following. A certain Ignace Joseph de Claussin
(1766-1844), an engraver and fanatical collector, as well as being author of a
catalogue of Rembrandt's etchings, was in London in 1835 for the sale of the
Paul Carew collection. In the middle of the sale, when a rare state of *Arnold
Tholinx* (B. 284) was under the hammer, he could restrain himself no longer – his
first bid of £5 had already risen to £150 – pale and perspiring, he stood up and

Signature and date indicating the
collection of Pierre Mariette II
(1634-1716), Lugt 1790

[1] Frits Lugt, *Marques de collections*, 2 vols. (vol. I, Amsterdam 1921; vol. II, The Hague 1955).

said to the auctioneers, 'Gentlemen, you know me, I am the Chevalier de
Claussin; I have devoted part of my life to preparing a new catalogue of
Rembrandt's works. I have been looking for the lawyer Tholinx for twenty-five
years, and I have hardly ever seen this piece except in the national collections in
Paris and Amsterdam, and in the portfolio of the late [John] Barnard, which used
to contain this sheet here. If I don't get this sheet I shall have no more hope, at
my age, of ever seeing it again. I beg of my rivals... to be a little generous.'
There were tears in his eyes, but in spite of the emotion which his words aroused,
after he had bid £200 the inexorable hammer of the auctioneer came down and
assigned the print to the Dutch minister Baron Gijsbert Verstolk van Soelen.[2] De
Claussin died alone and forsaken with his collection of clocks, and with a folder
of precious drawings and prints which he kept at night under his pillow and
which he had refused to part with at any price. After his death they were sold, in

[2] Ibid., vol. I, pp. 88,89. The story was told for the first time by Charles Le Blanc, in *L'Œuvre de Rembrandt*
(Paris 1859), p. 98.

Paris, for very little. Note that in 1835 de Claussin, and perhaps others as well, knew of the existence of only three first state impressions of *Arnold Tholinx* (who was inspector of the Amsterdam Collegium Medicum, and not a lawyer); a fourth impression, the last in the first state, was one of the sensations of the Rudge sale in 1924.

Lugt reproduces in facsimile thousands of signatures and collectors' marks, and he helps one to understand the true significance of early editions and the importance of a long pedigree, indicated by collectors' marks, which can sometimes provide a basis for judgment. They must however be interpreted with care; and they are rarely in themselves an absolute guarantee of the best. In any case a mark only constitutes this sort of guarantee if the collector involved was one who acquired nothing but carefully selected prints, and not one who formed a large collection of the kind which today would contain hundreds of prints and which in the last century might have contained 50,000 (this is shown by several catalogues). Obviously, no more than a proportion of the prints in these large collections were of major importance. Thus authoritative signatures like that of John Barnard may appear on minor prints; that of the French dealer Pierre Mariette (1634-1716), who used to put his signature and the date of purchase on the back of his prints, is found on very valuable engravings and on others of very little importance. However, collectors' marks, especially the important ones, are much sought after and since the value of a print is higher if it bears a mark, there have been cases of forgeries, although fortunately they are not very common.[3]

REMBRANDT

Examples

The example appeared as no. 101 in the catalogue of an excellent exhibition held in Boston and New York, on the occasion of the tercentenary of Rembrandt's death.[4] This etching was the object of several years of study on the part of American museum curators who exhibited and commented on the finest examples from major collections in the United States. The exhibition was similar to that prepared by Christopher White a few months earlier at the British Museum, in that only 28 subjects were exhibited, but there were at least 118 prints because of the number of different states and above all the different qualities of each engraving. Of these, the great majority – 107 if I am not mistaken – bore collectors' marks, and not a few pedigrees dated back almost to the artist's lifetime. In the words of the most important Rembrandt scholar of our times, it would be very nice to see a pedigree like this on every one of Rembrandt's most valuable etchings.

St Francis beneath a Tree, Praying (B. 107)
Various bibliographical references. First of two states. 'This is one of five known impressions of the first state. The great freedom with which Rembrandt has scratched the image into the plate is paralleled by the bold painterly handling of surface tone. Heavy tone casts a veil of darkness over two-thirds of the sheet. The light triangular area between the saint and the tree trunk is here reduced, anticipating the addition of further landscape detail in the following state. Subtle wiping creates lights which half reveal the crucifix and create an aura around the head of the saint.'[4]

[3] When the French print dealer Odilon Roche (1869-1952) retired from the trade in 1925, he accepted an appointment at the Musée Rodin in Paris, and while in this post he formed for himself a fine collection of drawings and watercolours by the great sculptor, putting his own collector's mark on the back of them. This was forged at least twice and used in connection with forged Rodin drawings. See Lugt, op. cit., vol. II, p. 292.
[4] *Rembrandt: Experimental Etcher*, op. cit., p. 154, pl. 101.

74

Rembrandt, *Christ healing the Sick (The Hundred Guilder Print)*, *c.*1649. One of eight known copies of the first state

This then is a proof of an experimental nature, probably the second pulled by the artist, after another with denser burr which is kept in the British Museum,[5] where all five existing impressions were exhibited, each one different from the others. The American copy bore the following collectors' marks: P. Remy 1749 (L. 2106); Baron J. G. Verstolk van Soelen (L. 2490); J. H. Hawkins (L. 1471-72); Walter Francis, fifth Duke of Buccleugh (L. 402); G. W. Vanderbilt; J. Pierpont Morgan (L. 1509).

The collector's mark can sometimes spring a surprise, as in the following example:

The Hundred Guilder Print (Christ healing the Sick)
'etching, ... a fair impression, under inked in places on paper with a Strasburg Lily watermark similar to Churchill 401.'[6] (For a definition of 'fair' see below, p. 170.)
Reference is then made to damage and to the collectors' marks which appear on the print: 'Frederick Augustus II, King of Saxony (L. 972), A. J. Godby (L. 1119b), Sotheby's sale, 29 and 30 January 1935.'

[5] *The Late Etchings of Rembrandt*, catalogue of an Arts Council exhibition organized at the British Museum, London, by Christopher White, March-May 1969, nos. 108-112, p. 27.
[6] Christie's, 13 May 1969, £1,575 ($3,654).

I was able to do a little useful research into the history of this sheet. It was sold in 1935 for a paltry price,[7] while other far less important prints by the same artist were sold that year for as much as fifty times more. Subsequently the same print turned up in 1957, with the same collector's mark of course, as part of a large lot of about 220 etchings (including duplicates) by Rembrandt, all described separately but sold as a group.[8]

This example gives rise to three important observations. The King of Saxony's well-known mark was placed both on valuable and on very inferior sheets. The comparison of the watermark to that reproduced by Churchill[9] and dated specifically by him at 1625, i.e. a year before Rembrandt began etching, and more than twenty years before he etched the copper for this particular print, is absolutely meaningless. And the price paid for it in 1969 was, considering the poor quality of the impression, out of all proportion.

[7] *Print Prices Current,* vol. XVIII, p. 223, £12.
[8] Berne, 4 June 1957, 35,500 Swiss francs ($8,275).
[9] Churchill, op. cit., p. 83, ill. CCXCVII.

VI Copies and forgeries

Albrecht Dürer, *The Annunciation*, c.1510. Above: detail of the original. Below: detail of the Mommard copy, Brussels 1587 and 1644

The shrewd dealer prefers to make most of his purchases, particularly of old master prints, from someone who is in a position to provide him with a guarantee. There are many exceptions, of course, as for example the etchings of the Venetian masters or of Goya, originally published in sets, or certain of Dürer's woodcuts which can be checked without too much difficulty, prints in fact which do not require very specialized knowledge or experience. The dealer would, however, be much more hesitant if a stranger offered him an important line engraving by a sixteenth-century artist, or an etching by Ostade or Rembrandt, which in spite of his long years of experience could place him in serious difficulties. He would prefer to pay much more, thereby reducing his own profit, and buy from a colleague who in his turn had bought cautiously, or from an old client or at a specialized sale where the print has been catalogued by experts and inspected, before the sale, by even more expert connoisseurs. Aware as he is that valuable sheets by great artists are hard to come by these days, he would on the whole prefer to leave the bargains and the discoveries to the naïve art lover who spends his time at stalls and small shops where both buying and selling are often carried out on a basis of ignorance. It must be emphasized that this is the rule for valuable prints by important artists, but that there are exceptions.

At this point the reader may well ask whether there are really so many forged prints around. There are in fact relatively few, even though the scarcity of good engravings and their consequent high prices may tempt the unscrupulous. However, in these times when good quality impressions are becoming increasingly rare, the expert knows better than anyone that a certain special type of very clever imitation, called 'original', does exist, and that it could ruin a dealer's reputation forever if he were not shrewd and cautious: it is bound up with the question of posthumous and, more specifically, late editions. Against the other type of 'fake', the one which in a certain sense is genuine, there are several means of defence which the specialist must know and which I shall mention briefly.

The kind of print which is sometimes incorrectly called fake really originated a few decades after the birth of European engraving, in the fifteenth century, in the

Israhel van Meckenem, *Coat of arms with a boy doing a somersault*, c.1485–90. After an engraving by the Master of the Housebook

practice of making copies. There are innumerable examples, so many that several large volumes would be needed to describe and reproduce them all. The first engraver to copy the work of others on a large scale was Israhel van Meckenem, an artist of undisputed talent and at times a brilliant creative artist in his own right. It seems he was a pupil of the Master E.S., many of whose plates he used after the older artist's death; and he also copied and was inspired by the Master of the Housebook. Van Meckenem's style was so similar to theirs that some of his engravings are still of uncertain attribution. Schongauer, and later Dürer, also served as his models. Van Meckenem signed his engravings with his initials or his name, whether they were copies or the products of his own invention, sometimes adding the name of the place where he lived, Bocholt. Marcantonio Raimondi of Bologna reproduced on copper 17 of the 20 *Life of the Virgin* woodcuts by Dürer, initialling the first 16 of them 'AD'. They all bear an arabic serial number, added later. Marcantonio's original plates, still in use in the nineteenth century, are in the Calcografia Nazionale in Rome.[1]

[1] Carlo Alberto Petrucci, *Catalogo generale delle Stampe* (Calcografia Nazionale, Rome 1953), p. 156, no. 1684.

The early kind of copy, then, was usually intended as a reproduction rather than as a forgery, and as such it did not arouse any protest. The practice of making copies of paintings was very widespread, so that even today quite a few puzzling cases arise. Jan Wierix (1549-1615) was the founder of a well-known family of artists from Antwerp who engraved reproductions. While still a boy he copied almost all Dürer's most famous line engravings but he also engraved his name, which can be seen at the bottom of the prints, usually on a very narrow margin.[2] Because of Wierix's exceptional skill, many of these engravings can be mistaken for the originals by Dürer, especially if the narrow margin bearing the signature has been cut off. With the help of a good magnifying glass it is of course possible to discover the differences, and a careful examination of the watermarks is also helpful. Among the many who copied Rembrandt, the English engraver and dealer James Bretherton (d. 1799) stands out in particular; some of his copies are so skilfully engraved that they could easily fool anyone but an expert. Among the most notable works that he copied are the *View of Amsterdam* (B. 210), *Six's Bridge* (B. 208) and *La Petite Tombe* (B. 67).

True forgery of prints is a relatively recent phenomenon. It started when very accurate reproductions made for teaching purposes were used by unscrupulous people who claimed that they were originals. The amateur collector can learn a useful lesson from a classic example which I relate here.[3] Towards the end of the nineteenth century the Reichsdruckerei in Berlin, Armand-Durand in Paris and various others had some complete sets of old master prints reproduced for them, in particular those of Dürer and Rembrandt, in the original sizes. Working from an original of good quality, a plate was covered with a film of sensitized gelatine, then exposed photographically, to harden the gelatine in those areas that were not to print; the plate was then etched in the usual way. The paper used came from the specialized papermills of Arches in France, Van Gelder Zonen in Holland and Whatman in England. It was mechanically made and contained cotton fibre, had ordinary equidistant laid lines, and watermarks consisting of letters such as ARCHES or a crown and shield or a fleur-de-lys. Perfect reproductions were obtained but, now that the facts are generally known, it is not especially difficult to identify them, even where forgers have tried to make the paper seem old by artificial means and have trimmed any give-away margins, removing the watermark at the same time and, in the case of the Armand-Durand reproductions, scraped off the stamp which had been placed on the back of the print.

A different and more deceptive case is where reproductions have been printed on older paper or a paper similar to the Japan manufactured in France, which is difficult to identify without chemical analysis or examination under a microscope. This was the case for example with the reproductions contained in portfolios prepared in about 1880 for the collector and scholar Eugène Dutuit, who had the plates made for him by the expert Charreyre and then retouched with drypoint to produce rich and realistic burr. A skilful forger can scrape the back of a reproduction so as to make the paper thinner, then with great expertise lay it down on to a sheet bearing watermarks typical of those used by Rembrandt, like the foolscap or the arms of Amsterdam, and finally trim the print along the platemark, which is a characteristic of intaglio prints that is very difficult to

[2] F.L. Wilder, *How to Identify Old Prints* (London 1969). On pp. 54-9 an exhaustive list is given of the engravings copied by Wierix, with numerous enlarged reproductions of details from the originals and from the copies.
[3] Biörklund and Barnard, op. cit. See 'Paper used for Intaglio Reproductions' by Biörklund, pp. 183-4 and 'On the Detection of Forgeries' by Barnard, pp. 185-7.

reproduce convincingly: then even a connoisseur will have great difficulty in detecting the forgery. Osbert H. Barnard, one of the greatest living experts on old master prints, especially those of Rembrandt, with fifty years of specialized experience behind him, referred in an article he wrote three years ago to an exceptionally valuable print as being 'too beautiful to be authentic'. In fact the print turned out to be a forgery which was discovered after long and patient efforts: Barnard himself added, 'I have quite a few examples in my archives of mistakes which I myself have made during the last forty-seven years.' He also says that quite a number of perfectly reputable dealers have bought similar reproductions, especially of Rembrandts, believing them to be genuine although in fact they came originally from the Dutuit portfolios.

A good way of detecting these forgeries is by carefully examining the grain of the sheet, for in the print reproduced by the photographic process described above it will be decidedly more pronounced and tangible than in the original. Naturally, the examination must be made by a trained expert in a place where he can compare the doubtful print with unquestioned originals. There would be no point for an amateur to try to make the comparison.

To sum up, it is clear that certain things are necessary of one is to attempt to detect forgeries:

1 Long years of experience
2 A good magnifying glass, preferably one which enlarges 20 or 25 times (not a microscope which by over-enlarging would confuse details)
3 Facilities for comparing the print with a good original and also for obtaining photographic enlargements of details, both from the original and from the presumed reproduction
4 The possibility of consulting catalogues raisonnés which for each print by an important artist may give details of all the known impressions and their individual characteristics
5 Provided an immediate reply is not required, the possibility of having a laboratory analysis carried out.

There can of course be forged watermarks, collectors' marks and signatures. Forgeries of modern prints are a somewhat different matter, and I can only advise the collector to purchase from an expert and reputable dealer. With regard to lithographs in particular I consider that the points made in the first three chapters should be sufficient.

Catalogues for important sales are prepared by specialists who if necessary call upon the advice of other experts; and yet mistakes are easily made. Here are two recent instances, both of them interesting and instructive, which prove that even an expert can sometimes be mistaken.

Examples

ANTHONY VAN DYCK
Frans Snyders (M.-H. 11; Holl. VI, 11)
'Etching, second state, printed on vellum...plate D.'[4]
This brief description is typical of the firm of Sotheby's. The reference to the second state, still the work of the artist himself, and to the printing on vellum, together with the illustration, said all that was needed about the importance of the print. Yet it turned out to be a forgery which, when pointed out, was withdrawn from the sale. In fact Marie Mauquoy-Hendrickx in her important

Anthony van Dyck, *Frans Snyders*: the forgery

[4] Sotheby's, 9 October 1969.

work on Van Dyck had referred to the existence of a facsimile of the second state (out of seven) of this etching.[5]

REMBRANDT

Polander standing with his stick: profile to right (B. 142 and other bibliographical references).

Rembrandt, *Polander standing with his stick: profile to right*: the original

'Etching. Outstanding early example, with rough margins and burr,' (in German the word for burr also means heavy inking) 'printed with surface tone, in very good condition with about 5 mm outside the platemark. This sheet is very rare; Rovinski (1890) called it "extrêmement rare" and unwittingly reproduced a copy. Biörklund and Barnard [in their critical catalogue] reproduce an unfinished proof. Certainly no other example exists in such outstanding quality. It dates from 1631, the last year of [the artist's] residence in Leyden.'[6] The description is marked with an asterisk to indicate special importance, and the print is reproduced in its actual size as pl. II of the catalogue.

The print was withdrawn from the sale as a reproduction, probably etched in the nineteenth century by the Chevalier de Claussin, whom we have already met (above, p. 71) and who, ironically enough, managed to deceive Rovinski who is quoted in the catalogue description. White and Boon list six examples of this small etching, of which only the one in Vienna is printed with surface tone.[7]

Errors like these are rare, and no firm intentionally puts copies or forgeries into its sales. However, one sometimes finds in catalogues the following kind of generic description for a parcel of prints to be sold in one lot: 'Various engravings by Dürer, Leyden, Callot, Rembrandt, Ostade, etc. One parcel. About 40.' Often no reference is made to possible late impressions, or to the fact that the parcel may contain copies or forgeries, since it is understood that the guarantee clause does not extend to the exact number of prints. It is therefore up to the buyer to sift through the prints in order to see whether there are enough good ones among them which could be of interest to a collector, and then discard the rest. But if the purchasing dealer is not an expert, he might in perfectly good faith insert in his own sale catalogue, perhaps with illustrations of the engravings he thinks important, say the copy of Dürer's *Willibald Pirckheimer* (M. 103) engraved by Jan Wierix in the second half of the sixteenth century, or else the copy made by an anonymous engraver of Lucas van Leyden's *Calvary* (H. 74) which is illustrated in Hollstein's book.[8] He might even describe the impressions as very fine: this is not unknown.

[5] Marie Mauquoy-Hendrickx, *L'Iconographie d'Antoine Van Dyck* (Brussels 1956), text p. 93.
[6] Berne, 17 June 1970.
[7] White and Boon, op. cit., text p. 73.
[8] F.W.H. Hollstein, *The Graphic Art of Lucas van Leyden* (Amsterdam n.d), p. 53.

Lucas van Leyden, *St George freeing
the Princess*, 1508

VII Early prints

Books about prints often quote examples of wood, metal or stone matrices which have produced documented editions of hundreds of thousands of copies; of these, it is added, no more than a few or sometimes only one sheet survives. This is not surprising, and it is technically feasible. But nobody is in a position to tell us how many prints were taken from certain of Mantegna's, Schongauer's, Dürer's or Rembrandt's blocks or plates, though in some cases very many must have been taken, to judge by the number of sheets which continue to turn up several centuries after the impression was printed. It is still supposed that an important or at any rate interesting work defies the passing of time more than a print of less account; but often this is not true. Before taking a closer look at the subject of editions, the importance of which is self-evident, I must first of all say that normally editions are broadly divided into contemporary or early, that is editions printed during the artist's lifetime or a few years later, and posthumous editions or reprints, which extend right up to the time of so-called new or modern editions.

The number of prints which can be pulled depends mainly on three factors: the matrix, the depth of the engraved mark, and the technique used. In addition to these basic factors there are many others, of a more incidental nature, such as the engraver's scruples or whims, the printer's skill, the success enjoyed by the artist's work during or after his lifetime, and the vicissitudes undergone by the copper or wood over the centuries: after use did the engraver leave the matrix in good condition? did it suffer the wear and tear of time? did the printers who subsequently came into possession of it treat it with care? And so on. There is therefore a practically unlimited range of factors influencing the number of prints which were or might have been taken from a matrix, different for every artist and indeed for each individual print, so as to preclude even the most general theory. With the help of various authoritative texts, it is possible to arrive at the following very rough estimates regarding total numbers which it would be possible to print, always remembering that they should in no way be taken as definite:

Woodcuts from wood cut along the grain: a few hundred very good impressions, and tens of thousands of further impressions progressively decreasing in quality.

Line engravings: a few hundred very good impressions, and tens of thousands of further impressions progressively decreasing in quality.

Antonio Pollaiuolo, *The Battle of the Nudes, c.*1470

Etchings: no artist has ever made any definite statement concerning this highly personal indirect technique. It is the opinion of all the most authoritative scholars that the editions supervised by the artist himself, those which he considered acceptable, could have ranged from 50 to 100 or even more impressions. Other factors which count here are the thickness of the plate,[1] the nature of the etching and above all the result which the artist was setting out to achieve.

Drypoint: this technique, which is almost always combined with etching and often with line engraving, gives 10 to 15 very good impressions with characteristic burr effect; then perhaps a further 10 or 15 of steadily declining quality, even though the engraver may have decided to scrape away the flattened burr which might have spoiled the print.[2] More impressions can of course be taken, but then the resulting prints, while still bearing the name of this technique, will not have its characteristics. Obviously, where several states have been produced, with the plate retouched with drypoint in various parts, the total number of impressions with burr will be greater.

[1] Rembrandt's plates were of a maximum thickness of 1mm (about $^1/_{16}$ inch), those of Picasso about 4 mm (about $^3/_{16}$ inch).
[2] Nora Keil, in the appendix to *Fünf Jahrhunderte Europäische Graphik* (Munich 1965-6), refers on p. 246 to a maximum of 30 good impressions. A. M. Hind in all his studies speaks of a maximum of 15-20.

84

Mezzotint: the technique is similar to drypoint and cannot give more than 50 or at most 100 good impressions.

Colour prints: not many good impressions can be obtained; the number would range from 100 to 200, regardless of whether the printing involves several plates or the so-called English method, where the single plate is inked with a different colour after each impression.

It can be an arduous and in many cases impossible task to try to decide whether a particular print comes from a 'contemporary' edition or from an 'early' edition, that is, one printed perhaps several years after the artist's death, but when the matrix would still have been in good condition. One often has to rely on guesswork and circumstantial evidence. The expert's diagnosis naturally takes into account the factors which we have already discussed: the paper, watermark, collector's mark, the feel of quality, rarity, the sometimes useful bits of information contained in critical catalogues which often (not always) summarize the results of research carried out by specialists. So-called first impressions, also incorrectly called first edition impressions,[3] are sometimes easier to recognize than the less rare contemporary or early impressions.

[3] The expression 'first edition' is almost meaningless unless the total number of sheets printed is specified, or unless the special features of the print in question are explained.

87

Examples

ANTONIO POLLAIUOLO (c.1433-98)

The Battle of the Nudes (H. 1)

This is a very rare line engraving, especially if the sheet is early and of good quality, a feature of the early impressions being the very clean-cut lines and the distinct planes which in later impressions seem to merge. In fact, of the five or six sheets[4] which have changed hands in the last thirty years, only one is worthy of note, the exceptional print from the collection of Edwin Alfred Seasongood (L. 907a) which in 1951, when engravings were very cheap, fetched a higher price than any of the other fine and rare engravings in the sale of that famous collection.[5]

ANDREA MANTEGNA

The Risen Christ between St Andrew and St Longinus (H. 7)

'Line engraving. Very good quality impression, rich in contrast, more complete than the one reproduced by Hind. The paper bears the watermark P.M., which the author has found in contemporary copies, etc.'[6]

The print was indeed a very good one, better than had been seen for years, though inferior in quality and above all in completeness to the outstanding sheet in the Rijksprentenkabinet in Amsterdam, shown in 1968 at the exhibition of European engraving in Turin.

Virgin and Child (H. 1, second state)

'Fine impression on paper watermarked with the siren similar to Hind 154. The sheet measures 19.3 × 25 cm [$7^5/_8$ × $9^7/_8$ inches], so 5 mm of the engraved part is missing on the right and left sides. (The plate measures 26.8 × 34.5 cm [$10^9/_{16}$ × $13^5/_8$ inches].)'[7]

The description is very meticulous: it says how much of the engraved part is missing and what the size should have been if it had extended to the platemark (the area of this print is in fact just over half of what it would have been if complete). In view of the thoroughness of the cataloguer, the restrained phrase 'fine proof' is somewhat discouraging, with regard both to quality and to the likelihood or otherwise of this being a contemporary impression; one's doubts are increased by the catalogue illustration, which is not very persuasive. This uncommon engraving, like the one described above, is considered rare if it is complete, even without margins. The size of the first state impression in the British Museum is exceptional.

JACOB VAN RUISDAEL (c.1628-82)

The Travellers (D. 4)

'Superb impression, one of the first taken, in an intermediate state between the first and the second... Coll. (L. 799b).'[8]

Ruisdael made very few etchings, and today they are very rare. The earliest impressions, always much sought after, are very attractive. This print might be regarded as inferior in quality in the second state; the third state, printed in the eighteenth century and perhaps even in the nineteenth, is indescribably poor.

Jacob van Ruisdael, *Landscape with Trees and Houses on a Riverbank*, 1646

Giovanni Battista Tiepolo, *Boy seated, leaning against an urn*, c.1740

[4] Arthur M. Hind, *Early Italian Engraving*, 7 vols. (London 1938-48). On p. 191 of vol. 1 the author lists about forty impressions known to him, very few of them of good quality and several poor; among the former was the sheet in the Seasongood collection.

[5] New York, 5-6 November 1951, $8,000.

[6] Berne, 16 June 1965, 71,000 Swiss francs ($16,395).

[7] Paris, 6 June 1969, 36,000 French francs ($6,545).

[8] Berne, 14 June 1967; intermediate state, 9,000 Swiss francs ($2,100); second state, 850 Swiss francs ($196).

Giovanni Battista Tiepolo, *Young
Man standing and Old Man seated with
a Monkey*, c.1750-65

Giovanni Domenico Tiepolo,
Old Man in a Cap, looking right,
c. 1750-55

Opposite:
Giovanni Battista Piranesi, *Massive
Doorway surmounted by a wide circular
opening*, before 1750. First state

Canaletto, *La Piera del Bando,*
V.(enezia), *c.* 1743

GIOVANNI BATTISTA TIEPOLO

Catalogo di varie opere inventate dal celebre Gio. Batta Tiepolo... e l'altre incise dalli Figli
Giandomenico e Lorenzo... (catalogue of various works designed by the famous
Giovanni Battista Tiepolo and others engraved by his sons Giovanni Domenico
and Lorenzo...), published between 1771, the year following Giovanni Battista's
death, and 1776 at the latest, the year in which his son Lorenzo died.[9]

This volume was at one time common and not highly valued; now it has become
very rare. It contains altogether 194 etchings by the three Tiepolos, excluding
however the *Capricci* (V. 3-12) by Giovanni Battista. It is worth noting that the
23 etchings of the *Scherzi di fantasia* (V. 13-35) were numbered from this period
onwards, and also that contemporary impressions before numbers are found more
frequently than numbered impressions, which probably date from immediately
after Tiepolo's death.

Varj Cappricij

Fine complete set comprising the title and ten etchings, large margins.

The set, designed and etched between 1740 and 1745, is very rare in a contempo-
rary edition.[10] It is known to most people in the 1785 edition, which contains
impressions that are still very good: the present example, dedicated to Girolamo
Manfrin, is practically the only one in circulation (except for a recent case).[11]

[9] Berne, 27 May 1964, 45,000 Swiss francs ($10,400).

[10] New York, November 1969, $3,500. On 25 March 1971 a very rare set with frontispiece dated 1749 was sold
at Sotheby's for £6,000 ($14,400): it included the 72 chiaroscuro woodcuts made by Antonio Maria Zanetti
after Parmigianino, and the ten *Capricci* by G.B. Tiepolo. It would be reasonable to suppose that the *Capricci*
alone would account for at least two-thirds of the total amount paid.

[11] For approximate dating of the etchings see Terisio Pignatti, *Le acqueforti dei Tiepolo* (Florence 1965).

Canaletto, *La Preson. V.* (enezia), *c.*1743

GIOVANNI BATTISTA PIRANESI

Invenzioni Capric di Carceri all acquaforte datte in luce da Giovanni Buzard in Roma Mercante al Corso (H. 1-16).

'The set of fourteen unnumbered etchings from the first edition, except H. IX which may be earlier,[12] very good well-printed impressions printed on thin laid paper with a fleur-de-lys in single circle watermark (like H. I), all with full margins and with the usual vertical centre folds, contained in a portfolio.'[13]

This is, if I am not mistaken, the first time in the past twenty-five or thirty years that the famous set, complete in the very first Buzard edition, has been up for auction. Single sheets of the first states are not all that rare.

CANALETTO

Vedute Altre Prese Da i Luoghi Altre Ideate... (V. 1-31)

Etchings. Set with large plates in the first state (the small ones are practically all in one state only) in very fine impressions on paper bearing the three crescent moon watermark, all with large margins, signs of a centre fold. Ex libris Charles Tennant.

With the exception of the set belonging to the American Philip Hofer, a former keeper of the Houghton Library at Harvard, the example described above (by Sotheby's) is the finest of any I know. Another very good complete set, previously in the collection of Canaletto's patron, the British Consul Joseph Smith, was up for auction in 1968 in the same saleroom, in a sale of printed

[12] According to Robinson, op. cit., pl. ix (H.9) of the series, before the signature, must be regarded as the only impression.
[13] Sotheby's 25 March 1969, £11,500 ($27,600).

books. A third complete set on paper watermarked with the double F (Palluc-chini and Guarnati no. 17) was sold in 1969, again at Sotheby's. Lastly, a fine fourth example was sold in Switzerland the following year.[14]

At this point a brief comment is necessary, since it may well be that in the last two years a further early set (with the 31 etchings printed on 18 sheets) has changed hands, in addition to 50 or 60 loose sheets of good or fair quality. The reason for such an abundance of good Canalettos in such a short space of time (for the first time in many years – and if it continues the demand for them may slacken) might be the recent sharp rise in prices for Venetian prints which has encouraged people who acquired them cheaply to sell them now at a good profit. The relatively high prices, in addition to reflecting more fairly the true value of the work, perhaps also show that collectors and dealers are beginning to understand that a contemporary or at any rate early impression by an eighteenth-century master is really more valuable than a common, later and therefore often poor quality impression by a sixteenth- or seventeenth-century master.

[14] In order of mention, the prices paid were: at Sotheby's, £13,000 ($31,200), £10,000 ($24,000), £11,500 ($27,600); at Berne, 126,000 Swiss francs ($29,230).

VIII Posthumous impressions

Rembrandt, *Abraham and Isaac*, 1645. Only state

Above:
detail of an early impression

Below:
detail of an early nineteenth-century impression

The process of establishing the age of a contemporary or early impression can present difficulties which are sometimes insuperable, even with the scientific aids available today, and the problems presented by posthumous prints and reprints are no less thorny. The dividing line between early and posthumous impressions is of course flexible, and often varies according to the print in question.

There are additional questions to be asked, for example about re-biting in the case of etchings, about new marks on a plate which increase the number of states, about the paper, and so on. Obviously the older the original plate and the more it has been used over the years, the greater the number of doubts surrounding it, even though the eye of a real connoisseur should at least be able to distinguish between an early impression and posthumous one, or more specifically what is called a *late impression (tirage postérieur, späterer Druck, esemplare tardo)*, which in fact is the one which causes most trouble to amateurs and even experienced collectors. The difference between two impressions, even when one is much later than the other, is often so hard to measure that it escapes even the most thorough analysis.

Today, while there is a growing scarcity of early original prints, late impressions are still quite common and can be a real trap for the unwary and inexpert collector. He must therefore know what he is buying, and if necessary should not scorn late impressions, if they are openly described and priced as such. The fairly long and detailed list of examples which follows, while it does not claim to be a scientifically precise guide, may be of use to him.

ANDREA MANTEGNA

Of the seven line engravings attributed with some degree of certainty to Mantegna, the five considered to be of lesser artistic value are very common; or at any rate there are very many late impressions of them in circulation, even though fine impressions are rare. It is difficult to say why the best prints by this master are so uncommon while other engravings by him continued to be reprinted for so long: this is not the case with some other equally important artists. It cannot be that they ceased to be printed after the fifteenth century. Hind, writing about these

95

School of Mantegna (Zoan
Andrea?), *Silenus with Putti, c.*1490-
1500

engravings, says: 'The outline is firm and broad, but the cross-lines of shading seem to have been but lightly scratched on the plate, and were consequently worn away in a very few printings, leaving most of the late impressions (which are not uncommon) mere ghosts of the composition in its original state.'[1]

The Entombment (H. 2)

No less than four different impressions of this engraving were sold recently, one after the other, immediately followed by the two sheets of the *Battle of the Sea Gods* (left and right hand parts of the frieze, H. 5 and 6) which were sold together as one lot. According to the catalogue they were good impressions, almost complete, with no serious damage.[2] There are also many impressions, from late editions, of the *Bacchanalian Group with Silenus* (H. 3) and the *Bacchanal with the Wine Cask* (H. 4).[3] Similarly there are many engravings of the school of Mantegna, including *The Descent into Hell* (H. 9) and the four sheets of *The Triumph of Caesar* (B. 11, 12, 13, 14).[4]

[1] Arthur M. Hind, *A History of Engraving and Etching*, 3rd ed. (London 1923), p. 57.
[2] Berne, 17 June 1970, cat. nos. 128, 129, 130, 131, 132, sold for, respectively, 2,300, 2,500, 3,200, and 4,800 Swiss francs. These low prices, and those which follow, require no comment.
[3] Sotheby's, 8 October 1968, both engravings, £58 ($139.20). The four *Bacchanal* and *Battle* engravings were executed by Mantegna almost certainly after 1490.
[4] New York, 26-28 May 1970, $180 and $225.

Hendrik Golzius, *Arcadian Landscape*, c.1595

Hercules Seghers, *Mountainous Landscape with Plateau* (slightly enlarged), c.1620

Martin Schongauer, *The Censer*, c.1475-80

MARTIN SCHONGAUER

There are numerous prints by this great master, and several thousand impressions of them must have been taken even in the century after his death. Among the most common are *The Temptation of St Anthony* (L. 54), the large engraving of *Christ bearing the Cross* (L. 9) which inspired Dürer, Raphael and Memling, and *The Crucifixion with Four Angels* (L. 14), of which a late impression watermarked with the Gothic p and flower was sold as recently as 1968 for a trifling sum.[5] In fact, fine early impressions by Schongauer now fetch very high prices, as for example *The Censer* (L. 106), of which a sheet was recently described in a catalogue as a good impression, with printing defects and without margins, on paper watermarked with the Gothic p and flower (probably different in size and shape from the watermark mentioned above).[6]

ALBRECHT DÜRER

A short catalogue published in England in 1970 included among many notable old master engravings a considerable number of important prints by Dürer.

[5] Berne, 12 June 1968, 2,000 Swiss francs ($463).
[6] Christie's, 13 May 1969, £9,450 ($22,680).

97

Albrecht Dürer, *St Jerome in his Study*, 1514

There were at least three different impressions of *The Knight, Death and the Devil*, each of which has sold for the price of a more ordinary Canaletto print. A few days later in Switzerland a catalogue offered in one lot another *Knight* together with eleven no less famous line engravings, including *St Eustace*, *St Jerome in his Study* and *Nemesis* (M. 72): all twelve engravings were sold for an amount equivalent to about a thousand dollars. The descriptions of the prints, it must be admitted, were not enticing.[7]

Dürer made 105 engravings on metal, very many of which are known in impressions printed *c*.1560-80, frequently even after the middle of the seventeenth century; this naturally does not apply to rare states of which few impressions are known. Taking at random the last dated engraving, *Erasmus of Rotterdam* (M. 105), we read in Meder's authoritative work that worn impressions were still being taken in the middle of the seventeenth century; but even H impressions are printed on paper with a watermark which can be dated at about 1600; while the preceding variant G, dated 1550-90, is considered good. Quality A, the best, is on paper with one of two watermarks: either M. 158, which was in use between 1520 and 1526, or M. 314, 1510-70. Very rich and well contrasted impressions, extremely rare, have a platemark which is smudged with printing ink.

Almost all Dürer's woodcuts are also known in late impressions. The Emperor Rudolf II, who became King of Bohemia in 1575, a patron of the arts and sciences, owned a set of Dürer's woodblocks which he presented to his Flemish court painter, Bartholomeus Spranger, who died in Prague in 1637. Apparently the artist's son took the blocks to the Netherlands where a new edition was probably printed.[8] Quite apart from the extreme example of *The Beheading of St Catherine* (M. 236), of which eighteenth century impressions are known, according to Meder, and probably nineteenth-century ones as well,[9] it is certain that there were editions of Dürer's great volumes later than 1511. It is for instance certain that the *Apocalypse* (M. 163-178) was reprinted, still with the Latin text of 1511 on the back of the sheets, several years after the artist's death. This is proved by the fact that numerous complete sets of this work, often of deplorable quality, are seen almost every year: some of the sheets, perhaps the best, are watermarked with the flower on a triangle (M. 127), or else with the tower with crown and flower (M. 259); others have a watermark similar to one seen in paper of a later date.

A fine Meder A woodcut, like *The Knight and the Lansquenet* (M. 265), watermarked with the imperial orb with line and star (M. 53), can be worth more than two dozen important engravings of a fairly late date.[10]

LUCAS VAN LEYDEN

Frits Lugt, after long years of patient research, managed to gather a collection of line engravings and woodcuts by this artist which was the finest to have been formed in this century; but it is well known that for many years now it has been almost impossible to find a really good impression of a print by Lucas van Leyden. One explanation, seeing that a number of excellent sheets by Dürer, his contemporary, are still to be found, could be that his engraved line is lighter: this is probably due to the fact that as a youth Lucas van Leyden was trained as an

[7] Sotheby's, 28 May 1970; Berne, 17 June 1970.
[8] Meder gives several examples of late editions in Holland in the seventeenth century, for example the portrait of *Ulrich Varnbüler* (M.256) printed by Heindrick Hondius and then again by Willem Janssen of Amsterdam (see pp. 238-9); *The Rhinoceros* (M.273) was also reprinted by Hondius after 1620.
[9] Since 1921 the block has been kept in the Metropolitan Museum of Art in New York (Meder, p. 197). The British Museum possesses 36 of the original 37 woodblocks for Dürer's *Small Passion*. Some of these, and other larger ones, which previously belonged to the successors of Basan in Paris, were shown in the exhibition commemorating the fourth centenary of the artist's death, in 1928 (see the catalogue, p. 17).
[10] Sotheby's, 4 December 1969, £2,800 ($6,720).

Albrecht Dürer, *St Jerome in a Cave*, 1512
Left:
early sixteenth-century impression
Right:
late sixteenth-century impression

enameller. He could never have imitated Dürer who in 1523 sent to the Archbishop of Mainz the plate and 500 prints of his portrait, *Cardinal Albrecht of Brandenburg* (the so-called *Large Cardinal* version, M. 101).[11]

Bartsch, writing near 170 years ago, already noted the rarity of fine impressions by Lucas van Leyden. Many of his engravings are to be found loose or in large parcels, but they are all shockingly poor in quality: this is an obvious indication that printing had continued long after the death of the engraver, who like all true artists would never have allowed proofs to circulate which would have discredited him. Many of them bear the address of the publisher Petri, added posthumously, but I have never seen one of these myself. *The Milkmaid* (B 158) is one of the masterpieces of graphic art. It is almost impossible to find a good impression of it, and yet every year one or even two sheets are sold, cheaply.[12]

SIXTEENTH-CENTURY MASTERS

In the case of many engravings by great masters of the sixteenth century there are practically no sheets in circulation any longer, while quite a lot of posthumous impressions of others turn up fairly frequently, although contemporary impressions are rare. To take one example from thousands of prints of sought-after subjects by great masters, the line engraving *The Penance of St John Chrisostom* (B. 1) by Cranach is quite common even in impressions described as 'fine', but good early impressions of it are really rare.

[11] Langen Müller, *Albrecht Dürer, Tagebücher und Briefe* (Munich 1969), pp. 169-70.
[12] Sotheby's, 13 February 1968 and 9 October 1969.

Opposite:
Albrecht Dürer, *The Four Horsemen of the Apocalypse*, c.1497

Lucas van Leyden, *Susannah and the Two Elders*, 1508

Pieter Bruegel the Elder, *A Man of War, seen from behind at an angle*, 1564-5. Engraved, after a drawing by Bruegel, by Th. Galle

Lucas van Leyden, *The Milkmaid*, 1510

Federico Barocci, *Virgin and Child in the Clouds*, c.1590

The Annunciation (B. 1), the masterpiece of Federico Barocci (1528-1612), is very common in the eighteenth-century edition, when it is worth $50-200, depending on the quality of the print. Barocci's copperplate is in the Calcografia Nazionale in Rome, where it was still being printed from a few years ago. Higher prices are fetched by the well-known chiaroscuro woodcut by Ugo da Carpi after Parmigianino, *Diogenes* (B. 10), even though the print does turn up several times a year. Nor is it difficult to obtain late impressions of the *Virgin and Child in a Landscape* (W. 12) by Albrecht Altdorfer (c.1480-1538), or even *The Bewitched Knight* (C. 85) by Hans Baldung Grien.[13] Jacopo de' Barbari is more rare, with the exception of a few of his prints such as *Judith with the Head of Holofernes* (H. 47). 'Fair proofs' of the set of twelve large plates of *Nuptial Dancers* (H. 160-

[13] Sotheby's: Altdorfer, 11 July 1968, £35, ($84); Baldung Grien, 8 October 1968, £28 ($67.20).

Jacopo de' Barbari, *Pegasus*, *c*.1500

71) by Heinrich Aldegrever (1502-*c*.1558) can be worth eleven times more than 'late proofs'.[14]

Hieronymus Cock (*c*.1507-70), the great publisher who had a famous work-shop at Antwerp, the 'Four Winds', was active in the sixteenth century. He himself cut a great many of the engravings and etchings after the drawings of Pieter Bruegel the Elder (1515/25-69). These prints are very common in seventeenth-century editions, which are worth as little as one-twentieth of the fine and rare early impressions (see below, pp. 143-6).

SEVENTEENTH-CENTURY ETCHERS

Even the complete works of the landscape artist Anthonie Waterloo (1609-*c*.1676), comprising about 130 etchings, are often obtainable; in the nineteenth century the plates were still owned by the press of the successors of Basan in Paris. Also common are the 50 prints by the etcher of animal subjects, Karel Dujardin (1622-78), 'in the second, third and fourth states, before some of the subjects were reduced';[15] and so is the set of 63 prints of *Warriors and Soldiers* by the Neapolitan Salvator Rosa (1615-73), the copperplates of which are also in the Calcografia Nazionale in Rome. The fascinating etchings by Claude Gellée, called Claude Lorrain (1600-82) are very rare and fine in early impressions, and common

[14] Sotheby's, 9 October 1969, £550 ($1,320) and £50 ($120)
[15] Sotheby's, 'Waterloo', 4 July 1967, £130 ($364); Christie's, 'K. Dujardin', 26 June 1970, £26.2s ($55).

Jacques Callot, *The Fair at Gondreville*, 1624
Callot was one of the first artists in the history of printmaking to use several biting processes, thus obtaining different tones and smooth transitions in shading

Opposite:
Jacques Callot, *The Temptation of St Anthony* (second plate), 1634. Detail

Below:
Stefano della Bella, plate from *Paysages divers*, 1643

Israel excud. cum priuil. Regis

2

and poor quality in posthumous ones, which are marked with arabic numerals, apparently added in the eighteenth century. The plates, lost for a time, were rediscovered at the beginning of the last century in London where a new edition of several hundred impressions was made.[16]

Claude Lorrain, *Leaving for the Fields, c.*1640

JACQUES CALLOT

'Œuvres de Callot et Bella, published by C. Bance, Paris (n. d.), comprising 298 engravings by Callot and 226 by della Bella, etchings, mostly mounted... with portrait of Callot and engraved list of plates on p. 1, 18th-century half calf...'[17]

Among the works by Callot were the complete sets of the *Beggars,* the *Petites* and *Grandes misères de la guerre,* the *Gobbi,* the *Balli di Sfessania,* the two *Grandes vues de Paris* (the latter were still being printed in recent times), all in Lieure's last states, and certainly printed in the second half of the eighteenth century, long after the time when the plates had belonged to Henriet and to Silvestre in Paris. Also included in the volume were several attractive but poor quality sets by Stefano della Bella (1610-64).[18] The album described above was sold

[16] Wilder, op. cit., p. 98: 'his etchings have great charm, but must be seen in early impressions.'
[17] Sotheby's, 25 March 1969, £1,400 ($3,360).
[18] An edition of over 100 etchings by the Florentine engraver still exists, printed on soft, almost absorbent paper, and published in London by H.R. Young in 1818 with the title *A Collection of Etchings by that Inimitable Artist Stefanino Della Bella.* At Sotheby's on 28 April 1960 it fetched £10 ($28).

Adriaen van Ostade, *The Mountebank*, 1648

in 1969. Eleven years earlier the collection of Viscount Bateman, one of the most beautiful and complete collections to have been formed during this century, was sold: it comprised over 850 etchings, practically all the best of Callot in the most sought-after states (but excluding the first, unobtainable version of *The Temptation of St Anthony* (L. 188)); it is indicative that *The Fair at Gondreville* (L. 561) and the two *Vues de Paris* (L. 667-8) were all in the first state.[19]

ADRIAEN VAN OSTADE

Recently, while glancing through the rare catalogue of the Pieter de Haan sale (Amsterdam 1767), in which were listed the 76 *Kopere Konst-Platen* by Rembrandt (see above, p. 53), I read under no. 80 on page 235 that 50 copperplates by Ostade, and five others attributed to him, were sold as a lot with over 2,500 prints (50 per plate) for the total amount of 129 guilders 10 stuiver: not even Louis Godefroy, meticulous scholar and cataloguer of the graphic work of the Dutch engraver, seems to have been aware of this fact.[20]

While first state etchings by Ostade are extremely rare – indeed, literally impossible to come by – later ones done by the very skilful Bernard Picart, who

[19] Sotheby's, 2 December 1958, £1,800 ($5,040).
[20] Louis Godefroy, *L'Œuvre gravé de Adriaen van Ostade*, Paris 1930: see the interesting introduction.

Martin Schongauer, *Christ bearing the Cross* (large plate), *c*.1475-85
Above:
fifteenth-century impression
Below:
very late impression

was able to acquire the copperplates in Holland at the beginning of the eighteenth century, are more common (though not all that common). The plates then passed into the hands of de Haan and subsequently to Pierre-François Basan of Paris. A large number of impressions were taken in the nineteenth century, and it is these which are most often on sale, at very low prices. Apparently the plates were all, or practically all, steelfaced, for up to a few years ago an almost unlimited number of sheets of some of the subjects was available.

REMBRANDT

We already know that Rembrandt's graphic works present difficult and in some cases insoluble problems, not only with regard to the different editions but often with regard to the complex engraving and printing techniques, of which we can have no sure knowledge, as Boon points out; and this is in spite of more than two centuries of research and uninterrupted study. In the case of Rembrandt, I shall often abandon the method used so far, of making continual and detailed references to catalogues: I shall instead have to generalize and give information in a condensed form, while trying to be more cautious than the American collector Nowell-Usticke.[21] However, although he approached the problems of the cataloguing and printing of Rembrandt's etchings in a manner which was too personal and extremely unreliable, his work does have the merit of having drawn attention to the mystery surrounding Rembrandt's graphic work. Perhaps one of his greatest errors was to want to draw hasty conclusions from an examination of the London sale catalogues of the last twenty years: while Nowell-Usticke would undoubtedly have found in these catalogues, for that period alone, ten or twelve thousand Rembrandt prints, most of them would have been very late or modern impressions, worthy of curiosity rather than of study.

When the question, which was not so naïve as it seemed, was put some time ago to Karel G. Boon and to the doyen of Rembrandt scholars, Frits Lugt, as to whether the master could have printed as many as 150 or 200 etchings from some of his plates, the two connoisseurs were patently surprised. At most this could conceivably have happened when the management of Rembrandt's business affairs passed into the hands of Hendrickje Stoffels and his young son Titus, after he had concluded an agreement with them according to which, in exchange for his technical assistance, they were to maintain him and give him half the profits.[22] This took place two years after Rembrandt had gone bankrupt, in 1658; the plates at least had been saved from sequestration. Both Boon and Lugt moreover excluded the possibility that many of the artist's prints could have been lost over the centuries, since already by the seventeenth century enthusiastic collecting of his graphic work had begun. They were both extremely firm about the limited number of good impressions possible when drypoint has been added to etching.

It is worth remembering, however, that of the barely 300 plates attributed to Rembrandt, 78 finally came into the possession of Pierre-François Basan, some of them via de Haan and Watelet. Basan used them for the first edition of his famous *Recueil de Rembrandt*, printed between 1789 and 1797. In the second edition printed by his son, H.-L. Basan, *Jan Lutma* (B. 276) was added; the last of the many subsequent editions was printed in Paris in 1906 by Michel Bernard.[23]

[21] G.W. Nowell-Usticke, *Rembrandt's Etchings, States and Values* (Narberth, Pa. 1967).
[22] C. Hofstede de Groot, *Die Urkunden über Rembrandt* (The Hague 1906), no. 233.
[23] Biörklund and Barnard, op. cit.: see 'The Editions of Basan's "Recueil de Rembrandt"' by Barnard, pp. 161-3. Barnard, who was once the owner of one of the two complete sets of the first Basan edition (the other is at the Hermitage in Leningrad), has told me that a considerable number of the etchings in this edition could still be called good, that they are less good in the second edition, and that they then deteriorated very rapidly in the numerous later editions.

Rembrandt, *Joseph relating his Dreams*, 1638
Above:
detail of the second state
Below:
detail of the third, definitive state, late impression

Rembrandt, *The Blindness of Tobit: Large Plate*, 1651

Out of the Basan collection of plates one, *The Death of the Virgin* (B. 99) was lost at the end of the nineteenth century, while another small one was bought in about 1930 by Isaac de Bruijn and then presented to the Rijksprentenkabinet of Amsterdam. The remaining ones, acquired by an American collector, are now preserved in the North Carolina Museum of Art at Raleigh, N.C. Now, allowing for the fact that perhaps another ten or so plates were used for editions printed in 1800 and even later, it could be said with a degree of certainty that almost one-third of the original copperplates were used for further impressions which were printed, in some cases intermittently, for two hundred or two hundred and fifty years after they were first etched.

At least late impressions can be posited from those plates which, after having been used for impressions printed in the seventeenth century and perhaps even after, were subsequently lost. However, the etchings of this second group as well appear quite frequently at big sales and are often described as fine or outstanding impressions (I shall discuss the question of burr later). Here I list some which are notable: many of them belong to the artist's so-called mature period.

Rembrandt with Raised Sabre (B. 18), second state
The Small Jewish Bride (B. 342)
Adam and Eve (B. 28), second state

Louis-Marin Bonnet, *The Charms of the Morning*, c.1775

Rembrandt, *The Windmill*, 1641.
'Craquelures' can be seen in the sky

St Jerome by a Pollard Willow (B. 103)

St Jerome reading, in an Italian Landscape (B. 104), second state, on French laid paper

View of Amsterdam, without surface tone

Cottage and Hay-Barn (B. 225)

Cottage with a Large Tree (B. 226)

The Windmill (B. 233), with 'craquelures' in the sky still discernible

The Omval (B. 209), second state

Farm Buildings, with a Man sketching (B. 219)

Ephraim Bueno (B. 278), second state

Three Gabled Cottages beside a Road (B. 217), third state

The Blindness of Tobit: Large Plate (B. 42), first of two states

Abraham Entertaining the Angels (B. 29)

St Francis beneath a Tree, Praying, second state.[24]

There are also many others, including *The Goldweigher's Field* (B. 234)[25] and naturally *The Hundred Guilder Print* which turns up in seventeenth-century

[24] On the subject of the prints listed and also of various others, a glance through sale catalogues of the last few years could be useful; also of interest is the long list which is given under no. 241a in the Gutekunst und Klipstein catalogue, Berne, 4 June 1957.
[25] The plate for this etching was sold before the war in London and is now in the United States: see Wilder, op. cit., p. 106.

Samuel Howitt, *Pheasant Shooting*, c.1804

impressions several times each year, often even on Japan paper; although very occasionally there will be a proof which is just about fair, more often they are extremely poor. Some of these etchings, the plates of which were never owned by Basan, could also perhaps be included in that group of 'strongly etched plates' which 'continued to yield satisfactory impressions well into the eighteenth century'; Hind concludes that 'there is undoubtedly more quality in some of these which can still be purchased from between £5 and £15 than in the best photogravures.'[26]

I shall not deal with another group of Rembrandt's prints, sheets of which are 'unobtainable, of extreme or great rarity' (Nowell-Usticke). In these cases, only two or three sheets are known, and they have all been in museums for a long time. There are also a few other proofs which are still the subject of controversy and therefore come outside the scope of our discussion here.

I shall return to Rembrandt later to discuss an interesting example of the drypoint *Clump of Trees with a Vista* (B. 222) in the second state; but for the moment I merely want to stress the difficulty of distinguishing those of Rembrandt's etchings which are definitely early impressions and of very good quality from others of the same subject which are probably later impressions but nevertheless of good quality: it is a task that few experts are able to tackle.

CANALETTO AND PIRANESI

It seems that Canaletto, once he had produced his plates, was no longer interested in the printing of them. It is generally considered that the second states of the large *Vedute*, those which bear a number on the bottom margin, are posthumous. In the case of the small, loose *Vedute* an assessment of whether an impression is early

[26] Arthur M. Hind, *A Catalogue of Rembrandt's Etchings*, 2 vols., 2nd ed. (London 1923), vol. I, p. 34. The figure of £5 to £15 mentioned by Hind would have to be multiplied by at least a hundred today.

Charles Meryon, *L'Abside de Notre-Dame*, 1854

or posthumous has to be made mainly on the basis of its quality, since an examination of the complete sheet is not very helpful, nor, as we have already seen, is the watermark, which is often the same in different editions.

Hind's catalogue is still of fundamental assistance in making an adequate though approximate estimate of the date of the different editions of the etchings by Giovanni Battista Piranesi. His description of the states, the paper, the principal watermarks used by the artist, then by his sons and by successive publishers in Rome, Paris and then again Rome (the new Calcografia Nazionale), makes it slightly less difficult to assess the quality of early impressions, which were always good during the lifetime of the artist, vigilant director of his own printing press. It should be remembered that fine early impressions are not so numerous, even though his volumes and sheets are often seen at auctions: the indication at the foot of a print of the price (*paoli due e mezzo*) on the first seventy *Vedute* is not always a sure sign of the age of the impression.

NINETEENTH-CENTURY PRINTMAKERS *(number of impressions unknown)*
Charles Meryon and James Abbott McNeill Whistler cancelled their plates themselves: only a very small number of unimportant plates, which had perhaps been mislaid by the artists, were used for later impressions, like *Billingsgate* (K. 47) from Whistler's Thames Set, which was in fact steelfaced. No posthumous lithographs exist by Honoré Daumier, who drew on the stone. Thirty plates by Edouard Manet (1832-83) which were left in his studio after his death were used in 1890 for a small edition supervised by his family. Subsequently further small editions were printed by M. L. Dumont and, in 1905, by the publisher Strölin. All the plates have since been kept at the Bibliothèque Nationale in Paris, except for two of the three small portraits which, having been steelfaced, can still be printed from.

Much more could be written about editions of prints by French artists which in some cases have run to exceptionally high numbers. I shall just mention that several copperplates exist by Auguste Renoir (1841-1919) which, as they were steelfaced, are still usable; and that Delteil's reference to *pierres détruites* and to an edition of 100 sheets in connection with the lithograph *L'Enfant au biscuit* (D. 31) is puzzling: if what he says is true, it is incredible that seventy years after the date of this very popular lithograph, so many colour and black and white impressions are still circulating. *Boulevard* on China paper (R.-M. 74) by Pierre Bonnard (1867-1947) is still extremely easy to come by: therefore the statement that in 1900 Insel Verlag printed only 100 sheets must be wrong. The same goes for the very common and well-known lithograph *Profil de lumière* (M. 61) by Odilon Redon (1840-1916) which according to Mellerio's catalogue was printed in an edition of 50 on 'Chine appliqué' paper, while the first state on 'Chine volant' was not put into circulation. The colour lithograph *Le Soir* by Paul Signac (1863-1935) was printed by the periodical *Pan* towards the end of the nineteenth century in an edition of 1,100; the same was true in 1895 of the third state of the beautiful colour lithograph *Mlle Marcelle Lender, en buste* (D. 102) by Toulouse-Lautrec; but these examples, as I have said, do not constitute posthumous editions, but rather very large original editions of which cataloguers have often been unaware.

DECORATIVE PRINTS - JAPANESE PRINTS

Decorative prints, especially coloured ones, were once very fashionable and today are back in demand. The fact that they were intended to decorate rooms, and were therefore always framed, has often had a harmful effect on their condition. Today specialized dealers in the West End of London are always ready to pay several thousand pounds for any of the famous sets of sporting aquatints, provided that the sheets are in loose form and, preferably, accompanied by the portfolio which originally contained them.[27] Naturally, many of these plates, both English and French, were steelfaced.

The field of Japanese prints belongs to the expert in Oriental art. However, late impressions of both black and white and colour woodcuts by Katsushika Hokusai (1760-1849) and by Utagawa Hiroshige (1797-1858) are fairly common: in these late versions aniline colours were used, and any doubts about their age can be dispersed by a simple chemical analysis.

[27] Wilder, op. cit., p. 173. The well-known series of eight large colour aquatints, *The Quorn Hunt*, engraved by F.C. Lewis after drawings by Henry Alken, was on sale in 1830 at the publishers Rudolf Ackermann in London for 4½ guineas.

IX Modern prints

For historical purposes, modern prints are generally regarded as those produced from about 1800 onwards, although the work of artists like François Janinet and Philibert-Louis Debucourt (1755-1832) is grouped with early prints and the work of Francisco Goya and William Blake with modern prints, despite the fact that all these artists were active during the same period. Technically speaking, however, modern printmaking began only in the second half of the nineteenth century, quite a long time after the lithographic technique had been invented and when the means of steelfacing copper and zinc had been developed, thereby allowing the artist to print large numbers of impressions of uniformly good quality. In fact, several years were to pass before artists, publishers and dealers realized that abuse of these technical innovations was going to lower the value of prints and that editions would therefore have to be deliberately limited.[1]

The lithographic stone allows a large number of proofs to be printed, especially if the printer uses his press skilfully. One has only to think of Daumier's works, almost always printed in a few thousand copies, of which certainly several hundred were of excellent quality. And yet it must be remembered that in cases where the mark made by the pencil or lithographic ink has nuances, where the stone has been scraped as in a mezzotint, or where tonal effects are pronounced, a long printing run is harmful to the quality of the impression.

Steelfacing allows a very great number of impressions to be printed from a copperplate, the quality diminishing only after thousands of impressions have been taken: this is clearly demonstrated by the editions of Picasso's *Chef-d'œuvre inconnu* (G. 123-135) – see above, p. 70 – or the major works of Marc Chagall, in which several hundred sheets printed from each of the steelfaced plates are all of the same good quality, apart from a variation in brilliance, due to the use of different kinds of paper for the various editions.

[1] The controversy over large and small editions is outside the scope of our discussion here, and it seems that it does not take into account the fact that while in the case of early engravings the number of impressions seriously affected the quality (the larger the edition, the poorer the quality of the last impressions), in the case of modern prints size of edition has much less effect.

Paul Gauguin, *Nave Nave Fenua*
(Terre délicieuse), c. 1894

The mention in the introductory chapters of rather unorthodox technical procedures, and of large numbers of sheets often printed from plates by famous artists, does not mean that printmakers today are not capable of serious and enthusiastic experimentation in graphic techniques. I know several who have gone to great lengths to get hold of old screw presses and roller presses, which are now no longer used in large printing works. They process the plate as was done in the past: they do the inking, printing and drying themselves, and know

Edvard Munch, *Vampire*, 1902

the difficulties of pulling prints from a copperplate which has not been steelfaced, and gives only a small number of good quality impressions. Only by visiting studios like these can the art lover and collector begin to understand what print making really means.

Artist's proof (épreuve d'artiste, prova d'artista). It is a fairly recent custom to assign to the artist a certain number of extra prints over and above the fixed size of the edition. Instead of a number, 'artist's proof' is written on the bottom right where the signature usually, and in this case invariably, appears. These proofs should not generally exceed five per cent of the total number of prints in the edition, but in certain regrettable cases they have equalled or even surpassed that number.[2] They do not increase the value of the print; on the contrary they diminish it, if for example it is not known how many of them were actually issued. At one time, the unscrupulousness of certain publishers and dealers (happily few in number) combined with the naïvety of novice collectors to create a strong demand for proofs of this type, which of course then fetched higher prices. Today this practice has fortunately diminished.

There is still a persistent demand for low edition numbers: a print numbered 7/100 is much more desirable than 90/100, while 100/100 is simply never seen. Now it should be noted (and this subject was written about in England at the end of the last century, by Whistler and others) that in the case of normal editions the printing is continuous, running on rapidly from the first to the last impression

[2] Zigrosser, op. cit., pp. 85-6.

Above left:
Ernst Ludwig Kirchner, *Portrait of Dr Grisebach*, 1917

Above:
Erich Heckel, *Self-portrait*, 1919

Left:
Max Beckmann, *Jacob wrestling with the Angel*, 1920

Opposite:
Ernst Ludwig Kirchner, *Little Mountain Boy in the Sirocco*, 1919

The numbering can be done as soon as the print is dry, or months later; and it is not beyond the realms of possibility that the employee responsible for the numbering might begin with the last impression, and end with 100 marked on the first to be printed. Nevertheless the serial number is still a useful guide for collectors.

Information about editions of modern and contemporary prints, and the actual number of impressions printed, while not so complex as in early prints or reprints, is nevertheless sometimes far from satisfactory, contrary to what one might expect. Unfortunately it has to be said that the problems involve major artists (though not all of them, of course) to a greater degree than those less famous. The reasons for these difficulties are various. For example 'Edvard Munch and the German Expressionists, such as Emil Nolde (1867-1956) and Ernst Ludwig Kirchner, and graphic artists with style and spontaneity like Paul Gauguin, frequently engraved or drew directly on to the matrix using all kinds of techniques, then printed the proofs or had them printed, sometimes in small numbers, sometimes in large numbers, more or less as they felt inclined. In these cases we can do no more than hazard a rough guess at the number of prints originally pulled, based on the number of sheets which turn up at the big sales. Sometimes four or five impressions of the same print will appear every year,

Above:
Georges Braque, *Fox*, 1911

Above right:
Paul Klee, *The Tightrope Walker*, 1923

while in other cases one turns up only once every three or four years; but the conclusions that can be drawn from this method are of value only if the survey is continued over a long period. Gustav Schiefler,[3] who was a friend of the three great Expressionists, gives specific information about states in his catalogues raisonnés but rarely discusses the number of impressions pulled.

The situation is much clearer in the case of lithography, for which numbering is more or less the custom, and in France where an exact account of editions has always been kept, even though for some artists only very imprecise information is obtainable, through exhibition catalogues or catalogues raisonnés. Practically everything is known about the editions of some artists, for example André Dunoyer de Segonzac (b. 1884) and Jacques Villon (1875-1963). On others – like Georges Braque, Marc Chagall or Pablo Picasso – information has been meted out in small doses, perhaps a little more in the last few years. But it would be a good thing if we could have much more information on editions, and especially on the fate of the matrix – whether or not it has been cancelled, whether there are to be further editions once the present one is sold out, and so on. In fact the

[3] Gustave Schiefler, *Verzeichnis des graphischen Werkes Edvard Munchs*, 2 vols. (Berlin 1907-26); *Das graphische Werk Emil Noldes*, 2 vols. (Berlin 1911-27); and *Die Graphik Ernst Ludwig Kirchners*, 2 vols. (Berlin 1926-31).

actual value of a print, whether early or modern, depends on the number of good impressions which are known or presumed to be in existence. Both the museum curator, buying on behalf of his print room, and the private collector should be able to find out whether a contemporary work has been printed in an edition of fifty or two hundred. (With old master prints different valuation criteria apply.)

EDVARD MUNCH

Examples

Among his works the most often seen are the black and white lithograph *Eva Mudocci* (Sch. 212), the colour lithograph *Madonna* (Sch. 33), and the colour woodcut and lithograph *Vampire* (Sch. 34). These can be bought almost every year at sales in Berne, New York and London (not in Paris), so a fairly large number of sheets must have been printed, even if it is conceivable that, given the sharp rise in prices, there has been speculative buying and selling of some prints, thereby giving the impression that they are more numerous than they really are. Some other prints by Munch are decidedly more rare, such as the small colour mezzotint *Young Girl on the Shore – The Lonely One* (Sch. 42), of which, according to a catalogue published by Eberhard W. Kornfeld in 1970, only six sheets were known; a seventh was found in 1971. More information about Munch editions will be forthcoming as soon as the exact inventory of the Munch Museet in Oslo

is known: 15,000 prints of 700 different subjects were left by the artist in his will to the city of Oslo.[4]

ERNST LUDWIG KIRCHNER

Similar uncertainty surrounds the editions of Kirchner's graphic work. The colour woodcut *The Pines* (Sch. 369), for instance, has been seen only two or three times at important sales in the last ten years; on the other hand the *Head of Ludwig Schames* (Sch. 281), a black and white woodcut, can be bought from any print dealer.

GIORGIO MORANDI (1890-1964)

There is a catalogue by Lamberto Vitali on Morandi, the greatest Italian graphic artist of the twentieth century, so the amateur collector can make his purchases with a fair degree of certainty.[5] Morandi 'forgeries', about which much has been said, are, so far at least, so badly done that a dealer with any knowledge at all can very easily detect them.

PABLO PICASSO

Tête de femme, IV, colour aquatint (Bl. 1340).

A recent catalogue from a sale of Picasso prints states that only one impression is known of this 1939 aquatint and that the Parisian printer Lacourière did not in fact carry out the complete edition as planned. Many people who were present at the sale did not doubt this statement at all; but an indication as to whether or not the plate had been cancelled, or perhaps a note supplied by the artist, would nevertheless have been welcome.[6]

MARC CHAGALL

According to the catalogue prepared by the Museum of Fine Arts in Boston, which frequently refers to other sources, the total edition of the 107 etchings of the set *Les Ames mortes* consists of 368 prints, including 50 on 'Japon nacré'; that of the 100 etchings of the *Fables of La Fontaine*, of 300; and that of the 105 engravings of the *Bible*, of 395.[7] Apparently, 85 prints of the *Fables* series and 100 of the *Bible* were hand-coloured by the artist (as far as I have seen, this consisted of a brush-stroke of a few square centimetres). Since the two series comprise respectively 100 and 105 prints, the artist must have painted a total of 19,000 prints. Nothing is said about whether the plates were cancelled or not. It really is to be hoped that Kornfeld, in the second volume of his catalogue, which is at present in preparation, will tell us something more on this subject.[8]

[4] In addition to the 15,000 prints, Munch also left to the city of Oslo 4,500 drawings and 1,000 oil paintings: see Ole Sarvig, *Edvard Munch Graphik* (Winterthur 1965), p. 15.

[5] Lamberto Vitali, *L'opera grafica di Giorgio Morandi*, revised ed. (Turin 1964). This is a conscientious catalogue, apart from some confusion regarding states, since Vitali frequently classifies as first state what is in fact the definitive state (in fact, where Morandi has numbered a plate, from which further prints will be taken only in the next century, one cannot speak of more than one state). The lack of reference to the first editions, which were very small in any case, is irrelevant. What is surprising, however, is Vitali's reluctance to consider Morandi as a *peintre-graveur*, as this is what every inventive graphic artist from Munch to Picasso would have claimed to be.

[6] Berne, 13 June 1969, 205,000 Swiss francs ($47,560).

[7] *The Artist and the Book*, op. cit., pp. 41-4. According to other sources, and also to another interpretation of the declared editions, the number of impressions of one or two of the three works may be slightly higher.

[8] E.W. Kornfeld, *Verzeichnis der Kupferstiche, Radierungen und Holzschnitte 1922-66*, vol. 1 (Berne 1970). Often, but not always, the information which accompanies major illustrated works includes a list of the various editions and a note as to whether the plate has been cancelled, as well as a description of the paper used. The fact that sale catalogues often avoid mentioning information known to them (perhaps so as not to indicate how big the edition really was) may rightly arouse the collector's suspicion.

X Quality

The concept of quality assumes different meanings according to the object referred to. In the case of a work of art it has a particular sense if the work is a painting, and another if it is a drawing, in which the deciding factor is the 'line'. Quality has quite a different meaning when applied to prints, for several specimens of each print are normally known, sometimes differing one from the other. An assessment of the quality of a print will also take into account the technical procedures used by the artist and will further consider that there is a different set of values to be applied to an old master print from those applied to a modern one, which is by nature more uniform. Moreover, a print of which only one impression is known has to be judged differently from another of which many sheets exist which seem almost identical but which, if the best and the worst examples are compared, nevertheless show characteristics that differ widely from an aesthetic point of view.

The engraved mark remains substantially the same, although a less good print loses that afflatus, that feeling of the artist's creation, which can be sensed only in a print of very high quality. This way of judging the aesthetic qualities of various impressions of the same print is particularly subjective: it was at one time applied sparingly and prudently, but its importance is now inflated, and it has become a very fashionable attitude, adopted in all circumstances. Its meaning therefore ought to be restricted and more rigidly defined. It is in fact quality above all which counts in a print; if it does not have it, though it may be a very important work, its value can lie only in the fact that it may be rare. But where there is quality, rarity and good condition, one arrives at the optimum, and at this level a masterpiece of graphic art can take its place alongside any great artistic creation in another medium.[1]

Quality in early prints has today assumed a different meaning, decidedly inferior to that which it used to have. This is inevitable. We have seen how when many sheets are printed from a plate the prints become steadily less fine, at a rate which depends on the technique used. The number of excellent impressions could never have been high, and over the centuries many were lost or irreparably damaged,

[1] Black and white prints, to a greater extent than colour prints, are considered by many to be a substitute for paintings.

Above left:
Albrecht Dürer, *Standard Bearer*,
c. 1500

Above:
Albrecht Dürer, *Galloping Rider
(The Small Courier), c.* 1496

Left:
Albrecht Dürer, *Madonna with a
Pear*, 1511

Opposite:
Albrecht Dürer, *St Jerome
in Penitence, c.* 1497

while the best remaining impressions must always have found their way gradually into public collections: the logical conclusion is that the available number of good quality old master prints is rapidly diminishing. This is confirmed when we look through the thirty or more sale catalogues which are printed every year, and which altogether contain a much smaller number of excellent impressions than a single catalogue from an important sale of the last century. Some of these old catalogues had supplements containing perhaps several thousand prints in three or four hundred lots, which today would make up a dozen important, richly illustrated catalogues.

In 1931 Meder,[2] referring to the terminology then in use to describe the quality of a print, wrote: 'With regard to the quality of prints, grades of quality have been introduced into the trade, both in saleroom catalogues and in those published by graphic art galleries; according to this new scale, prints which at one time would have been considered worthless or worn are now called "good" or "still good", while the prints once considered good are now "very good", and the better ones "outstanding".' Now if this difference was noted by Meder forty years ago in comparison with prints current at the beginning of the

Rembrandt, *Christ preaching (La Petite Tombe)*, *c.* 1652
Impression with burr, especially on the left sleeve of Christ's robe and on the clothing of the man in the left foreground

[2] Joseph Meder, op. cit., *Technisches Erläuterungen*, p. 52.

century, what can the position be today, when the demand is more than ten times as great, and the finest proofs, at one time fairly common, have become exceptionally rare? Meder's assessments referred in particular to the line engravings and woodcuts of Dürer, but they can obviously be extended to prints by other sixteenth-century masters and even more so to those of the preceding century. The situation regarding graphic art of the seventeenth century has also become decidedly worse.

It is not my intention to discourage the collector, yet he ought to be aware of the facts. He must be able to content himself with what the market has to offer him, and accept that the dealer must base his judgment on ordinary sheets available, not on the unobtainable impressions preserved in museums. This does not mean that sales may not occasionally include sheets which even in the past were considered to be superb, and which the Germans, having exhausted the numerous qualifying adjectives at their disposal, call *von einmaliger Qualität* – 'of a quality to be found only once'. The demanding collector will nevertheless have an extremely limited choice of subjects among the many by Dürer, Cranach or any other old master, and it will be difficult for him to find just what he wants. On the other hand it will be easier for him to find good prints by artists nearer to our time, for example etchings by the great Venetian masters and by Francisco Goya. The shrewd and discriminating collector, who over the years has developed a deep understanding of the meaning of quality, will now and then choose one of these prints rather than a worn copy of a Mantegna, a Dürer or a Rembrandt, unless he is willing to pay a very high price.

The quality of an impression depends above all on four factors:
1 The faultless and even character of the printed line
2 The care with which the sheet has been printed
3 The choice of paper, which in any case must always be of the very best quality
4 The skill with which the plate has been inked, especially when the impression is intended to have certain tonal effects

It appears, then, that a fair assessment of the first and essential requisite of a print, its quality, requires a profound knowledge of prints acquired over many years; it also requires research and comparison with other impressions of the same subject, and this can be done only in a major print room where the print may be seen in several impressions of varying quality.

In modern prints, especially those of the twentieth century, when both artists and printers have had more advanced techniques at their disposal, quality does not have the same importance as it once had: barring accidents during printing,[3] the sheets are of uniformly fine quality, a little more brilliant if the impression has been printed on special paper, and decidedly better in the very few proofs pulled before the copper has been steelfaced.

Examples

ALBRECHT DÜRER

Very many woodcuts and line engravings by this artist are offered for sale every year, as can be seen from catalogues. But why is it that Dürer, though he is so much in demand and so greatly admired, and though his most important prints forty years ago realized almost as much as the best Rembrandts, no longer fetches the same prices as in 1930, account being taken of monetary devaluation? (The case of *St Eustace* is unique, as I have pointed out above.) The only plausible reason is that it is now almost impossible to find impressions of the most important and sought-after subjects as good as those available in the past.

[3] In this case the print ought to be destroyed.

The classification which Meder has drawn up of the artist's prints makes it
possible to assess whether an impression is early or late with some certainty, even
though the period involved could be quite long: during twenty or thirty years of
continuous printing the impression remained substantially the same. But substan-
tially does not mean qualitatively. By that I mean that of the early impressions
still to be found, very few are among the very first pulled, the ones which are
rich in contrast and shading, which could never have been very numerous even
in the sixteenth century. However, among the best known of Dürer's line
engravings it is still possible to find impressions which could be judged as fairly
good, and some as good, always at very steady prices. Examples are *Melencolia*
(M. 75), the *Galloping Rider* and the *Standard Bearer* (M. 79 and 92), the *Madonna
with a Pear* (M. 33), *St Jerome in his Study* and *The Knight, Death and Devil*. It is
more rare to find good impressions of *The Nativity* (M. 2) and *St Eustace*; and the
drypoint *St Jerome by a Pollard Willow* (M. 58), of which ten impressions in public
collections are known, is literally unobtainable. Regarding Dürer's woodcuts, to
take only those in the three great volumes, the proofs before the text of 1511, the
sheets of the *Apocalypse*, with German or Latin text of 1498 and the few known
impressions before the text, are no longer common, even in loose form.

REMBRANDT

I have already quoted several examples of prints by Rembrandt which are still
common, and I should like to return to them now. The etchings which were
made in combination with drypoint (to a greater or lesser extent) have very

Rembrandt, *The Agony in the Garden*, c.1657
The impression on the left, in the British Museum, is certainly one of the first two or three to have been printed. The deep velvety quality of the burr gives the composition the dramatic effect that Rembrandt must have been aiming at.
The version on the right, printed later in the seventeenth century, is usually described in sale catalogues as having burr, though in fact it does not. Anyone not very familiar with Rembrandt's graphic work can easily be deceived by heavy inking

clearly visible burr in the editions supervised by the artist himself; and therefore, where there was a single state only, there could never have been more than ten or fifteen really good impressions of one subject. However, despite the fact that the number of good impressions in circulation is steadily declining, not a year passes without several sheets, sometimes of the same subject, appearing in the major saleroom catalogues: the entries refer to the richness and the quantity of burr, or, if the worst comes to the worst, to 'traces of burr'. One is led to think that there has been either some mistake in interpretation or excessive optimism in describing the print, rather as in the case of Dürer whose prints in mid-century underwent a sharp qualitative promotion. It is probable, or at any rate possible, that the 'effect of burr' mentioned in a nineteenth-century catalogue has often become a 'velvety burr' today: the reason for this could be the lack of opportunity for making a careful comparison with better proofs. On the other hand it may lie in the skilful inking of the copper, in which Rembrandt, the greatest experimenter in the history of graphic art, excelled: the film of ink which he spread over the plate, then removed in some places, left in others, produced those dramatic contrasts between light and shade in the print, sometimes varying in each individual impression – artistic creations never before imagined and never again equalled in the history of graphic art.

Rembrandt was one of the first to use a soft ground,[4] different from the hard ground which gives cleaner lines, similar to those of a line engraving and typical of Callot. But this soft ground which enabled him to draw more freely, and with more sensitivity, reduced the potential number of good impressions. Then the fact that he subjected his plates to gentle, slow biting, using an acid which must

[4] Ludwig Münz, *Rembrandt's Etchings. A Critical Catalogue,* 2 vols. (London 1952), vol. II, p. 12 ff.

have been weaker than nitric acid 'which bites strongly, tending to enlarge the line',[5] is also a sure indication that even for his works which were entirely or predominately etched, the number of proofs printed could not have been high.

We know from evidence that Rembrandt, once he had completely mastered the technique of printmaking, was personally responsible for the printing and for the choice of paper for the first impressions, the so-called trial proofs which for him (and for us today) were the truest representation of his work. By that I do not mean that the artist did not print or allow to be printed impressions without burr, although it is unlikely that such an artist would approve the circulation of sheets which were no longer as he had intended them.

Münz and, more recently and more thoroughly, White, have made detailed and critical studies of Rembrandt's complex techniques which I cannot summarize here. Similarly, there would be little point in dwelling on the various methods used subsequently by skilful printers in an attempt to prolong the life of Rembrandt's plates – methods which can be described generically with the term *retroussage* (see above, p. 12), i.e. skilful inking of the plate before printing. The reader will find in the illustrations some examples of impressions with varying amounts of burr and these will give him a better idea of the diversity in quality to which I have referred. I shall now quote an interesting example, leaving other details to the footnote.[6]

La Petite Tombe (B. 67),[7] etching, drypoint and line engraving in a single state, *c*.1652. There are numerous impressions which were made as late as the first half of the last century. The plate, once retouched in drypoint by Watelet, underwent further adulteration by Jean-Pierre Norblin (1745-1830). Confronted with the following descriptions by experts of nine different impressions of this print, 'all rich or with abundant burr' (and they are certainly not the only ones to have been on the market in the past seventeen years), it is exceedingly difficult to express an opinion, even taking into account the likelihood of dense hatching on the plate which would have facilitated *retroussage*:

1 'outstanding impression on Japan paper, abundant burr, collection R.S. Holford (L. 2243) and Weisbach (L. 2659)'
2 'outstanding impression, abundant burr, coll. P. Remy (L.2173) and A. Curtis (L. 94)'
3 'outstanding impression on Japan paper, abundant burr'; without collector's mark
4 'outstanding impression on Japan paper with burr, coll. F. Debois (L. 985)'
5 'a very fine impression with burr... inscribed in ink on the back "Claude Augustin Mariette 1693" (L. 1786).' (See illustration on p. 130)
6 'only state, a very fine impression with strong burr... From the Collections of George Hibbert (L. 2849)', etc.

[5] White, op. cit., text p. 13.
[6] Some time ago I was surprised to discover that in the Rothschild collection at the Louvre there was no sheet of *The Agony in the Garden* (B.75) which, in velvety impressions, is one of the artist's masterpieces. With the help of advice from Karel G. Boon, I did a little research in order to see how many outstanding impressions there were in public collections. My findings, based on sheets I knew myself, on information supplied by various people, and on an examination of practically all the sale catalogues of the past fifty years, showed that not more than four or five existed which would stand up to the most stringent and selective appraisal, in other words those with really good burr, typical of the early impressions (cf. White and Boon, text p. 40). Another impression was unexpectedly added to these in 1970, from the Firmin-Didot collection (L. 119). Still on the subject of this print, and of Meder's qualitative promotions, to which I have already referred, it is interesting to note the different descriptions of the same sheet with the same collector's mark: in 1927 it was 'fine with platemark visible' and on 27 November 1970 it had become 'very fine with burr and narrow margins'.
[7] The name *Petite Tombe* derives from the sheet owned by a certain La Tombe who lived in Rembrandt's time, and which a friend of the artist, the print dealer Clement de Jonghe, described in his inventory as *Tombisch plaatjens*. The name was translated into French by E.F. Gersaint (1751).

Morandi 1929

Giorgio Morandi, *The Three Houses of the Campiaro at Grizzana*, 1929

7 'a fine early impression on Japan paper, with rich burr and wide margins'; without collector's mark

8 a very fine impression, rich in burr, trimmed inside the platemark; without collector's mark

9 'a fine "black sleeve" impression, rich in burr', without collector's mark.

The nine sheets listed,[8] each of which I have either examined or seen in good reproductions, all had burr on the left hand sleeve of Christ and on the tunic of the man in the left foreground; they were not therefore examples without burr which the Dutch call *met het witte mouwtje* (with white sleeve).[9] If we add to this list another fine impression formerly in a Swedish collection (1967) and known to various experts, and yet another, trimmed along the margins and described in a French catalogue (Paris 1963) as *chargé de barbes*, and also others I have seen in public collections or illustrated in exhibition catalogues, the number of prints

[8] (1) Berne, 11 March 1954, (2) 28 April 1955, (3) 4 June 1957, (4) 8 June 1961, (5) Sotheby's, 29 June 1965, (6) New York, 30 April-1 May 1968, (7) Christie's, 28 November 1967, (8) New York, 11 November 1969, (9) Sotheby's, 25 March 1971, £5,500 ($13,200).
[9] White and Boon, op. cit., text p. 34.

Pablo Picasso, *Le Bain*, from *The Acrobats*, 1905

with the characteristic velvety burr left by the drypoint would seem to be rather too high.

Even though none of the sheets listed can stand comparison, for example, with that in the Pierpont Morgan collection[10] (which is certainly an early impression, and probably the one which appeared as no. 81 in the John Barnard sale catalogue, 1798), I cannot help thinking of the words of the Dutch painter and man of letters Arnold Houbraken (1660-1718), *das Vollenden seiner Radierungen*

[10] *Rembrandt: Experimental Etcher*, op. cit., p. 70, pl. 44.

136

Pablo Picasso, *Salomé*, from *The Acrobats*, 1905

sein Geheimnis: his engraved work is a mystery which died with him.[11] After this, it seems almost banal to mention a few extreme cases of Rembrandt's etchings 'with burr': *Abraham's Sacrifice* (B. 35) and *The Triumph of Mordecai* (B. 40), both in a single state, appear in important sales every year; but the record may be claimed by *Ephraim Bueno*, of which three very good impressions, all with burr and collector's mark, were sold in London between the end of November 1970 and June 1971, and no fewer than thirty sheets were sold between 1945 and 1970.

[11] De Groot, op. cit., no. 407.

GIOVANNI BATTISTA TIEPOLO

I recently came across a striking demonstration of quality, which I will record here for its own interest, and because it should please all those who love Tiepolo's work and rightly lament the fact that no complete set of his greatest etchings, even in second states, has existed in Italy. In June 1971 I was able to see, in a private collection in Italy, the twenty-three sheets of the *Scherzi di fantasia* before numbers, with full untrimmed margins, and of superb quality. They were undoubtedly very early impressions, so that they resembled pen and brush drawings. I confess that never, in any museum in Europe or America, had I seen a set of such quality; if it were widely known, it would convince even the most hostile critics of the greatness of Tiepolo as a graphic artist. This magnificent set had returned to Italy after an absence of some two hundred years. I am sure that its fortunate owner would willingly exhibit it in a museum for the benefit of all who would like to become better acquainted with Tiepolo's graphic work.[12]

PABLO PICASSO

A considerable variation in quality can be seen in the impressions of the different editions of the *Acrobats* series. It is still very high in the first edition, printed by Auguste Delâtre in 1905 before the plates were steelfaced. There is a certain difference in the edition which Fort printed in 1913 between the impressions on Japan and those on Van Gelder wove paper: the latter are at times uneven, with varying intensity of inking.

GIORGIO MORANDI

Even in the etchings printed by the Calcografia Nazionale of Rome differences can be noted from one example to another, with some sheets lightly and others evenly inked.

[12] Needless to say, I am not the owner. Among the prints shown at the fine Tiepolo exhibition which was prepared by Aldo Rizzi in Udine to mark the bicentenary of the artist's death were the twenty-three *Scherzi*, almost all in the second state. The nine major Italian museums lent examples, and the more rare impressions were on loan from the Rijksprentenkabinet in Amsterdam. See the catalogue *Le acqueforti dei Tiepolo*, by Aldo Rizzi (Udine 1970).

XI Rarity

Another important factor governing a print's value for collectors is rarity. As the number of sheets available on the market decreases, until some items disappear altogether, the word is sometimes used loosely in connection with the quality or condition of a print. Phrases like the following can frequently be read in catalogues: 'today almost impossible to find in this quality' or 'of exceptional rarity for its excellent condition'.

The word 'rare' can be used in its absolute sense when it is presumed that the few known impressions are now all in public collections. There are many thousands of these prints, all of course of different subjects, some by great masters, others by minor artists. A few examples of this class of print are:

The 4,000 known incunabula, often unique prints; the 91 engravings by the Master of the Housebook, of which 78 are unique impressions, mostly housed in the Rijksprentenkabinet in Amsterdam; the 56 etchings by Hercules Seghers – some in single sheets only, though there are several different experimental proofs of others – again almost all in the Rijksprentenkabinet; the 314 line engravings by the Master E.S., all exceptionally rare, of which a few or sometimes only one impression is known, and of which at least 25 are in the Pinacoteca Nazionale in Bologna

A now considerable number of Rembrandts, which in the rare first states are no longer found in private collections

Some of the prints which are most rare today may have been issued in large numbers originally but have gradually disappeared over the centuries; of others, very few sheets would ever have been printed. However, early prints which have come down to us usually represent only a part of the original total number of impressions in circulation.[1]

[1] Presumably fifteenth-century playing cards, many of which are known in single impressions only, were, for functional purposes, stuck down on card and would have been thrown away when they became worn and dirty.

Master of the Housebook, *The Idolatry of Solomon, c.* 1480

Right:
Master of the Housebook, *The Young Man and Death, c.* 1480

Opposite, above:
Master E.S., *The Letter M, c.*1464-7

Below left:
Master W.A., *Bishop's Crosier* (upper part), *c.*1470. The whole engraving, of which two copies are known, was printed from two plates

Below right:
Master E.S., *The Virgin praying, half-length,* 1467

The rarity of prints by the Master of the Housebook may be due not only to the technique – drypoint and line engraving – and to the metal alloy used for the plate which was perhaps less strong than copper, but also to other reasons of which we are unaware.

Slight damage, such as corners or even small areas of the impression missing, which in other cases would sharply reduce the value of a print, is tolerated in prints which are truly very rare, and does not appreciably diminish their value.

MASTER E.S. Examples

The Letter M (L. 294)

'Engraving, a very fine impression with a small bear, staff and star watermark (Lehrs fig. 3)'. Collections: Duke of Buckingham, sold by Phillips of London on 18 July 1834 for £4.6s.

This engraving had been owned by Sir John Rushout, second Earl of Northwick (L. 2709a), whose great grandchildren sold it, with other very rare prints, at the C.G. Boerner auction in Leipzig, 22-24 May 1933 for 7,600 marks.[2] There are five other known impressions of the *Letter M*, all in public collections.

The Virgin praying, half-length (L. 60)

Here is a summary of the catalogue description, which runs to over six hundred words.

'Engraving on paper watermarked with the bear, staff and star, illustrated under no. 1 in Lehrs. According to Briquet the paper with this watermark was manufactured by the Thal papermill near Berne in the years 1466-7. The same small sheet, in the collection of Count Yorck von Wartenburg (L. 2669), was sold at the same saleroom in Berne in 1948.'[3] Only four other impressions of the engraving are known.[4]

MASTER P.M.

One searches in vain for information on this important artist: even the major art encyclopaedias do not mention him.

Women Bathing (L. supplement 2709a)

'Somewhat damaged impression, formerly in the collection of the Earl of Northwick [see above], sold by C.G. Boerner of Leipzig, 22-24 May 1933.'[5]

The Master P.M., once believed by Hind to be Italian, was in fact German, perhaps a wood engraver by trade, active near Cologne in the Lower Rhine district around 1490. His technique must have been influenced by Schongauer. His treatment of the nude, as can be seen in this engraving, was extraordinary for his time. Only one slightly torn fragment exists of another impression, and the collector W. H. Willshire (L. 1111) left it, with other very rare works, to the Guildhall Library in London.

PIETER BRUEGEL THE ELDER

An example of rare quality. In 1964 an album was put up for sale in London containing many of the finest engravings after Bruegel, including *The Rabbit Hunt* (B. 1), the only one to have been engraved by the artist himself. The prints,

[2] The same Leipzig buyer, G. Schocken, sold it at Sotheby's on 17 March 1966 for £13,000 ($36,400).
[3] Berne, 17 June 1970, 130,000 Swiss francs ($30,160).
[4] Max Lehrs, *Geschichte und kritischer Katalog des deutschen, niederländischen und französischen Kupferstiches im XV. Jahrhundert*, 9 vols. (Vienna 1908-34), vol. II, p. 119.
[5] Sotheby's, 17 June 1970, £32,000 ($89,600). Sold by G. Schocken, together with other very rare engravings (see above, n. 2). At Leipzig he had paid DM 15,000 for it.

The only complete impression
known of this bold composition,
engraved at the end of the
fifteenth century

contrary to what would at one time have been the practice, especially in the case
of Bruegel, were sold sheet by sheet. The set was being sold by an old European
princely family who wished to remain anonymous, and had been formed by an
ancestor of the vendors, probably in Bruegel's lifetime; it may have been bought
by subscription from Bruegel's publisher, Hieronymus Cock, one by one as the
prints were issued. The work was presumed to be of early date for two very good

Above:
Pieter Bruegel the Elder, *The Rabbit Hunt*, 1566. This etched and engraved print is the only one Bruegel himself produced

Left:
Willem Buytewech, *Landscape*, c.1615

Overleaf, above:
Rembrandt, *Clump of Trees with a Vista*, 1652
Rembrandt used drypoint alone for this print, as in a very few others. Altogether six copies are known of this, the first state

Below:
Rembrandt, *Clump of Trees with a Vista*, second state, 1652

Henri de Toulouse-Lautrec, *La Grande Loge*, 1897

Rembrandt f. 1652.

reasons: the prints were laid down on sheets which bore the watermarks Briquet 304 and 308, current between 1552 and 1588;[6] and the quality of the engravings was so high and the inking so fresh that they seemed to have just come off the press (the fact that they had been kept in an album for centuries had contributed greatly to this). The first thought which must have struck anyone present at the sale was that the Bruegels normally found on the market must be posthumous or even very late impressions.

Another notable characteristic of these prints was the almost complete absence of margins, practically all the engravings being trimmed along or within the platemark; and there were also some creases which had occurred during printing – defects which on the one hand were a negative factor, but which on the other hand almost suggested that in the posthumous editions rather more careful printing and wider margins must have been used in a way to make up for the lack of quality. *The Rabbit Hunt*, which had not been seen in the salerooms for very many years, realized such a high price that during the next two years two collectors, encouraged by this result, sold two similar examples – a rare event in any circumstances.[7] On the subject of quality, particularly of the posthumous editions printed from the Bruegel-Cock plates, one might note that another impression of *The Resurrection* (B. 114), admittedly in the later state, in 1969 fetched fifty-five times less than the album version.

Canaletto, *Imaginary View of Venice*, c.1743. The fifth known impression

[6] Briquet, op. cit., vol. 1, p. 34.
[7] Sotheby's, 10 March 1964, £10,500 ($29,400), 23 March 1965, £6,500 ($18,200), 17 March 1966, £5,500 ($15,400).

Above:
Francisco Goya, *Blind Man with a Guitar*, c. 1778

Right:
Francisco Goya, *The Colossus*, c. 1815

WILLEM BUYTEWECH (*c.* 1591-*c.*1624)

Landscape Set (H. 35-44)

'A set of ten plates, including title, first state ... good early impressions on paper with a jug and LDS watermark (similar to Churchill 462[8]) with wide margins.' Only nine complete sets are recorded, and of these only one set in Frankfurt is in the first state. The Buytewech etchings were sold in an album with other landscapes by Antoine Perelle, etc.[9]

The high price paid for this small set, with individual engravings measuring 8.8 × 12.8 cm (3$\frac{1}{2}$ × 5 inches) is due partly to its extreme rarity and partly to its style, which was new and unusual at the beginning of the seventeenth century: Adrian Eeles wrote, 'They are above all atmospheric, with their tall, sinuous, apparently leafless trees and deserted buildings. The sense of "nature" is very strong.'[10] The landscapes by Hercules Seghers and by Rembrandt make one think that the two masters must have known the graphic work of this artist, who did very few paintings.

JACQUES CALLOT

The Battle of Avigliana (L. 663)

Lieure considers the first state of this etching to be exceptionally rare and classifies it as '3 R', and yet the print cannot be considered rare even though fine impressions are very expensive. The second state, which ought to be common, is on the other hand impossible to find.

Above:
Francisco Goya, *Landscape with Buildings and Trees*, before 1810

Opposite:
Francisco Goya, *Landscape with a Waterfall*, before 1810

The first of these compositions is known in two experimental proofs and the second is known in one. They were etched by Goya on a single plate which he then divided. He later used the back of the two plates for four scenes from the *Desastres de la Guerra*. Both plates are preserved in the Calcografía Nacional in Madrid, where in 1920 an attempt was made to print a few proofs from the two placed side by side

[8] Churchill, op. cit., p. 86, date 1611?, pl. 462.
[9] Sotheby's, 8 April 1970, £10,500 ($25,200).
[10] 'Willem Buytewech', in *Art at Auction 1969-70* (London 1970), pp. 69-72.

REMBRANDT

Clump of Trees with a Vista, second state.[11]

This is the only print which Rembrandt did entirely in drÿpoint. Only six impressions are known of the first state,[12] a sketch which must have been drawn from life, out of doors.[13] In the second state however it has been completed, still with drypoint only, in the studio. The second state should therefore be very rare as well. And yet, I can quote offhand three recent descriptions of the print, and I know of another from several years ago:[14]

1 English gallery catalogue, 1967: the sheet is described as outstanding and very rare, though there is no explicit mention of the burr; no collector's mark. It is probably of the same Swedish provenance as the *Petite Tombe* mentioned on p. 134.

2 very fine early impression, with burr, formerly in the collection of Leonard Gow.[15]

3 a very fine impression, with rich burr; no collector's mark.[16]

The last example, though not perhaps on a level with the best, must have been the finest to be sold during the last thirty years.

[11] Frits Lugt identified the view as being of a place near the Amstel: see *Mit Rembrandt in Amsterdam,* German ed. (Amsterdam 1920), p. 120.
[12] F. Lugt, *Les plus belles eaux-fortes de Rembrandt* (catalogue of an exhibition held at the Louvre, Paris, 1969-70), no. 78, p. 42.
[13] White, op. cit., text pp. 215-17.
[14] *American Art Journal* (New York 1949), p. 467: Parke-Bernet, 4 April 1946, $950.
[15] New York, Nowell-Usticke sale, 31 October-1 November 1967, $13,000. The same sheet had fetched £231 at the Leonard Gow sale at Christie's on 31 May 1937.
[16] Christie's, 13 May 1969, 12,000 guineas ($30,240).

CANALETTO

Apart from three small fragments of slight artistic value, not included in the albums of the *Vedute*, the most rare etching is the *Veduta fantastica di Venezia* (P.G. 12). There are impressions of the first state, when the plate was still whole, in Paris, Berlin, the Fogg Art Museum at Cambridge, Mass., and the Courtauld Institute in London. In November 1970 a fifth sheet was put up for sale in London. A drawing in the British Museum, until recently attributed to Canaletto and thought to be a preparatory sketch for this etching, has now been shown to be a copy after the print.

FRANCISCO GOYA

I have already spoken of the large series of prints. The four lithographs *Los Toros de Burdeos*, printed by Gaulon in an edition of 100 in December 1825 at Bordeaux, were last sold as a complete set, though not by auction, at the beginning of 1963. Much more rare are the etchings *Blind Man with a Guitar* (H. 20), of which four impressions are known; the *Landscape with Buildings and Trees* and *Landscape with a Waterfall* (H. 23, 24), etched originally on a single plate which was probably divided before printing took place, and known respectively in two experimental proofs and in one; and the mezzotint *The Colossus*, of which five impressions were known until 1964 when a sixth came to light.

NINETEENTH- AND TWENTIETH-CENTURY PRINTS

Among the extremely rare prints of these two centuries are: the first states of the *Eaux-fortes sur Paris* (D.W. 17-39) by Charles Meryon, quite a few Whistlers, Edouard Manet's early proofs, many Daumiers before letters, and the *Self-portrait* (D. 1) which was Degas' first experiment in graphic art, at the age of twenty-one, and which can be compared with the best Rembrandt portraits.[17] There are also prints of the late nineteenth century and of this century which are undoubtedly almost impossible to come by, such as certain woodcuts which Paul Gauguin printed in Tahiti,[18] certain prints by Munch, perhaps even some Picassos of which very few sheets are known, even though it is not certain whether or not the copperplate has been destroyed.

[17] Altogether only a very small number were printed of all five states. Of the third, the best of all, six or seven examples are known, probably all now in America.
[18] The Parisian reprints carried out by his son Pola in 1921 in Copenhagen are on the other hand common. Up to a few years ago impressions were still being taken from some of the blocks.

XII Condition

The value of a print depends to a considerable extent on its condition. As with quality, there is a special scale of descriptive terms which range from 'outstanding' to 'good', and from absence of comment (which could be cause for suspicion) to an actual mention of damage. With old master prints the collector must be more tolerant now than in the past; but he can still be quite exacting with regard to eighteenth-century prints, and even more so with regard to those of the nineteenth and twentieth centuries. To hold out for perfect condition in prints which are definitely old, even if not quite contemporary impressions, in the case of engravings done in the fifteenth or even the sixteenth century, would in effect prevent one from collecting prints made in those centuries. Slight damage or a half-inch tear in an engraving, something which at one time would have made a collector like Baron Edmond de Rothschild shudder – unless it was an outstandingly rare impression – and which even ten of fifteen years ago would have caused a sharp drop in the value of the print, would today be almost overlooked by a not too demanding purchaser. In any case a skilful restorer can make the damage almost invisible.

A print cannot be regarded as in perfect condition unless it has at least a small margin all round. Here, however, a few brief remarks are necessary. The earliest matrices were made of wood, which was inexpensive: the designer need not therefore be concerned if he used a block larger than was strictly necessary for his design. It was a different matter, however, with metal engraving, almost universally done on copper, which has always been a fairly expensive material: even an established engraver had a small profit margin,[1] hence he could not afford to use a plate larger than necessary. The distance from the margin of the print to the platemark is therefore very small, and often the sheet of paper itself was scarcely larger. Collectors used to stick their prints down on to cardboard or more often

[1] It may well have been to save money that Rembrandt decided to buy two copperplates which had already been used by Hercules Seghers, using one for his large *Flight into Egypt* (B.56) for the second state onwards, and the other probably for *The Three Trees* (B.212). Picasso, for his first important etching, done in 1904, *Le Repas frugal* (G.2), employed a zinc plate which had already been used, as can be seen if one examines the print, where marks which the artist had to scrape away can still be perceived.

on to the pages of an album, and therefore margins did not have much aesthetic value for them. Furthermore, if the print were subsequently removed from this backing, the margin would be damaged and sometimes reduced in size.

Later, in the eighteenth century, both French and English decorative colour prints and views like those by Canaletto and Piranesi were often sold in bound sets as souvenir albums, and had much wider margins, partly to protect the prints. The margin also constituted an aesthetic element which gave balance to the composition itself.[2]

So the collector must not be over critical in the case of engravings by fifteenth-century Italian masters, particularly those by Mantegna, which are not only without margins but have often actually been cut down from the original size (probably because they were so large). The smaller German engravings of the same period are more likely to be complete. Sixteenth-century woodcuts should always have at least a black outline, while line engravings of the same period and etchings of the seventeenth century should show the platemark impressed in the paper.

REMBRANDT

Rembrandt leaning on a Stone Sill (B. 21)
'Etching and drypoint, the rare first state of two, before the cap band was finished, a fine, delicate impression with burr... split in the paper in the top right corner, a small repair in the lower left corner.'
This etching is fairly rare in the first state. A similar but undamaged sheet fetched about the same price six years earlier; another one, almost perfect and with traces of burr, commanded more than eleven times as much in 1970.[3]

'Margins probably added' is a description found very occasionally in English sale catalogues, and practically nowhere else, usually in connection with prints by Rembrandt. This rather vague but quite honest description could refer to the fact that sometimes during printing the pressure might have been so strong that it weakened the paper around the platemark to the point of actually cutting it; but it could also mean that at a later date a border of paper was added by a skilful restorer. The doubt expressed by the cataloguer naturally suggests that the print has in fact been repaired. 'Possibly repaired' also suggests that some restoration, which one can almost sense rather than actually see, has been carried out on the print.

Example

Rembrandt, *Rembrandt leaning on a Stone Sill*, 1639

[2] It is well known that from 1880 onwards Whistler used to trim the margins of his etchings, in particular those of the two Venice Sets, with the characteristic remark that he did not intend to break with old custom. Whistler also thought that if paintings did not have margins, prints could do without them too.
[3] Sotheby's, 11 July 1968, £540 ($1,296); 19 November 1962, £520 ($1,456); 26 November 1970, £6,000 ($14,400); the latter had fetched £546 at the Rudge collection sale at Christie's on 16 December 1924.

XIII Restoration and conservation

Restoration

A print which is not too badly damaged can be satisfactorily repaired by a qualified restorer, who may even be able to give it back some of its original characteristics. However, it must be a print of considerable value, because the expense of repairing can be very great. The usual practice today is for the restorer to calculate his fee not according to the work done or to a fixed tariff, but on the basis of what the value of the impression might have been before and what it might be after repairing; in other words the restorer normally asks for a kind of share in the profit which his client could derive from the repair. Properly executed restoration on a valuable print might cost its owner twenty per cent of the price he paid for it; in extreme cases, over a thousand dollars. But in return for this outlay, he will have a print in which repairs on worm-holes, cuts or tears half an inch or an inch long, and the replacement of margins or other missing unengraved parts of the print (a square inch or so), will probably be invisible even under a magnifying glass which enlarges twenty times. A few very skilful restorers, using special antifluorescent gums or pastes, are able to render repairs imperceptible under virtually any kind of examination.[1] It is however possible – or so I have often been told – that even a highly sophisticated piece of restoration might become visible again after two or three years, when it is too late for the owner to protest.

An honest dealer will normally declare any damage he knows of, but there are others who do not; therefore, when buying a print, it is prudent to ask for a written declaration which includes a reference to the print's condition. Almost all sale catalogues declare any damage to the print or indicate if it is perfect. The absence of the word 'perfect' can give rise to unpleasant wrangling in the case of a subsequent complaint.

A cautious collector will never neglect to examine the back of the print (as one does with a carpet), where it is easier to perceive any damage because of the

[1] Sue W. Reed, of the Boston Museum of Fine Arts, has informed me that in the United States they know about certain 'miracles' performed by European restorers, but that the Department of Prints and Drawings at that museum has so far had no occasion to carry out any research on restoration of this kind. Usually the paper, especially in doubtful cases, will be examined under a microscope in the laboratory, and also inspected under ultra-violet or infra-red light.

overall white of the paper; he will look at it against the light or place it face upwards on a piece of frosted glass with an electric light underneath; another method is to place the sheet on a black background and illuminate it from above, as Marie Mauquoy-Hendrickx does when looking for elusive watermarks.[2] Finally, with the help of a good magnifying glass, he will at least be able to discover any damage or badly done repairs which would otherwise escape his notice. It can also be useful to compare the measurements of the print with those given in a catalogue raisonné, but account must be taken of factors such as humidity, which might cause the measurements to vary by as much as eight per cent.

A valuable print which is laid down when it is bought should be taken off the paper or cardboard to which it is fixed, unless the pasting was done at an early date, when glues were not made with the chemical substances they contain today and which are likely to corrode the engraving. A specialist – never an amateur – can easily detach the print unless the paper is damaged. He can also remove almost all stains by immersing the sheet in a solvent which loosens them, and then in an anti-acid solution to take away the biting chemicals of the first solvent which have become impregnated in the sheet; lastly he will treat the print with glue size which will give it back its original consistency. Grease marks are more difficult to remove but there are ways of dealing with them.[3]

Old laid paper is easier to restore than the kinds of paper manufactured today, the more dense wove papers, Japan paper and thin China paper, even though restorers do have the means (pulp, etc.) to cope with difficulties which at one time would have been insuperable. It is on the other hand a decidedly more arduous task to restore a sheet to its original quality, especially if it has become fragile, or burnt after having been exposed to the sun for a long time, or else damaged and weakened by previous, badly done soaking and repairing.

In any case an amateur would do well to get the advice of his dealer. The latter, if it is a question of simple unsticking, will do the job himself or else he will seek the help of a book restorer. For repairs, however, he will entrust the task to an expert, provided of course the value of the print makes it worth while.[4]

For some years now, freedom to examine material in print rooms has been increasingly restricted, to an extent which goes far beyond the prohibition of the use of ballpoint or fountain pens or copying pencils, which could obviously cause irreparable damage to the engravings. Often the most precious prints are shown only in the presence of a member of staff, while the visitor is not even allowed to touch them: for some years this has been the practice in the Rijksprentenkabinet in Amsterdam, and it has always been true at the Cabinet Rothschild in the Louvre. It seems to me right that prints, which after all are on fragile pieces of paper, and which have come down to us through many centuries, often, unlike early paintings, still with their original freshness and quality, should be so strictly protected for the benefit of future generations.

There are certain fairly specific rules governing the correct conservation of prints, and they ought to be known. The basic ones are listed here, divided into two categories, the first relating to the damage which can be caused by external factors, and the second relating to how prints should be conserved.

Conservation

[2] Mauquoy-Hendrickx, op. cit., text p. 96.
[3] Contrary to what was once believed, it seems that normal damp stains are not transmitted from one print to another, nor do they get bigger, if kept in a dry atmosphere.
[4] For further and more detailed information, see Zigrosser and Gaehde, op. cit., part II, pp. 99-117 (by M.A. Gaehde).

Jean Duvet, *Christ on a White Horse*, from the Apocalypse, *c.*1550. The imaginative composition is somewhat spoiled by the lines, which are heavy and at times confused

Causes of damage Strong sunlight on a print, even if it is under glass, will in a few months turn the paper brown; natural light which arrives indirectly, i.e. by reflection, can also cause damage, though more slowly; strong electric light is particularly harmful.

A very dangerous enemy is humidity, which leads to the formation of mildew. Even more harmful perhaps than damp is dust which, though it might seem innocuous, if it accumulates on the print can penetrate the pores of the paper and seriously damage it. Smog in industrial cities and combustion residues from central heating installations are absorbed by the paper which can become slightly corroded as a result. Variations in temperature (with accompanying variations in the humidity content of the air), which between winter and summer in an unheated house can involve differences of up to fifty degrees Fahrenheit, are also harmful to prints, especially if they are subjected to these conditions over a period of years.

Paper which is handmade, from rags, suffers less from these conditions than does paper made from cellulose.

Conservation The collector should place a print in a special cardboard mount, or mat. This consists of a thick backing to which is attached, by means of adhesive tape, a piece of cardboard with an opening with bevelled edges, slightly bigger than the engraved area of the print. The latter is fixed to the mat with two or three small hinges of gummed paper, containing no corrosive substances and similar to those used for postage stamps, though stronger and larger. These hinges are also stuck to the back of the engraving, usually on the top margin. The print will be further protected by a piece of tissue paper, or very thin cellophane. Some people advise against the use of cellophane because it is easily inflammable and also because of the damaging chemical substances it contains.

Mats are kept in a wooden case called a solander case, normally covered in black cloth. This can hold from ten to thirty mats, depending on their size and weight. Since the card from which the mat is made (generally several layers of Bristol, stuck together and then compressed) is in direct contact with the print, it must not contain substances which might harm it. In the United States there are specialized firms which manufacture solander cases, and papermills which make paper for mats. On the continent of Europe only a very few papermills manufacture special mat paper (there is only one in the whole of Germany), and then only on orders received from museums, dealers and collectors.

Solander cases and cloth-covered cardboard folders are kept horizontally in special cupboards with shelves or in drawers. Vertical conservation, mainly for sets of engravings bound in volumes, is today little used.

The print can also be framed, provided it is protected by its mat. If it is of real value it should not be kept in a frame for more than two or three years, but should be changed round every now and then with another print.

XIV Catalogues raisonnés

Over the years, dedicated scholars have been patiently compiling detailed lists of prints by graphic artists, from the early anonymous engravers of the fifteenth century up to those of today. In chronological order, the first catalogue known to us is the one by Edmé-François Gersaint (1696-1750), one of the most important art dealers of his time and author of the first critical inventory of Rembrandt's etchings, published in 1751 in Paris and the following year, in English, in London. A longer work, which also included many of the great early engravers, was the *Idée générale d'une collection complète d'estampes*, written in 1771 by Carl von Heinecken (1706-91), director of the Dresden Prints and Drawings Room.

Adopting new criteria, which in many respects are still valid, Adam Bartsch (1757-1821), keeper of the Hofbibliothek of Vienna, in 1797 revised Gersaint's catalogue on Rembrandt. Then, making considerable use of the inventory previously drawn up by Pierre-Jean Mariette for the prints owned by Prince Eugene of Savoy, he published his famous *Peintre-graveur*, in twenty-one volumes,[1] updated with a further six volumes by G. D. Passavant between 1860 and 1864. In the spirit of this first work on the *peintre-graveur*, numerous other catalogues raisonnés followed, often in many volumes, on French, German, Dutch and Italian engravers. The latest book with this title is the second volume by Geiser on Picasso, 1968.

The most complete works on very early graphic art were all published in the first half of this century, and written by outstanding scholars who devoted their entire lives to studying the engravings of particular periods or artists. Among them one must cite the Englishman Campbell Dodgson, for his research into incunabula and German and Dutch masters; the Germans Max Geisberg and especially Max Lehrs, who between 1908 and 1934 published in nine large volumes the fruits of fifty years of research on Northern European artists – German, Flemish and Dutch – and who travelled throughout Europe in order to study the prints at first hand;[2] W. L. Schreiber for his unique corpus of

[1] See above, p. 3.

[2] It was Lehrs who, in 1888, rediscovered at the Pinacoteca Nazionale in Bologna the single sheets by the Master E.S., and the engravings of the Master P.W. and others. These prints were known in the eighteenth century by the Abbot Zani and by von Heinecken of Dresden, but the latter never used to reveal the sources of his discoveries. See *Zeitschrift für bildende Kunst*, vol. XXIV (1889), pp. 14-17.

incunabula;[3] and finally Arthur M. Hind, who succeeded Dodgson at the Department of Prints and Drawings in the British Museum and who, ranging freely over four centuries of graphic art, wrote texts which are still valid and often unequalled on Piranesi, Rembrandt, fifteenth-century woodcuts and English engravings of the sixteenth and seventeenth centuries, culminating in his monumental history of early Italian engraving (1938-48).[4] Huge dictionaries of this kind, like the one by Loÿs Delteil which in thirty-two volumes described and illustrated most of the French graphic works of the nineteenth century, used to be printed in limited editions (Lehrs was printed in only 140 copies), almost always with financial backing from cultural organizations or great collectors. They had become absolutely unobtainable, due to the greatly increased interest in graphic art, but in recent years they have all been reprinted.

The material gathered in these catalogues is based not only on the authors' own research but also on innumerable studies published in exhibition catalogues, art magazines or specialized periodicals such as the famous *Print Collector's Quarterly*, 1911-41, which was published first in various cities of the United States and later in London. The complete set is a unique record totalling nearly 15,000 pages with about 700 essays by more than 200 specialists on different aspects of early and modern graphic art.

Catalogues raisonnés are today often richly illustrated, and contain selective lists of the artists' prints with comments of varying length, providing the reader with an introduction to each print. In the case of early works, each engraving will frequently be accompanied by complex and detailed information, but for modern works the text, although it does give all the basic information, is more in the nature of a list. The catalogue is usually arranged in the following manner:

1 the title of the print, preceded by an arabic serial number and followed by the exact or approximate date when it was executed
2 the technique or combined techniques used in the print
3 the measurements of the impression, in centimetres and millimetres (only in the United States are measurements still given in inches), height by width: in intaglio prints the platemark is measured, in relief prints the margin line, and in lithographs the drawing itself
4 where there are several states, the arabic numeral is followed by another, roman serial number;[5] for each individual state there is a detailed indication of the alterations made in the engraving with respect to the previous state

In catalogues of old master prints, various pieces of useful information may be added: in some cases, on the work from which the artist took his inspiration; on preparatory drawings; on collections which possess the finest impressions or most rare states; on prices realized at auctions; on the best known examples; and sometimes there will be a special section of plates, reproducing watermarks found on contemporary or early impressions.
For early prints, I have chosen a few simple but instructive examples. The first – one of Dürer's woodcuts – is taken from the now classic work by Meder;[6]

[3] Schreiber was among the first, together with Max Geisberg and Paul Kristeller, to record the incunabula kept in the Biblioteca Classense in Ravenna.

[4] A copy of this great work (see above, p. 89), marked with a 'D' and with Hind's ex libris, is now in an Italian collection. The volumes contain various notes which Hind himself made after examining prints in the collection of the princes of Liechtenstein of Vienna, sold in 1950 at Colnaghi's in London. The volumes also contain interesting correspondence with the author's Italian collaborators, and on reading this one is led to believe that there are certain errors in the classification of prints in Italian national collections.

[5] To indicate the third of five states, for instance, the arabic numeral would be followed by III/V. The practice of implying that a print is in the last state by omitting the roman numerals is disapproved of. The last state, for example the fourth, should be indicated by IV after the arabic numeral.

the second – an etching by Rembrandt – is from a recent catalogue raisonné, by White and Boon,[7] which has also prompted me to make a few observations on recent developments. My third example consists of a brief note on the cataloguing of the various editions of Goya's graphic work, as carried out by Tomás Harris.[8] The fourth example concerns a Picasso etching described in the second volume of Geiser's work.[9]

Examples

ALBRECHT DÜRER

The Resurrection (last plate of the *Large Passion*). Meder 124. Monogram and 1510 – 5 engraved on the back. B. 15 H. 1140 R. 185 D. 105 Fr. 71 K. 218 W. 228.

(The first letter stands for Bartsch, the others indicate the authors of subsequent catalogues o inventories of Dürer's graphic works.)

Before the text
a) Light, clear-cut, sometimes laid down, full margins. Watermark (Meder) 53, imperial orb.
b) Similar, but darker, with a crack in the transverse pole of the standard. Watermark 316, Name of Mary. See *p. 48*.

Editions with 1511 text
No description. Reference to colophon. On the back of the sheet is printed in Latin: address, date and text. Watermark 316, Name of Mary, or 127, flower and triangle.

Editions after 1511, without text
a) Good, before the worm-hole, scratch on left armpit of the figure of Christ. Watermark 181, Hapsburg chalice with small shield, or 306, Name of Jesus.
b) Smudged impressions. Worm-hole in Christ's mantle, on the right knee. The *D* of the monogram damaged. Yellowed paper. Watermark 314, shield with fleur-de-lys (with) L and b.
c) Still strong, uneven, *auslassend* at bottom left [faded, the engraved line worn and blurred, some lines missing], on the right a *Lücke* [gap in the marginal line]. Undamaged monogram (restored?). Watermark 240, eagle, *c.*1600.
d) Hapsburg edition 1675. Similar. Watermark 178, Hapsburg shield with M, or 304, A in a circle with HW.

Meder's description is shorter than this translation: it is of superlative conciseness, every adjective he uses having its own specific meaning and weight.

Let us just try and discover why the author wrote the '*p. 48*' in italics, at the end of description 'b'. The reference is to his extremely useful *Technische Erläuterungen*. On the basis of many years' work, examining and comparing different proofs of the forty-eight sheets of the three great books (this one, the *Apocalypse* and the *Life of the Virgin*), Meder tells us that the *Probedrucke*, in this particular case the proofs before the text, can either be actual trial proofs (*Versuchsdrucke*), of outstanding quality, as the artist intended them to appear, or else they can be proofs which are also before the text, but which are not of the same excellent quality. The former are obviously very rare. In the forty-eight woodcuts before the text, the author found various watermarks like the ox-head, the scales in a circle, the high crown (all reproduced at the back of his book), and of course the very good imperial orb. He also found the Name of Mary watermark but, as he goes on to say, this is also found on sheets with the 1511 text. It should therefore perhaps be regarded as rather less valuable and less rare than the others, and a reference to the annotated list of watermarks bears this out. It is true, in fact, that impressions of the *Large Passion* are of finer quality, more rare and more sought-

[6] Meder, op. cit., pp. 128, 48, etc.
[7] White and Boon, op. cit., text pp. 10-11 and pls. 11-13.
[8] Harris, op. cit., vol. II
[9] Bernhard Geiser, *Picasso peintre-graveur, Catalogue raisonné de l'œuvre gravé et des monotypes*, vol. II (Berne 1968).

after if they have the watermark 53 (imperial orb) than if they have the watermark 316. Without wishing to lay down any rules I would nevertheless point out the following example as being significant: catalogue 127 of the Berne saleroom Kornfeld und Klipstein, 12 June 1968, lists under nos. 73 to 78 six different proofs before letters of the *Large Passion*. Four of them bear the Name of Mary watermark, one has the imperial orb, and the sixth has a different mark. Two in particular, M. 118 and M. 124, have the Name of Mary watermark instead of the imperial orb which is typical of the very early impressions.

Meder's observations are both useful and reliable. However, it must not be forgotten that the sheets he was examining were about 460 years old; and that there were not many of them, so that his conclusions, however painstakingly arrived at, cannot claim to be scientifically exact in every detail.

REMBRANDT

B.22 *Rembrandt drawing at a Window* G.27, M.160, H.229, Mz.26, B.-B.48-A

'Etching, drypoint and burin. 16 × 13 [cm: $6^5/_{16}$ × $5^1/_8$ inches]
Signed and dated (from II): *Rembrandt. f* 1648

I. Before the signature and date. Both hands and the edges of the drawing paper white. Very rich burr on the folds and shadows of the coat. Previous work only partially burnished out visible below the right hand.
 Amsterdam (Boon 212), *Berlin, London* (R.80; Mz.27; White 184), *New York* P.M.L., *Oxford, Paris* (R.81), *Paris* Rothschild and *Vienna* only.
 Impressions in *Amsterdam* and *Paris* on Chinese paper.
 The impression in *Vienna*, which has very pale etched lines and very rich drypoint, and also a white patch in the lower right, where the lines have failed to absorb the ink, is probably the earliest.

II. Signature and date added on a scroll at top left. Left hand shaded. Rework with burin on background, coat, table, etc.
 Amsterdam (Boon 213), *Berlin* (R.82), *Cambridge, London* (Mz.28; White 185), *Madrid, New York* P.M.L., *Oxford, Paris, Paris* Dutuit (R.83), *Paris* Lugt coll., *Vienna.*
 Impressions in *London, Oxford, Paris* and *Paris* Lugt coll., on Japanese paper; that in *Paris* is printed with surface tone.

III. Right hand shaded. Open parallel shading across right hand side of the figure.
 Amsterdam, Frankfurt, London, Oxford, Paris (R.84), *Vienna.*

IV. Landscape added. Cross hatching on window frame. Heavy reworking including drypoint work on tunic. Signature shaded out.
 Amsterdam, Berlin, Cambridge, London, Oxford, Paris (R. 85), *Vienna.* Impressions in *Cambridge, London* and *Vienna* on Japanese paper.

V. Contour of right cheek redefined with vertical lines. The additional work added in former state still visible but very worn. The face appears to have been lightened in tone by burnishing.
 Berlin, Cambridge, Haarlem, Leningrad (R.86), *London, Oxford, Paris* (R.87), *Vienna.*

de Haan, 1767
Watelet
Basan
Modern

Some of the older catalogues, including Claussin and Rovinski, describe nearly twice as many states.

The work added in the fourth and fifth states was probably not done by Rembrandt.

Lit.: H.E. van Gelder in *Oud Holland*, 1943 (LX) p. 34 (artist shown etchnig, not drawing).

COPY

Contemporary, in same direction (15.7 × 12.8 cm: [$6^3/_{16}$ × 5 inches]). *Amsterdam.*

Henri de Toulouse-Lautrec, *The Englishman at the Moulin Rouge*, 1892

Rembrandt, *Rembrandt drawing at a Window*, 1648. One of eight known impressions of the first state

Virtually a summary of three hundred years of study. The treatment is very thorough, but arranged quite differently from the preceding example. Indeed the case in question is very different, as is Rembrandt's technique – etching combined with drypoint – which he alone developed and no other artist ever attempted to use. As we have already seen, 'much of Rembrandt's technique is not susceptible to analysis by either printmaker or connoisseur. His effects are too personal, too imaginative, too closely blended.'[10] In his concise preface, Boon explains among other things why he was unable to include in his work examples of watermarks (many of the most valuable impressions in the great European museums are still pasted on to old paper or cardboard). The authors, even though they have examined the most rare examples of prints preserved in the forty most important public collections of Europe and America and also in the few private collections which still include one or two outstanding prints, nevertheless show extreme discretion and they quite rightly refrain from drawing any conclusions. The information given is exhaustive in spite of its conciseness; but in order to understand its significance fully one needs long training, and a profound knowledge of Rembrandt's graphic work.[11]

[10] White, *Rembrandt as an Etcher*, op. cit., p. 11.
[11] For the importance of White's book on Rembrandt, see above, p. 53.

The authors give some valuable new information, including interesting examples of the Oriental papers used by Rembrandt for many of his finest prints, given here for the first time.

Let us take a look at our example. Until recently, the fourth state (and, according to some, the fifth as well) of this print, which in its psychological insight is perhaps the supreme example of all self-portraits in graphic art,[12] was considered to be by Rembrandt's hand. Today, however, because of the 'heavy reworking' of the fourth state, the very worn fifth and the conclusion that the 'work added... was probably not' – read 'certainly not', in view of the authors' customary circumspection – 'done by Rembrandt', scholars have come to accept the Boon-White interpretation. Thus the authors of the catalogue of the important Rembrandt exhibition at Boston and New York ('Rembrandt: Experimental Etcher', 1969-70), which I have already mentioned, having simply heard about this latest interpretation (the Boon-White catalogue had not been published at that time) when referring to the heavy reworking in the fourth state, wrote: 'some authorities doubt that the work in this state is by Rembrandt.' Subsequently, beside no. 231 of the catalogue of the Rembrandt exhibition in Dresden Christian Dittrich wrote: 'From the fourth state [onwards] *certainly* the work of another hand, and similarly the landscape in the window.'

The new cataloguing has given rise to some understandable resentment on the part of art dealers: the first three states are no longer circulating in the trade, and now the value of the last two states has been considerably reduced.

Frits Lugt, when I asked him whether many other impressions existed of the first three states, in addition to those mentioned in the catalogue, said, 'Perhaps two or three, I don't think there are any more.' The list of impressions of the first three states may in fact be of the nature of a real census; those listed under the fourth and the fifth states, however, are obviously no more than selected examples. There is another second state impression, the only one it seems in eastern Europe, in Dresden; it is described under no. 230 of the catalogue mentioned above. There is also an interesting reference to a fifth state impression which once belonged to Prince Eugene of Savoy and which he must have bought, perhaps from Pieters Zoomer before 1730, during his long stay in the Netherlands. This fact probably disproves the fairly widespread supposition that Henri Watelet retouched the plate; he could not have owned it before 1767.

The following points should be noted in conclusion.

1 My brief commentary can usefully be extended by analogy to much of the graphic art of the seventeenth century.

2 Rembrandt himself printed only a limited number of impressions, that is, only as many as he considered acceptable.

3 The reference to the Japan papers used for the fourth state confirms something I have already pointed out, that others after Rembrandt used Oriental papers for certain of his plates (and apparently for his only), and that therefore proofs and states must not be assessed only on the basis of the paper they are printed on.

4 The authors, to avoid confusion, went back to the old classification according to Bartsch, hence the B. 22; the other initials which follow the title stand for five (out of sixteen) important earlier catalogues – Gersaint of 1751, Middleton of 1878, Hind of 1912 (revised 1923), Münz of 1952 and Biörklund-Barnard of 1955 (revised 1968); at the end of their text there are some useful comparative tables

[12] White, op. cit., text p. 133: 'Earlier he had depicted himself from the outside inviting us to be his spectators, but now he studies himself from within, and we feel ourselves intruders in this frank and intimate self-analysis in a mirror, in which one is as near to reading the mind as is humanly possible in a visual medium.'

which enable the reader to find the etchings in the catalogues by Hind, Münz and Biörklund-Barnard. Lastly, with regard to the census, the names of cities indicate particular museums: thus '*New York* P.M.L.' means that the print is only in the Pierpont Morgan Library, not in the Metropolitan; and, for Paris, 'Dutuit', 'Lugt coll.' 'Rothschild' means that there are impressions in the Petit Palais, in the Fondation Custodia at the Institut Néerlandais, and in the Louvre.

The next catalogue raisonné on Rembrandt

The White-Boon catalogue (Hollstein series), the seventeenth on Rembrandt, will of course not be the last. Even though the four most often quoted Rembrandt scholars are Europeans (K. G. Boon, C. White, O. H. Barnard and E. Trautscholdt), the next will probably be American, for in the United States there are greater possibilities of obtaining financial backing for studies of this kind.

The first problem that the research group will have to tackle will concern the watermarks in the French papers used by the artist. Indeed, all scholars complain that while years of research have been devoted to the paper and watermarks used by so many other engravers, for Rembrandt no study at all has been carried out on this subject. Even the experts are totally unclear about, for example, the editions which may have been printed in the last thirty years or so of the seventeenth century. With regard to Oriental papers, which were first systematically studied by the Swede George Biörklund, specialists in Oriental art could make a valuable contribution to Rembrandt studies. I do not believe that the fact that it is impossible to examine the printed sheets which are preserved in certain important collections, such as that of the British Museum, presents a serious obstacle: in fact, the Amsterdam Rijksprentenkabinet, the Pierpont Morgan Library in New York, and several other public collections contain perhaps over two thousand loose sheets, practically all the master's prints in their various states, and often in several impressions. Therefore it should be possible to make a serious start on research into Rembrandt's watermarks.

Future cataloguers will revise and complete the census of the most important sheets which was drawn up by Boon and White. They should moreover be able to show the pedigree of the most famous impressions, in a manner similar to Lehrs and Lugt, quoting the old prices in the original currencies (there is no need to give the equivalent in dollars), which would constitute a kind of history of values, and therefore of taste. The new cataloguers, of course, should consult as many copies as they can of the old sale catalogues preserved in the archives of museums and libraries in Holland, Belgium, France and England: they will undoubtedly find much interesting and useful information there, and they may learn things that have escaped the notice even of Bode, de Groot and Lugt.

The researchers will of course make use of the excellent White-Boon catalogue, and of White's *Rembrandt as an Etcher*, and they will not overlook that model catalogue from the Boston-New York exhibition, which they themselves produced – for it will almost certainly be the same team – and which has been greatly appreciated by the handful of connoisseurs and the thousands of enthusiasts who have been able to see it (see above, p. 41, n. 6). In other words, they will not be writing only for the initiated, for those twenty or so scholars who have read or heard of Pieter de Haan.

FRANCISCO GOYA

In February 1964, while I was examining some trial proofs by Goya at the Biblioteca Nacional in Madrid, I heard the news that Tomás Harris had died a few weeks earlier in a car accident in Majorca. It was his daughter Hilda who

supervised the publication of the work on Goya to which her half-English, half-Spanish father had dedicated a great part of his life. I have already made use of Harris' critical catalogue, and I shall again be calling on this unfailing source. What Hind did in 1922 for Piranesi, at any rate with regard to the *Vedute di Roma*, Harris has done for Goya's graphic work. Let me explain.

The term 'state' retains its old meaning since Piranesi's individual *Vedute* are prints; but the work as a whole, conceived as a continuous succession of episodes, a series of sheets taking the form of an illustrated book, must be considered as an edition in the sense used for a book. Once the definitive state had been established, in the early editions, it was only these editions which counted.[13] Harris naturally takes into account everything concerning the individual prints, noting among other things the first proofs, signs of wear in the impression, paper, watermarks, the bevelling which determined a new state; but, at any rate in the case of the four large works, each particular detail is, quite rightly, studied only in the context of the whole edition.[14]

PABLO PICASSO

The very well-known *Cent cuivres de Vollard* or *Vollard Suite*, all designed before 1936, were sold during the last war by Vollard's heirs to a French dealer, who after 1950 started selling prints taken from them. Bernhard Geiser, in his second catalogue raisonné, published after his death, finally provided the information needed to clear up the doubts about the Vollard edition which for a long time had been worrying both dealers and collectors. The following example was drawn up on the basis of information which the owner of the copperplates gave to Geiser, and the details are the same for all the hundred plates:

N. 331 *Kneeling Sculptor and Model*
1933 (8 April, Paris). Etching on copper, 367 mm high × 298 mm wide [$14^1/_2 \times 11^3/_4$ inches].
1st state, before the bevelling: at least two impressions on Arches wove paper, printed by Lacourière.
2nd state, after bevelling and steelfacing: Vollard edition, printed by Lacourière in 1939;
a) 3 impressions on vellum, signed and numbered in red ink;
b) 50 impressions on Montval laid paper of large dimensions, watermarked Montgolfier, some signed;
c) 250 impressions on Montval paper, small size, watermarked Picasso or Vollard, some signed.
The plate, cancelled in 1956, is kept in the Lacourière-Frélaut workshops.

It is rather surprising that the fact that the plates were cancelled seventeen years after printing was not made known for a further twelve years. A well-known illustrated inventory did refer to the edition in 1956, but it did not mention that the plates had been cancelled.[15] Until 1968, major sale catalogues avoided any reference to the number of impressions taken from the Vollard plates.

[13] With Goya the *Caprichos* and the *Tauromaquia* are in the definitive state only after bevelling.
[14] The work by G.B. Piranesi, *Antichità Romane de' Tempi della Repubblica...*, is dated 1748 and comprises 4 title pages and 26 etched illustrations. The series remained unchanged in its essence for thirty, perhaps forty years. Over this long period Piranesi used progressively thinner paper with different watermarks; the impression of course deteriorated and only the date remained the same. For the period between 1780 and 1790, however, after the artist's death (cf. Francesco Piranesi's catalogue of 1792) the title, while unchanged in many details, became *Alcune Vedute di Archi Trionfali...* The series now included also the *Arco di Aosta* etched by Piranesi after a drawing by Sir Roger Newdigate and the *Tempio di Minerva* etched by his son Francesco. The paper of the new edition is usually soft, and the watermarks correspond to Hind 4, then 5 and 6 and more rarely to 3.
[15] *Pablo Picasso – Suite Vollard* (Teufen, Switzerland, Stuttgart and Paris 1956), introduction p. XI.

XV Terminology used
in sale catalogues

Practically all sale catalogues issued by salerooms and graphic art galleries are written in English, French or German. The experts who compile them use a special terminology to describe the prints, with which a collector should be familiar. These catalogues tend to reflect the national traditions and characteristics of the country where they are published; English and American catalogues are pragmatic and concise in their descriptions, the French are concise and fairly brief, while the Germans are more analytical and like to provide very detailed information.

In English salerooms, the 'Sotheby formula' prevails and it is also adopted by the affiliated firm of Parke-Bernet in New York. Defects in impressions are described scrupulously and in detail; quality, to which little attention seems to have been paid until a few years ago (important prints were distinguished from others of less account only by the use of bold type), is nowadays described, though with perhaps no more than a single qualifying adjective. The rarity of a print is never expressly indicated, on the assumption that prospective buyers will know of it. Descriptions given in the catalogues of English and American galleries, as opposed to salerooms, are very detailed.

In France, catalogues of the public sales held at the Hôtel Drouot and – in the case of important sales – at the Palais Galliera are compiled by experts who by established custom are chosen from among specialized gallery owners. This leads on the one hand to a substantially identical form of presentation in auction and gallery catalogues and, on the other hand, to rather cautious and even vague descriptions, perhaps due to the experts' own scrupulousness and sense of responsibility.

After the great salerooms of Germany had closed down, at the end of the Second World War, their tradition was carried on by Kornfeld und Klipstein of Berne, whose criteria in cataloguing are similar to those of other German-language firms. The descriptions given in these catalogues are extremely detailed, even to the point of emphasizing the quality and condition of contemporary prints, which in other countries are mentioned only when they involve imperfections. With regard to old master prints, the collector needs to understand the

numerous terms used for describing quality, each one of which has a different meaning, so that *prachtvoll*, superb, is naturally better than *ausgezeichnet*, excellent, while *ganz ausgezeichnet*, literally quite excellent, really means no more than good: these seem like simple nuances, but the use of one adjective rather than another, even though they may both seem to say the same thing, can mean that the print's value is ten times greater or less. German-language gallery catalogues follow practically the same system.

After a few examples of catalogue descriptions, the reader will find a table of terms in English, French, German and Italian. The first section, *a*, concerns editions and the quality of the impression; the second, *b*, condition, defects and rarity; the third, *c*, some of the terms used specifically for Rembrandt's graphic work; the fourth, *d*, the basic terminology used at auctions. Where there is a blank space in a column this means that the term either does not exist in that particular language, or that it is used only very rarely. The table does not claim to be absolutely complete, nor, especially in the case of German, does it set out to establish a strictly accurate qualificative scale; nor does it attempt to give exact linguistic equivalents, which are often non-existent: it is intended only as a guide to the understanding of catalogues.

Francisco Goya, *Ni por esas*, from the *Desastres de la Guerra*, c.1810-20

Rembrandt, *The Presentation in the Temple, in the dark manner*, 1654. This fairly light impression was printed after the ink had been wiped off the plate; the retouching in drypoint is visible. If the film of ink has been only partially removed from the plate, the resulting impression is much darker: here this technique has been used to make certain areas stand out against the darkness, such as the faces of Simeon and the High Priest. Each print is different from the others. Only five impressions with surface tone are known

Examples

REMBRANDT

The Presentation in the Temple, in the dark manner.

B., R., S., Holl. 50; H. 279; B.-B. 57-1.

'Etching and drypoint, only state, a fine, strong impression of this rare plate with touches of burr particularly on the priest's cope, the Child's shawl and on Simeon's robe, perhaps slight signs of wear in the darkest places, with a small margin at the bottom, trimmed to the platemark at the left and at the top, cut unevenly close on the right edge (thus lacking about 2 mm from the sides).'[1]

References to the impression's illustrious pedigree follow: Richard Houlditch, d. 1736 (L. 2414), John Barnard (L. 1419) and the Worsley family, who owned the print for 154 years, from 1798 to 1952. At the sale, the etching, which seemed almost as fresh as if it had just come off the press, was covered by a piece of tissue paper so that it could not be harmed by the light.

[1] Sotheby's, 26 November 1970, £17,000 ($40,800).

Edgar Degas, *La Sortie du bain, petite planche*, 1890

The information is meticulous, perfect. There is even a mention of the rarity of the sheet, contradicting what I stated above – but in this case the etching merited it: the plate had undoubtedly been inked by Rembrandt himself in 1657, and the sheet printed by him. The cataloguer, aware of the importance and value of the print, has also mentioned the possibility of wear in one part of the impression, something he might not have mentioned for a less good example. He describes the quality of the print with the term 'fine' which in English and American usage comes in third place down the scale, after 'rich' (used in Meder's limited and conservative sense) and 'very fine', but before 'very good' and 'good', which comes last.

Some years earlier I had asked the same cataloguer why he had described one of the most superb etchings by Canaletto, of a kind rarely seen at auctions, with a simple 'good',[2] and in reply he had spoken of 'understatement'. Today the English have adapted themselves to the times and, while continuing to be loyal to the old tradition of using only five qualifying adjectives, they do tend to employ them more frequently, sometimes with emphasis, rather than as an understatement – but always according to the whim of the cataloguer. Therefore the collector, before purchasing, would do well to become familiar with the real significance of 'good' or 'fine' and also of the absence of one of these adjectives: a specific inquiry will always be answered objectively and precisely.

[2] Sotheby's, 9 October 1969 (*Le Porte del Dolo*, first state), £1,150 ($2,760).

FRANCISCO GOYA

Le Garrotté (L. Delteil, 21)

'Original etching. Very fine impression in the first of two states, before the copperplate was bevelled. Wide margins. Very rare.'[3]

The expert is aware of the value of the impression, which is also given a full page illustration. He could, however, have called it rich, emphasized the importance of the etching, at least said that the margins were not just wide, but very wide, even though not full. Evidently he prefers to reserve his praise for prints more in need of support than Goya's.

However, in using the phrase 'very rare', rather than *de toute rareté* (of the highest rarity), he has followed the old yet still excellent work by Delteil. In fact, when he was describing the print, Harris' critical catalogue had still not been published. He could not have known at the time that there were two editions before the plate was bevelled: the first, light impression, truly very rare, printed in about 1780 from the clean-wiped plate; and the second, less rare, printed in 1830 on absorbent wove paper, and not of especially good quality. The purchaser who eventually acquired the etching after brisk bidding must have guessed that it was from an edition of great value and rarity.

EDGAR DEGAS

La Sortie du bain. Petite planche. Lithograph.

'D. 63. This is an exceptionally rare lithograph, of which Delteil mentions only one impression, although since then others have appeared (Rijksprentenka-binet, Amsterdam). It is an absolutely perfect example, on stiff laid paper, signed by the artist in pencil at bottom right, "Degas". Quality of the impression perfect. The paper before printing already had a localized small thin patch. The print is from the year 1890 and must be regarded as one of the finest examples of nineteenth-century French graphic art. Impression and condition absolutely perfect.'[4]

The description is extremely scrupulous; the barely visible defect in the paper has almost been exaggerated. Everything there is to say about the print has been said. Perhaps the reference to the single example noted by Delteil (Bibliothèque de l'Université de Paris) should not have been taken as a sign of rarity, since the author of the catalogue raisonné, which was printed two years after Degas' death, sometimes gives six or seven collections which have impressions considered to be very rare, and for others, more common, only one example, or even none at all. Its rarity, in short, should have been looked upon as relative rather than absolute. The same cataloguer had previously discovered a first state of the same lithograph (this one therefore is in the second state) which Delteil did not know of, and yet it is not all that rare, at any rate according to the evidence provided by sale catalogues.

EDVARD MUNCH

Vampire. Lithograph.

'Sch. 34/a/II. The superb lithograph of 1895 in a very fine impression by Clot (the publisher) of Paris, in which the black-white values are delicately modulated so that they stand out, giving particularly rich contrasts. Chine collée. Signed on the

[3] Paris, 31 March 1962, 104,500 French francs ($21,300).
[4] Berne, 9 May 1963, 5,600 Swiss francs ($1,295).

a)
Impression

early impression	tout premier tirage	Frühdruck	fra le prime (stampe) tirate
	tirage ancien	zeitgenossisch	prova coeva
fair to late	épreuve encore bonne	noch gut	discreta ma tarda
late	tirage postérieur	späterer	tarda
modern	nouveau tirage	Neudruck	tiratura nuova o moderna

Quality

rich, outstanding	superbe, merveilleuse	prachtvoll, herrlich	superba, etc.
	splendide	wunderbar	meravigliosa
very fine	très belle	ausserordentlich, vorzüglich, vortrefflich	bellissima
fine	''	''	''
very good	''	sehr schön ausgezeichnet	''
good	belle bonne	schön, ganz ausgezeichnet	bella
fairly good, fair	encore bonne	noch gut	discreta (mediocre)
poor, bad			povera
wear (worn)		auslassend	stanca
		kontrastreich	ricca di contrasti
		exquisit	delicata
		silberig	brillante

b)
Conservation

good (= spotless, faultless) condition	conservation parfaite	tadellose, einwandfreie ausgezeichnete Erhaltung	conservazione perfetta
bad, poor	mauvaise, manquant de...	schlecht	cattiva
full (untrimmed) margins	toutes marges	vollrändig, ganzrändig	pieni (intonsi) margini
wide (large) margins	grandes marges	grosse Ränder	grandi margini
small, slight, thread	petites, très petites, filet de	kleine Rändchen	piccoli, sottili margini
margins added	remargée	neu umrändert	rimarginata
borderline (in woodcuts)	trait carré	Einfassungslinie	linea (nera) d'inquadramento
platemark	témoin du cuivre	sichtbare Plattenkante	impronta del rame visibile
trimmed (cut) close	coupée au témoin du cuivre	auf der Plattenkante geschnitten	tagliata all'impronta del rame
trimmed (cut) within the plate-mark	rognée, sans marges	inseits der Plattenkante geschnitten	tagliata all'interno dell'impronta del rame
cut (unevenly)	coupée	verschnitten	tagliata

Defects

laid down	doublée	aufgezogen	incollata
restored (repaired)	restaurations	restauriert	riparata
damaged	défauts	beschädigt	danneggiata
erased, scratch	égratignure	Ritz	graffi, raschiature
torn, tears	déchirures	gerissen	lacerata, strappata
creased	froissée	knittrig	stropicciata
damp stained, foxed	taches d'humidité (piqûres)	stockfleckig	macchie d'umido
stained, soiled	taches	schmutzig	macchie (polvere, sporco)
lacking	pertes	Fehlstellen	parti mancanti
centre fold, folded	pli	Falten, Hängefalten	pieghe, piega

Rarity

(very) rare	de toute rareté	von allergrössten Seltenheit	rarissima
	rare	selten	rara

c) Rembrandt

with rich burr	riche en barbes	mit reichem Grat	carico di barbe
traces of burr	quelques barbes	Gratspuren	tracce di barbe
with surface tone[1]	avec tonalité	mit Ton gedruckt	stampata con tonalità
clean-wiped[2]			impressione chiara, pulita
sulphur tint	teint de soufre		tinta con zolfo
foul biting area			superficie con morsura difettosa

d) Sales

auction	vente aux enchères	Versteigerung	vendita all'asta
charge	taxe	Aufgeld	diritto d'asta
adjudication	adjudication	Zuschlag	aggiudicazione
commission	ordre d'achat	Auftrag	ordine d'acquisto
	lot	Konvolut	pacco
lot number	numéro	Nummer	numero
set	suite	Folge	serie
framed	encadré	umrahmt	incorniciato

[1] When even a thin film of ink has been left on the plate.
[2] When the ink has been cleaned off the plate with a lint cloth or the printer's hand.

original mat in pencil in the artist's hand. Clean condition. Early impressions of this print are rare.'[5]

I have reproduced this example of an interesting and rather stylish, though unusually brief, description, to demonstrate how German-speaking cataloguers know how to give an overall and detailed description of modern prints.

I should also like to dwell for a moment on a particular aspect of modern prints which I touched on in the short chapter on 'Quality', and which deserves a little more attention. The expert may well be both more sensitive and more cultured than many scholars, but when he describes a print he does it with the purpose of selling it. He does not bother to tell his audience of knowledgeable collectors that Mantegna's *Virgin and Child* is outstanding, which would be stating the obvious. His 'outstanding' will refer purely to the quality of the print in question; or, in another sense, to its condition. When he addresses the prospective buyer who is well-versed in modern art, however, he does not need to say that an impression by Picasso is superb, since a modern print normally cannot be anything else. When, in short, we refer to a description of a graphic work by Villon, Picasso or Morandi, the 'rich' or 'fine' should be understood as an appraisal, not always necessary, perhaps, of the composition itself; it has nothing to do with the traditional type of qualification used for old prints.

[5]Berne, 11 June 1969, 33,000 Swiss francs ($7,655).

Part II

THE WORLD OF PRINTS

1 Early appraisals of graphic artists and their prints

ALBRECHT DÜRER

It is well known that the artist from Nuremberg, whose brilliance in the techniques of woodcut and line engraving has never been equalled, was also the author of both text and illustrations of scientific treatises on the proportions of the human body, on measurements and on the principles of fortification. It is perhaps not so widely known that he was also one of the first painters to be interested in landscape, making it the sole theme in his amazing watercolours; that he wrote delightful poetry and interesting chronicles and diaries; and that he conducted a fascinating correspondence with his friends. His writings have come down to us incomplete, but there is enough for him to be considered, after Martin Luther, as the greatest German writer of the sixteenth century.[1]

Among the evidence of the esteem which Dürer enjoyed in Italy is that provided by Giorgio Vasari,[2] who refers to the admiration which Marcantonio Raimondi showed for the artist's woodcuts, which he bought in Venice. Vasari also mentions the copy of the *Life of the Virgin* which Marcantonio made on copper, and Dürer's subsequent protest to the Signoria of Venice in 1506. Marcantonio later copied the woodcut *Small Passion*, but this time he omitted the monogram AD from the thirty-six copperplates.

Comments of a different nature on Dürer as a man and as an artist, as enthusiastic but more penetrating, come from such German reformers and humanists as Joachim Camerarius, Philip Melanchthon and Martin Luther, who knew the great engraver and, in many cases, were his friends. Erasmus of Rotterdam did complain about the engraved portrait of himself which Dürer did several years after having made a sketch of him in Flanders, though he admitted that his appearance might have changed in the meantime, but he also wrote (perhaps somewhat rhetorically) that no artist using colours could have expressed himself as well as Dürer could, using only black lines, 'even if it were a question of representing fire, storm, light or the soul of man himself.' Luther considered Dürer to be an enlightened, God-fearing man, 'the best'. Camerarius described

[1] Dürer coined many new German words, such as *Landschaft*, from which the English term 'landscape' is derived – and so it seems is the ending *age* after the French *pays*, which gives *paysage* and the Italian *paesaggio*.
[2] Giorgio Vasari, *Le vite dei più celebri pittori, scultori e architetti*, 4th ed. (Florence 1908), pp. 720-21. There are various English editions of Vasari's *Lives*.

Albrecht Dürer, *Coat of Arms of Death*, c. 1503

the artist's physical and moral beauty, his varied interests and the human warmth which attracted people to him. Melanchthon tells us of Dürer's love of nature, and of the new ideals which it inspired in him.[3] But the most moving words are those addressed to a friend by the learned humanist Willibald Pirckheimer, who for thirty years had been bound to the artist in brotherly friendship: 'I do not think I have ever, even though I have suffered so many losses in my own family, experienced a sorrow like that which I felt on learning the sudden news of the loss of our best, beloved Dürer. And perhaps rightly so, since among all my blood relations, none have I respected and loved more, for his innumerable gifts, for his rare good humour. Our Albrecht has gone away: let us weep, my dear Ulrich, for a wonderful man has been taken from us. I have lost in Albrecht my best friend, and nothing grieves me more than his death, which, by God's will, can have been directly caused by none other than his wife, who tormented him so

[3] Hans W. Singer, *Albrecht Dürer* (Munich 1908), pp. 98-9.

Henri de Toulouse-Lautrec, *Elsa the Viennese*, 1897

Albrecht Dürer, *Willibald Pirckheimer*, 1524.
A masterpiece of engraved portraiture. In this composition, executed in his mature years, Dürer has managed to infuse his friend's powerful features with an extraordinary sense of physical and psychological force: in the words of Kauffmann, 'the mass seems to have been transformed into energy'

B ILIBALDI·PIRKEYMHERI·EFFIGIES
·AETATIS·SVAE·ANNO·L·III·
VIVITVR·INGENIO·CAETERA·MORTIS·
·ERVNT·
·M·D·XX·IV·

Albrecht Dürer, *Cardinal Albrecht of Brandenburg (The Small Cardinal)*, 1519. Detail

that his death was hastened. Day and night she urged him to work so that he might earn money which she would inherit on his death. She behaved and still behaves as if she were near bankruptcy, and yet Albrecht has left her a fortune of about six thousand florins.'[4] Melanchthon recalls Pirckheimer's fervent discussions with Dürer, and how he would afterwards express to his friends his wonder and admiration for the way in which Dürer, with his sharp and ready reasoning, could disconcert even the most educated man.[5]

For information on the monetary values of prints by Dürer, and by other artists too, at the beginning of the sixteenth century, we must turn to the documentation which Dürer himself has left us. From a letter which he wrote at Nuremberg, dated 'beginning of the year 1520', and addressed to George Spalatin, chaplain to Frederick the Wise, we learn that the artist had received from

[4] Pirckheimer's estimate seems rather high, particularly in view of a letter written by Dürer on 17 October 1524 to the Nuremberg authorities (Singer, op. cit., pp. 88-9). For Dürer's interesting correspondence, especially with Pirckheimer, and for Pirckheimer's 'epitaph' on him, see the magnificent catalogue of the 1971 exhibition in Nuremberg, *Albrecht Dürer 1471-1971*, pp. 36-44.
[5] Singer, op. cit., pp. 96, 98, 100-102.

Cardinal Prince Albrecht of Brandenburg, Archbishop of Mainz, in payment for the plate of his engraved portrait, plus 200 prints, at least 200 golden florins and over 15 yards of damask.[6] This was a generous payment at the time in the north,[7] as much as the most famous German artist would have received for a painting. It is probably only a fraction of what would have been paid to a contemporary Italian artist of Dürer's renown,[8] but it should be remembered that Dürer's Germany was not so rich in artistic traditions as Renaissance Italy, and that German patrons of the arts, including the Emperor Maximilian I and the wealthy Fuggers, were not inclined to compete with their more cultured Italian counterparts, and even less with the Pope.

Albrecht Dürer, *Adam and Eve*, 1504

Other specific figures are contained in another, brilliant document which is quite unique. This is the very vivid diary which Dürer kept between July 1520 and July 1521, during a journey to Flanders which he had undertaken to ask Charles V, Maximilian's successor, for confirmation of the imperial protection and of the annual pension of 100 florins granted to him by Maximilian in 1515. Heinrich Wölfflin rightly compared Dürer's work to the diary kept by Goethe, who in 1797, at the same age – fifty – visited Switzerland, finding in the two journals 'the same objective and acute way of observing things large and small, the same simple, lively interest.'[9] Dürer seemed to come into contact with a new world: he describes everything with natural, transparent objectivity, always perfectly at ease with the powerful men of the land, with the greatest scholars of the age, and with the most humble people as well. The diary has reached us complete; but of *Mein Büchlein*, the famous little book of sketches which he had with him, only 27 superb silverpoint drawings have survived (they are now in various public and a few private collections). At Antwerp Dürer met his agent Sebald Fischer, who bought 16 complete sets of the woodcut *Small Passion* (with 37 prints in each) for 4 florins; 32 large books (each one containing the 16 woodcuts of the *Apocalypse*, the 12 of the *Large Passion* and the 20 of the *Life of the Virgin*) for 8 florins; and 6 sets of the engraved *Small Passion* (of 16 engravings each) for 3 florins. The artist therefore received 4 florins for 592 small woodcuts, 8 for 1,536 large ones and another 3 for 96 small line engravings: altogether 15 florins for 2,224 prints. His agent also bought from him many quarter, half and whole sheets, each with line engravings and woodcuts of several different subjects *(alle Art)* for just over 10 florins.

To private individuals Dürer naturally sold his prints at much higher prices, almost according to his mood. The line engravings were of course the more expensive: 4 stuiver for *Adam and Eve*, 12 for the engraved *Small Passion*, etc. He gave Tommaso of Bologna a complete set of all his engraved work in exchange for the complete works of Raphael, engraved by Marcantonio Raimondi. He then exchanged 8 florins' worth of his own prints for all the works of Lucas van Leyden. In the Netherlands he frequently made barters, in which he always seemed naïvely to underestimate the value of his own engravings and to place great value on the object he received in return, whether it was a parrot, a length

[6] Langen Müller, *Albrecht Dürer, Tagebücher und Briefe* (Munich 1969), pp. 164-6. The engraving was later called the *Small Cardinal* (M.100), to distinguish it from the *Large Cardinal* (M.101), the plate of which was sent to the Archbishop with 500 prints.

[7] The various florins current at the beginning of the sixteenth century had an almost equal gold content; assuming, however, that in 1520 these florins were worth a little less than late fifteenth-century Tuscan florins, it is worth recalling Machiavelli's annual salary in 1498: 'In the second Chancellery, Niccolò Machiavelli, secretary to the Signoria, with the usual functions of the office and a salary of 192 'seal' florins, or just over 128 'broad' gold florins.' (See Roberto Ridolfi, *Vita di Niccolò Macchiavelli*, 2 vols., 3rd ed., Florence 1969, vol. 1, p. 33).

[8] Rudolf and Margot Wittkower, *Born under Saturn: Artists and Patrons, remarks on a changing relationship* (London 1963), pp. 17-41.

[9] Albrecht Dürer, *Sketchbook of the Journey to the Netherlands* (London 1968), preface.

179

of cloth for his wife, who accompanied him on the journey, or a meal. He dined with Erasmus of Rotterdam and presented him with some engravings; he made two important drawings for Margaret of Austria, the aunt of Charles V, estimating their worth at 30 florins, and presented her with a copy of each of his engravings. He was in continual contact, more in friendship than on business, with princes and ambassadors, and also with all the great artists who were in Flanders during that year.

On 23 October Dürer was at Aachen where he was present at the coronation of Charles V: despite the pomp, this appears to have interested him less than a large whale he had seen washed up on a beach in Zeeland. He noticed and wrote about everything: two stallions seen at the horse market at Antwerp which were sold for 700 florins, the 4 stuiver which the doctor asked from him, the money he spent for a pair of spectacles, a dinner which cost him one stuiver and one which cost him a florin, small gambling losses, the many florins he had paid for hiring a carriage for the journey. Dürer was welcomed everywhere, by everyone, with joy and esteem, though he never makes a point of saying so. Generous and liberal, he repaid the most trivial favour with engravings and drawings. His diary, detailed, lively and shrewd, has only one interlude, a moment of reflection when the artist expresses his fears and his anguish over the imprisonment of Martin Luther.[10]

REMBRANDT

About 1686 Filippo Baldinucci, the Vasari of European engraving, wrote of the 'Life of Reimbrond Vanrein, that is Rembrante del Reno, Painter and Engraver in Amsterdam'[11]. He based his work on information received from others, particularly from one 'Bernardo Keillh of Denmark, much praised painter, who today works in Rome, and was eight years in his [Rembrandt's] school'. Baldinucci's work contains several faults of judgment (he calls Rembrandt a 'painter with more credit than talent') and absurd opinions and erroneous information, such as the '3,500 Tuscan scudi' which he says the artist received for the *Night Watch* (in fact Rembrandt was paid, in Dutch money, about a quarter of this sum, i.e. 1,600 guilders on the basis of the 100 paid by each person represented in the painting).[12] But this does not detract from the fact that much of the basic information given in the Florentine writer's portrayal is extremely significant, interesting and accurate, and some of it has been confirmed by subsequent historical studies. 'The real worth of this craftsman lies in the strange manner, which he invented, of cutting copper with aquaforte, also of his own invention, never again used by others, nor seen again, with those long and short strokes, even lines and no contours, yet creating a deep, forceful chiaroscuro effect. In truth, Rembrandt was highly esteemed by teachers of art for this manner of engraving.' Baldinucci also tells us, though he clearly misunderstood the situation, of the 'extravagant generosity' of the artist, of his lavishness, of his purchases at auctions made regardless of cost, of all kinds of antiques and curios (this last detail is strongly contradicted by the bankruptcy inventory),[13] and of capricious spending to the extent that 'finally with all this his assets were so much

[10] Langen Müller, op. cit., pp. 83-8.
[11] Filippo Baldinucci, *Cominciamento e progresso dell'arte dell'intagliare in rame*, 3rd ed. (Milan 1808), pp. 193-9.
[12] C. Hofstede de Groot, *Die Urkundem über Rembrandt* (The Hague 1906), nos. 205 and 206.
[13] The inventory of Rembrandt's property was drawn up on 25 and 26 July 1656. It comprised 363 items. There was little furniture, but there were many valuable paintings: as well as those by Rembrandt himself, there were several by Hercules Seghers, Lucas van Leyden and other famous artists, past and present. There were also whole albums of Rembrandt's drawings, engravings by Lucas van Leyden, many oriental objets d'art, etc. Items 97 and 130 were two printing presses, one of them of oak; there is however no mention of plates. See the interesting description in *Rembrandt and the Italian Renaissance* by Kenneth Clark (London 1966), pp. 193-209.

diminished that he was reduced to an extreme condition: he became bankrupt, something which has rarely been said about other painters.' And there is one observation which sounds like a reproof but which I like very much, because Rembrandt was certainly not rich: 'While he was working he would have refused to listen to the first monarch of the world, who would have had to come back again and again, until he found him finished with that business.'

Another appraisal, earlier in date and much more authoritative, comes in a letter of 13 June 1660 from the Italian painter Guercino to Don Antonio Rufo of Messina, the greatest Italian collector of the century, who had asked him for a painting – called *Il Cosmografo*[14] – as a pendant to the *Aristotle* which he had purchased directly from Rembrandt in 1653. Guercino replied: 'On the question of the half-length portrait by Rembrandt which has come into Your Excellency's

[14] The painting by Guercino is lost. What is probably the preparatory drawing for it is preserved at Princeton University, New Jersey.

possession, it cannot be other than absolutely perfect, because I have seen several of his works in prints which have arrived in these parts, and which have proved to be very fine, engraved in good taste and well done, so one may suppose that his colouring too is quite exquisite and perfect; candidly, I regard him as a great virtuoso.'[15]

A few years later Don Antonio Rufo acquired two other paintings by Rembrandt, *Homer* and *Alexander*,[16] and also 189 etchings which arrived in Messina in 1669, sixty days after the artist's death, so that they must have been despatched while he was still alive. So great was the Sicilian nobleman's admiration for Rembrandt that when writing to Abraham Brueghel, a Flemish dealer resident in Rome, he affirmed that no one in Italy had been able to paint a half-length portrait that could stand comparison with the one he possessed by Rembrandt; and that he would have liked not three but six paintings by him, so much so that he had asked the artist for sketches 'on sheets of paper, in red or black pencil, or however you like'.[17]

According to Marco Ricci's brilliant essay (of which only 250 copies were printed, more than fifty years ago), the lack of success and understanding which Rembrandt's work met with in Italy – and still meets with today, if one is to judge from the icy silence maintained there on the occasion of the recent tercentenary of the artist's death – was largely due to Baldinucci's unflattering evaluation of his paintings: as Ricci points out, Baldinucci was until fairly recently regarded as a kind of oracle, in the absence of any better text. Ricci lists twenty or more important paintings by Rembrandt which were sent to Italy in the nineteenth century, only to be sold again by their rich owners to foreign collectors and collections.[18] 'The hostility continues', Giovanni Romani wrote a year ago, referring among other things to 'the small number of paintings and the reduced availability of the artist's drawings in our galleries'. The quality of the works by Rembrandt in Italian public collections is in fact so low that it was probably wise not to organize a special exhibition to display them.

In 1675 Joachim von Sandrart, the German painter and scholar, recalled a visit he had made to Rembrandt's studio in 1639: 'He has engraved on copper numerous and varied subjects, printed by himself, from which it is easy to discern that he was a diligent and indefatigable man.'[19] John Evelyn, founder member of the Royal Society and author of the celebrated diary, wrote in 1662 of 'the incomparable Reinbrandt, whose Etchings and gravings are of a particular spirit...'.[20] The artist's disciple, Samuel van Hoogstraten, writing in 1678, considered the artist to be one of the greatest of the century and reminded his pupils of the words spoken by him: 'Let your rule be that of applying consciously what you already know: later you will learn that which is still beyond your grasp and which you desire to know.'[21] Finally, the poet Jeremias van Dekker, in a *Dank-Bewys* in 1666, almost prophetically acclaimed Rembrandt as 'the greatest of all'.[22]

[15] Marco Ricci, *Rembrandt in Italia* (Milan 1918), pp. 11-14.
[16] *Aristotle* is now in the Metropolitan Museum of Art in New York, *Alexander* in the Calouste Gulbenkian Foundation in Lisbon, and *Homer* in the Mauritshuis at The Hague; the drawing for the latter is in the National Museum in Stockholm.
[17] Ricci, op. cit., pp. 26, 77-78.
[18] Ibid., pp. 63-77.
[19] Joachim von Sandrart, *Teutsche Academie...*, vol. I (Nuremberg 1675). Of particular interest is the information on Rembrandt's studio, crowded with young painters who paid him 100 guilders a year for their apprenticeship.
[20] John Evelyn, *Sculpture* (London 1662).
[21] From 'Introduction to the Academy of Painting', 1678, quoted by Karel G. Boon in *Rembrandt* (Milan n.d.), p. IV. See also De Groot, op. cit.
[22] *Rembrandt*, Dresden catalogue, op. cit., p. 5.

Before taking a brief look at some of the events in the artist's life and reporting some of the prices paid in early times for his engravings, with the help above all of the long and painstaking study by Hofstede de Groot, I should like to draw the reader's attention to the present-day revaluation of Rembrandt as man and artist. 'The romantic interpretation,' writes P. J. J. van Thiel, 'which helped so much in understanding the master's genius, must be revised, just as the number of paintings and drawings and, to a certain extent, of prints too has had to be revised and reduced, too much having been attributed to him by over-generous criticism. We no longer want to see in Rembrandt "the painter of the flesh and the soul", the praised talent and the misunderstood genius, the happy years with the rich Saskia, then the domestic troubles, the bankruptcy in 1656, and (in 1660) the removal to a poorer district where the dejected, impoverished and forgotten genius was to create the misunderstood masterpieces of his maturity.'[23]

The truth is indeed somewhat different. That Rembrandt suffered family sorrows is certain; that he knew hard times is also undisputed: one has only to think of the effects of the Thirty Years' War, which certainly did not spare Holland or its inhabitants. His spiritual crisis – and he was not the only artist to experience one – undoubtedly alienated all but a few of the rich clients he once had. His character and his somewhat odd temperament meant that relations with other people were not always easy for him. He was for instance not a good administrator, and was inclined to be extravagant; he did not understand the value of money except when he was in real financial difficulties. The bankruptcy itself, on which so many books have been written, grew less out of real, objective difficulties than out of his disordered, though not intemperate, life. In any case, the intelligentsia of Amsterdam continued to respect him.[24] Above all, he must also have been earning quite well, as is indicated for instance by the prices paid to him for each painting by Don Antonio Rufo, who was certainly not his only client. The sum, 500 guilders with all expenses paid by the customer, was more than three times as much as the fee which Guercino usually received, even though he was very popular;[25] and, to extend the comparison to England, as much as Samuel Pepys received from the Exchequer for the whole of the year 1657.[26] In short, the reality no longer fits the old stereotyped image which still persists, according to which the aged Rembrandt, 'with ugly plebean face, matched by abject and filthy dress',[27] created the works that made him immortal.

In Holland there existed a body of very reputable experts who directed auction sales and also lent their services for the valuation of property in respect of dowry contributions, legacies, etc. Here is the valuation made by one of them in June 1647 of a few prints by Rembrandt, the property of a certain Reynike Gerrits, widow of Hendrick Ulenburch: three small prints, 1 guilder and 12 stuiver, *Ecce Homo* (the vertical version, since the horizontal one was done only in 1655), 6 guilders. At an auction in The Hague on 17 April 1662, 73 prints

[23] P. J. J. van Thiel, *Nederland en Rembrandt 1669-1969* (catalogue of an exhibition at the Rijksmuseum, Amsterdam, 1969), pp. 21-2.
[24] Among the clients who remained loyal to Rembrandt after his bankruptcy were the doctor Antonides van der Linden, friend of Nicholas Tulp; the pharmacist Abraham Francen, tutor to the artist's young daughter Cornelia; Jacob Haaringh the younger, a lawyer at Utrecht; Arnold Tholinx, Inspector of the Amsterdam Collegium Medicum and brother-in-law of Jan Six; and perhaps also, among others, Ephraim Hezekiah Bueno, the famous Jewish doctor and writer of Portuguese origin, whose portrait Rembrandt had engraved years before.
[25] Ricci, op. cit., p. 17. For the *Cosmografo* Guercino asked 60 ducatoni, equivalent at the time to 300 lire, and thus just under 150 guilders.
[26] Percival Hunt, *Samuel Pepys in the Diary* (Pittsburgh 1968), p. 69.
[27] Baldinucci, op. cit.

by Rembrandt were sold in nine lots, without indication of the subjects (they probably included prints by pupils), for a total of 3 guilders 1 stuiver. On the other hand, we have a precious document of 1655, the codicil to the contract for the purchase of Rembrandt's house (payment fixed at 4,000 guilders in cash and 3,000 guilders in paintings and etchings), countersigned by the pharmacist Abraham Francen, who noted, 'in addition a portrait of Otto van Cattenburch' (the other contracting party), 'which the above mentioned van Rijn will etch from life, of the same quality as the portrait of Jan Six, at a value of 400 guilders.'[28] The print has not come down to us; probably it was never made, but the document remains proof of the esteem which the master enjoyed and of the tangible value attached to portraits engraved by him on commission.[29]

On the back of one of the eight known examples of the first state of the *Hundred Guilder Print*, now in the Albertina in Vienna, there is the inscription *de 6 print op de plaat – 48 Gulden* (the sixth print taken from the plate – 48 guilders). The price is certainly accurate, even though the writing dates from the eighteenth century. What is more puzzling, however, is the contemporary inscription by the famous Dutch dealer Pieters Zoomer (1641-1716) on the back of the first state of another print of the same subject, preserved in the Rijksprentenkabinet in Amsterdam. It states that Zoomer had obtained the etching in exchange for the engraving *The Phrygian Plague* by Marcantonio Raimondi after Raphael. Now, assuming that the dealer, who was then very young, could have been in fairly close contact with the already elderly artist (which of course cannot be altogether ruled out), this would suggest that in about 1665 Rembrandt possessed works of considerable value.[30] Information on the prices of engravings is not very plentiful, but this should not lead us to suppose that the most sought-after prints were not already highly valued. It is reasonable to assume that the etchings which probably already in the seventeenth century were known as the 'hundred guilder', 'thirty guilder' and 'twenty guilder' prints (i.e. *Christ healing the Sick*, the vertical *Ecce Homo* and *The Descent from the Cross: Large Plate*) had in Rembrandt's time the market value that the names suggest. The first is described in the report on the royal collection of Rembrandt's prints, made on 10 January 1744 for Augustus III, king of Saxony, by Johann Heinrich Heucher, court doctor and keeper of the collection: 'A famous work of art, known by the name of "the hundred franc sheet" [sic], above all because Rembrandt sold it to Hollar [the engraver] for a hundred guilders.' The Dresden etching, which Heucher was referring to, had belonged to Prince Eugene, whose very rich collection had passed to Princess von Hildburghausen and was purchased by Augustus III in Leipzig in 1743 through the Amsterdam dealer Pieter Schenk the younger.[31]

De Groot's work not surprisingly gives more references to paintings valued or sold at auctions. The price or valuation of these ranges from a few dozen guilders (probably for the smaller ones) and several hundred guilders, to the 1,500 guilders paid for an oil painting which in 1657 was part of the legacy of the art dealer Johannes de Renialme of Amsterdam (and which is now in the National Gallery in London). De Groot's study also gives examples of purchases made by Rembrandt, almost always at auctions: for example, in Amsterdam in 1637 he paid 637.10 guilders for a single album of engravings and drawings by Lucas van Leyden; again in Amsterdam, the following year, he paid 224 guilders for

Giovanni Battista Piranesi, *View of the Baths of Titus*, 1775. Detail

[28] De Groot, op. cit., nos. 112 and 251
[29] Ibid., no. 163.
[30] Ibid., no. 266. See also White, op. cit., p. 55, n. 29.
[31] *Rembrandt*, Dresden catalogue, op. cit., p. 89, no. 240 and p. 19. See also Christian Dittrich, 'Die Radierungen Rembrandts in Dresden', in *Pantheon*, vol. XXVIII (March 1970), pp. 244-5. Many of the etchings by Rembrandt that belonged to Prince Eugene went to the Hofbibliothek in Vienna.

Ruega por ella.

drawings and prints which included Dürer's *Life of the Virgin*; on an unspecified date he paid at least 1,400 guilders for fourteen of the finest engravings of Lucas van Leyden, among them the *Ecce Homo,* the *Large Crucifixion, The Dance of the Magdalen* and *The Journey of St Paul to Damascus*; another time, he paid nearly 80 rijksdaalder (about 200 guilders) for the rare etching *Till Eulenspiegel*. Finally in 1666, almost as if to prove that his circumstances were not all that precarious, Rembrandt made an offer of 1,000 guilders for a painting attributed to Holbein.[32]

GIOVANNI BATTISTA PIRANESI

One of the few major printmakers for whom we have reliable information on prices paid during their lifetime is the Venetian Giovanni Battista Piranesi; this is partly because of his unique method of selling. In 1760 Piranesi settled in *Strada Felice presso la Trinità de' Monti,* and in 1761 he began issuing a special catalogue to inform his vast European clientele about the individual prints which he published.[33] He brought it up to date periodically, correcting titles and adding

[32] De Groot, op. cit., nos. 51, 56, 326, 286, 340.
[33] In the Print Room of the Fogg Art Museum at Harvard University I was able to examine, in 1963, two volumes of the *Vedute di Roma* with 98 plates (corresponding to no. 10 in the Hind catalogue) presented to Harvard in 1772. The contemporary inscription written in pen on the first blank page of the first volume reads: 'The gift of Thomas Palmer Esq. of Boston, 1772'.

186

EZEKIEL.

I take away from thee the Desire of thine Eyes

William Blake, *Ezekiel*, 1794.
Blake, with his excellent technique,
brought a new dignity to line
engraving

new ones in spaces which had been left blank. The catalogue, which got thicker every year, makes it possible to follow Piranesi's growing production and the prices paid for his etchings. Here, for instance, is information from the catalogue of 1768, the eighth according to Hind's list.[34]

The four volumes of the *Antichità Romane* with 'two hundred and eighteen plates' cost 15 zecchini. The *Portrait of His Holiness Pope Clement XIII*, 6 paoli. The volume of the *Architetture diverse*, 4 Roman scudi. The *Carceri d'Invenzione* of 16 plates on atlantic sheets, 20 paoli, i.e. 1.25 each. For this last work, Piranesi's first catalogue of 1761, which did not include the sixteenth plate, had given the price as 15 paoli, one per sheet. Also in the earlier catalogue are the much rarer *Invenzioni Capric di Carceri*, from which the *Carceri* derived, which consisted of 14 plates, also at one paolo each. For the more sought-after *Vedute di Roma*, of which only 54 were listed in 1761 (there must have been 132 at the time of Piranesi's death), the value of 'two and a half paoli' was not indicated in the catalogue, but in 1764 it was added at the bottom of the first seventy *Vedute*, thus also determining a new state. A catalogue in French, containing more pages but of smaller format, published posthumously in 1792 in Rome by the artist's son

[34] Hind, *Piranesi*, op. cit., p. 6. Hind lists 13 catalogues. At least three earlier than 1761 should be added to this number, and perhaps five after 1780.

Francesco, gave more detailed prices, even mentioning baiocchi. Right at the bottom of the last page, clearly legible, are printed the equivalent values at the current exchange rates, in livres tournois, shillings and Dutch guilders: *l'écus romain vaut à peu près en monnoie de France L. 5,5 tournois/en monnoie d'Angleterre chelin 5/en monnoie d'Hollande un peu moins de florins 2½*. Since a Roman scudo of 10 paoli was worth 5 shillings, the price of 2½ paoli for each of the *Vedute di Roma* was equal to just over a shilling: Hind was thus able to establish that at the end of the eighteenth century these prints were worth the same as a mezzotint was then worth in London. However, the latter, given the nature of the technique, which could produce only a very limited edition, would quickly rise in value.

In order to understand these values in Roman currency, it is worth remembering that one zecchino was worth two scudi; each scudo was divided into ten paoli; each paolo was worth 0.55 French livres, later 0.5 livres.

An examination of the text of the very rare *Lettere di Giustificazione* of 1757 gives us a fairly clear idea of Piranesi's publishing and commercial activities. He was stirred into printing his famous letters by Lord Charlemont's failure to pay the amount he had promised in recognition of the four title pages of dedication which were to be inserted in the four volumes of the *Antichità Romane*. This angered the artist, and after a few volumes of the work had been printed he left out the dedications. He also made some interesting calculations which I shall summarize here. He writes that, assuming that a fair remuneration for the dedications would be 300 scudi, and if he sold 4,000 impressions at 2½ paoli each, for a total of 1,000 scudi, after subtracting the cost of the 4,000 sheets of paper at 4 baiocchi each, i.e. 160 scudi (1 paolo = 10 baiocchi), he would be left with a profit of about 1,200 scudi; on this basis, however, the expenses and proceeds on the remaining plates (at about 1.35 paoli per illustration) would have to balance. He also states that Pope Clement XIII had generously given him 1,200 scudi, without asking for anything in return. It is true that the Pope did give him financial assistance, but the amount involved was not 1,200 scudi but only 1,000.[35]

The four popes who succeeded Clement XIII to the papal throne during Piranesi's activity in Rome all helped him, to a greater or lesser degree; as did numerous tourists, especially the English, who readily commissioned dedications from him. Firstly there was the architect Robert Adam, his companion on wanderings in the Roman Campagna,[36] to whom he dedicated the volume *Il Campo Marzio nell'Antica Roma*; and there were seventy or so other people who were happy to be remembered with a few lines under a vase, a sarcophagus, or an urn, in the work entitled *Vasi, Candelabri, Cippi*, etc. They had to pay the artist a small sum of money or else purchase an antique object, since Piranesi devoted a great amount of time to excavating during the last ten years of his life. This income, when added to the earnings from his activities as engraver and publisher, enabled him to print his luxurious volumes regardless of cost, and to maintain, at a fairly modest standard, his own large family which, in addition to Francesco, Pietro and Laura, had included other children who died young, and whose names we do not even know.

Aggressive and stubborn, as appears from his many polemics on the independence of Roman art in relation to Greek art, quarrelsome, according to what the French architect Jacques-Guillaume Legrand wrote on the basis of statements

[35] A letter from Piranesi to Robert Mylne, dated November 1760, speaks of a gift from the Pope of 1,000 scudi. The letter is in the library of the Royal Institute of British Architects in London.
[36] John Fleming, *Robert Adam and his Circle* (London 1962), pp. 165-70, 174-76, 230-31, etc. The book is full of interesting information on Piranesi and his character. For his character see also R. and M. Wittkower, op. cit., p. 82.

Théodore Géricault, *The Flemish Farrier*, 1821

Overleaf:

Left, above:
Honoré Daumier, *Landscape Painters at Work*, 1862

Below:
Honoré Daumier, *A Demosthenic Oration*, from *Gens de Justice*, 1847

Right:
Edouard Manet, *The Cats' Rendezvous*, 1868

made by the artist's own children,[37] Piranesi had scarcely any friends in Italy, apart from a few members of the Holy See who did often give him protection. On the other hand, he had many friends in England, which was in a way his adopted country. He was elected as a Fellow of the Royal Society of Antiquaries in 1757, four years before being admitted to the Accademia di San Luca of Rome. A few months after his death his colleague, the doctor E. Lodovico Bianconi, gave a 'Historical Eulogy' at the Accademia, referring to Piranesi's adventurous life, his rebellious nature, and to his distortions of history; he did admittedly give recognition to his outstanding skill as a printmaker, but really he understood nothing of the art of this great master,[38] who was later to be generally acknowledged as the greatest exponent of graphic art in Italy over five centuries, the 'Rembrandt of architecture' as Arthur M. Hind called him.

FRANCISCO GOYA

On the front page of the newspaper *Diario de Madrid* of Wednesday 6 February 1799, immediately under the title and the weather information, was a summary description of Goya's *Caprichos*, which made a point of stating that the satirical themes of the work did not aim at ridiculing the faults of particular people, but of humanity as a whole. On the second page of the *Diario* readers were informed that the album was on sale at no. 1 Calle del Desengaño (the house where Goya lived), at a price of 320 reales. A second announcement, in the *Gazeta de Madrid* on the following Tuesday, repeated the information in shortened

[37] See *Notice historique sur la vie et les ouvrages de G.B. Piranesi*, Paris, Bibliothèque Nationale, Manuscrits, Nouv. Acq. Fr. 5968 (Paris 1799).
[38] *Antologia*, nos. XXXIV, XXXV and XXXVI (February and March 1799).

Rodolphe Bresdin, *The Comedy of Death*, 1843

Opposite:
Rodolphe Bresdin, *The Holy Family*, 1855

form. We do not know whether the album remained only a few days in the perfume and spirit shop in the Calle del Desengaño, or whether it was there for four years, which is much more likely, since in a letter to the minister Cajetano Soler, dated 7 July 1803, Goya wrote that 27 prints had been sold in two days, at the rate of one ounce of gold each (27 grams), while the plates would allow the printing of another 5-6,000 sheets! The fact is that he managed to obtain from Charles IV a pension of 12,000 reales for his son Xavier's studies and journeys, in return for handing over the 80 copperplates and 240 sets of prints (he had given away another 33 sets to friends). The king in his turn gave the plates and prints to the Calcografía, which in 1816 reduced the price of each volume to 200 reales, equivalent to 50 French francs.[39]

The public announcement of the second large series of prints, the *Arte de lidiar los toros*, better known as *Tauromaquia*, appeared in the same *Diario de*

[39] Harris, op. cit., vol. 1; for further details see pp. 95-110.

Opposite:
James Abbott McNeill Whistler,
Nocturne Palaces, 1879

Right:
James Abbott McNeill Whistler,
Ponte del Piovan, 1879

Below:
James Abbott McNeill Whistler,
La Riva I, 1879

Madrid in October 1816 and was repeated the following December in the *Gazeta*. The definitive first edition, of about 250 sheets, appears to have been printed by the same skilful Rafael Esteve who had been responsible for the first edition of 300 sheets of the *Caprichos*. The price was fixed at 300 reales for each series of 33 plates. This time the results of the publishing undertaking seem to have been less catastrophic, thanks to to the Spaniards' interest in their favourite sport. Nevertheless, as with the *Caprichos,* the greater part of the edition was bought by foreign collectors, particularly by French dealers, at meagre prices. It was in any case a failure for Goya, for the relatively small number of impressions of his two works, instead of going to public and private collections, for decades after his death were still available from bookshops or print dealers.

Scholars and critics were to wait until the end of the nineteenth century before expressing their opinions, even though artists like Delacroix, Daumier and Manet had already learned to appreciate Goya's work. It is not surprising, therefore, that the artist did not feel inclined to bear the cost of printing the *Desastres de la Guerra*, engraved between 1810 and 1820, of which no more than a few contemporary impressions are known, or of the *Disparates*, better known as the *Proverbios*, engraved in about 1816. His son Xavier, who owned the copperplates, died in 1854, and the Real Academia de Madrid, having found them in a storeroom where they had been deposited, published the first edition of the two works in 1863 and 1864.[40]

Goya as a graphic artist is, with his personal vision and his detachment from earthly things, highly reminiscent of Rembrandt. He did not, however, improvise

Above left:
Odilon Redon, *Tree*, 1892

Above:
Odilon Redon, *Centaure visant les nues*, 1895

Opposite:
Odilon Redon, *The Reader*, 1892

[40] Ibid., pp. 173-6.

his inventions on copper, using just a sketch, a motif or a memory, as Rembrandt had done: for each of his etchings Goya prepared a drawing (almost all of these have survived) which he then placed on the plate by a transfer process. In fact, his prints are not only of the same dimensions as the preparatory drawings, but they also appear the same way round, i.e. not in reverse. Catharina Boelcke-Astor thinks that the reason for Goya's method may have been his relative unfamiliarity with printing, a technique which Rembrandt and other Northern European artists had in their blood.[41] Among 'born' printmakers one might also recall the great Italian engravers of the eighteenth century, especially the Venetians, active while Goya was a young boy, who had also been great exponents of the etching technique. It should however be noted that Spain, in spite of having suffered as many upheavals and crises during the nineteenth century as Italy did, and in spite of her complete lack of graphic traditions, nonetheless managed to secure for herself – through enlightened collectors like Valentin Carderera (1796-1880) – almost all the drawings, several superb and very rare prints, and the most sought-after editions of her first great graphic artist (the second was to be Picasso); even though most of the best first editions and many of his most in-

Pierre Bonnard, *Paravent in four sections*, 1899

[41] *De Grafiek van Goya* (catalogue of an exhibition at the Rijksprentenkabinet, Amsterdam, 13 November 1970-17 January 1971): see the introduction by Catharina Boelke-Astor, pp. 15-18.

teresting impressions found their way into the great museums all over Europe and America. In Italy on the other hand, the finest prints by the Tiepolos, Canaletto and Piranesi were sold, amidst the general indifference of Italians, to foreign collectors and tourists. In 1845, for example, the entire collection of engravings which had once belonged to Giovanni Domenico Tiepolo was sent from Venice to Paris, to be sold there at absurdly low prices at the Hôtel des Ventes, on 10-12 November of the same year.[42]

WILLIAM BLAKE

If it had not been for the enlightened curiosity of Dante Gabriel Rossetti and his brother William, and the subsequent *Life of William Blake* which their friend Alexander Gilchrist published in 1863, several more decades would probably have passed before literary and artistic criticism recognized in the poet of the *Songs* a lyricist worthy of the Shakespeare of the sonnets and, moreover, a brilliant painter and engraver. Enough has been written about the basis of Blake's art to make discussion here unnecessary. It is well known that he looked above all to the old masters, and more than any other to Michelangelo, while he regarded artists like Titian, Rubens and Rembrandt with aversion and indeed scorn. He expressed these opinions in the short catalogue of his first and only exhibition, organized in 1809 in his brother James's haberdashery shop in London, at 28 Broad Street. The exhibition was a failure, even though the artist, painting and engraving in the manner of classical painters, overflowed with fantasy and visionary audacity: in 1807, in *A Vision of the Last Judgment*, he had written 'I look through my eyes and not with them.'

In order to summarize some of his best years, which were the last years of his life, I shall turn to a study by Geoffrey Keynes, brother of the economist, who dedicated years of his life to the study of Blake's work.[43] John Linnell was a young English painter who had since 1818 admired Blake and helped him by purchasing his works. On 23 March 1823 Linnell wrote a kind of memorandum or contract – countersigned on the back by Blake, who also acknowledged receipt of a payment on account of £5 for the purchase of the copperplates – according to which the artist was to engrave on twenty plates, of his own free invention, the story of Job. Linnell was to pay him a total of £100 for this; and as much again if the profits from the sale of the prints allowed it.

On the basis of documents sold by Linnell's heirs at Christie's, Keynes was able to draw up an exact record of the accounts relating to the agreement. On 14 July 1826, four months after the work had been printed, Blake acknowledged receipt of £150.19.3, largely made up of a payment on account, but including a smaller amount from subscribers to the work, and including even the item 'coal' which Linnell had paid for to heat the elderly artist's apartment during the winter. Blake had engraved twenty-two plates instead of twenty, but Linnell in his turn had been more than generous, since, as we now know, by the time Blake died the proceeds from the sale of the prints had not even covered the amount Linnell had spent on them. Indeed he had added £111.15.6 for the cost of the copperplates, the printing and the paper. A total of 315 impressions was printed, and by 1833 only 40 had been sold, at an average price of 4 guineas each, so those who really gained from the operation must have been John Linnell's great-grandchildren and, perhaps to an even greater extent, the collectors who acquired Blake's works half a century ago.

[42] Harris, op. cit., vol. I, p. 13.
[43] Geoffrey Keynes, *Blake Studies* (London 1949): see ch. XIII, 'The Blake-Linnell documents', pp. 135-45.

Charles Meryon, the brilliant engraver of the *Eaux-fortes sur Paris*, was with Whistler undoubtedly the greatest etcher of the century. He suffered misunderstanding, lack of success and real poverty during his life as an artist, which was brief (Meryon suffered from a mental illness similar to that which had caused his mother's death at an early age). Charles Baudelaire, who sensed Meryon's genius and wrote of it several times in his *Critique artistique*,[44] wanted at all costs to establish some form of collaboration with Meryon, *une collaboration entre poètes*. But he tried in vain, and in a letter written on 9 March 1860 to the publisher Poulet Malassis, he closed with the words: 'This Meryon does not know how to do things; he knows nothing about life. He doesn't know how to sell; he doesn't know how to find a publisher. Yet his work could be sold so easily.'[45] Baudelaire's analysis is borne out by the lines which Frederick Keppel wrote in 1908 in his preface to an article on Charles Meryon: 'Beillet, the printer, told me that one day Meryon had come into his studio almost furtively, looking more nervous and worried than usual. He had with him two sheets of paper and the plate for the *Abside de Notre-Dame*. "Monsieur Beillet," he said to him, "I should like you to print two proofs for me", adding timidly that he would not be able to pay for them until he had sold them. "Please don't refuse," he begged. I asked Beillet how much he had asked for the printing. "Oh, ten centimes for the two," he replied. The idea that Meryon was unable to pay for the printing of the plate which he liked best aroused in me a certain bitterness which Beillet misinterpreted. "But, sir," he said, "I never got my money."'[46]

Everyone knows that Honoré Daumier was one of the greatest artists of the nineteenth century – the author of prints in which humour and satire barely hide his dramatic vision of the world, a sculptor with few equals, and a painter of true masterpieces. But how many of us know, except through reproductions, a single one of his eighty or ninety major paintings, which are distributed among fifty museums, from the Baltic to California? Perhaps a few of his bronzes, cast several decades ago from his waxes, are known to us, and perhaps also the *Ratapoil*. On the other hand we are more familiar with several or even many of his 4,000 lithographs. We also know a great deal about his life: we have read about the persecutions and the misunderstanding he suffered, his existence so full of privations, and of his friend Camille Corot who, with great generosity, gave him a little house at Valmondois so that he could end his days in relative comfort and peace.

The misunderstanding that surrounded Daumier can be partially explained. A hundred years ago Paris could count at least as many artists, some just beginning their careers, some already mature, who were later to be recognized as geniuses, as could Rome, Florence and Venice in the sixteenth century. However, Paris did not have a rich papal court or rich patrons to rival a Julius II; Durand-Ruel was not enough. The question of Daumier's poverty nevertheless needs a closer look. Fairly recent studies have demonstrated that among the avant-garde artists who were his contemporaries, only Degas and Corot and two or three others were better paid than Daumier (Cézanne, who earned nothing from his work at that time, came from a wealthy family). Daumier received from *La Caricature* and then from *Le Charivari* between 40 and 50 francs per lithograph and 20 for each drawing on wood. If we add to these amounts the 2,000 francs per year which he made on his watercolours and paintings from 1850 onwards, and which by 1870

[44] Charles Baudelaire, *Critique artistique*, in *Œuvres complètes* (Paris 1961), pp. 1083, 1147-50, 1705.
[45] Loÿs Delteil, *Le Peintre-graveur illustré, Charles Meryon*, vol. II (Paris 1907), *Avis au lecteur*.
[46] 'Charles Meryon', in *The Print Collector's Bulletin* (New York), 21 September 1908.

Vincent van Gogh, *Dr Gachet
(Man with a Pipe)*, 1890

had become 4,000 francs, we are near to an average net annual income fluctuating between 5,000 and 7,000 francs from 1835/40 to 1870. (This excludes the pension of 1,200 francs which the State paid to him during the last years of his life, but it also does not take into consideration the period 1860-63, when, having been barred from *Le Charivari*, Daumier worked only for *Le Boulevard*.) Daumier's 'poverty' was therefore a far cry from the real poverty in which artists like Claude Monet were struggling in 1870; indeed, it is on a level with the salaries paid to the highest civil servants in France, who, with 500 francs a month, could live in comfort with their families. The fact is that Daumier was quite simply over-generous; he helped everyone, and money burned holes in his pockets.[47]

'America has produced two extraordinary high-priests of the mystery of art, Edgar Poe and James McNeill Whistler. Poe, who offers strangeness as the distinguishing mark of Beauty, Whistler, whose subtle harmonies and power of suggestion have perhaps gone further than any other art form in Western civilization . . . I can still see Whistler's lordly figure, erect, wearing a black frock-coat, with his charming head of curls' (Focillon). Baudelaire too admired Whistler as a printmaker and wrote about him. Whistler married the sister of Seymour Haden, surgeon, engraver and collector, but Haden later broke with him, as

[47] Georges Besson, *Honoré Daumier* (Paris 1959), pp. XXXVIII-XLVII.

202

Giovanni Fattori, *Tuscan Landscape,*
*c.*1890

did John Ruskin who had regarded him highly at one time. Cosmopolitan, independent, man-about-town, though not well-off, Whistler was an eccentric, and also very good looking. He had all the right qualities to please and therefore to achieve the success which was denied to other artists, Meryon among many. But he also had two serious disadvantages, if we can call them that: as the first Impressionist in the history of printmaking, he was designing not for his own generation but for the one to follow; and, being undoubtedly more intelligent than the critics, men of letters and artists who surrounded him, he used this intelligence too crushingly, thereby ruining all his chances of material success. This is shown by the resounding failure of his two best works, the twelve etchings of the first Venice Set exhibited at the Fine Art Society in London in 1880, and the twenty-four of the second Venice Set exhibited in 1886 in the nearby gallery, Dowdesell and Dowdesell. The controversial invitation which he issued to this second exhibition, and the reviews which followed, alienated his best English and even American clients. The price of 50 guineas fixed by the artist for the whole series, printed in a few dozen sets, was considered absurd and presumptious.[48]

TWENTIETH-CENTURY PRINTMAKERS

An artist can usually make a name for himself only over a period of many years, however good he may be. Some artists may have known success in their lifetime, but so many, like Paul Gauguin, were denied that satisfaction. But in the modern age a new situation arose: the artist was no longer alone, at least not always; he could at times be sure of real assistance if he needed it. The team of artists who were published by Ambroise Vollard, emulator of Durand-Ruel, were lucky in that he had sensed that with Impressionism a new art had been born, an art that

[48] Harold J.L. Wright, 'Three Master Etchers: Whistler, etc.' in *Journal of the Royal Society* (London), 19 September 1930, pp. 1112-32.

was to have important developments. The artist's genius could how be backed by the talent of another person, who knew how to appraise his work, give encouragement and help. In this sense Vollard showed himself to be more commendable than the old-style patron and more intelligent than the dealer looking for a safe field. Durand-Ruel risked everything, even bankruptcy, for ideals perhaps more than for gain.

Ambroise Vollard, an intellectual, dealer, publisher and writer, generous though not lavish, was among the first to understand the greatness of Cézanne, to discover Van Gogh, and to invest in prints a considerable proportion of what he had earned from dealing in paintings.[49] This was very long-term investment, so much so that in 1939, when Vollard died at the age of seventy-one in a car accident, he had still not reaped the fruits of all the seeds he had sown, in some cases as far back as the end of the nineteenth century. The two editions of the *Album des peintres-graveurs*, which included names like Toulouse-Lautrec, Odilon Redon, Pierre Bonnard and Edouard Vuillard, artists who were to 'contribute very effectively to the revival of the print', were published in 1896 and 1897. It was on a suggestion from Vollard that Pierre Bonnard in 1899 drew the twelve splendid colour lithographs *Quelques aspects de la vie de Paris*, and in 1900 and 1902 illustrated *Parallèlement* and *Daphnis et Chloé*.[50] Vollard was also responsible for the magnificent series of twelve colour lithographs *Paysages et*

[49] Ambroise Vollard, *Souvenirs d'un marchand de tableaux* (Paris 1937).
[50] Claude Roger-Marx, *Bonnard* (Monte-Carlo 1952), pp. 77, 168, 170.

Intérieurs by Edouard Vuillard (1868-1940).[51] Such works, which for many years remained unsold or were disposed of at very low prices, were not fully appreciated until after the end of the Second World War, over half a century after they had been created. Marc Chagall, while still in Berlin, also had contacts with Vollard, for whom he engraved the illustrations to *Dead Souls*, *The Fables of La Fontaine* and the *Bible*, 312 etchings altogether: these were however published (by Thériade) only after the end of the war.[52] Another artist who made prints for Vollard was Georges Rouault, among whose numerous works the *Réincarnations du Père Ubu* and the *Miserere* are outstanding. The most famous of Vollard's protégés must certainly be Picasso: Vollard owned the plates of the *Acrobats* (1904-5), the *Chef-d'œuvre inconnu* (printed in 1931) and the *Vollard Suite* (above, p. 164).

I have referred to Ambroise Vollard not so much because of his outstanding personality, or because of his contribution in the field of graphic art, or because he persuaded a number of artists to make prints who perhaps would never have worked in the medium if it had not been for his advice and encouragement; but because in this century an increasing need is felt for the kind of intelligent dealer who is able to advise and help the artist. In the case of the artists mentioned, all of whom were also very good painters, it was only towards the end of their lives that they obtained recognition as graphic artists and made a modest profit. Exceptions are Toulouse-Lautrec, Marc Chagall (partly because he was younger than the others), and Picasso who, because of his outstanding genius, because of his gifts as a graphic artist and also, admittedly, because of his longevity, has lived to see his prints highly prized. But even Picasso did not find immediate success. In fact Frits Lugt, who knew him well, recalled: 'His beginnings in this art were not brilliant, from the point of view of sales. His only client then [before 1914] was Clovis Sagot who kept a rather bohemian avant-garde art shop at no. 46 rue Lafitte. When Clovis Sagot gave him an order for one or, more rarely, two prints, Picasso used to go to his printer Delâtre, who kept the printed sheets which the artist had been unable to pay for all at once. Picasso would pay him at the rate of 5 francs a sheet and then deliver them to Clovis, who bought them for 20 francs each.'[53] These were the sheets of the *Acrobats* series, printed from the plates which before 1913 were not steelfaced.

It was decidedly more difficult for the Norwegian Expressionist Edvard Munch and the Germans Emil Nolde and his younger contemporary Ernst Ludwig Kirchner to establish themselves. English and American markets were not interested in avant-garde works and the French, aesthetically much more open-minded, still adopted a protectionist attitude in art matters. The Expressionists thus had to rely on Scandinavian art lovers and, above all, on the more numerous enthusiasts in Germany – until Hitler's rise to power. Their work is of course now widely appreciated.

Giorgio Morandi is the greatest Italian etcher of the twentieth century. His graphic work, known to very few before the war, is today admired throughout the world. Before 1940 the artist used to ask a few dozen lire for his prints; even at the exhibition held in 1948 at the Calcografia Nazionale in Rome, prices were around 4-6,000 lire a print (in devalued currency). Only after the publication of Lamberto Vitali's catalogue, which followed the edition of prints issued by Carlo Alberto Petrucci, then director of the Calcografia, did prices begin to rise. Morandi's best etchings, which in about 1960 were offered for sale at Berne for a tentative 1,000 Swiss francs or less, now realize ten times as much at sales today.

[51] Claude Roger-Marx, *Vuillard* (Monte-Carlo 1948), p. 91.
[52] *The Artist and the Book*, op. cit., pp. 41-3.
[53] Frits Lugt, *Les Marques de collections*, op. cit., vol. II, p. 298.

II Changing monetary values and the fluctuating fortunes of prints

In the preceding chapter I examined the success which some of the important printmakers enjoyed during their lifetime. Now I propose to follow the works of the artists mentioned, and of several others as well, in their alternating fortunes over the years, making use of documentation which becomes gradually more specific as time goes on. My principal sources of information are the catalogues of the big sales, and Frits Lugt's inventories.[1]

It should be remembered, however, that up to the last years of the eighteenth century, because of the low value placed on prints, it was customary to sell them (and usually drawings as well) either in parcels or else pasted into large volumes, which makes the task of identifying particular prints much more difficult. Another factor to be kept in mind is that even after the eighteenth century sources frequently refer to artists who never engraved (for example Raphael, Titian and Leonardo), and therefore the prints in question must be attributed to copyists, such as Raimondi and his school; and that the name 'Baccio Baldini', which one comes across so often, frequently represents the Master of the Prophets and Sibyls or other Italian engravers in the fine manner and the broad manner. Finally, a great deal of confusion can arise from the question of states, which are nowadays more rigidly established, from subjects known today under different titles and of course from erroneous attributions.

Collecting has a very old tradition which, in the case of prints, dates back to the fifteenth century. In Italy, for example, Giacomo Rubieri, a cultured lawyer from Parma, had by 1480 collected about forty incunabula, mostly the work of Italian engravers: the same incunabula today form the most important collection of its kind in Italy and are preserved in the Biblioteca Classense in Ravenna.[2]

[1] I have examined most of the catalogues relating to sales (excluding however some which are unobtainable) even though I have often preferred to rely on Frits Lugt's sound information. For sales not mentioned by Lugt, because the prints in question belonged to collectors who did not place their marks on the back of their sheets, I have frequently made use of the introductions to the catalogues. However, for further details see Frits Lugt, *Les Marques de collections*, op. cit., vol. I, nos. 1851, 1852, 2034, 1511, 780, 1897, 2580, 2662, 2617, 2038, 2199, 2490, 345, 1060, 119, 1944, 2071, 1375, 2229, 402, 2243, 130; and vol. II, nos. 658, 773, 877, 654, 1052, 2445, 2669, 1052, etc.

[2] W.L. Schreiber, *Einzel-Formschnitte des Fünfzehnten Jahrhunderts in der Biblioteca Classense in Ravenna*, vol. LXVIII (Strasbourg 1929).

Later, in the seventeenth century, the formation of a print collection became fairly widespread among the cultured members of the aristocracy and the middle classes. To the latter belonged the Abbé Michel de Marolles (1600-81), a rich man of great knowledge and a writer, who between 1635 and 1665 put together a collection of over 123,000 prints, gathered in 520 large volumes, which he himself thought 'perhaps not unworthy of a royal library'. It comprised works by 6,000 artists, 570 of them engravings by Raimondi and his school, 74 by Mantegna and his pupils, the works of Dürer (and also 15 of his pen drawings), the complete works of Lucas van Leyden and 224 etchings by the school of Rembrandt and by Rembrandt himself, who was at that time active in Amsterdam. In 1667 Jean-Baptiste Colbert, the Minister of Finance, acquired the abbé's entire collection on behalf of Louis XIV for 28,000 French livres: it was the nucleus of what was later to become the first museum of prints in the world, the Cabinet des Estampes at the Bibliothèque Nationale in Paris.

Towards the end of Louis XIV's long reign Paris was beginning to replace Amsterdam as the artistic centre of Europe, and it was in this city that the Mariette family, dealers in prints and drawings, established themselves. The line stretched from Pierre Mariette, active at the beginning of the seventeenth century, up to his great-grandson Pierre-Jean (1694-1774), the most famous of all. Educated by Jesuits, this brilliant man had a background firmly rooted in humanistic culture and since early childhood had lived in close contact with art. His father's

Above left:
Title page of the catalogue of the sale of the outstanding collection of prints and drawings which belonged to the French collector Pierre-Jean Mariette. Paris 1775

Above:
Title page of the catalogue of the sale of Sir Edward Astley's prints. The name of Arthur Pond, at whose sale Sir Edward had bought his finest Rembrandt etchings, is given special prominence. London 1760

Mariette

Pierre Bonnard, *La Petite Blanchisseuse*, 1896

Giovanni Domenico Tiepolo, *The Holy Family passing under an arch*, *c.*1750-55

vast business and his own enthusiasm and refined taste enabled him to establish long-lasting friendships with illustrious artists and the most enlightened collectors of the day, such as Pierre Crozat, who was pre-eminent in the field of drawing, Antoine Watteau, Rosalba Carriera and the well-known archaeologist and engraver Comte Anne-Claude de Caylus. After spending the years 1717-19 in Vienna classifying the prints and drawings belonging to Prince Eugene of Savoy he went to Italy, where he met Luigi Crespi, son of the painter Giuseppe Maria Crespi, Giovanni Bottari, who was to become the keeper of the Vatican Library, and the Venetian engraver Antonio Maria Zanetti, himself an enthusiastic collector. Later he had dealings, though not in person, with Piranesi, whose polemical *Osservazioni... sopra la lettre de M. Mariette* (1765) is well known. Mariette, who preferred studying and collecting drawings to carrying on his father's business, eventually retired from dealing in 1750. He died twenty-four years later, in 1774, having clearly expressed his desire that the prints left to him by his family and his own collection of drawings (the latter, especially the drawings by Italian masters, being in his opinion 'perhaps the best chosen and most complete in Europe') should not be disposed of by auction, but passed to the French royal collection. Unfortunately his heirs refused the king's offer of 300,000 livres, and decided on a public sale from which they hoped for, but did not get, a larger return.

The disposal of Mariette's entire collection of drawings and prints took place between 10 November 1775 and 30 January of the following year. The total receipts amounted to 288,500 livres, less commission. I pick out here some most important lots of prints with the prices they made:

724 engravings by Raimondi and his school, 'the collection of which has taken over a century', 4,600 livres; an outstanding collection of works by Della Bella (over 1,540 prints in 3 volumes) which had been formed by François Langlois, printer and personal friend of the artist, 920 livres. (Of this Mariette had written 'this collection has been kept in my family. It is so beautiful that if I ever found I had to get rid of many *curiosités* this one would be the last I would agree to part with'.)

190 first-state impressions by Giovanni Battista and Giovanni Domenico Tiepolo, 170 livres; all the etchings published up to then by Piranesi, in the first state, gift of the artist to Pierre-Jean, 851 livres; 800 chiaroscuro woodcuts by Italian, Flemish and German masters, 290 livres; 1,100 prints of the school of Rubens, grouped in 115 lots, altogether 7,857 livres; 100 etchings by Ostade, in various states, 222 livres.

A volume with 117 outstanding line engravings by Dürer, which once belonged to the cartographer Abraham Ortelius (1527-98), an important and discerning collector,[3] 1,650 livres; another volume from the same source with 300 prints, among them almost all Dürer's woodcuts, 180 livres. (We shall come across these volumes again.)

The magnificent works of Lucas van Leyden, almost 200 sheets gathered in one volume, 2,141 livres; 1,300 etchings by Callot, 500 livres.

423 etchings by Rembrandt, arranged according to Gersaint's first catalogue, 5,488 livres. (Unfortunately the inadequate description of these sheets does not enable us to evaluate the importance of the collection, nor of the few, better-known etchings sold separately. I shall therefore give below other examples of prices for this artist.)

Because of the fame of Mariette's collection, and the fact that every person in Europe who was interested in drawings and engravings was present at the sale, it gives a good idea of the values placed two hundred years ago on the various artists who represented three centuries of graphic art.

First of all it can be seen that prints had still a rather low value, and that the fascination of prestige names like Titian, Raphael and Rubens tended to put original graphic works in the shade. How else can one explain the prices paid for Raimondi and the Rubens school, while Dürer was ignored, in spite of the immense influence he had had on European art? Della Bella was apparently greatly appreciated,[4] but Callot was little regarded even though his brilliant works had influenced the young Rembrandt, Jacques Bellange and Della Bella as well. The success enjoyed by Giovanni Battista Tiepolo, who had died six years earlier, greatly admired, does however contrast with the fact that for almost a hundred and fifty years, practically nothing more was to be heard about his prints or those of his son Giovanni Domenico. Piranesi realized rather higher prices than in Rome; but his success was not to last long: he fell into absolute oblivion during the whole of the nineteenth century. The great art encyclopaedias did not even mention him, and his works disappeared from the salerooms, partly because they were so cumbersome, heavy and troublesome to museum curators. He was eventually rediscovered in the twentieth century by the

[3] Letters by Abraham Ortelius, referring specifically to his collections of prints by Schongauer, Dürer and Lucas van Leyden, were sold at Sotheby's on 14 February 1955.

[4] On 30 November 1970, in London (Sotheby's catalogue no. 185), a letter from the Florentine engraver was auctioned. It was dated 10 January 1656 and addressed to Pierre Mariette I (d. 1658), founder of the famous family. His son, grandfather of Pierre-Jean, married the widow of Langlois, who published Della Bella's works. The Mariettes, as agents of the Florentine artist, must certainly have possessed early impressions of all his works.

Americans and by the English, who had been his first admirers in Rome.[5] The 2,141 livres paid for the work of Lucas van Leyden was obviously not only a homage to his greatness, but also early recognition of the rarity of his prints in fine contemporary editions. Adriaen van Ostade and Claude Lorrain (the latter's works fetched only a trifling sum) still had to wait for many years before being appreciated.

In 1776 England was on the threshold of a period of demographic and economic expansion brought about by the industrial revolution. But this was pre-capitalist England of the century of enlightenment, the England of Dr Johnson and Boswell, of Edward Gibbon. They were years in which the Scottish philosopher Adam Smith was formulating the principles of a new science, political economics; the years in which James Cook was preparing his last circumnavigation of the globe, while the English nobility and cultured middle classes were rediscovering Athens and Rome. The country was enjoying greater economic stability than other European nations, and this was a major contributory factor to the pheno-menon which grew and spread rapidly in England and which is so characteristic of the Anglo-Saxon world – collecting. Here the typical French love for *curiosités* assumes a different form, it becomes a hobby, a kind of pastime, a particular interest in the chosen object. The Englishman collects with enthusiasm and determination, and so it came about that at the end of the nineteenth century England, a country with fewer artistic traditions than most, came to possess more works of art than any other nation.

It was in London, where for two centuries sales of prints were richer and more numerous than anywhere else, that Rembrandt's name was to echo more loudly and more continuously than that of any other artist. In addition to various single sheets and a certain number of small collections known to have existed in every European country from the second half of the seventeenth century onwards, we know of three big collections of his work formed during Rembrandt's lifetime or in the years immediately after his death. Two of these, as we shall see, were brought to England almost in their entirety, and a considerable part of the third collection followed them. Over the years these works passed from collector to collector, collections were broken up and then re-formed in smaller but perhaps more selective collections; finally, after many years of wandering, prac-tically all the sheets found their way into the print rooms of the great museums in England, on the continent of Europe and in the United States. I shall, of course, deal only with 'Rembrandts by Rembrandt', that is to say the old etchings, the experimental proofs which he himself printed on precious Oriental paper – outstanding impressions with abundant velvety burr, often differing one from the other, and so almost contradicting the traditional meaning of the term print. These etchings are, of course, far removed from the hundreds of Rembrandt prints which continue to be sold every year at European and American auctions.

It was probably Jan Six, the longstanding friend of Rembrandt who from 1691 was a burgomaster of Amsterdam, who bought a large number of the artist's etchings at the sale following his bankruptcy (1658). Six's heir, his grandson Willem, disposed of his collection in 1734, and the Rembrandts were acquired by the Dutch engraver Jacobus Houbraken for 572 guilders. He in turn sold most of the sheets to Baron Cornelis van Leyden, whose superb collection, further

Jan Six

5 After Piranesi's long period of oblivion, the first exhibition of his graphic work was organized by the American collector, Atherton Curtis, in 1903 in his own house at Mount Kisco near New York. In 1963 I managed to trace, at Columbia University, the only surviving copy of the short catalogue of the exhibition.

enriched by successive acquisitions, is now housed in the Rijksprentenkabinet in Amsterdam; other sheets were sold by Houbraken to the English artist Arthur Pond, whom Mariette mentions in his *Abecedario*. Pond, who certainly had other precious Rembrandt prints in his collection, decided to get rid of them anonymously in a sale held at Langford's in London in 1748, realizing a total of £195.12s. A *Hundred Guilder Print* on Japan paper, later recognized as one of the eight first state prints in existence, was sold for £3.13.6; the rest, in the usual parcels, for prices ranging from a few pence to a few shillings per print. All the etchings were purchased by Sir Edward Astley, who disposed of his collection at the same saleroom in 1760, scarcely more than a year after the death of Pond. This time there was more publicity: the catalogue gives the name Astley in smaller type over that of the 'lately deceased' collector Pond (see above, p. 208). Here are two prices which were considerable sums for those days: *Jacob Thomasz. Haaringh* and *Jacob Jacobsz. Haaringh*, together, £10.15; *The Goldweigher's Field*, £18.18. These are almost as high as the best prices at the Mariette sale.

Over about fifty years, spending wisely the money accumulated by his father, John Barnard (d. 1784) succeeded in forming a collection which was perhaps better than any other in England. 'One of the best judges in his country as far as art was concerned. The sheets which came from his collection are always of the best, in quality and condition. John Barnard's mark is the most revered of all English collectors' marks' (Lugt). After the death of this eccentric collector (he had disinherited his ward, the sculptor Joseph Nollekens, simply because the latter had not admired his drawings by Italian masters), his collection was sold at Greenwood's, the sale beginning on 16 April 1798 and lasting four weeks.

 Let us briefly follow the very rare catalogue from that sale. It is exceedingly concise, but gives very clear information based on Barnard's own notes. Dürer's *Adam and Eve*, superb, fetched £17.17, perhaps the highest price paid in the eighteenth century for an engraving by this artist. The small print *The Musicians* by Lucas van Leyden made £14, and a group of the best Raimondi works an average price of just over £7 each; Van Dyck's complete *Iconography* (over 200 prints, including the 17 etchings engraved by the artist himself, all in the first state) went for £27.6, and a complete Della Bella with a few sheets by Callot for £34.6. Claude Lorrain was still not highly valued, but the Bohemian Wenzel Hollar was fairly sought-after in England and made good prices.

 One of the four weeks of the sale was devoted to Rembrandt – probably all the prints from the Pond and Astley collections, plus numerous other etchings added by Barnard. They were almost all experimental proofs printed on precious Oriental paper – 450 prints in different states grouped in 435 lots, some sold singly and some in batches. The short preliminary description which the 1798 catalogue gives is interesting and very unusual: 'To avoid the disgusting repetition of the quality of every print, it is sufficient to observe, once for all, that the impressions are wholly of the very first, and, with few exceptions, fine as possible; and their condition not less desirable.' Here are some of the more interesting prices for rare first state prints: *The Hundred Guilder Print*, £33.1.6; *Ephraim Bueno*, with black ring, one of three known impressions, £3.16; *The Three Crosses* (all the five states were up for sale), £2.12.6; the horizontal *Ecce Homo* (of which the later states were also represented), £4.11; *St Francis beneath a Tree, Praying*, £4.4. The highest prices were paid for *Lieven Willemsz. van Coppenol: Large Plate* (£57.15) and a landscape which I have been unable to identify (£19.8.6).[6] Many other sheets which were later to be sold for thousands of pounds went for between six shillings and two pounds each ('the prices seem mouth-wateringly cheap to the present-day lover of prints', commented Frits Lugt in 1920). And yet the total sum realized – for prints, drawings and books – was £5,030.9; for Rembrandt's etchings, according to my calculations, just under £1,000, equal to almost 25,000 French livres (see the table opposite).

Cornelis Ploos van Amstel (1726-98) was a man of many and varied activities. He was a big dealer who had grown rich by trading in timber, he practised engraving, was a friend of artists and, having become 'the connoisseur *par excellence* of his generation' (Lugt), he was also a discerning collector. In about 1765, he purchased an outstanding item which, four years earlier, had been bought at Delft by the expert Hendrick de Leth from the widow of the well-known collector Valerius Röver (seven Rembrandt paintings which he once

<div style="text-align: right">John Barnard</div>

<div style="text-align: right">Ploos van Amstel
Röver
Aylesford</div>

[6] Lugt calls it *Paysage au carrosse*; the John Barnard catalogue mentions *The Coach Landscape* (250-207) under the twentieth day of the sale. I have been unable to ascertain the name which is now given to the print, though I have consulted the Gersaint catalogue, which was in use then, as well as recently compiled comparative tables. Probably it is a print that is no longer attributed to Rembrandt.

214

Approximate currency equivalents: 1700-1913[1]

England[2]	Holland	France	Germany[3]	Switzerland	USA[4]	Italy
£1	12 guilders	25 livres After 1800, 25 francs	5-7 thalers 12 florins until 1870, then 20 marks	after 1850, 25 francs	after 1792, $5	25 lire theor. parity up to 1900

Holland	England	France	Germany	Switzerland	USA	Italy
1 guilder	£—.1.8	L 2 Fr 2	Fl 1 M 1.60	Sw Fr 2	$0.40	L 2

France	England	Holland	Germany	Switzerland	USA	Italy
1 livre 1 franc	£—.—.10	G 0.50	Fl 0.50 M 0.80	Sw Fr 1	$0.20	L 1

Germany	England	Holland	France	Switzerland	USA	Italy
1 florin 1.60 marks	£—.1.8	G 1	L 2 Fr 2	Sw Fr 2	$0.40	L 2

Switzerland	England	Holland	France	Germany	USA	Italy
1 Swiss franc	£—.—.10	G 0.50	L 1 Fr 1	Fl 0.50 M 0.80	$0.20	L 1

USA	England	Holland	France	Germany	Switzerland	Italy
$1	£—.4.—	G 2.50	L 5 Fr 5	Fl 2.50 M 4	Sw Fr 5	L 5

Italy	England	Holland	France	Germany	Switzerland	USA
1 lira	£—.—.10	G 0.50	L 1 Fr 1	Fl 0.50 M 0.50	Sw Fr 1	$0.20

[1] For ease in calculation, a discrepancy which may in some cases exceed five per cent has been allowed.

[2] Devaluation during the period of the Continental blockade has not been taken into account.

[3] The numerous thalers of the various German states were roughly equivalent to 1.75 florins; more rarely to 2.5 florins.

[4] The small devaluation of 1834 and the small revaluation of 1900 have not been taken into account.

This table of parities, prepared with the help of various manuals of metrology, was kindly revised by experts at the London School of Economics.

It will be seen that for two hundred years, particularly in the case of old English, French and Dutch currencies, there was constant intermonetary parity, only slightly affected by imbalances due to crises and wars. The long survival of these parities should of course be related to the pegging of the various currencies to the price of gold.

owned now form the most valuable treasures in the museum of Kassel in Germany). This consisted of seven volumes containing 456 sheets by Rembrandt; it had cost Leth 1,500 guilders and Röver, at the beginning of the century, perhaps 500.

As he had left no instructions in his will, the valuable collections of Ploos van Amstel were put up for auction at Amsterdam in 1800: the total amount realized was 75,650 guilders and 18 stuiver for the drawings, 21,380 guilders for all the prints, except those by Rembrandt (which were withdrawn, because the bidding was too low, and reserved for a later sale in 1810). Here are a few prices: the complete graphic works of Lucas van Leyden, 351 guilders; a large quantity, perhaps 200, of very fine line engravings and woodcuts by Dürer, 752 guilders; *The Massacre of the Innocents*, one of the many engravings by Raimondi in the sale, 49.10 guilders. Quite high prices were paid for reproductions, but ridiculously low ones for original masterpieces by great artists. The failure of the sale should perhaps be seen partly in the light of the political situation in Holland at the time. The Rembrandt collection, rich in exceptionally fine and rare proofs, to which had been added other sheets which were meticulously catalogued by Christian Josi, did not find a purchaser until 1810. It was then sold, through Josi, to the English collector Heneage Finch (1786-1859), fifth Earl of Aylesford, who was a descendant of the engraver and patron of Piranesi. The Aylesford collection, which was apparently enlarged by the addition of some of Zoomer's sheets,

acquired through the dealer Woodburn, must for several years have been the richest and most select collection of Rembrandt etchings ever owned by a private individual, with the sole exception of John Barnard.[7]

We have already met Jan Pietersz. Zoomer, a contemporary of Rembrandt's son, Titus. He had become the largest art dealer in Amsterdam and had a vast clientele among the most high-ranking people in Europe. Prince Eugene of Savoy, a very enthusiastic collector, used to frequent his shop while he was Governor of the Low Countries, and it is therefore quite likely that many of his most valuable sheets (which are today preserved in Dresden) came from Zoomer. From 1690 to 1715 Zoomer was present, in his capacity of official expert, at all the major sales held in his country and, since he was a collector himself, he certainly did not lose the opportunity of forming his own collection of prints and drawings of his favourite artists; among these of course was Rembrandt. When his last daughter died, and he was ill and alone, Zoomer decided to sell his prints. In 1720, in London, he sold to Antonio Maria Zanetti (1680-1757) his three large volumes containing 428 Rembrandt etchings. A note written by him on the first volume stated that these were the complete works in outstanding impressions in the various states, of a beauty never before seen. This major collection, together with many other superb sheets by Callot, Lucas van Leyden, Raimondi and other engravers, remained as a hidden treasure in Venice for over seventy years. Eventually, in

Zoomer
Zanetti
Vivant-Denon
Woodburn

Above left:
Lucas van Leyden, *Portrait of the Emperor Maximilian*, c.1518. Pen and brush drawing

Above:
Lucas van Leyden, *Portrait of the Emperor Maximilian*, 1520. Engraving

[7] In 1959 I examined the short handwritten inventory of the Earl of Aylesford's collection: there were often several sheets of the same print, however rare its quality, state and paper.

Israhel van Meckenem, *The Artist with his Wife Ida*, *c.*1485-90. The first self-portrait in the history of graphic art

1791, a grandson of the engraver, who was rich but not interested in prints, sold it to Dominique Vivant-Denon, collector, engraver and art scholar: the widely-held belief that the work left Venice during the Napoleonic occupation is therefore without foundation. Vivant-Denon, who was later ennobled by Napoleon, became director of the Beaux Arts in 1803, at a time when so many masterpieces from all over Europe were flowing into the Louvre. When the collector died, his heir, General Brunet-Denon, sold the precious collection in 1826-7; among the paintings were masterpieces by Murillo, Fra Angelico and Watteau, and there were also very many drawings and prints. The total proceeds from the sale were so low, 250,000 francs, that Brunet-Denon bought back a third of the collection, including the Rembrandts. The Callot collection (now at the Bibliothèque Nationale in Paris), comprising 1,574 etchings in three volumes, fetched 1,000 francs – Zanetti had bought it a hundred years earlier, in 1721, probably from the Mariettes, for the sum of 1,950 livres (in other words, twice as much) and had written of it, 'it is said, although I cannot confirm it, that Callot had formed the collection himself... and that even the King of France or Prince Eugene did not own such a fine collection'. The work of Lucas van Leyden, which had belonged to Zoomer and Zanetti, was however withdrawn at 3,500 francs and sold in 1843 for 5,000 francs. The outstanding Rembrandt collection was sold in 1829 to the important English dealer Samuel Woodburn for only 40,000 francs.

We can therefore now hazard a guess that in 1829 at least two thirds of Rembrandt's graphic work in the finest and rarest impressions was in England,

especially after the sale in 1829 of the collection of the Dutch expert Christian Josi. The rest was in public collections in Amsterdam, Dresden and Paris, and, of course, in a few private collections as well. Over the next fifty years or so, European collectors were making purchases in London and the English were buying on the Continent, but the balance was to remain the same almost until the end of the century.

Let us begin with what was then a modern engraving: *The Last Supper*, after Leonardo, by Raffaello Morghen (1758-1833) fetched £37.16 at the 1824 sale of the collection of Sir Mark Masterman Sykes. Prices at the sale were very high; the *niello* engraving *La Pace*, attributed to Maso Finiguerra, was bought by Woodburn for £315 (surely the highest price paid for a print up to 1860), and other *niello* engravings went at £50 each or more. A complete set of *Tarocchi*, perhaps those attributed to Mantegna, though it was never established whether they were originals or copies, fetched £78.15, and the well-known and rare *Half-length Portrait of a Woman* attributed to Leonardo, £64. Old prints, especially by

Early prints I

218

PETRVS ARRETINVS ACERRIMVS VIRTVTVM AC VITIORVM
DEMOSTRATOR
NON MANVS ARTIFICIS MAGE DIGNVM OS PINGERE NON OS
HOC PINGI POTERAT NOBILIORE MANV
PELLÆVS IVVENIS SI VIVERET HAC VOLO DESTRA
PINGIER HOC TANTVM DICERET ORE CANI

Italian copyist engravers, made very high prices, single sheets by Raimondi reaching £50. English mezzotints were also in steady demand. At the sale of the Thomas Wilson collection in 1830, however, the two highest prices were paid for the rare *Raising of Lazarus* by Veit Stoss (active 1477-1533), formerly in the famous collection of Count Moriz von Fries, at £34.13, and for the *Lion Hunt* by the monogrammist P.P., also at £34.13. The following low prices were recorded at the sale of the collection belonging to the writer William Young Ottley, 1837: *Portrait of the Emperor Maximilian* by Lucas van Leyden, £3.7; three landscapes by Hercules Seghers, £4.4; an unfinished proof of Dürer's *Adam and Eve*, only four impressions of which are known, £3.6; *The Penance of St John Chrysostom* by Cranach, £5.10; and the *Small Passion*, 12 engravings by Schongauer, £8.15.

The sale held in London at Phillips' in 1834 must have caused a sensation. The auctioneers published three large catalogues with the title *Ancient and modern prints – the property of a nobleman of high rank*. There was no collector's mark on the prints (therefore they are not mentioned by Lugt) and only later was it discovered that this was the large collection formed by the Duke of Buckingham. The sale,

which lasted from May to July, comprised 4,058 lots covering several tens of thousands of prints divided into three groups: 'Rubens, Van Dyck, Raffaello Morghen, etc.'; 'Hollar, Rembrandt, German School, etc.'; 'German primitives, Italian School, Marcantonio Raimondi, etc.'. The prints were sometimes of uneven quality but there were also many impressions which were outstanding both in quality and rarity. The prices were still low, absurdly so for Dürer and for the Italian primitives: *The Battle of the Nudes* by Pollaiuolo fetched £13; the *Virgin and Child* and *The Risen Christ between St Andrew and St Longinus*, two sheets by Mantegna, together, £2.15; six engravings by the Master of the Prophets and Sibyls, in the first state, £1.15; *Adam and Eve* by Dürer, £11, and other line engravings by him, a few shillings (by Rembrandt there was the first state of *Rembrandt drawing at a Window*, £35.12). There were some very good prints by Schongauer sold for between 3 shillings and 4 pounds; the most rare and precious engraving by Israhel van Meckenem, *The Artist with his Wife Ida*, £2.8; and 17 letters of the alphabet by the Master E.S., sold for between £2.5 and £4.6. The total proceeds from the sale were £6,710.1.6.

Another important sale, though the prices were not high, was that of the collection owned by the banker William Esdaile, a collector to whom I shall refer further on. Here are some prices fetched at Christie's in June 1840: complete Canaletto, 31 etchings, £5.5; *Adam and Eve* by Raimondi, £10.10; *Hercules and Antaeus*, school of Mantegna, £4. A very fine impression of Dürer's *Adam and Eve* made £7.7, and one of *St Eustace*, £9.5. Better priced, at least in comparison with the more important names, was Jacob van Ruisdael, whose etching *The Travellers* fetched £22.1.

Similar sums were realized at the sales of the collections of John Heawood Hawkins (London, 1850) and of Prince Karl von Paar (London, 1854). It is worth looking at sales of prints owned by the French art historian Alexandre-Pierre-François Robert-Dumesnil, author of the famous *Peintre-graveur français*. He was a very odd collector who bought prints in order to study them and then resold them (often losing money in the process) between 1836 and 1838 in London, and subsequently in Paris. Among the sales of his prints which took place in England it is worth recalling *David playing the Harp before Saul* and *Ecce Homo* by Lucas van Leyden for £4 and £6.16; Dürer's best line engravings, between £5 and £6; at least 46 line engravings, again by Dürer, probably not quite so fine, sold together for £76.15.6; a proof of Raimondi's *Climbers*, £36.11. In Paris, in 1843, 52 etchings by Claude Lorrain, some of them duplicated, almost all in the first state, fetched 5,132 francs; this represents an increase over prices recorded half a century earlier, yet the amount is still small, even though a few individual items did reach 400 and 500 francs; 3 line engravings by Jean Duvet (1485-c.1561), today so much in demand, were sold for 50 francs each.

Ambassador for many years to the Russia of the Czars and later a minister, Baron Jan Gijsbert Verstolk van Soelen (1776-1845) is one of the personalities of the art world who must not be overlooked. His gallery of paintings, drawings and prints by Dutch old masters was judged to be unique in Holland at the time. He stipulated in his will that his heirs were to leave it to his native city of Rotterdam; but Rotterdam rejected the offer, thereby provoking indignation, not only in Holland. Van Soelen was a discerning and ambitious collector who had managed to secure for himself at the great European sales (including those of the collections of the Duke of Buckingham, T. Wilson and Robert-Dumesnil) the best available prints, often regardless of expense (see p. 72). So in Amsterdam in 1824, at the virtually compulsory sale of the famous art collection formed by the

Verstolk van Soelen

Above:
Title page of the catalogue of the sale of the famous collection of prints belonging to Dr Luigi Angiolini of Milan. Stuttgart 1895

Above right:
Title page of the catalogue of the sale of duplicates of valuable prints from the Hermitage in Leningrad and from other Soviet public collections. Leipzig 1930

Viennese Count Moriz von Fries, the baron acquired for 2,000 guilders the volumes containing all of Dürer's line engravings and woodcuts, which we know from the Mariette sale: they had originally belonged, as I have already said, to Abraham Ortelius who had bequeathed them to his grandson, the architect Jacques Collius; they had also been in the collection of Burgomaster Jan Six, as stated in a note written by Mariette. At the same sale the baron also purchased several volumes containing one of the finest Rembrandt collections that a private individual had ever managed to put together on the continent of Europe.

When the time came for Verstolk van Soelen's works of art to be sold, the family put the task into the hands of the Amsterdam firm Vries, Brondgeest and Roos; the drawings were sold in March 1847, the prints in June and October of the same year. The sale of drawings was considered satisfactory, but not that of the prints, a few of which were withdrawn and then sold in 1851. The total amount realized by the prints at both sales was 171,000 guilders; the drawings made 80,500. An outstanding lot of Adriaen van Ostade's work was purchased by a certain Guichardot for 2,100 guilders (the same purchaser resold it in 1875, without the duplicates, for 57,000 francs – equivalent to 28,000 guilders). The superb collection of Dürer's woodcuts, which had belonged to Ortelius, and which Count Moriz von Fries had gathered in two volumes, was bought by Colnaghi's of London for 760 guilders. The line engravings from the same provenance were sold loose (some of them bought by the Rijksprentenkabinet of Amsterdam): *Adam and Eve* fetched 200 guilders, *The Nativity*, 100 guilders, the drypoint *St Jerome by a Pollard Willow*, 450 guilders. There were good prices for Raimondi and his school, and rather high prices for modern Italians, like Giovanni Volpato, Raffaello Morghen and others. But the prices of the Rembrandts

were catastrophic: he was represented by at least 815 etchings in various states and with duplicates, and these fetched 55,000 guilders – under £4,300. *Arnold Tholinx* in the first state, which de Claussin had seen escape him at a high price, fetched only 1,800 guilders; *Ephraim Bueno* with black ring, 1,650; the *Hundred Guilder Print* and horizontal *Ecce Homo*, both in the first state, on Japan paper, 1,600 and 950 guilders; other etchings made only a few dozen guilders, among them six different proofs of *The Three Crosses*. It is not at all surprising therefore that many of the most precious Rembrandts came back to England again in 1847. Unfortunately, the brief notes I have given here can give the reader no more than a vague idea of the treasures described in those thick catalogues, which I was recently able to inspect at the Cabinet Rothschild in Paris and the Rijksprentenkabinet in Amsterdam, and again in June 1971 at the British Museum, whose catalogues contain interesting notes, at times not very flattering, on some of the best known sheets.

Let us now take a quick look at the changes in values of old master prints in the brief but eventful period 1870-85. In April 1870 experts and collectors gathered at Prestel's saleroom in Frankfurt, where the collection formed at the end of the eighteenth century by the Viennese Johann Melchior von Birckenstock was to be sold. The great sensation was Marcantonio Raimondi's work, for which the major collectors and the great museums were contending. Incredible prices were realized: *Bacchanal, Offering to Priapus* fetched 7,100 florins; *The Climbers*, 4,401; *Pietro Aretino*, 5,430, and so on; making a total of 122,000 florins for Raimondi alone. By contrast, *The Descent into Hell* and the *Virgin in a Grotto*, then attributed to Mantegna, made 490 and 900 florins. Five years later, when the Friedrich Kalle collection was sold at the same saleroom in Frankfurt, interest seemed to have shifted to Martin Schongauer. A superb impression of the *Death of the Virgin* made 8,000 marks, or about 5,000 guilders.

In the same year the collection belonging to the art critic Emil Galichon was disposed of. The complete set of the so-called *Tarocchi* of Mantegna, 50 engravings, was auctioned for 17,000 francs; several Raimondi works went for between 3,000 and 7,000, while other very fine Italian prints by Mantegna and his school, by Giulio Campagnola, and by Mocetto, fetched 2,000 and 6,000 francs. Lucas van Leyden seems at last to have been accorded rather more favour: 3,900 francs was bid for the *Round Passion* of nine engravings; *The Return of the Prodigal Son* went for 3,500 and *The Dance of the Magdalen* for 8,500. Dürer on the other hand was still making fairly low prices: the best line engravings were sold for between 2,000 and 3,000 francs. Still in Paris, the fine collection belonging to Ambroise Firmin-Didot, son of Piranesi's famous publisher, was sold in 1877. Among the highest prices this time was that for the rare drypoint by Dürer, *St Jerome by a Pollard Willow*, which made 4,500 francs; but four Schongauers were sold for an average of 2,000 each; the woodcut *Crucifixion* by Hans Baldung Grien, for 1,030 francs; another *Crucifixion* by the Master LCz, very rare, for 1,605; the important chiaroscuro woodcut by Burgkmair, *The Emperor Maximilian on Horseback*, for only 1,025. At Frankfurt in 1880 the highest price in the sale of the fine collection of the industrialist Carl Schlösser was paid for a proof before letters of *The Last Supper* by Raffaello Morghen, 6,220 marks.

Marquis Jacopo Durazzo, an Austrian citizen, had been friend and secretary to Duke Albert of Sachsen-Teschen, to whom the Albertina of Vienna owes so much. Durazzo, who was ambassador at Venice while Sachsen-Teschen was Governor of the Low Countries, collected prints in Italy for the Duke, and he

obviously took the opportunity to form a collection of his own. This later passed to the Italian branch of his family at Genoa, and was sold on behalf of his heirs at Stuttgart at the Gutekunst saleroom. It was a very large collection, so the sale had to take place in two instalments: the first, lasting several weeks, from 19 November 1872, with a catalogue of 4,990 items; the second, from 20 May of the following year, with a catalogue of 2,220 items. Altogether there were over 50,000 sheets. It goes without saying that all the big collectors in Europe were present at the sale. Here are some prices, taken from the catalogues which once belonged to Baron Rothschild: Canaletto's *Vedute*, complete album of 31 etchings (at that time the states did not matter, since the work was so little appreciated), described as superb and with untrimmed margins, 60.30 florins; the seven *Vices* and the seven *Virtues* by Bruegel, 17 florins; *The Battle of the Nudes* by Pollaiuolo, 155 florins; *Hercules and Antaeus* by the school of Mantegna, attributed in the catalogue to Pollaiuolo, 60 florins; *Christ and the Woman of Samaria* by Giulio Campagnola, 750 florins; one of the Otto prints, here attributed to Baccio Baldini, 1,901 florins. By Dürer, *The Triumphal Arch of the Emperor Maximilian*,[8] the complete set of 92 sheets, in the first edition of 1517-18, which had formerly been in the collection of Dr Christoff Pirkheimer, a direct descendant of the artist's friend Willibald, made 730 florins; the *Apocalypse* in 16 sheets with full margins, in a portfolio, 296 florins; *St Jerome in the Wilderness*, superb, 2,813 florins. The rare engraving of the *Virgin and Child* by Girolamo Mocetto (*c*.1458-*c*.1531) fetched 3,800 florins; the 50 '*Tarocchi* of Mantegna', in the first version, 1,880 florins, in the second, 900. By Israhel van Meckenem, *The Artist with his Wife Ida*, 680 florins; *The Dance of Herodias*, 800 florins. The letters P, X, I, S, A, D, Y, S by the Master E.S., between 200 and 485 florins each. The many *niello* engravings were almost all bought, at fairly high prices, by Auguste Danlos for the Rothschild collection. Relegated to the supplement to the second catalogue were 215 sheets by Giovanni Battista and Giovanni Domenico Tiepolo, untrimmed, fetching altogether only 50.30 florins.

At the same saleroom in 1895 another collection was auctioned, that of Luigi Angiolini, the only truly great Italian collector of the time.[9] Born in Milan in 1810, he graduated in humanities at Pavia and, thanks to a large fortune left to him by a maternal uncle, was able to dedicate himself to his passion: collecting prints. During journeys over a period of about forty years, which took him all over Europe, he gathered together a really outstanding collection. The catalogue of the sale which his heirs arranged a year after his death includes 3,973 lots comprising at least 20,000 prints – some common ones, but others outstanding, as is proved by the names of the purchasers placed beside the individual lots. Having had the good fortune to discover a catalogue with all the prices marked up, after several years of fruitless searching, I am able to mention also some names then neglected and today held in high regard. Beginning with the more important sheets, 12 line engravings by the Master E.S., of which *The Holy Child under a canopy with angels* and the *Armed Knight with lady and flag* were bought by Danlos for Rothschild for 5,110 and 5,610 marks respectively; *The Bishop's Crosier* by Israhel van Meckenem, an outstanding impression, made 13,800 marks; *David*

[8] Volume VII in the Hollstein series, *Albrecht Dürer*, lists few examples of the first edition of 1517-18; that in the Angiolini collection is mentioned but not that of Durazzo. The size of the whole sheet is 3.41×2.92 m (11 feet 2 1/4 inches×9 feet 7 inches). Several artists including Albrecht Altdorfer participated in the execution of the work, which was conceived by Dürer. The wood was cut by Hieronymus Andreä. See also Meder, op. cit., pp. 205-23.

[9] The print collection of the sculptor Emilio Santarelli of Florence should also be mentioned, even though it is much less important. The collection was sold at Leipzig in 1871.

and Goliath and *The Planet Jupiter*, attributed to Baccio Baldini, fetched 8,800 and 6,500; the rare *Stag chained to a Tree* by Giulio Campagnola, 580; the large engraving *Hercules and the Giants* attributed to Pollaiuolo, much more rare than the well-known *Battle*, 115. By Dürer there was *The Triumphal Arch of Maximilian*, complete in 92 sheets, in the first edition, 3,015 marks, and the engraved *Small Passion*, 1,600 marks. The Dürers on the whole were not so good as those in the Durazzo collection, but the Rembrandts were rather better, and two of them were of first rate quality. Passing now to some of the prints which (incomprehensibly today) were considered unimportant, there was a complete Canaletto, not perfect, 20 marks (about £1). Giovanni Battista Tiepolo's *Adoration of the Magi* in the first state, the complete set of 23 superb etchings and title page of the *Scherzi di fantasia*, also in the first state, and the complete series of the *Capricci*, all outstanding sheets and with full margins, fetched respectively 12, 20 and 10.50 marks – in other words the whole lot made just over £2. In the supplement, the part of the catalogue reserved for unimportant engravings, under no. 3373 we find no less than 27 very fine etchings by Jacques Bellange, the lot selling for 6.50 marks, that is, 7 shillings. (Here a brief comment is needed. The print historian Robert-Dumesnil had carefully catalogued Bellange's work before 1850; Hind,

Edouard Vuillard, *La Cuisinière,* 1899

on the other hand, in the third edition of his classic *History of Engraving*, 1923, does not mention the artist even in the large index of printmakers; even Zigrosser left him out of the 1956 edition of *The Book of Fine Prints*. Today, good quality impressions by Bellange are hard to find and expensive.)

Modern prints I

There have been, and there always will be, enthusiasts who collect prints by contemporary artists; indeed there are far more of these collectors than of those interested in old engravings. There are only two reasons for my not having mentioned them so far: in some cases the artists in question were fashionable and sought-after in their own times but do not mean anything at all to us today (perhaps wrongly; it may be that some of them will eventually be reconsidered by art lovers and critics), or else they were names which today we consider important, but which collectors and critics in the past ignored, making it extremely difficult to trace them in catalogues. This is not surprising when we realize that it is only now, or in the past few years, that Goya and Blake, for example, have enjoyed success, or if we think of the centuries of oblivion which the great Venetian masters suffered, even though during their lifetime they had been quite highly regarded.

Edouard Manet, *The Races*, 1864

Among collectors of modern prints in the forty years before the First World War, there are a few names which should be mentioned. Jules Niel, librarian at the Ministry of the Interior in Paris, had been a great admirer of Charles Meryon; it is therefore natural that he possessed the complete works of the artist he rated so highly. On his death in 1873, the finest and most rare impressions by Meryon were sold for sums varying between 100 and 200 francs each – at least ten or probably twenty times the price at which Meryon had sold them seven or eight years earlier. Philippe Burty, a respected French art critic and also an intimate friend of Meryon, had formed a larger collection of prints by modern and contemporary artists which included etchings by Goya and almost all the English and French engravers who were active at that time. Here are some of the prices made at a sale he held in 1876 at Sotheby's: the first state of the *Abside de Notre-Dame* by Meryon, £17; *La Cardeuse* by Jean-François Millet (1814-75), £5; several etchings by Sir Francis Seymour Haden, between £3 and £17; finally the first edition of Goya's *Tauromaquia*, 33 plates, £5.15 (almost an improvement, if one considers that in 1845 the Marquesa de Guadalcazar y Souza, friend of the Duchess of Alba, had sold to Count Clement de Riz a volume containing the 80 plates of the *Caprichos* by Goya in its first edition, for 20 francs).[10] In Paris in 1897 the collection owned by the brothers Edmond and Jules de Goncourt was sold: *La Rue Transnonain, Le Ventre législatif* and *Enfoncé Lafayette* by Daumier were sold for respectively 235, 190 and 245 francs. Good prices were also paid for Alphonse Legros (1837-1911) and Seymour Haden, whose etching *Sunset in Ireland* made 255 francs; rather less for the Swede Anders Zorn (1860-1920), Millet and other contemporary French engravers. These however are all fairly low prices. In a little over ten years the situation changed spectacularly.

Opposite:
Jean-François Millet, *La Grande Bergère*, 1862

[10] The same impression was sold at Christie's, 24 March 1970, for £4,410 ($10,604).

In the Jules Gerbeau sale in Paris in 1908 the finest Meryons were bought for between 2,000 and 5,700 francs; *Rosita Mauri* by Anders Zorn made 1,250; Whistler fetched from 1,000 to 4,200 francs for the first state of *Nocturne Palaces* of the second Venice Set; *La Grande Bergère* by Millet made 750 francs. Much in demand were decorative colour prints, French and English: *Les Deux Baisers* and *L'Oiseau ranimé* by P. L. Debucourt made 4,950 and 8,100 francs. In London in 1910, at the sale of the first, modern, part of the H. S. Theobald collection, some splendid Meryons came up: the unfinished *Stryge* made £280 and the first state of the *Abside de Notre-Dame* £640; *Paysage d'Italie* by Camille Corot, in the first state, £24; *River in Ireland* by Haden, £94.10.

But, before the First World War broke out, attention was focused on modern prints, especially French, at the sale in Paris (26 April to 2 May 1914) of the large collection belonging to the famous art critic Roger-Marx (1859-1913), director, as Vivant-Denon had been, of the Beaux Arts. With the help of the catalogue, from which many prices are unfortunately missing, the information given by Lugt can be supplemented: there were almost 200 lithographs by Toulouse-Lautrec, among them *La Grande Loge*, 2,300 francs and *Elsa the Viennese*, 1,000 francs; the rare first state of Manet's lithograph *The Races*, 1,100, and his even more rare *Self-portrait*, 2,550. The drypoint *Portrait of Victor Hugo* by Auguste Rodin (1840-1927) made 3,000 francs (at the Goncourt sale in 1897, the same subject and state had made only 240). Goya's *Tauromaquia*, first edition, made 2,550 francs; *At the Louvre* by Degas, 2,800, and several etchings by Zorn between 1,000 and 2,000. Almost at these price levels, or just under, were engravings by artists today considered to be of minor importance, like Félix Buhot (1847-98), Félix Bracquemond (1833-1914), Théophile Alexandre Steinlen (1859-1923), Legros, Seymour Haden and others. Eugène Delacroix (1793-1863) had been in demand for some time. His very rare lithographs *Lion from the Atlas Mountains* and *Royal Tiger*, which at the His de la Salle sale in 1881 had together realized 41 francs, both in the very rare first state, now went for over 1,000 francs each in the third state. In Germany Max Klinger (1857-1920) fetched much more.

Let us now examine a very important catalogue, that of the English lawyer Henry Studdy Theobald who, on becoming blind, sold all his prints – the modern ones, as we have seen, in London, the old ones in the same year (1910) at the Gutekunst salerooms in Stuttgart. Almost sensational results were achieved: Lucas van Leyden, Claude Lorrain, Adriaen van Ostade, the Italian engravers, Canaletto, and above all Dürer were being fully appreciated for the first time. Schongauer's *Virgin in a Courtyard* made 6,100 marks. Dürer's *Madonna with a Monkey*, of which a finer impression may never have been seen since, 16,800 marks; *The Nativity*, 14,200; *St Jerome in his Study*, 5,850; the engraved *Small Passion* series, 3,250; the 20 woodcuts before letters of the *Life of the Virgin*, 6,600. Many of Dürer's best engravings had come from the August Sträter sale in Stuttgart in 1898, where the collector had bought them for as little as a fifth or a sixth of the price they were to make twelve years later. The first states of the *Iconography* etched by Van Dyck: *Self-portrait*, *Frans Snyders* and *Lucas Vorsterman*, made 6,100, 4,850 and 3,750 marks; the second state of Claude Lorrain's *Bouvier*, 3,350. *The Holy Family*, *Mohammed and the Monk* and the *Portrait of the Emperor Maximilian* by Lucas van Leyden fetched respectively 4,550, 4,800 and 6,400 marks. A fine impression of *The Risen Christ between St Andrew and St Longinus* by Mantegna, 2,400; *St Sebastian bound to a Tree* by Jacopo de' Barbari, 1,060. A complete Canaletto with the large etchings in the first state, 4,400 (many decades were to pass before this price was bettered). Raimondi, who by this time had

Above:
Eugène Delacroix, *Royal Tiger*, 1829

Below:
Eugène Delacroix, *Lion from the Atlas Mountains*, 1829

clearly lost ground, aroused little interest. The second state of *Rembrandt drawing at a Window* fetched 32,000 marks and *Jacob Thomasz. Haaringh*, also in the second state, 44,000.

We left Samuel Woodburn in 1827 returning to London with the albums containing the precious Rembrandt sheets which for so many years had remained in the Zanetti family in Venice. Apparently the Earl of Aylesford had first choice from the collection, but after that, things become a little confused. In 1846 Aylesford sold part of his collection to Woodburn for £3,000; Woodburn in his turn sold seventeen of the most valuable Rembrandts to Sir Robert Stayner Holford for £3,500; others passed to John Heawood Hawkins and then to Walter Francis, fifth Duke of Buccleugh; an option was offered to the British Museum, and several other people certainly obtained prints from the great dealer's inexhaustible supplies before he died in 1853. At the Buccleugh sale, held at Christie's in April 1887, the 368 Rembrandts made a total of £10,000, an amount which was then considered a record. Among the most important prices were: a *Hundred Guilder Print* in the first state on Japan, previously in the Six-Barnard-Aylesford collections, £1,300 (purchaser the Berlin print room); a horizontal *Ecce Homo*, first state on Japan, £1,150; *The Three Crosses* in the same state, £290 (the Zoomer-Zanetti-Denon-Hawkins copy), in the fourth state, only £39; the second state of *Lieven Willemsz. van Coppenol: Large Plate* (Rothschild), £190; *La Petite Tombe* (with effects of burr), £31; *St Francis beneath a Tree, Praying*, first state, £110; *The Agony in the Garden*, said to show burr, £16. The Holford sale at Christie's in 1893, the catalogue of which I have in front of me, included just over 150 etchings by Rembrandt, also almost all of outstanding quality and all of them with illustrious pedigrees. Baron Rothschild, through the expert Danlos, bought about ten of them, among them the two first states on Japan of the horizontal *Ecce Homo* and of the *Hundred Guilder Print* for £1,250 and £1,750; *Rembrandt leaning on a Sabre*, £2,000; *Ephraim Bueno*, with black ring, £1,950 (this was the third and last of the known impressions, as the *Hundred Guilder Print* was the last of eight). Among other sheets worth mentioning were *The Three Crosses* in the first state, also on Japan, and in the fourth, purchased with other fine proofs, for £200 and £19 respectively, by the Berlin banker Valentin Weisbach. *La Petite Tombe*, also on Japan, £31; *Three Gabled Cottages beside a Road*, in first, second and third states, respectively £275, £100 and £40. *Six's Bridge* in the second state, £24, *The Triumph of Mordecai*, £22. Among the other prints (this is 1895), the line engravings by Raimondi were still making about two or three times the price of the Dürers: *The Phrygian Plague* £370, as against a marvellous *Knight, Death and the Devil*, £145 and *St George on Horseback* by the Master I. A. M. of Zwolle, £265.

But the highest Rembrandt prices before war broke out were realized at the sale of Professor Alfred Hubert's collection, in Paris in 1909: a *Hundred Guilder Print*, on Japan but in the second state, formerly in the Verstolk van Soelen collection, fetched 61,500 francs, and the third state of the portrait of *Jan Six*, which at the Holford sale had cost the French collector £390, was knocked down to the American collector John Pierpont Morgan for 71,000 francs (with commission, about £3,200).

The last great private collection of Rembrandt was sold at Christie's on 16 and 17 December 1924; after that we come across only small collections of any great value, or else bigger collections but with few pieces of real importance. The sale was a real sensation, 'the greatest event of this century' (Lugt); no one expected it, for no one remembered that a hundred years earlier Edward Rudge (1763-

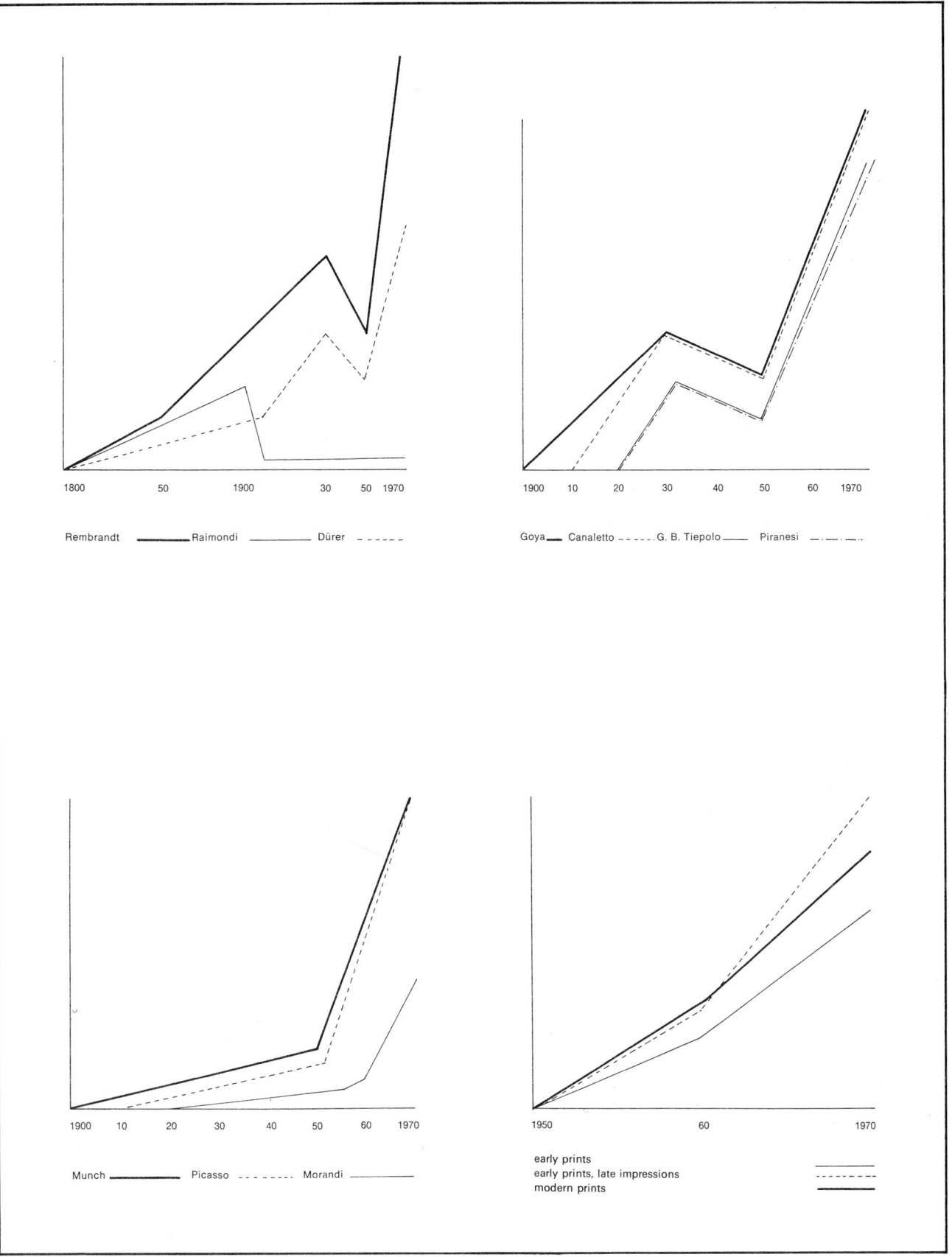

Rembrandt ━━━━━ Raimondi ───── Dürer - - - - -

Goya ━━ Canaletto - - - - - G. B. Tiepolo ─── Piranesi — · — · —

Munch ━━━━━ Picasso - - - - - - Morandi ────

early prints ────
early prints, late impressions - - - - -
modern prints ━━━━━

These graphs, which are related to examples given in the text, represent not changes in monetary values but trends in the market. The fourth graph, covering the period 1950-70, shows that prints by modern artists generally increase in price at a faster rate than old master prints, which had already benefited from previous increases in value; and also that late impressions of early prints, partly because their low prices have made them accessible to a larger number of people, have usually undergone a sharper rise in value.
During the 1970-71 season a certain levelling-off of prices was registered, and in the case of many of the more common impressions, which are less sought after, there was a reversal of the upward trend.

232

1846), famous archaeologist and botanist, had collected Rembrandt etchings, let alone that, according to the instructions contained in the will of the owner, the collection could be broken up only on the coming-of-age of a great grandson unborn in Rudge's day. The collection, valued at £500 when it had been deposited in a bank and at £7,000 by the experts who examined it in 1924, sold for £34,172.16s; this is very little by present-day standards, certainly less than would have to be paid today for any one of the ten most valuable etchings out of the 450 included in the 376 lots listed in the catalogue. The catalogue was drawn up in the laconic style of the day, by the young expert Osbert H. Barnard, and recorded some outstanding pedigrees: Sir Edward Astley, John Barnard, the Duke of Buckingham, etc. Among the most important landscapes was *The Goldweigher's Field*, which has not been seen for a number of years now with velvety burr, £1,732.10s (as no. 277 of the John Barnard catalogue of 1798 it was sold for 10s 6d); *Christ healing the Sick* in the second state made £1,135, the same price as for the first state of the horizontal *Ecce Homo*, but on Japan, while the fourth state of the same subject printed on Oriental paper made £420, exactly the same amount as the second state of *The Three Crosses*. Among the portraits, *Arnold Tholinx*, the fourth example known in the first state, was bought for £3,780; it was to go to Richard Zinser and then to the United States, to return to Europe and then to end up in an unidentified American private collection.

Modern prints II

In the inter-war period, from 1919 to 1940, the names of Pablo Picasso, Edvard Munch and of the German Expressionists ought to be met with frequently. But because of the American crisis of 1929, with its immediate repercussions in Europe, and the particular situation which had arisen in Germany, those years have to be considered as a kind of incubation period for the major contemporary printmakers active at the time – a long wait, which was to last until after the end of the war. So a sum of 200-300 Swiss francs paid for a Picasso, a little more for Munch, who was older, represents more or less a top price for their most sought-after prints: the growing fame of these artists only just counterbalanced the effects of the precarious economic situation. For this reason I shall have to restrict myself to giving a few prices for nineteenth-century artists and contemporary English printmakers who, especially in London, and despite the crisis, were to continue enjoying particular popularity.

In November 1918, the print collection from the atelier of Edgar Degas, who had died the year before, was sold in Paris. Here are a few prices (it should be remembered that the French franc was worth less than half of the pre-war franc): by Edouard Manet the lithographs *The Barricade* and *The Races*, both in the first state, 1,000 and 720 francs; the very rare *Ballon*, 4,100. By Degas himself, the etching *At the Louvre*, in the first state, 3,000; another impression of the same subject in the second state, 4,200. At the Nicolas-Auguste Hazard sale, December 1919, two sheets of *La Rue Transnonain* by Daumier made 2,556 and 2,400 francs; *Ernest Renan* by Anders Zorn, 5,500; and two sheets of *The Toast* by the same artist, in the third and fourth states, 12,500 and 13,300; by Millet, *La Grande Bergère* in the single state, 1,980. In 1921 and 1922 Marcel Guérin put several of his Toulouse-Lautrec prints and other engravings up for sale. *Elsa the Viennese* made 5,000 francs; the famous series *Elles* of ten colour lithographs, 3,340; *La Grande Loge*, 3,650; *Self-portrait* by Degas, 6,200; *La Rue Transnonain* by Daumier, 4,085; Goya's *Tauromaquia*, in the first edition, 6,200, and the four very rare lithographs of the *Toros de Burdeos*, 11,400.

In 1928, still in Paris, the art critic Loÿs Delteil's collection was broken up. By this time the franc was worth only a fifth of what it had been worth before the

Henri de Toulouse-Lautrec, *Réjane and Galipaux*, 1849

war, but it should be remembered that it was not the only currency which was losing its purchasing power. The four *Toros de Burdeos* lithographs by Goya fetched 57,000 francs, *Le Pont au Change* by Meryon, in the first state, 52,500 (this is an interesting comparison); the best etchings by Zorn between 20,000 and 60,000. Meanwhile in Zurich, in 1938, now that the worst of the crisis was over (although the economy was still at a standstill), the following prices recorded at the sale of the Emile Laffon collection are of interest: the famous complete set of 12 colour lithographs *Quelques aspects de la vie de Paris* by Bonnard, 480 Swiss francs; three of the best Millet etchings, between 400 and 600 each; the most sought-after subjects by Camille Pissarro (1830-1903), between 100 and 300; Odilon Redon, between 35 and 260. The Toulouse-Lautrec colour lithographs were most in demand: *La Clownesse assise*, 590 Swiss francs; *La Grande Loge*, 1,200; *Le Tonneau*, 785 and *Napoléon*, 335. The same year at Berne the famous collection owned by the German Heinrich Stinnes was sold: *The Bathers*, the large colour lithograph by Paul Cézanne (1839-1901), made 460 Swiss francs; one of the *Manao Tupapau* prints by Gauguin, 580; Munch's *Madonna*, 560; *Le Bain* by Picasso, a proof on Japan signed and dedicated to Guillaume Apollinaire, 900 (Lugt gives the prices in marks).

The English and American market in modern prints seemed to be extremely conservative, with the exception of a few nineteenth-century European works. Muirhead Bone and James McBey (1883-1953) were popular on both sides of the Atlantic. By the former, *Spanish Good Friday*, *A Rainy Night in Rome* and *Night in Ely Cathedral* often exceeded £200 and £300 in London and therefore $1,000 and even $1,500 in New York. By McBey *Dawn, a Camel Patrol setting out*, fetched £445 on 8 May 1928. Charles Meryon, whose *Eaux-fortes sur Paris* in the first state had become almost unobtainable, regularly made between £200 and £400 in good but ordinary impressions. Whistler seemed almost to go against the tide: £913.10s was paid for the second Venice Set of 24 etchings in June 1936 in London. The individual etchings in the Graves collection in New York still made high prices: *The Dyer*, $3,500, *Annie Haden*, $2,600, *The Two Doorways*, in the fourth state, $1,710, *Nocturne*, also from the second Venice Set, in the second and third states, $2,500 and $1,700. Virtually no prices are quoted for Paul Gauguin; a *Danseuse assise* (not further identified) by Henri Matisse (1869-1954) made $30 in New York on 22 June 1936; the same day Picasso's *Repas frugal* made $100: a year earlier *La Toilette de la mère* and *Salomé*, from the *Acrobats*, had made $35 and $55.

The real revelation however was William Blake, who, partly because he was discovered relatively recently, must be considered among the modern artists. Let us look at a few prices from the sale at Sotheby's in July 1924 and May 1936, limiting ourselves to works printed by the relief etching technique and then hand-coloured by the artist, each one being different from the other, and known in few impressions, from 4 or 5 up to a maximum of 10 or 12.
1924: *Europe, A Prophecy*, 17 prints, 12 sets known, £500; *America, A Prophecy*, 18 prints, 4 sets known, £215; *Vision of the Daughters of Albion*, 11 prints, 10 sets known, £385.
1936: *Songs of Innocence and Experience* (the two works together), 54 small prints, £1,050; another set, in March 1937, £1,400. There is no record however of *The Song of Los* being auctioned (8 prints, 4 sets known).

During the years we are considering, 1920-40, the market in early prints can be divided into two phases, the first of which (up to 1930) was marked by further very substantial price increases, the second by sharp drops and in some cases almost collapse.

<div style="text-align: right">Early prints IV</div>

Many of the most important sales took place in Germany. In fact the Germans had made large purchases during the prosperous period before the war, particularly in England; then, driven by circumstances, they frequently had to sell their collections. They usually did this through German firms of auctioneers, in particular C.G. Boerner, founded in Leipzig in 1826, and Puppel und Hollstein in Berlin. The most important sale in those years was that of the collection formed by Paul Davidsohn of Danzig, which included about 10,000 sheets, almost all of them valuable. The first three sales took place in Leipzig in May and November 1920 and April 1921. Given that in 1920 the dollar was worth 40 marks and in 1921 about 65, as against about 4 in 1913; I shall give the approximate equivalent dollar value in brackets, as a guide. In 1920 a superb impression of Dürer's *Adam and Eve*, which at the Sträter auction in 1898 had made 1,360 marks, now made 200,000 marks ($5,000); *The Witches*, the chiaroscuro woodcut by Hans Baldung Grien, 65,000 ($1,625); *The Risen Christ between St Andrew and St Longinus* by Mantegna, one of the finest impressions, 43,000 ($1,075). In 1921 Rembrandt's *Presentation in the Temple, in the dark manner* fetched 120,000 marks ($1,800), and *Three Gabled Cottages beside a Road*, probably in the second state, 130,000 ($2,000). I have given only a few prices from this very rich collection because they are not a very sure indication of value, since the mark was then near to collapse. But

Left:
Edvard Munch, *Girl in a Nightdress at the Window*, 1894

Below:
Edvard Munch, *The Sick Girl*, 1896

Opposite:
Edgar Degas, *Chanteuse de café-concert*, c. 1875

Paul Gauguin, *Manao Tupapau*
(Elle pense au revenant), c.1892

when in 1925 it was given back its old value and the entire German debt was annulled, it again became a strong currency. Thus at Boerner's in Leipzig, when the heirs of the collector Franz von Hagens sold up his famous collections in 1927, the prices were more real. Dürer's *Adam and Eve*, the sheet from the Ortelius collection which had made 200 guilders in the Verstolk van Soelen sale in 1851, now fetched 42,000 marks (at the new rate of exchange, exactly $10,000): to this must be added the increased commission of fifteen per cent which had been in operation since 1922. *The Knight, Death and the Devil*, a superb impression for which the collector had paid 1,310 marks at the Carl Schlösser sale in 1880, now fetched 15,000 marks. Rembrandt's *The Three Trees,* also outstanding, 28,000; *Jan Lutma*, in the first state, 34,000.

In Amsterdam, at the Six family sale of 1928, the portrait of their ancestor *Jan Six*, in the third state on Japan paper, made a price which was to remain unbeaten for thirty years: 90,000 guilders, equal to £8,200. Colnaghi's of London bought it, and a few hours later sold it to a collector looking for a good investment; he put it up for sale again in December 1935 at Christie's but took only £2,730.[11] In May 1929 in Berlin, at Puppel und Hollstein, *The Artist with his Wife Ida* by Israhel van Meckenem made 38,000 marks, being bought by Lessing Rosenwald of Chicago. Still at the same saleroom in Berlin, in 1930, while the effects of the American crisis were beginning to be felt in Europe, an impression of Dürer's *Erasmus of Rotterdam*, of unsurpassable quality, made 62,000 marks, and the 20 woodcuts of the *Life of the Virgin*, all before the printing of the text, in Meder's true experimental proofs, were bought for 130,000 marks by the Boston Museum of Fine Arts.

It is well known what economic difficulties the Soviet Union was passing through in the twenties; the government tried to remedy the situation by every

[11] See *Print Prices Current*, vol. XVIII (1935-6), p. 219. Innes Collection.

Lyonel Feininger, *Lüneburg*, 1924

means possible, including the selling of works of art. Thus various masterpieces by artists such as Raphael *(The Alba Madonna)*, Botticelli *(The Adoration of the Magi)*, Rubens and several Rembrandts, of which the Hermitage in Leningrad had many examples, all passed through three important art galleries (Colnaghi's of London, Matthiesen's of Berlin and Knoedler's of New York) to European and above all American public collections – in particular to the National Gallery of Art in Washington whose founder, the financier Andrew Mellon, made an exceptionally large contribution to the purchase of these works from the Soviet Union. The prints, however, were sold by C.G. Boerner at Leipzig in three sales, between May and November 1930. By Dürer, the finest known impression of *St Jerome in his Study*, which in 1805 at the Kreuchauf auction had cost three *thalers* (about 6 florins), now fetched 27,200 marks; by Rembrandt, *The Presentation in the Temple, in the dark manner* made 27,000 and a sheet of *The Three Crosses* in the fourth state, 14,500. *Nude in a Landscape* by Giulio Campagnola sold for 5,000; the *Virgin and Child* and *The Risen Christ between St Andrew and St Longinus,* by Mantegna, both outstanding impressions, respectively 2,100 and 1,650 marks. From the sale of eighteenth-century colour prints, which at the time were eagerly sought by certain collectors, I shall quote only *La Rosa* and *La Main* by Debucourt, which together cost 36,000 marks, an amount lower than the highest prices made a few years before.

I can do no more than briefly mention the very many sales which took place in this period. Leipzig, May 1932, same saleroom: sale of the famous collection owned by Count Ludwig Yorck von Wartenburg (foreword to the catalogue by Max Lehrs): Schongauer, *Christ appearing to Mary Magdalene*, 13,500 marks and the *Passion*, 12 small engravings, 10,000; the Master E.S., *The Nativity*, 12,500; Altdorfer, *The Beautiful Virgin of Ratisbon*, colour woodcut, 6,000; Dürer, *The Knight, Death and the Devil*, 21,000. The last engraving, as Campbell Dodgson of the British Museum wrote, was the best example known,

no museum being able to boast of a similar one.[12] Leipzig, May 1933: sale of sheets from the old collection of Frederick Augustus II, King of Saxony, and of the more rare sheets from the collection of Captain Edward George Spencer-Churchill, descendant of Sir John Rushout (see p. 142). I shall refer only to those prints which I have not mentioned in the first part: Pollaiuolo, *Battle of the Nudes,* superb, 6,200 marks; Schongauer, *Standing Virgin and Child,* 14,000; Rembrandt, *The Three Trees,* 11,500. The very rare engraving by the German primitive, the Master of the Crayfish (identified with Frans Crabbe), *The Adoration of the Shepherds* was offered at 900 marks; it remained unsold, with many others, and was later bought in 1965 by an American museum for 24,200 marks.[13]

At this point, before referring briefly to English and American sales, I should like to record a comment on the period 1930-40, made by one of the greatest connoisseurs of early graphic art, who has taken an active part at all the great sales held in the past fifty years in Europe: 'The ten, twenty, thirty thousand marks sometimes paid for single prints, almost a fortune in those difficult

[12] *The Print Collector's Quarterly,* vol. XIX, no. 3 (July 1932), p. 185: 'The finest impression in existence', Campbell Dodgson.
[13] Information kindly supplied by Dr Eduard Trautscholdt. Catalogue of C.G. Boerner of Düsseldorf, 1965, no. 15 (41).

Edvard Munch, *Moonlight*, 1896

241

times, were given for impressions of a quality which has perhaps never been seen again since. Today, if offered on the market, they would probably make prices ten times higher.' These words referred in particular to Dürer, the German primitives, Rembrandt, and in a general way to all early engravings of first rate quality. They are proved by the example given just now of the engraving by the Master of the Crayfish.

Sales at the Hôtel Drouot in Paris can be held only when there is a required minimum number of participants. An elderly French expert once told me that at some sales during that period, when a customer was absolutely determined to buy, he had to beg a passer-by to put in an appearance at the saleroom so that the auction could begin. It is easy to imagine the bargains which were offered, enabling collectors to procure impressions which not many people would be in a position to buy today.

In 1935, at Sotheby's in London, the large but not outstanding collection of Rembrandts belonging to A. J. Godby was sold. Some of them were to finish up in the Downe collection, which I shall mention later on; the highest price was paid for the *View of Amsterdam*, described as superb, £170; there was also the fifth state, bearing the address of Carelse, of *The Three Crosses*, £122 (it was to reappear in 1968 in New York); another impression from a different collection, in the fourth state, offered in the same saleroom, fetched £220, and the fourth state of the horizontal *Ecce Homo*, £310. Decidedly better results were recorded at the sale of the Leonard Gow collection at Christie's in 1937: Rembrandt's *The Three Crosses*, in the first state on vellum, fetched £2,100; *Landscape with a Square Tower*, in the fourth state, £525; *The Three Trees*, £924; *Jan Lutma* in the first state on Japan, £840. In New York in 1935 and 1936 high prices were paid at Anderson's for superb sheets from the Graves and Innes collections: Dürer's *Adam and Eve*, having passed through the collections of Abraham Ortelius, J. Collius, Jan Six, Mariette, Saint-Yves, von Fries, Verstolk van Soelen, John Griffith and Franz von Hagens, was bought for $10,000; Dürer's *St Jerome in his study*, formerly in the Mariette, Holford and Mayer collections, made $2,400. A *Hundred Guilder Print* in the second state, by Rembrandt, made $7,300 (the previous year another sheet from the Stein collection had made $10,500). Finally, in the field of sporting and decorative prints, there were the 13 *Cries of London* aquatints by Francis Wheatley, which in New York in 1934 fetched $6,200, and the 8 *Beaufort Hunt* aquatints by Henry Alken after Charles Howard Hodges (formerly in the well-known Dixon collection) disposed of in 1937 at $12,000.

The history of values of modern and early prints since the last war belongs to our times. Many prints by artists active from the end of the nineteenth century onwards must have lain unsold in dealers' shops for years, indeed for decades; there could be no other explanation for the quantity of sheets put up for sale after 1945. This applies not only to Munch and Picasso, but to Gauguin, Bonnard, Vuillard, Matisse, Villon, Morandi, Segonzac and many others. The small number of monographs written on the graphic work of these artists (which meant that they remained relatively unknown) and, even more so, the early catalogues of modern prints, give a clear picture of the situation. In Italy and Spain these modern artists were unknown, in Germany they were prohibited, in England and the United States they were not popular; so French artists could look only to France and Switzerland, and the Expressionists to Switzerland alone: this was hardly enough.

There were no startling developments in the period 1945-55. It began with a carryover of the low pre-war prices; the effects of the war were felt everywhere,

Modern prints III

Rembrandt, *The Three Trees*, 1643

money was scarce, salaries only partially adjusted to the new cost of living; the transfer of currencies was prohibited and there was almost the feeling of living in watertight compartments. Then slowly, and subsequently at a faster pace, though with an almost imperceptible pause in 1962-3, prices rose, and from 1964 to 1969 climbed at an average rate of about thirty per cent a year. In 1970 there was a temporary halt for some artists and in a few cases even a small recession. After the sales of the great collections of early and modern prints belonging to the American banker Edwin Alfred Seasongood in New York in 1951-2, of the rich and cultured industrialist Gabriel Cognacq, André-Jean Hachette and the stockbroker Henri-Jean Thomas (these three in Paris between 1950 and 1952), practically no collections of any importance were sold, apart from a few special cases (usually sales of works by a single artist: Daumier, Toulouse-Lautrec, Picasso); but there were quite a number of sales, some quite small, some very big, formed by the gathering together of many small collections from sellers who preferred to remain anonymous.

I have drawn up a few tables showing some important prints by major artists and their changing value over a period of 10-25 years. The reader should bear in mind the limitations of these tables imposed by the difficulties encountered in carrying out the survey, above all since I have tried to choose prints of the same subjects and impressions similar in state, in first rate quality and in condition. He will also recall that the prices given are, as usual, nett, and for Continental sales to transform them into actual amounts paid he must add the commission as indicated in the chapter on auctions. As well as the year of sale I have given, after

243

Lucas Cranach the Elder, *St George and the Dragon*, *c*.1510

the price realized, the equivalent value in dollars at the exchange rate in force that year; consequently the currency given first will indicate whether the sale took place in Paris, London, New York or Berne (see p. 248-9).

For early prints in the period 1945-70 what I have said about modern prints could also apply, even though the question is a little more complex for various reasons. First of all, when the pedigree of a print is not known, comparison between the two or three impressions of the same subject by the same artist is extremely difficult, indeed it is rash to attempt a comparison, owing to differences in condition, the various dates of printing (not always specified) and differences in quality. The steady and sometimes undiscriminating demand for an important early artist, even for late editions of his prints, does not make an objective appraisal easy. Lastly, the reappearance and new popularity of prints by artists at one time not highly regarded, such as Bellange, Goya, the two Tiepolos and Piranesi, also influence the whole picture.

Early prints V

In the years immediately after the war early prints, too, had remained at the low pre-war prices. At auctions it was not difficult to find a proof before the text of the *Life of the Virgin* by Dürer at £15-£20, the same price as for a large etching by Canaletto in the first state and five or six times more than a *Capriccio* by Tiepolo or a *View of Rome* by Piranesi. The fine series by Callot and by Della Bella, the former so expensive today, the latter rare in early editions, could be had for trifling prices. In London, as the catalogues from the early fifties clearly show, 'Basan' or later impressions of Rembrandt were worth from a few shillings to a few pounds each; the same ones today would cost from £20 to £200. Older impressions, printed perhaps in the eighteenth century, which could then have

Albrecht Altdorfer, *Christ raised on the Cross*, c.1515

Albrecht Altdorfer, *The Beautiful Virgin of Ratisbon*, 1519-20

been acquired for ridiculously low amounts, have recently (according to Wilder) been making astonishing prices at sales.[14] Equally low prices were made in France where, as in England, because of currency restrictions, the market was virtually limited to local dealers. In Switzerland the prices were a bit higher, so that quite a number of prints were sent there to be sold. The New York sales, attended only by Americans, were not outstanding. Prices of £1,000 or £2,000 for a print were considered rather exceptional in London; for example in 1954 when the coloured *manière criblée* incunabulum of the *Virgin* by an anonymous fifteenth-century German master, two impressions known, fetched £2,800, or in 1955, when a very fine second-state impression of *Six's Bridge* by Rembrandt made £1,020.

During these years no more really important collections were sold up, and as far as early prints are concerned this is only to be expected; but many small or very small collections came on to the market, at times containing some important sheets. There were two exceptions which I shall mention at the end of this section, but they were noteworthy more for the quantity of prints than for

[14] Wilder, *How to Identify Old Prints,* op. cit., p. 25. On the subject of late states, Wilder refers to 'rework... done to many plates after the lapse of more than a hundred years and...ignored by some authorities.'

Early prints 1798-1970

Artist	Work	Up to 1850	Up to 1914	Up to 1940	Up to 1970
Master E.S.	Letter M	1834: Buckingham £4.6.0		1933: Northwick M 7,600 (£380)	1966: Schocken £13,000
	The Virgin praying, half-length				1957: Sw Fr 13,000 (£1,060) 1970: Sw Fr 130,000 (£13,000)
Schongauer	The Saviour blessing the Virgin		1861: Arozarena Fr 341 (£13.10.0)		1955: Curtis Sw Fr 6,800 (£560)
Master P.M.	Women Bathing			1933: Northwick M 15,000 (£750)	1966: Schocken £32,000
Dürer	Adam and Eve, Ortelius Collection		1851: V.v. Soelen Fl 200 (£17)	1927: Hagen M 42,000 (£2,100) 1936: Graves $10,000 (£2,000)	
	Life of the Virgin (before the text of 1511)		1875: Kalle M 850 (£43)		1957: Sw Fr 13,000 (£1,065)
	St Jerome in his Study	1803: Kreuchauf Fl 6 (£0.10.0)		1930: Hermitage, Leningrad M 32,200 (£1,600)	
Lucas van Leyden	Adoration of the Magi		1861: Arozarena Fr 380 (£15)		1965: Sw Fr 16,600 (£1,200)
Rembrandt	Six's Bridge (2nd state)	1834: Buckingham £10.10.0		1924: Rudge £210 1937: Gow £315	1967: Nowell-Usticke $45,000 (£19,000)
	Ephraim Bueno (2nd state)	1829: Josi £12	1895: Holford £135		1954: Weisbach Sw Fr 13,000 (£1,060) 1970: Downe £6,000
	The Three Crosses (3rd state)			1932: Albertina, Vienna, M 23,000 (£1,150)	1966: £30,000
	The Three Crosses (4th state)		1895: Holford £19		1954: Weisbach Sw Fr 30,500 (£2,250)
	Three Gabled Cottages beside a Road (2nd state)		1895: Holford £100		1954: Weisbach Sw Fr 28,000 (£2,350)
	The Presentation in the Temple, in the dark manner	1798: Barnard £1.10.0			1970: Downe £17,000
Audubon	Birds of America (435 aquatints)			1922: Burdett-Coutts £600	1969: £90,000

£ = pounds sterling, $ = US dollars, Sw Fr = Swiss francs, Fr = French francs, Fl = Dutch florins, M = marks.

Currency equivalents are approximate.

John James Audubon, *Wood Ibis,* c.1825

Modern prints 1945-1971

Artist	Work	1945-1950	1951-1955	1956-1960	1961-1965	1966-1971
Blake	The Book of Job			1958: £100 ($280)		1969: £1,750 ($4,200)
Bone	A Spanish Good Friday	1946: $1,250				1969: $1,200
Bonnard	Place Clichy		1955: SwFr 460 ($107)			1969: £1,700 ($4,080)
Braque	Job			1958: SwFr 1,060 ($247)		1968: SwFr 10,200 ($2,361)
Bresdin	The Good Samaritan	(before 1950, about $200)			1963: SwFr 5,400 ($1,250)	1970: SwFr 25,000 ($5,800)
Cézanne	The Bathers (large plate, colour)	1946: $300				1970: SwFr 24,000 ($5,570)
Chagall	Mother and Son (Mein Leben)			1958: SwFr 350 ($82)		1969: SwFr 3,300 ($766)
Corot	Souvenir d'Italie (1st state)		1952: Fr 45,000 ($130)			1970: SwFr 8,400 ($1,950)
Daumier	Rue Transnonain	1947: $225				1970: SwFr 12,500 ($2,900)
Degas	Au Louvre: Musée des Antiques (state not specified)			1957: £75 ($210)		1968: SwFr 11,000 ($2,546)
Ensor	The Entry of Christ into Brussels		1954: £11 ($31)	1957: SwFr 490 ($150)		1968: SwFr 8,200 ($1,900)
Gauguin	The Ox-cart (Tahiti)			1957: SwFr 800 ($186)		1968: SwFr 13,000 ($3,009)
Goya	Los Caprichos (1799 ed.)		1953: £250 ($700)	1959: £2,800 ($7,840)		1970: £9,000 ($21,600)
	La Tauromaquia (1816 ed.)			1958: £680 ($1,900)		1969: £11,000 ($26,400)
Kirchner	Head of Ludwig Schames		1954: SwFr 420 ($98)			1967: SwFr 27,000 ($6,235)
Klee	The Tightrope Walker		1955: SwFr 1,450 ($338)			1970: SwFr 28,000 ($6,496)
Manet	Civil War	1946: $190				1966: £380 ($1,064)
	The Races (1st state of the 1st ed.)	(before 1950, abour $1,000)				1970: £6,500 ($15,600)
Matisse	Dancers (10 lithographs)		1954: £105 ($294) for all 10			1969: SwFr 4,400 ($1,020) for one only
Meryon	La Morgue (4th state)	1947: $220				1970: £577.10.0 ($1,386)
Millet	La Grande Bergère		1954: £38 ($106)			1970: SwFr 5,100 ($1,180)

Modern prints 1945-1971

Artist	Work	1945-1950	1951-1955	1956-1960	1961-1965	1966-1971
Morandi	Still-life with Landscape (V. 89)				1961: SwFr 1,950 ($453)	1970: SwFr 8,600 ($1,995)
Munch	Girl on the Bridge	1950: SwFr 850 ($197)				1969: SwFr 23,500 ($6,134)
	Self-portrait		1955: SwFr 2,350 ($547)			1970: (3rd state) £1,500 ($3,600)
	Sin			1957: SwFr 5,900 ($1,375)		1970: SwFr 80,000 ($18,560)
Nolde	The Three Magi			1959: SwFr 3,900 ($902)		1970: SwFr 14,700 ($3,410)
Picasso	Le Repas frugal (ed. of 250)	1946: $275	1952: Fr. 80,000 ($230)		1964: SwFr 14,500 ($3,356)	1970: £4,200 ($10,080)
	L'Atelier		1954: SwFr 460 ($107)			1969: SwFr 11,500 ($2,668)
	L'Abreuvoir (ed. of 250)		1954: £8 ($22.50)			1969: SwFr 14,500 ($3,364)
	Bust of a Woman after Cranach				1962: £580 ($1,624)	1969: SwFr 106,000 ($24,593)
Pissarro	La Masure (1st state)			1959: £28 ($78)		1969: SwFr 4,400 ($1,020)
Redon	The Tree	1947: $160				1969: £1,900 ($4,560)
Rouault	Miserere (58 aquatints)			1957: subscription price Fr 300,000 ($810)		1969: $11,500 1971: £3,600 ($8,640)
Toulouse-Lautrec	Bust of Marcelle Lender (3rd state; ed. of 1100)		1954: SwFr 520 ($121)			1966: £750 ($2,100)
	Elles (title and 10 colour lithographs)	1948: $2,100				1966: £8,000 ($22,400)
	Yvette Guilbert (English series of 8 lithographs)	1946: $190		1957: SwFr 1,100 ($257)		1970: SwFr 9,600 ($2,228)
Vuillard	Landscapes and Interiors (12 lithographs)		1952: Fr 600,000 ($1,714)			1968: SwFr 62,000 ($14,352)
Whistler	The River (No. 2, 1st state)		1955: £32 ($90)			1970: £840 ($2,016)
Zorn	Ernest Renan (state not specified)	1947: $200				1969: ($375)

Comparative values of major currencies in Swiss francs

Year	England	USA	France	Germany	Holland	Italy
	£1	$1	Fr 100	M 100	Fl 100	L 100
1913	25.31 Sw Fr	5.19	100.25	123.67	208.71	98.47
1920	21.68	5.93	41.48	10.09	203.38	28.94
1930	25.08	5.16	20.25	123.06	207.51	27.02
1940	16.64	4.41	9.42	176.31	236.92	22.19
1950	12.23	4.32	1.24	103.90	114.83	0.70
1960	12.13	4.32	88.06*	103.54	114.50	0.70
1970	10.31	4.31	78.00	118.50	119.50	0.69
1971 (Sept.)	9.825	3.98	74.50	118.50	116.50	0.645

Sources: Crédit Suisse, Zurich, Swiss Statistical Abstract, 1969. * Adjusted to the new franc.

Jacques Callot, *The Organ Grinder*, 1622

quality. The major figure in these two sales will of course, inevitably, again be Rembrandt, or rather, what is left of him. Here, too, I shall provide a small table (which, however, is arranged differently from the tables of modern prints since, to make a valid comparison, I have in this case had to consider some examples of the 'same' print, guided by the collector's mark or by the catalogue which I was consulting). The period under consideration is naturally much longer, but no less interesting for that. For Rembrandt's etchings my task has been less arduous since his most valuable prints have been carefully tracked for centuries now; it was much more difficult however in the case of other old masters, since in these cases the habit of placing a collector's mark on prints is more recent, making it less easy to follow the print's history over the years. In this case for prices referring to the distant past I have also given the approximate value in pounds sterling, obviously not in dollars, as this currency did not have international importance then (see p. 247).

Earlier in this book I quoted some extremely interesting prices made at sales in the past few years, so here I shall choose other examples of prints which are very valuable for their quality and rarity. At the Seasongood sale in New York in 1951, besides the Pollaiuolo already mentioned, a magnificent *St John the Baptist* by Giulio Campagnola realized $4,000 and *The Nativity* by Dürer, $5,700. In Paris, at the very important Hachette sale, the highest price was given for Rembrandt's portrait of *Jan Six* in the third state, 45,000 French francs ($13,200). In the space of a few years some outstanding sheets passed through the Berne salerooms. In 1954 at the sale organized by the heirs of Valentin Weisbach and his son Werner, the well-known art historian, there were various etchings which the former had bought in 1895 at the Holford sale: the sheet of *The Three Crosses* in the fourth state fetched 30,500 Swiss francs ($7,110), the portrait of *Jan Six* in the same state, 34,000 ($7,900) and several rare landscapes, still from the same collection, only slightly lower prices; prices that are by 1970 standards ridiculously low. In 1955, at the sale of the collection owned by the American Atherton Curtis, who had previously left a large number of engravings to the Bibliothèque Nationale of Paris, another sheet of *The Three Crosses*, in the second of five states, made 83,000 Swiss francs ($19,390) and Schongauer's *Ornament with parrots and other birds*, 13,500 ($3,175). In 1958 one of eight known impressions, and the only one in black and white, of the *Town with four towers* by Hercules Seghers made 122,000 Swiss francs ($28,435), a new record which was to broken in 1961 at the sale of the private Rembrandt collection owned by the publisher, dealer and collector Alfred Strölin; some outstanding etchings such as *The Phoenix* and *The*

Increase in the cost of living, based on a figure of 100 in 1958

Annual average	England	Holland	France	Germany	Switzerland	USA	Italy
1750	12						
1800	32.4						
1850	22.3						
1900	20						
1914	23	27	0.5	—	40	37	0.3
1920	59	51	1.7	—	90	75	0.9
1930	36	37	2.8	64	63	58	1.5
1940	43	38	4	57	60	49	2.3
1950	68	77	63	85	88	83	76
1958	100	100	100	100	100	100	100
1970	152	158	166	134	140	138	153

Sources: Crédit Suisse, Zurich, Swiss Statistical Abstract, 1969; for England (1750-1900), Central Statistical Office, London.

Blindness of Tobit, both formerly in the John Barnard collection, *The Windmill*, with clearly visible craquelures, and a horizontal *Ecce Homo* in the fourth state, which made 144,000 Swiss francs ($33,335). The same year the chiaroscuro woodcut by Hans Burgkmair *St George, Protector of the Christian Virtues* realized 81,000 Swiss francs ($18,740). From that time on the Berne saleroom, while not neglecting early prints, nevertheless began to concentrate more on modern graphic art, so that fewer really important prints were being sold there; of those that were, however, in addition to the ones already mentioned, it is worth recalling: in 1965 Schongauer's *Virgin in a Courtyard*, 72,000 Swiss francs ($16,630); in 1968 Dürer's three great books, 48 woodcuts with the Latin text of 1511, in mid-sixteenth century binding decorated with the Nuremberg coat of arms, 144,000 ($33,250), about double the price that a similar work in an old binding had made in 1960 at Karl und Faber at Munich; in 1969 a coloured incunabulum of the German school, 64,000 Swiss francs ($14,840); by Dürer a beautiful *Melencolia* in the second state, 43,000 ($10,000); in 1970 a line engraving from the series of six engravings of *The Unicorn* by Jean Duvet, 58,000 ($13,460).

In about 1960 London, where sales of early prints had continued to be more numerous than in other places, again became the almost exclusive market for graphic art, to an even greater extent than in the nineteenth century, and today it is also the major centre for modern graphic art. A few important examples can be singled out from among the several tens of thousands of prints listed in a few hundred catalogues. In 1962 the fourth state of *The Three Crosses* by Rembrandt, with the signature and date 'Claude-Augustin Mariette, 1663' written on the back, made £5,800 ($16,200). In 1964 Goya's mezzotint *The Colossus* was sold for £20,500 ($57,400); it is the sixth known impression, the other five having been for many years in public collections (the one preserved at the Bibliothèque Nationale of Paris was purchased at the Lefort sale in 1869 for 38 francs); *The Bear Hunt*, c.1470, line engraving by an anonymous Italian master, £1,900 ($5,320); a fine but slightly trimmed sheet of *Mars and Venus* by Jacopo de' Barbari, £1,300 ($3,640); *Three Trees* by Rembrandt, fine but with defects, which in 1831 had cost 6 guineas, now went for £3,000 ($8,400). By contrast, Raimondi's *Massacre of the Innocents* which in a sale in 1831 had made the top price at 15 guineas, here made exactly the same price. In 1965 some very fine Dürers were offered from the Henri Harper Benedikt collection: *Adam and Eve* in the Hollstein fourth state,

Jacques Villon, *Renée de trois-quarts*, 1911

perhaps Meder quality C, fetched £3,400 ($9,520); *St Eustace*, probably Meder D, £2,400 ($7,560); by Rembrandt, the portrait of *Jan Six*, fourth state on Japan paper, formerly in the John Barnard and Sir Edward Astley collections, £7,800 ($21,840); and in the same year, a coloured incunabulum by an anonymous German master, c.1470, £3,600 ($10,080).

But these are still decidedly low figures. In March 1966, the collector G. Schocken put up for sale some rare prints he had bought in Leipzig in 1933 at the sale arranged by the heirs of the second Earl of Northwick. In addition to the notable engravings already referred to, there were: a *Hundred Guilder Print* in the second state on Japan, formerly in the Earl of Aylesford's and then in J.H. Hawkins' collection, 1850 (£48), then in Firmin-Didot's, 1877 (8,550 French francs), now realized £26,000 ($72,800). In the following November, sold as 'The Property of a gentleman', *The Three Crosses* in the second state, which as a duplicate from the Albertina in Vienna was sold at Leipzig in 1932 for 23,000 marks, now made £30,000 ($84,000) – an amount which to date has been surpassed at an auction only by that paid for the engraving by the Master P.M. that I have already referred to. In 1968 *The Three Marys at the Sepulchre* by Jacques Bellange, a fine impression but with trimmed margins, £2,900 ($6,960); by Dürer an *Erasmus of Rotterdam*, Meder quality A (?), £3,800 ($9,120), the small *Virgin seated on a Wall*, Meder B, £2,500 ($6,000). The disparity of the last two prices can be explained only by the difference in quality of the impressions.

Still in New York in 1967 and 1968 at Parke-Bernet's the collection of Rembrandts belonging to the American collector Captain G.W. Nowell-Usticke was sold. There were two excellent bound catalogues with hundreds of reproductions, and over 400 items; the sale was attended by museum directors, collectors and dealers, including many from Europe. The collection was quite a fine one but, apart from a few sheets, did not include the more rare states, the so-called experimental proofs or even examples of the more important etchings. A good *Three Trees* realized $20,000; *Six's Bridge* in the second state, $41,000 (formerly in the Duke of Buckingham's collection, 1834, £10.10); *Trees, Farm Buildings and a Tower* in the fourth state, $19,000; *Jacob Thomasz. Haaringh* in the second state, good but not excellent, $19,000. There were some quite fine etchings which at one time were perhaps considered of minor importance: among them in particular *The Blindness of Tobit: Large Plate*, and *Abraham and Isaac*.

On 26 November 1970, at Sotheby's, the first part of the collection formed by Richard Dawnay, tenth Viscount of Downe, was sold: 'He put together a remarkable series of Rembrandt etchings, perhaps the most important private collection of its kind in Great Britain' (Lugt). The etchings were uneven in quality but some were very good, such as *The Presentation in the Temple, in the dark manner*, £17,000 ($40,800) – this however was not the dearest print in the sale; the third state out of five of *The Three Crosses*, good but cut within the platemark on each side, £9,500 ($22,800); a surprise, partly because of the intensity of its burr, was *The Descent from the Cross: By Torchlight*, £8,000 ($19,200), sold in 1937 at the Leonard Gow sale for only £71.8s. Two days earlier at Christie's the *St Jerome reading, in an Italian Landscape*, in the first state on Japan paper, made £12,500 ($30,240); by Dürer, *The Knight, Death and the Devil*, Meder quality B, £4,200 ($10,080); the etching *Veduta fantastica di Venezia* by Canaletto, whole plate, £7,000 ($17,640). It is interesting to learn in connection with this sheet that it had belonged to Count Corniani of Venice, who had sold it with the other thirty etchings of the *Vedute* to Edward Cheney. The whole album when put up for sale at Sotheby's in April 1885 was sold for £5 to the expert Auguste Danlos of Paris (Rothschild's buyer).

London, end of June 1971. The spring sales, generally the most important of the year, finished here on 29 June. Since the next ones do not begin until towards the end of November, I shall make a survey of the past twelve months. The itinerary followed by dealers in a period of just over six weeks, from April to June, was the following: New York, Paris, Berne, London, short pause, then London again. In New York there was a mixed sale of early and modern prints, not of great importance, but there was growing interest in Whistler, whose etchings from the two Venice Sets fetched up to $2,000-3,000 each; it seems that before long collectors will have to pay unusually high prices for one of the finer and rarer impressions by this artist. In Paris on 25 and 26 May the fine collection formed by the French collector and patron of the arts, David David-Weill (d. 1952) was sold. It was many years since a similar sale had been held in France. Among the more notable items and prices were the very rare *Ballon* by Manet, 150,000 French francs ($27,300), *Elsa the Viennese* by Toulouse-Lautrec, 110,000 francs ($20,000), *Odalisque à la culotte bayadère*, the beautiful lithograph by Matisse – now the most sought-after of all modern artists – 80,000 francs ($14,600): three record prices. There were of course some much lower prices as well. The reader will recall that a commission of ten per cent must be added to French prices and fifteen per cent to Swiss prices, which I shall now turn to.

There was a large modern section in the sale at Berne at the beginning of June. Prints by Norwegian and German Expressionists at times repeated the 1969 and 1970 prices, but more often they made less. The following example is interesting: three different impressions of the mezzotint *Young Girl on the Shore – The Lonely One* by Munch made the following prices: in 1969 146,000 Swiss francs, in 1970 110,000 Swiss francs, and in 1971 93,000 Swiss francs. On the other hand Picasso's *Repas frugal* was still in demand; his more common prints, however, less so. In the small section of early prints there were two fine Dürers; the *St Jerome in his Study* and *Adam and Eve* in the third state, 'good but not outstanding', 65,000 Swiss francs ($15,100), the highest price ever paid at an auction for a Dürer (see 'Review of the Art Market' in the *Financial Times*, London, 26 June 1971).

At Christie's, still in June, some outstanding prints were up for sale, in addition to the usual *Knight, Death and the Devil*, in this case a very good example (Meder B). The third state out of eight of Rembrandt's horizontal *Ecce Homo* (formerly in the Verstolk van Soelen collection, Amsterdam 1847, 950 guilders) was sold on behalf of Lord Margadale of Islay for 32,000 guineas ($80,604), five per cent more than the price paid for the engraving by the Master P.M. (see above, p. 142). Considering however that in five years the pound has lost almost forty per cent of its purchasing power, partly as a result of the 1967 devaluation, and that in the meantime valuable impressions have more than doubled their price, this sum represents only a nominal record. Another sensation at the same auction was the sale, sheet by sheet (contrary to normal practice) of the *Toros de Burdeos* lithographs by Goya: altogether they realized £30,135 ($72,324), 36 times more than the price which a similar work (Hartshorne collection) made at Parke-Bernet's on 23 January 1946. And again, two small Goya lithographs (H. 274 and 279), of which three and four impressions, respectively, are known, made £12,075 and £8,925 ($28,980 and $21,240). Finally on 29 June at Sotheby's another good *Knight, Death and the Devil*, probably Meder B, was sold for £4,200 ($10,080), a very good *St Eustace*, Meder B or C (Sträter collection, 1898) but which Adrian Eeles had described only as 'good' (see above, p. 168), went for only £5,500 ($13,200), because it was trimmed along the plate-mark. Finally the first edition of Goya's *Caprichos*, with plate 45 before the inscription and number, made £12,000 ($28,200).

Above:
Stefano della Bella, *Sultana*, 1650

Right:
Hercules Seghers, *The Larch*, c.1620

Below:
Hercules Seghers, *The Three Books*,
c.1620

By contrast, not a single noteworthy impression by Canaletto or Callot has been seen during the whole season, unlike previous years; no fifteenth-century engraving (not counting late Mantegnas, of course); not even a Dürer *Apocalypse* with the 1511 text, which had turned up several times in recent years; even late Dürer and Rembrandt sheets have been less numerous. One is reminded of the words spoken at the beginning of the century by the great dealer Georg Gutekunst to Hans W. Singer, director of the Print Room at the Dresden Museum: 'If only I had something to sell: selling is child's play; but getting hold of prints! There aren't any more to be found.'[15] Undoubtedly if Gutekunst had been alive now, he would have found only one subject of interest to him in the whole of 1971: the *Ecce Homo* which I have just referred to; not the Dürers which, judged by 1900 standards, would not have meant much to him; not even the Goyas which did not then arouse much enthusiasm.

The prices recorded in this chapter should not lead the reader to make hasty conclusions, thereby misinterpreting the nature of the information I have given: assuming, for example, that with the undisputed increase in prices – 10 or 30 times in twenty years, or whatever it may be – a 'wise' purchase would always assure the collector of a very large real or potential gain. It would be absurd to deny that such cases could and indeed have happened... one might have managed to buy a Dürer or a Picasso in 1950 for, say, £500 and then had the courage to buy another in 1960 for £4,000, and finally been bold enough to pay £10,000 for another in 1970; naturally, in the hope that inflation would continue indefinitely. In short, one would have to have known, in order to make a sound investment (I prefer not to speak of speculation) that prints, and in general any valuable objet d'art or antique, would become a real 'blue chip': looked at in this way, it would perhaps have given the collector satisfaction, but undoubtedly no aesthetic or spiritual enjoyment.

[15] See Hans W. Singer, *Der Kupferstichsammler*, 3rd ed. (Leipzig 1923), p. 66.

Edvard Munch, *Sin*, 1901

III Drawings: a brief survey of values

Drawing and engraving are the purest forms of graphic art, which was the first kind of illustration which man used as a means of artistic expression.

Even taking into account the collection owned by Cardinal Leopoldo de' Medici, whose drawings had formerly belonged to Naddi, Vasari and also to Lorenzo the Magnificent, the title of greatest collector of the seventeenth century must go without a doubt to Everhard Jabach (c.1607-95) of Cologne. He was very rich; he settled in Paris in 1638; and in 1664 was appointed by Colbert to the post of administrator-general of the Compagnie des Indes which had been founded that year. Intimate friend of great artists – Van Dyck painted him three times – Jabach was able to purchase in London a large part of the famous English royal collection, during the years immediately following the execution of Charles I: he acquired about a hundred paintings, among them several Titians, Leonardos and Giorgiones, and a few thousand drawings, particularly by Italian masters. Most of the latter had been bought from the Dukes of Mantua by the English Crown. In 1670 Jabach, finding himself in financial difficulties, was forced to sell to the French Crown, through Colbert, all of his collection of paintings and drawings, for about half of what he had paid, to be precise 221,883 livres 6s 8d. His collection was to be the basis of the future Louvre museum, as that of the Abbé Marolles, three years earlier, had formed the nucleus of the Bibliothèque Nationale collection.

More detailed information is available about Pierre Crozat (1665-1740), once known as the 'king of drawings', who had become rich in his native Toulouse where, together with his brother Antoine, the Marquis du Châtel, known as *le riche*, he was a tax collector for the states of Languedoc. There was no important auction at which Crozat did not acquire large numbers of drawings of all schools. But it was above all in Italy that the French collector was able to secure the very best works. In 1714-15, in Rome, on behalf of the regent of France, he purchased the collection of paintings and drawings which had belonged to Queen Christina of Sweden; and for his services as agent, *en bon auvergnat*, he managed to obtain a gift of a hundred or so of the drawings, the only ones which were of real value.

In Italy, Crozat, as well as skimming the cream off the finest collections, which were still numerous at that time, bought twenty-six drawings by Raphael from Marchese Antaldi, direct descendant of Timoteo Viti, the 'master, friend and later imitator of Raphael' (Lugt). In the words of Mariette, 'it is not drawings bought piecemeal, but complete collections, and collections of the first order, that are gathered together at M. Crozat's.' In fact as well as the Italian acquisitions the collector had made other important purchases, particularly in London and Amsterdam. When Crozat died, since 'the King had enough clutter, without adding to it', the collection of about 20,000 drawings was sold in 1741 for 36,401 livres 2s: the Italian drawings alone made over 23,000 livres. Chief buyers were the Swedish Count Tessin, whose drawings are today one of the major treasures in the National Museum of Stockholm, the Duke of Tallard and Pierre-Jean Mariette who, having been a member of the Crozat circle, knew better than any one else the drawings owned by the collector.

A few examples of prices will give us a clear idea of the value of drawings in those years:

1 66 drawings by Leonardo da Vinci (heads, draperies, studies for the *Last Supper*) were sold in five lots for a total of 62 livres 4s; a few dozen drawings by Giotto, Masaccio, Lippi, Pollaiuolo, Paolo Uccello, etc., grouped in three or four lots for a total of 30 livres; 158 drawings by Fra Bartolomeo in lots of 2 to 34 drawings each, all for 37 livres 12s;

2 120 drawings by Michelangelo, all for a total of 237 livres; 155 Raphaels, in several parcels, for 2,850 livres 6s;

3 351 sheets attributed to Rembrandt, in twelve lots, 129 livres 18s; 105 drawings by Dürer, 114 livres. And so on.

Today of course we cannot accept all the old attributions; however, successive studies, some carried out this century, have shown that a good number of the drawings in the collection were authentic. Crozat's heirs sold his paintings to Catherine II of Russia, who was thus able to form the nucleus of what was later to become the Hermitage Museum at Leningrad.

I have already discussed Pierre-Jean Mariette in the preceding chapter. We know about his shrewd acquisitions in Italy and about the drawings from the Crozat collection: he himself had been director of the sale and he bought many of the best examples. An examination of the drawings he owned shows that, as Frits Lugt has pointed out, no one in that century possessed his intuition and accuracy in determining the authenticity of a work. Here are a few examples from the sale of Mariette's drawings, held at the same time as the sale of his prints, in 1775:

2 volumes containing 550 small drawings by Della Bella, 695 livres; the large *Entry of the Polish Ambassador to Rome*, by itself, 900 livres; 4 drawings by Giovanni Bellini, formerly in the collections of Vasari, Jabach and Crozat, 48 livres; 2 large drawings by Canaletto, 272 livres

Michelangelo: 40 sheets of studies, tombs, figures and heads in eight lots, altogether 818 livres; Parmigianino's *Self-portrait*, 321 livres

Raphael: 35 drawings, for trifling sums (Boileau bought the three most important of them, one of them with 20 figures)

Tiepolo: seven lots with various charcoal drawings, between 19 and 74 livres per parcel; Poussin: 62 sheets in eleven lots, much more expensive than the Raphaels; Rembrandt, hardly represented: 2 studies of lions, 48 livres the pair, etc.

The Crozat of the nineteenth century was undoubtedly Sir Thomas Lawrence (1769-1830), the famous English painter who invested in drawings the large sums of money he got from the sale of his paintings. With the help of Samuel

Giovanni Battista Piranesi, *Portrait of the Artist: suggested design for his own tomb*, 1778. Pen and brush drawing. This superb and moving drawing by Piranesi was done six months before his death, when he was already ill. It bears a note in his hand: '12 May 1778. Drawing done by Cav. Piranesi to give an idea of his tomb'

Woodburn he had managed to gather together an outstanding collection which included names like Dürer and Rembrandt, which were all but absent from older collections. On the painter's death, in accordance with the instructions given in his will, the collection was offered on option to English museums for £18,000. After the rejection of this offer, which aroused indignation even in France, the heirs sold the collection for slightly less to Samuel Woodburn. The latter in his turn, between 1835 and 1838, adding a few drawings of his own, organized in his famous gallery ten exhibitions in which were offered: 100 Rembrandts for a total of £1,500, all bought the first day by the collector William Esdaile (1758-1837), known for his fine collection of Rembrandt's etchings; again the same year 100 drawings by Claude Lorrain, also bought by Esdaile for £1,800. Subsequently an outstanding series of 430 Fra Bartolomeos was sold for £1,200; 100 drawings by Dürer for £800. Then 75 by Leonardo, including the cartoons, 50 by Parmigianino, 30 by Andrea del Sarto, etc. Over 50 important Raphael and Michelangelo drawings were finally purchased, after years of negotiations, for £7,000 by Oxford University, where they can still be seen today. Some of the attributions

are no longer considered valid, but some are undisputed masterpieces and some have never been called in question.

It is evident that at that date drawings by artists who also engraved, like Dürer, Claude Lorrain and Rembrandt, were decidedly lower priced than their prints. Shortly after, at the sale of the great collections belonging to the banker William Esdaile (1840) several Rembrandt drawings, only recently bought, and about whose authenticity there is no doubt, fetched quite a lot more: for example the important portrait of *Cornelis Claesz. Anslo*, formerly in the Verstolk van Soelen collection, now in the Rothschild collection at the Louvre, £72.9s; others from £5 to 20. In 1912-13 another outstanding collection was sold, the one formed by the English stockbroker John Postle Heseltine. About 600 sheets by the most illustrious old masters changed hands, apparently for £150,000, to the London firm of Colnaghi and Obach, and from there they went to the British Museum, the Louvre and other museums and collectors; the Italian drawings went to the banker Henry Oppenheimer. Another part of the collection, divided into two catalogues, of which one alone contained about 30 Rembrandt drawings, almost all of them superb, was sold at Frederik Müller's in Amsterdam: the *Rembrandt, standing*, which Lugt thinks may be the same which had belonged to Crozat (now in the Rembrandthuis in Amsterdam), realized 22,500 guilders; Baron Rothschild bought several of the drawings, including two outstanding landscapes *The Banks of the Amstel* and *Clump of Trees on a Riverbank*, for 22,200 and 20,000 guilders. The highest price, 30,100 guilders, was paid for another landscape. These are definitely higher prices, yet they are only on a level with, or even just below, the prices paid for the best etchings in the Hubert sale in 1908.

Now for a quick look at the sale of the Henry Oppenheimer collection in London, held at Christie's on 13-14 July 1936. The description of the 460 drawings, of old and illustrious provenance (Crozat, Lawrence, Heseltine), was written by K. T. Parker and other scholars. The artists represented, this time by one or a few sheets, were Leonardo, Michelangelo, Raphael, Fra Bartolomeo, Pisanello, Dürer, the two Holbeins, Baldung Grien, Fouquet, etc., and there were also some drawings by Canaletto, the two Tiepolos and others. At the sale, despite the continuing financial crisis, which affected some of the prices, curators of the most important museums of America and Europe were present. The top price was paid for a *Head of a Cleric* (19.5 × 13 cm: $7^{11}/_{16} \times 5^{1}/_{8}$ inches) by Jean Fouquet, bought by Lord Duveen, £10,700; next in order or price came a small drawing by Leonardo, *Rider on a rearing horse*, £4,305; by Michelangelo, *Bust of a Man and Various Studies* (23.8 × 21 cm: $9^{3}/_{8} \times 8^{1}/_{4}$ inches), £3,570; a *Wise Virgin* by Dürer, £2,415, etc. The less important drawings by Canaletto and the Tiepolos fetched a few dozen pounds each; the more valuable ones, a few hundred pounds.

In 1918 in England, the Dominions and in the United States, the figure of William Blake was already well known and it was considered that the highest point in his work as an artist was represented by the 102 large watercolours for Dante's *Divine Comedy*, which the artist had done for John Linnell. Exhibitions had been organized everywhere with a view to selling the work, which by the express wish of the owner could only be bought as a unit. No museum felt inclined to buy the whole work, so the Tate Gallery bought it on 15 March 1918, partly on behalf of other subscribers, at a total price of £7,665 (perhaps a quarter of what one of the drawings alone would be worth today). The watercolours were then divided up: 20 remained at the Tate, 13 were assigned to the British Museum, 36 to Australia (to the National Gallery of Victoria in Melbourne), 23 to a private American collector who in 1943 presented them to the Fogg Art

Giovanni Domenico Tiepolo, *Punchinello on a Swing*, c.1790. Pen and brush drawing from the famous album *Divertimenti per li ragazzi...*

Museum at Cambridge, Mass.; the remaining 10 went to various English museums.[1]

On 6 July 1920 Colnaghi's bought at Sotheby's an album with the following title: *Divertimenti per li ragazzi, carte no. 104*. It was the story of Punchinello (Pulcinella in Italian), from birth to death, drawn by Giovanni Domenico Tiepolo, probably when he was already an old man, for his grandchildren; it comprised altogether, with the title page, 103 drawings, 29×41 cm (11³⁄₈×16¹⁄₈ inches), one page having previously found its way into the Pierpont Morgan Library in New York. The drawings were on one of Giovanni Domenico's favourite themes, and they were executed with a vivacity and spirit of invention which have never been bettered. The price paid was £610; the firm re-sold the whole lot a short time later to various museums and collectors. J. Byam Shaw, the well-known scholar specializing in Italian drawings, spent many years trying to track down all the drawings and then in 1962 he wrote a learned and interesting monograph on the subject. In 1967 one of these drawings, *Pulcinella visita un circo*, was re-sold at the same salerooms for £5,800 ($16,240), as much as would have to be paid today for one of the best drawings by Giovanni Domenico's father, Giovanni Battista. These prices paid in 1920 for works by Giovanni Domenico Tiepolo remind me of the story told by Byam Shaw in another of his essays, on Francesco Guardi. In 1829 Count Teodoro Correr (after whom the museum in Venice was later

[1] Martin Butler, *William Blake. A catalogue of the works of William Blake in the Tate Gallery* (London n.d.), Foreword by Sir John Rothenstein, pp. 1-5. John Linnell gave Blake £2-3 a week for the *Divine Comedy* drawings.

named) bought 18 drawings by Guardi from the artist's son, Nicolo, who was already by that time an old man: he paid 18 lire – 6d per drawing.[2]

I shall end this chapter on drawings by quoting two prices, both world records, paid at Sotheby's in 1970: *The Flying Deer*, one of Dürer's very rare watercolours, 14.2×11.5 cm (5⅝×4½ inches), formerly in the collections of Horace Walpole, Earl of Oxford, Bale, Heseltine and Oppenheimer, £58,000 ($139,000); *Old Man Seated in an Armchair*, a drawing done by Rembrandt in his youth, signed and dated 1631, 23.3×16 cm (9³/₁₆×6⁵/₁₆ inches), £55,000 ($132,000). The latter had been sold in 1890 at the Prestel sale in Frankfurt for 1,960 marks, an amount then equivalent to about £100. Both drawings were purchased by the French actor Alain Delon.

[2] J. Byam Shaw, *The Drawings of Domenico Tiepolo* (London 1962), pp. 19-20. See also J. Byam Shaw, *The Drawings of Francesco Guardi* (London 1949), p. 13.

IV The last of the great collectors

There are naturally more people today enthusiastic about works of art than there were in the past. But the kind of private collection which even fifty years ago could have included a thousand or more important impressions is no longer a possibility, unless the subjects are contemporary works: I have already given the reasons for this. After having written briefly about the collections of the past, I feel I cannot close without recalling some of the last great collectors – men who were cultured and sensitive, discerning in their tastes. They collected with enthusiasm and perseverance for the whole of their lives, they spent vast amounts on what might seem like an obsession or a whim; then they made generous donations which formed the nucleus of new foundations or museums, or enriched museums already in existence.

Rothschild

Baron Edmond de Rothschild (1845-1934), whose grandfather had founded the Parisian branch of the bank of the same name, shared with the cousins, grandchildren and great grandchildren of his ancestor a love for art and antiques. *Une génération de lutte, une autre de succès, la troisième étant faite pour jouir tranquillement de ceux-ci* wrote Suzanne Coblentz[1] (One generation struggles, another succeeds, and the third enjoys the fruit in peace). I am rather more sceptical of the maxim that 'a Rothschild never lets himself be carried away by his enthusiasm to the point of paying excessive prices.'

It would be impossible to give even an outline of over sixty years in the life of a collector who was initiated into this art – because after all it is an art – early in the 1870s, when he was still a pupil at the Lycée Bonaparte (now Condorcet), and who was still taking an active interest in prints in 1924, at the Rudge sale. They were long years dedicated partly to business, it is true, but mostly spent in choosing paintings by great masters, pieces of furniture such as the Choiseul desk, which apparently cost him almost a million francs in about 1900, and tapestries; this was in addition to his interest in archaeology, which was channelled into a number of important projects, and to his varied and intelligent patronage

[1] Susanne Coblentz, *La Collection d'estampes Edmond de Rothschild au Musée du Louvre* (Paris 1948).

of the arts. But Rothschild's great passion was for prints. Auguste Danlos, his trusted expert, advised him and represented him at all the important auctions on the Continent and in England; in fact I have often found in old catalogues the name of Danlos marked beside the most important pieces, and subsequently learnt that these did finish up in the Baron's collection. Rothschild also paid his – expensive – tribute to Marcantonio Raimondi, in 1870 at Frankfurt, where, in competition with the British Museum and with his friend Eugène Dutuit he was trying to secure the best items for himself. Among his other rivals there was the brilliant Henri-Eugène-Philippe-Louis d'Orléans, fourth son of Louis Philippe, the most cultured member of the family. (Every time the republican government objected to any of his pro-monarchic activities, he responded with generous gifts – forty drawings by Fouquet, bought at Frankfurt for a fortune, incomparable collections of drawings and also of prints, and finally the château of Chantilly itself, which had once belonged to the Condé family, and which he presented to the Institut de France of which he was a member.) Rothschild's more dangerous rival, partly because he concentrated on prints and drawings, from primitives to Goya's experimental proofs, was Eugène Dutuit, who left his splendid collection to the city of Paris (he had even thought of leaving it to Rome), which then assigned it to the Petit Palais.

After the Baron's death, by his express wish, the collection was given by his children to the Louvre, where it is housed in the Cabinet Edmond de Rothschild. It contains over 40,000 prints: German primitives (there are over 80 line engravings by the Master E.S. alone), Schongauer, Israhel van Meckenem, Cranach, Baldung Grien, Burgkmair, the seven Mantegna sheets, Giulio Campagnola, Jacopo de' Barbari and of course the complete Marcantonio Raimondi; Dürer, also complete, and quite incomparable; and finally a collection of Rembrandts than few museums can boast of. At the Duke of Buccleugh's sale in 1889 and the Aylesford sale in 1895, Rothschild had bought about fifteen Rembrandt prints for sums which in those days would have bought a *palazzo* in the Via Manzoni in Milan. There are perhaps even more Italian *niello* engravings than in the British Museum, many precious incunabula, and several very rare fifteenth-century blockbooks. Almost the entire range of French eighteenth-century colour printing is represented, and each example is of outstanding quality. Among the drawings are several thousand by the greatest Italian artists, masterpieces by Dürer, and wonderful Rembrandts with the most illustrious pedigrees – Valerius Röver, Ploos van Amstel, Verstolk van Soelen, Lawrence, Woodburn, Esdaile, Heseltine.

Pierpont Morgan

John Pierpont Morgan (1837-1913) was, towards the end of the nineteenth century, considered to be the richest financier in the world, and, according to Lugt, he decided to become the greatest collector as well. In fact, it was not until he retired from business that he became involved with the collecting of objets d'art, and then of prints. It was only in 1901 that he acquired the rich collection of books and rare old master engravings which had belonged to the American collector Theodor Irwin; he then added to it the important collection which had belonged to his friend George W. Vanderbilt, and the drawings owned by the English painter C. Fairfax Murray. This was just the beginning. Morgan, a cultivated man who in his youth had studied at Göttingen in Germany, turned to illuminated books, and to manuscripts, and eventually he succumbed to the Rembrandt disease which afflicted every great collector without exception.

He was extremely wealthy and paid prices higher than any that had ever been seen before; at the Hubert sale in Paris in 1909 he bought some valuable etchings by Rembrandt at almost ten times the price that the French collector had paid a few

From left to right and from top to bottom:
Collector's mark of Valentin Weisbach (1843-99); Lugt 2539b
Collector's mark of Professor Werner Weisbach (1873-1953); Lugt 2659a
Collector's mark of Dr August Sträter (1810-97); Lugt 787
Old mark of the British Museum collection, Lugt 389
Collector's mark of Sir Edward Astley (1729-1802), Lugt 2774
Collector's mark of Frits Lugt (1884-1970), Lugt 1028
Collector's mark of Ambroise Firmin-Didot (1790-1876), Lugt 119

Edvard Munch, *Madonna*, 1902

Giulio Campagnola, *Nude in a Landscape*, c.1505. Edmond de Rothschild Collection, Louvre, Paris

years earlier at the Holford sale. He thus managed to put together a collection of Rembrandts which had no equal in America, as was apparent at the tercentenary exhibition held in Boston and New York (see above, p. 41, n. 6). He experienced only one setback in his collecting activities: at the Huth sale (London 1911) the telegram which he had sent, making what was certainly a higher bid than Rothschild's, went astray and arrived too late, and the two precious volumes of Dürer's woodcuts, which had once belonged to Abraham Ortelius, were bought by the Baron for £5,400. They are now, after three and a half centuries of wandering, housed permanently in the Louvre. The Morgan collection is still being enlarged with rare and precious works, such as 130 Piranesi drawings out of a known total of 300. It is housed in the Pierpont Morgan Library in New York, one of the most interesting museums in the city.

de Bruijn

Isaac de Bruijn (1872-1953) was Dutch, as was the great collector Justus Bierens de Haan, whose spendid collection of engravings is today preserved in the Boymans Museum in Rotterdam. De Bruijn was a banker in New York until the time of the great crash, and he then settled at Spiez on Lake Thun in Switzerland. He collected nothing but Rembrandt and, having decided to leave the collection he was busy forming to the Rijksprentenkabinet in Amsterdam, he accepted the advice of the well-known Dutch scholar Schmidt-Degener to acquire the very best works still to be found, having regard to what the rich Amsterdam collection still lacked in the way of experimental proofs and rare states. By the end of 1932, de Bruijn was able to publish a book on the first 200 etchings he had collected.[2] There were over 500 of them when he died, a total which no other collector had been able to acquire in the period between the wars. Thanks to de

[2] Isaac de Bruijn and J.G. de Bruijn-van der Leeuw, *Catalogus van de Verzameling etsen van Rembrandt* (The Hague 1932).

265

Bruijn's exceptional contribution, which also included some drawings, the collection in the Rijksprentenkabinet now almost equals that in the British Museum.

Lugt

Frits Lugt (1884-1969), also Dutch, bought his first print at the end of the last century, when he was still a student. In 1901 he took up a post in the famous Amsterdam firm of art dealers, Frederik Müller, of which he was a partner and later director until 1915. 'But the innate desire to possess the object which was my passion was incompatible with the work I was doing, and so I left the gallery.'

What were his interests? First, naturally, Rembrandt. Lugt was able to acquire many of the most precious duplicates which the Albertina of Vienna was forced to sell, for financial reasons, at the end of the First World War, and he also managed to obtain from the heirs of Jan Six the album in which the latter had kept Rembrandt's etchings. He then collected the most rare engravings of the Dutch and Flemish schools. As it was becoming increasingly difficult to find very good examples of the prints he most desired, Lugt turned his attention to drawings – Lucas van Leyden, Pieter Bruegel the Elder, Adriaen van Ostade and other great names. He managed to acquire almost thirty Rembrandts, quite a large number considering that there are not more than a thousand authentic drawings by Rembrandt in the whole world. His collection included Italian

El famoso Americano, Mariano Ceballos

Opposite:
Francisco Goya, *The Divided Ring*,
from the *Toros de Burdeos*, 1825.
Lessing Julius Rosenwald
Collection

Above:
Francisco Goya, *The Famous
American, Mariano Ceballos*, from
the *Toros de Burdeos*, 1825. Lessing
Julius Rosenwald Collection

masters as well, such as the splendid Pisanello which he showed me during our last meeting. From drawings to paintings is a short step, and so Lugt also collected Dutch paintings; then antique furniture, and ceramics. Finally he also became interested in archaeological treasures from ancient Egypt and Greece.

His fervent activity as a collector was interspersed with pauses in which his personality almost seemed to be split: on one side was the enthusiastic and discerning collector, on the other was the scholar. During the First World War he wrote a first volume on collectors' marks, and between 1920 and 1940 the eleven volumes of the *Ecole du Nord*, in which he catalogued all the drawings of the Flemish, Dutch and German masters housed in the Louvre and in the various museums of Paris; during the Second World War he began the next volume on collectors' marks, which he later completed. Aside from all this there was the interest he took in the encyclopaedic *Répertoire des catalogues des ventes* which, once finished, will constitute the standard work of reference on all the great art and antique sales held in every country of the world from the end of the sixteenth century up to the present day.[3] Lugt also established a library on the history of

[3] *Répertoire des catalogues des ventes* published at The Hague: 'Première période', 1600-1825 (1938); 'Deuxième période', 1826-60 (1953); 'Troisième période', 1861-1900 (1964). The 'Quatrième période', 1901-20, is imminent. By the end of the third volume 58,704 catalogues had been classified, with notes on the date and place of sale, the saleroom, the object in question (painting, furniture, engraving, etc.) and an indication of the museum or library where the catalogue itself is to be found.

art at the National Institute of Documentation in The Hague, and in 1957 he founded the Institut Néerlandais in Paris, of which he was president up to his death. Here his outstanding collection is housed as the Fondation Custodia; the headquarters of the Foundation are in Basle. The following words, once spoken by a French scholar, give a perfect idea of Frits Lugt as a collector: 'more than on money, his precious collections were built on the intelligence and flair of a great connoisseur.'

Lessing Julius Rosenwald, born in Chicago in 1891, once president of one of the biggest companies in the United States, devoted himself to collecting – particularly prints and illustrated books – from about 1925. From then on there was no important sale in Europe that was not attended by one of his experts, charged with selecting for him the best items available. The inter-war period, and in particular the years of the depression, which dragged on for so long, must have been advantageous to him, as it was to other collectors like de Bruijn and Lugt. Presumably Rosenwald too bought some of the duplicates from the Albertina of Vienna, and prints and books from the collection of the Dukes of Arenberg, and he must also have been able to obtain sheets from the fabulous collection that Otto Gerstenberg had formed at the beginning of the century out of the finest engravings which had formerly belonged to the Duke of Buccleugh, the Earl of Aylesford, Baron Adalbert von Lanna, etc.[4] Rosenwald also managed to acquire the most substantial group of incunabula existing today in the United States, a collection put together over a long period of years by the rich banker Martin Aufhäuser of Munich, who had carried on this activity unbeknown to his wife and children. This 'roll of old papers' was the only possession that Aufhäuser had been able to take with him when he fled from Germany to America: it allowed him to spend his last years fairly comfortably.

Rosenwald

The Rosenwald collection was universal in its coverage, ranging from incunabula and the Northern European and Italian masters of the fifteenth and sixteenth centuries right up to Munch and Picasso. It is housed in a villa that stands in the middle of a beautiful park at Alverthorpe in Pennsylvania, and there Rosenwald himself cordially welcomes the many visitors. In 1943, Rosenwald presented the early illustrated books and those illuminated by Blake to the Library of Congress, and all his prints and some drawings to the National Gallery of Art in Washington, D.C.[5]

[4] Lugt, op. cit., vol. II, no. 2785, also no. 1536. Several of the finest Rembrandts from the Gerstenberg collection were bought by the son of J.P. Morgan, for the Morgan Library.
[5] *Fifteenth-Century Woodcuts and Metalcuts* (National Gallery of Art, Washington, D.C., 1968), with a foreword by L.J. Rosenwald.

V The big auctions

Selling by auction, where the object goes to the highest bidder, is an institution which dates back to the earliest times. We are interested here only in the more recent auctions, apart from a few incidental references, and specifically in those concerned with prints. A few decades ago there were very many salerooms, particularly in Germany; today, of all the major firms there remain only the two old-established ones in London, two in Paris and one in New York, while the firm operating in Berne has partially replaced the old German ones (see above, p. 165). Despite the fact that the number of people interested in works of art is constantly increasing, what we are witnessing is an actual process of concentration, typical of the modern industrial world. Moreover, reversing a tendency which is general in other fields, it is Europe and more specifically England, which has with rare exceptions taken over all the European and extra-European markets, including the American. In fact, the London firms of Sotheby's, founded in 1744, and Christie's, founded in 1766, whose activities are reported in newspapers and magazines, have for some years now controlled about eighty per cent of the entire world auction market. The explanation lies partly in a favourable environment, in the facilities granted to English firms, such as an almost absolute freedom to import and export works of art and currency; but it also lies in the efficient management of the English firms, which are therefore in a position to offer more advantageous terms to clients.

New York is the home of Parke-Bernet, which since 1963 has been affiliated with Sotheby's. In Paris there is the Hôtel Drouot, founded in 1853, and to this has been added in recent years the Palais Galliera, for more important sales. Both are State owned: they are controlled and presided over by officials of the Ministry of Finance, the *commissaire-priseurs*, who are assisted in selling by experts, in whose own premises the objects are exhibited before the sale. Kornfeld und Klipstein, founded in Berne in 1920, originated in an older firm founded by Heinrich Georg Gutekunst in Stuttgart in 1864. Unlike New York, London and Paris, Berne concentrates on prints and, in particular, on those by modern artists; there is only one sale a year, usually in June, which lasts three

or sometimes four whole days. This then is how the market is distributed geographically. For a more comprehensive though not complete list of salerooms which handle prints from time to time, see below.[1]

What functions does sale by auction perform? It represents first of all an economically valid meeting point for offer and bid; it is the place where the contents of collections have traditionally been acquired and dispersed, the natural market for certain objects which would otherwise be difficult to buy and sell; the place, finally, where generally speaking there can be the most realistic valuation of works of art, since at a public auction this valuation will inevitably be tied up with the general economic situation. In Europe more than in America, the main figure at an auction is the expert dealer. He buys sometimes for himself, as part of his trade, sometimes in order to satisfy the requests of his clients, and sometimes on behalf of museums.

Less frequently dealers are also vendors; sometimes a museum will be selling material, usually duplicates, and using the proceeds to make new acquisitions; more often, however, the vendors are collectors who for a variety of reasons want to get rid of all or part of their collections. In England, a large number of sales are motivated by the very high death duties (after a million pounds, as much as eighty per cent), which force the inheritors of large fortunes to sell a large part of their inheritance: the first things to go are objects such as porcelain, pictures, furniture, engravings, etc., accumulated by the family since the age of the 'grand tour' or during the prosperous nineteenth century. It is not surprising to find famous names in auction room catalogues, since it is often the owner himself who arranges the sale of his collection, thus ensuring that the items on sale have a certain prestige, a pedigree that the prospective purchaser appreciates – and pays for. On the continent of Europe the practice of identifying the owner would be unthinkable, partly perhaps for tax reasons, but even more because it would threaten one's anonymity, and might lead a friend or acquaintance to suspect that one is in financial difficulties.

Sale by auction, then, is a means of gathering a large number of people together, and it offers them a wide choice of objects – in our case, of historical and modern prints – in a number of sales spread out through the year. In addition, it can provide purchasers with some indication as to the authenticity and status of a particular impression, partly through the reaction of experts present at the auction.

The auctioneers will ask from their client a payment for their services, in the form of a commission on the price paid for the work. The conditions of sale are set out at the beginning of every catalogue. Usually it is presumed that these conditions are known, except in France and in Switzerland where they are read out before the auction begins. In London and in New York, particular emphasis is laid on the fact that the firm is selling as an agent on behalf of a client and that it does not assume responsibility for the authenticity of the object or for any error in cataloguing; that, however, any complaint to the effect that an object which has been auctioned is a forgery or a copy will be accepted if it is presented within twenty-one days of the sale, provided that the object is returned during the fourteen days following the sale, i.e. seven days before the expiry date for lodging the complaint. In Switzerland this concession is only made to a purchaser who was not actually present at the auction; and in any case the purchaser's

[1] In Germany, the famous firms of C.G. Boerner of Leipzig and Puppel und Hollstein of Berlin were active until 1940. Present day salerooms include Karl und Faber in Munich, Ketterer, also in Munich, Gerda Bassenger in Berlin, Gerd und Rosen in Frankfurt, Ernst Hauswedell in Hamburg and Otto Lempertz in Cologne. The old-established firm of Frederik Müller in Amsterdam and the Dorotheum of Vienna also occasionally organize sales of prints.

complaint must be made within three days of receiving the object, and no later than four weeks after the sale. In France, where purchases are paid for on the spot, in cash, a complaint cannot be made once the bidding is over (unless there are special clauses of which I am not aware).

These regulations are strict, but various factors should be borne in mind: the buyer has had ample opportunity and time to examine the object; the firm naturally has an interest in preserving its own good name, and therefore in selling genuine works, so that any reasonable complaint will be given a fair hearing; and a firm, which is acting on behalf of third parties, cannot make itself guarantor for an indefinite period, since it will have transferred the payment to its client (usually within thirty days). Commission is requested by firms of auctioneers in accordance with local practice. In English-speaking countries only the vendor pays a commission, which is slightly higher for prints and other items which require careful handling and longer and more detailed cataloguing: Sotheby's charge 15%, Christie's 15% up to £500, 12.5% up to £10,000 and 10% above this amount. Parke-Bernet's retain a commission of 20% up to $500, then 18% up to $3,000, and 15% beyond that figure. Purchasers resident in the state of New York must also pay an additional state tax, 2-5% depending on the distance of their residence from New York City. On the continent of Europe the commission is paid by both vendor and purchaser. In Paris, where some years ago the rate of commission was reduced because it had become too high, the purchaser pays 16% up to 6,000 francs, 11.5% from 6,001 to 20,000 francs, and 10% above that amount; similar fees are paid by the vendor. In Berne and in many other European salerooms, the purchaser pays a fixed commission of 15% (the commission was 5% in the nineteenth century and in some cases up to 1914, and 10% up to 1922), and the vendor pays 20%. These high rates of commission may be slightly reduced in the case of important consignments. Some firms set a minimum estimated value on a consignment, below which they will not handle it.

A collector of prints who leaves the task of buying at auctions to his own trusted expert, after discussing selections and prices with him, will usually have to pay 10% of the purchase price for the expert's services as agent; in the case of very large amounts it will be rather less, down to a minimum of 5%.

In an important catalogue the illustrations of the more valuable prints – especially though not only in the case of early ones – are not reproduced from existing negatives, which might be rather misleading in particular details: new photographs and new catalogue reproductions are made. The actual sale can sometimes take on a distinctly speculative character. The firm as a rule remains impartial, adapting itself to the wishes of its clients, at most deciding on the number of prints to be put up for sale. The acquisition of large numbers of items by a single group of dealers, who thus ensured a virtual monopoly of the trade in prints, sometimes used to happen, but it is no longer possible because of the large number of potential buyers and because of the high prices.

Some salerooms, particularly in Switzerland and in some places in Germany, attach to the catalogue a kind of bulletin with estimated sale prices of the prints (rarely anywhere near accurate); in the United States and in Britain, estimates are given verbally while material is on view. After each sale the firm usually distributes to catalogue subscribers (for an extra fee) a leaflet giving the individual prices paid for each print, and these prices do assume the weight of actual valuations, especially in the case of modern prints; these leaflets are extremely interesting and useful. In Paris, the individual prices are published in the weekly *Gazette des ventes de l'Hôtel Drouot*. English buyers, perhaps more by custom than for tax reasons (since in any case they could not escape), allow the

auctioneers to print their name or that of their firm on the price bulletin; in the case of European or American buyers, the name listed may be their own or it may be an invention, in which case only a person who was present at the sale could identify the purchaser. Bids to purchase unlimited quantities indiscriminately are refused by all reputable salerooms.

Pablo Picasso, *Bust of a Woman after Cranach*, 1958

VI Notes and digressions

The old florin

To help the reader in making evaluations, some authors have worked out a rough relationship between the florin of Dürer's time, the less valuable florin or guilder of Rembrandt's time, and the dollar. Perhaps on the basis of the recorded price of a meal in a tavern in Antwerp early in the sixteenth century, in Amsterdam in the middle of the seventeenth century and in New York today, they conclude that Dürer's florin was worth $10 and Rembrandt's $5. This may strictly speaking be true, but one could also say that the relationship is one to a hundred, or even one to a thousand, so much have values, and not only monetary values, changed since then. On his Netherlandish journey Dürer drew on his inexhaustible supplies and sold, gave away or exchanged his engravings and his woodcuts. They were works of art, already in those times sought-after and esteemed, but the concept of prints was different from the one we have today; it still had the meaning of illustration or picture, which it was to maintain for a long time and which for some people it still has today.

Adam Smith

We can learn from Adam Smith that about 1760 the ordinary English workman earned from four to five shillings a week; and a skilled workman, such as a mason, earned from seven to eight shillings a week.[1] This means, assuming full occupation which in those days was unusual, especially for a mason, an annual income of £10 or 12 for most workers and £18 or 20 for skilled workers. In France in 1726, the annual income of a journeyman, for 300 working days of 10 hours each, was not more than 220 livres, including that part of it which was given in kind; in 1794 it was 300.[2] From these amounts about twenty-five per cent must be subtracted for the presumed period of unemployment. Information on the earnings of master builders, bailiffs, clerks or haberdashers is less precise, but it would be fair to suppose that they were not much more than double that of the journeyman; perhaps their income was more certain, with less risk of periods of unemployment. Definitely higher however were the earnings of civil servants,

[1] Adam Smith, *The Wealth of Nations* (London 1961), vol. I, pp. 115-16.
[2] Jean Fourastié, *L'Évolution des prix à long terme* (Paris 1969), pp. 44-50.

professionals, and sometimes writers too, in England more so than on the continent of Europe.[3]

A 'major art'

The nineteenth century was a time of exceptional economic expansion, marked by a sharp rise in wealth, as yet not fairly distributed, and also a slow increase in prices for labour and goods, matched by an almost equally slow decline in the purchasing power of money, which eventually brought about a healthy stability and greater harmony in the social and economic structure.

If we look at the hundred years between the fall of Napoleon and the First World War, and if we consider that in that space of time we passed from an era of horses and carriages to the most amazing inventions man has ever produced, it appears as a long bridge stretching between the old times and the new. During this period printmaking – which, thanks perhaps to the French portrait engravers and in particular to Robert Nanteuil (1623-78) had been raised to the status of an *art majeur* in 1660[4] – finally received the recognition for which it had waited so long.

Prosperity and art

In the United States and in the countries of Europe which interest us most, where art dealing is carried out freely, general prosperity has increased markedly, and the poverty which at one time was widespread has now been transformed into what is, in comparison with the past, genuine well-being. In the last hundred years, production has multiplied in proportions which escape all comparison, while population in the same period and in the same countries has increased only threefold.[5] This could mean that where in 1870 there was one potential purchaser, today there are three; but obviously there are many more, and the amount of money available for spending on inessential goods has also increased enormously.

We have seen that already by about 1900 some of Rembrandt's etchings were realizing up to £3,000. This is a considerable price, if we think that by investing this amount a modest middle-class family could have lived, at the more frugal standards of the age, on the income alone, without touching the capital. Today that sum (taking into consideration the three devaluations of 1933, 1950 and 1968) might perhaps correspond to the £32,000 paid in 1966 for a much less important print.[6] No one would be surprised if an American museum or a wealthy and intelligent collector were willing to spend three or four times that amount in order to secure a fine and important colour etching by Hercules Seghers or a rare Rembrandt subject (for instance the first state of *The Three Crosses* on vellum, or *Rembrandt drawing at a Window*, also in the first state), if by some extraordinary chance one of these turned up at an auction. One need hardly cite the case of the 2,200,000 guineas paid at Christie's in June 1970 for the oil portrait of *Juan de Pareja* by Velasquez: one has only to observe the progress of long-term inflation, which used to creep and is now galloping. Viewed from

3 John Dryden earned £1,200 in 1690 for his translation of Virgil; Alexander Pope earned over £4,000 for his translation of Homer's *Odyssey* and *Iliad*. See George Clark, *The Later Stuarts*, 2nd ed. (London 1956), p. 356. John Fielding received £700 in 1750 for *Tom Jones*; a short time later, partly because of the success of his first novel, he was paid £1,000 for *Amelia*. A very large number of copies were printed of these two novels, which were bought by subscription from bookshops – who were then publishers as well – even before the book came out. The price of a copy to the public varied from ten shillings to £2. For an interesting census of earnings in England in 1686 see 'Gregory King's Tables' in G. Clark, *The Wealth of England 1496-1760* (London 1946), pp. 193-4.
4 By the edict of St-Jean-de-Luz, 1660, Louis XIV promoted the print to the position of liberal art *qui ne peut être assujetti à d'autres règles que celles du génie* (subject to no rules but those of genius), and sanctioned the establishment in France of professorships in engraving. The credit for this decision is ascribed to Robert Nanteuil who, having engraved at least eleven portraits of the king, must have exerted a certain influence on him. After Nanteuil had delivered one of his engraved portraits, Louis XIV told him, *Partez content, Monsieur de Nanteuil, je suis content de Vous* (depart pleased, Monsieur de Nanteuil: I am pleased with you).
5 See the *Grand Dictionnaire Universel du XIXe siècle* (Paris 1865-76), and the *Demographic Yearbook 1969*, published by the Statistical Office of the United Nations (New York 1970).
6 See above, p. 142, n. 5.

Robert Nanteuil, *Louis XIV*, 1664

BEER STREET.

Beer, happy Produce of our Isle
Can sinewy Strength impart,
And wearied with Fatigue and Toil
Can chear each manly Heart.

Labour and Art upheld by Thee
Successfully advance,
We quaff Thy balmy Juice with Glee
And Water leave to France.

Genius of Health, thy grateful Taste
Rivals the Cup of Jove,
And warms each English generous Breast
With Liberty and Love.

Design'd by W. Hogarth. Published according to Act of Parliament Feb. 1. 1751. Price 1.s

William Hogarth, *Beer Street*,
c.1740

Opposite, above:
Honoré Fragonard, *The Family of
Satyrs*, c.1761-4

Below:
Philibert-Louis Debucourt,
Promenade publique, 1792

276

Martin Schongauer, *Virgin in a Courtyard*, c.1475-85

the present day, the sharp rise in prices that occurred in the sixteenth century is almost minimized, although it too originated in a surplus of money. Long-term inflation, of course, does not exclude the possibility of periods of standstill or recession in prices.[7]

Today, when it is easier and more common for governments to slacken or tighten credit controls, the cyclic process of expansion and recession is to a certain extent held in check and suitably adjusted. It was not always like this.

The impassioned phrase *bon marché désespérant* (mouth-wateringly cheap) with which Frits Lugt more than once commented on the result of an important sale in the past, never disturbed or intrigued me so greatly as when I was examining the catastrophic prices recorded at the outstanding sale of treasures belonging to Baron Verstolk van Soelen, carried out in 1847 and 1851 in Amsterdam. The prosperous city was at that time one of the three major centres of art dealing, along with London and Paris. How was it that while collectors had for a number

[7] *I prezzi in Europa dal XIII secolo ad oggi* (Turin 1967), and Earl J. Hamilton, *Metalli preziosi d'America e prezzi in Andalusia, Studio sulla rivoluzione dei prezzi in Spagna*, pp. 153-84.

Opposite:
Jacques Bellange, *The Adoration of the Magi*, c.1610

278

Left:
Anders Zorn, *The Toast*, 1893

Below:
Paul Helleu, *Marcel Proust on his Death-bed*, 1922

Opposite:
Giovanni Boldini, *Portrait of Paul Helleu*, c.1900

of years been combing Europe for important engravings, the most rare and finest works of graphic art available at the time were overlooked to such an extent that years earlier less valuable impressions by the same artists had fetched a great deal more? The prime reason for the outcome of the sale lies in the fact that 1847 and 1851 were troubled years for the whole of Europe; they represented the peak of a crisis, the famine of the 'hungry forties', during which mass emigration to America increased threefold.[8] It is therefore understandable that prices for works of art reflected the recession to a very marked degree.

Landscape was a product of the romantic movement, and it was the English who discovered it. Until just over a hundred years ago, incredible though it may seem, man had shown an almost complete lack of interest in the beauties of nature. Today we cannot do without them. This shows clearly that fashion is a phenomenon which really does exist and which can be investigated as an objective fact.

We must begin by acknowledging our debt to education. It is this which by increasing our knowledge and stimulating our curiosity enables us to investigate and to evaluate with greater knowledge and judgment those things which would otherwise leave us indifferent. It is thanks to education that our interests, instead of remaining within a limited sphere, can multiply, and that our liking for painting can be extended to engravings and drawings, and that a preference for early works is no longer incompatible with an interest in modern works and vice versa. Naturally there must also be what is perhaps the innate gift of sensitivity; and taste, which, though it may change from one decade to another, is a special factor. Nevertheless some of the rapid changes in the attitude to particular prints, which emerged so clearly from several examples I have given, can be explained only by the phenomenon of fashion. It was fashion, for instance, that created the popularity of Marcantonio Raimondi and sustained it for nearly a century, and then brought about his fall, almost overnight, perhaps more finally than he deserved. Only fashion could have clouded the mind and vision of the many collectors who for over half a century sacrificed the most illustrious masters in order to acquire, for huge sums, Morghen's *Last Supper*.

There are, however, many other outstanding cases which are more perplexing. The great Martin Schongauer who, at the Duke of Buckingham's sale in 1834, was considered so much less important than Wenzel Hollar (1607-77), was forty-one years later, at the Kalle sale in 1875, promoted to the ranks of the great masters. Dürer's case is even more extraordinary: in the sixteenth century he was regarded as the greatest engraver of the age, and in the seventeenth century he was much esteemed by Rembrandt, but in 1775, at the Mariette sale, he was classified among what were almost the least important artists. Over the next 135 years his fortunes steadily improved until finally in 1910, at the Theobald sale, he regained the fame which had been his exactly four centuries earlier. The fortunes of Lucas van Leyden have undergone similar changes, though he was not perhaps neglected for quite so long. The creative Italian engravers suffered greatly from comparison with their fellows who engraved reproductions, but in the end they too won recognition. The brilliant Callot, eclipsed for so long by his excellent pupil Della Bella, re-established himself only in the middle of this century. We have already seen the change in attitude to the Venetian masters, Goya and Bellange, and others whose recognition was late in coming.

[8] *The New Cambridge Modern History*, vol. x (London 1967): see Herbert Heaton, 'Economic Change and Growth', chapter 11, p. 26 ff. See also André Armegaud, *Population in Europe 1700-1914* (London 1970), p. 57: 'Following the economic crises of 1845-48, emigration from Europe suddenly jumped to 200,000 and even 300,000 persons a year.'

James Ensor, *The Cathedral*, 1896

The case of Hercules Seghers is different. The extreme rarity of his sheets and the difficulty which nineteenth-century collectors had in understanding his art, combined with the fact that since early times practically all his *œuvre* has been housed in the Rijksprentenkabinet in Amsterdam, delayed appreciation of his work. The varying fortunes of French and English colour prints are easier to understand.

Rembrandt is, as always, different from all the other artists. His etchings are unique in the long history of prints, in that for three hundred years interest in them has been uninterrupted, and has only increased with the passing of time.

Engravings by Legros, Liebermann, Klinger and Forain are no longer sought after, and those of Anders Zorn are much less popular than they were at one time. James Ensor (1860-1949) made his etchings during the last ten years of the nineteenth century, but it is only in very recent years that they have been appreciated. Meryon today may attract a little less attention than he did; but it is difficult to assess his position because his finest work, in the rare and good quality states, is no longer in circulation.[9] Whistler is definitely more prized. Some contemporary engravers, who at the beginning of the fifties enjoyed great popularity, now leave us quite indifferent; as perhaps do early *niello* engravings, whose value lies mainly in their rarity.

There are second-rate impressions for which the art lover is prepared to make a sacrifice, but only out of homage to a great name such as Dürer, Rembrandt or Picasso. And finally, there are reappraisals. Harold Joachim, in drawing attention a few years ago to some prints by so-called minor engravers – Buhot, Bracquemond, Boldini, Helleu and others – who had been overlooked because they were working during the long years of the depression and then gave way to more brilliant artists, concluded that they are 'artists who, after all, have much to offer those who have eyes to see and the intelligence to understand.'[10]

Most of the innumerable artists who have fallen from popularity, perhaps for ever, are ignored: *The Times*-Sotheby's index, I believe, does not take them into account.

Interest in a particular subject may change: tastes can vary, become more refined; and they can differ from one country to another. Italians for example have a loathing for the skeletons of Rouault's *Miserere*; English and Americans on the other hand like them very much. Picasso as a Cubist is much admired, but does not command high prices: while his colour linocut *Bust of a Woman after Cranach* now arouses unprecedented enthusiasm and praise, the early *Repas frugal* of 1904 is still the most popular modern print, even with collectors who are interested only in abstract art.

Prices for *The Three Crosses*, from the seventeenth century until after the Rudge sale in 1924, have clearly shown that the more discerning collectors preferred at least fifty other etchings by Rembrandt to this one. Today, however, it is rightly regarded as the supreme masterpiece of graphic art. The so-called *Twenty Guilder* and *Thirty Guilder Prints*,[11] which used to fetch high prices, are now much less prized than *The Blindness of Tobit* or *The Agony in the Garden*.

[9] The third state out of nine of the *Rue des Toiles à Bourges*, one of Meryon's least sought-after subjects, was fiercely contended at Berne in 1969 and realized 3,700 Swiss francs ($860).
[10] *Forgotten Printmakers of the 19th Century*, Kovler Gallery, Chicago, 1967-8.
[11] See above, p. 184.

Select bibliography

Index of illustrations

Index of names

Select bibliography

Abbreviations: the books listed below are standard works, normally referred to by the initial letter or letters of the author's name, and this convention has been followed in the present work. Where two authors share the same initial, the relevant title can easily be identified by the subject

A. Andreas Andresen, *Der deutsche Peintre-graveur*, 5 vols., Leipzig 1875-82

B. Adam Bartsch, *Catalogue raisonné de toutes les estampes qui forment l'œuvre de Rembrandt*, etc., 2 vols., Vienna 1797

B. Adam Bartsch, *Le Peintre graveur*, 21 vols., Vienna 1803-21

B. René van Bastelaer, *Les Estampes de Peter Bruegel l'ancien*, Brussels 1908

B.-B. George Biörklund and Osbert H. Barnard, *Rembrandt's Etchings, True and False*, 2nd ed., Stockholm, London & New York 1968

Bl. Georges Bloch, *Picasso. Catalogue de l'œuvre gravé et lithographié 1904-67*, Berne 1968

Cr. A. Croquez, *L'Œuvre gravé de James Ensor*, Paris 1935

C. Hans Curjel, *Hans Baldung Grien*, Munich 1923

D. Loÿs Delteil, *Le Peintre-graveur illustré*, 32 vols., Paris 1906-26

D.-W. L. Delteil and H. J. L. Wright, *Catalogue raisonné of the Etchings of Charles Meryon*, London & New York 1924

D. Eugène Dutuit, *Manuel de l'amateur d'estampes*, 5 vols., Paris 1881-8

G. Bernhard Geiser, *Picasso, peintre-graveur*, 2 vols., Berne 1955-68

G. M. Guérin, *L'Œuvre gravé de Gauguin*, 2 vols., Paris 1927

H. Tomás Harris, *Goya. Engravings and Lithographs*, 2 vols., Oxford 1964

H. Arthur M. Hind, *A Catalogue of Rembrandt's Etchings*, 2nd ed., 2 vols., London 1923

H. Arthur M. Hind, *Early Italian Engraving, A critical catalogue...*, 7 vols. (2 of text, 5 of plates). London 1938, 1948

H. Arthur M. Hind, *Giovanni Battista Piranesi. A critical study*, London 1922

H. or F. W. H. Hollstein, ed., *Dutch and Flemish Etchings, Engravings and Woodcuts*
Holl. (1450-1700) 19 vols. to date, Amsterdam 1949 etc. White and Boon's major
 work on Rembrandt (see White, below) is in the Hollstein series

H. or F. W. H. Hollstein, ed., *German Engravings, Etchings and Woodcuts, ca. 1400-*
Holl. *1700*, 8 vols. to date, Amsterdam 1954 etc.

 L. Max Lehrs, *Geschichte und kritischer Katalog des deutschen, niederländischen und
 französischen Kupferstichs im XV. Jahrhundert*, 9 vols. with portfolios,
 Vienna 1908-34

 L. Jules Lieure, *Jacques Callot*, 5 vols., Paris 1924-9

 L. Frits Lugt, *Les Marques de collections*, vol. I, Amsterdam 1921; vol. II,
 The Hague 1956

M.-H. M. Mauquoy-Hendrickx, *L'Iconographie d'Antoine van Dyck*, 2 pt., Brussels
 1956

 M. Joseph Meder, *Dürer-Katalog*, Vienna 1932

 M. André Mellerio, *Odilon Redon, Catalogue de l'œuvre gravé et lithographié*,
 Paris 1913

 M. Fernand Mourlot, *Picasso lithographe*, 4 vols., Monte Carlo 1949-64

 P.-G. R. Pallucchini and G. F. Guarnati, *Le acqueforti del Canaletto*, Venice 1944

 R.-D. A.-P.-F. Robert-Dumesnil, *Le Peintre-graveur français*

 R.-M. Claude Roger-Marx, *Bonnard lithographe*, Monte Carlo 1952

 R.-M. Claude Roger-Marx, *L'Œuvre gravé de Vuillard*, Monte Carlo 1948

 Sch. Gustav Schiefler, *Die Graphik Ernst Ludwig Kirchners*, 2 vols., Berlin 1916,
 1917-27

 Sch. Gustav Schiefler, *Verzeichnis des graphischen Werkes Edvard Munchs*, 2 vols.,
 Berlin 1907-28

 Sch. Gustav Schiefler, *Das graphische Werk von Emil Nolde*, Berlin 1911-27

 Schr. Wilhelm Ludwig Schreiber, *Handbuch der Holz- und Metallschnitte des
 XV. Jahrhunderts*, 8 vols., Leipzig 1926-30

 V. Alessandro Bandi di Vesme, *Le Peintre-graveur italien*, Milan 1906

 V. Lamberto Vitali, *L'opera grafica di Giorgio Morandi*, rev. ed., Turin 1964

 see Christopher White and Karel G. Boon, *Rembrandt's Etchings, an illustrated
Holl. critical catalogue*, 2 vols., Amsterdam 1969. In the Hollstein series

 W. G. Wildenstein, *Fragonard, aquafortiste*, Paris 1956

 W. Franz Winzinger, *Albrecht Altdorfer Graphik*, Munich 1963

Index of illustrations

Measurements are given in centimetres, with inches in brackets; height precedes width. Letter and number references ('B. 268', etc.) are to books listed in the Bibliography, overleaf: states follow, in roman numerals ('I/IV' means first of four states)

ALDEGREVER, HEINRICH *Spoons with ornamental handles, c.* 1540; engraving, 6.2 × 9.5 ($2^7/_{16}$ × $3^3/_4$). B. 268. London, Sotheby's *page* **67**

ALTDORFER, ALBRECHT *The Beautiful Virgin of Ratisbon,* 1519-20; colour woodcut, 34 × 24.5 ($13^3/_8$ × $9^5/_8$). W. 89, 84. British Museum, London **245**
Christ raised on the Cross, c. 1515 **245**

AMMAN, JOST *The Papermaker, c.* 1565; woodcut. B. 381, 8. Published in H. Schopperus, *Panoplia...,* Frankfurt 1568 **37**

ANDREA, ZOAN *see* MANTEGNA

ANONYMOUS BAVARIAN MASTER *The Martyrdom of St Sebastian, c.* 1410-20; woodcut incunabulum, coloured, 26.5 × 20 ($10^7/_{16}$ × $7^7/_8$). Schr. 1677. Staatliche Graphische Sammlung, Munich *facing p.* **16**

ANONYMOUS MASTER FROM COLOGNE *St Roch, c.* 1460-70; dotted print, coloured, 23.5 × 18 ($9^1/_4$ × $7^1/_{16}$). Schr. 2722. Biblioteca Classense, Ravenna **13**

ANONYMOUS FLORENTINE ENGRAVER *Gentleman, Lady and Musician, c.* 1470-80; engraving, diam. 13.7 ($5^3/_8$). H. 18. British Museum, London **33**

ANONYMOUS VENETIAN MASTER *St Anthony of Padua, c.* 1460-70; woodcut incunabulum, coloured, 28 × 20.2 (11 × $7^{15}/_{16}$). Schr. 1233. Biblioteca Classense, Ravenna *facing p.* **32**

AUDUBON, JOHN JAMES *Wood Ibis, c.* 1825; colour aquatint, 96.3 × 63.7 ($37^7/_8$ × $25^1/_8$). Field Museum of Natural History, Chicago (photo Sotheby's, London)
246

289

BALDUNG GRIEN, HANS *St Christopher*, c. 1511; woodcut, 35.8×26.5 (14^1/$_8$× 10^7/$_{16}$). B. 38. British Museum, London **10**
The Witches, 1510; colour woodcut, 37.7×26 (14^7/$_8$×10^1/$_4$). B. 55. Staatliche Graphische Sammlung, Munich *facing p.* **48**

BARBARI, JACOPO DE' *Pegasus*, c. 1500; engraving, 15.5×22.7 (6^1/$_8$×8^{15}/$_{16}$). H. 29. Rijksprentenkabinet, Rijksmuseum, Amsterdam **105**
Victory and Fame, c. 1500; engraving, 18.2×12.3 (7^3/$_{16}$×4^7/$_8$). H. 26. Cabinet Rothschild, Louvre, Paris **67**

BAROCCI, FEDERICO *Virgin and Child in the Clouds*, c. 1590; etching, 14.5×10 (5^{11}/$_{16}$×3^{15}/$_{16}$). B.3,2. Private collection **104**

BECCAFUMI, DOMENICO *St Peter*, c. 1520-40, chiaroscuro woodcut, 39×18 (15^3/$_8$×7^1/$_8$). National Gallery of Art, Melbourne (photo P.&D. Colnaghi, London) **10**

BECKMANN, MAX *Jacob wrestling with the Angel*, 1920; etching, 28.6×22 (11^1/$_4$×8^3/$_4$). Kupferstichkabinett, Staatliche Kunstsammlungen, Dresden (photo Deutsche Fotothek, Dresden) **120**

BELLANGE, JACQUES *The Adoration of the Magi*, c. 1610; etching, 59.4×42.4 (23^3/$_8$×16^3/$_4$). R.-D. 2, state not described, precedes the first of three. Craddock & Barnard, London **279**

BELLOTTO, BERNARDO *View of the Bridge at Dresden on the Elbe*, 1748; etching, 53.9×83.3 (21^1/$_4$×32^3/$_4$). V. 12, I/IV. Kupferstichkabinett, Staatliche Museen, Berlin **53**

BLAKE, WILLIAM *Ezekiel*, 1794; engraving, 46.5×54.5 (18^1/$_4$×21^1/$_2$). K. VIII. British Museum, London **187**
The House of Death, 1795; colour monotype, 48×60.5 (19^1/$_8$×24). Tate Gallery, London *facing p.* **64**
Illustrations from *The Song of Los*, 1795; relief etching, 24×17 (9^7/$_{16}$×6^{11}/$_{16}$). Lessing Julius Rosenwald Collection, Library of Congress, Washington, D.C. **16, 17**

BOLDINI, GIOVANNI *Portrait of Paul Helleu*, c. 1900; etching, 39×32 (15^3/$_8$×12^5/$_8$). Kovler Gallery, Chicago, Ill. **281**

BONNARD, PIERRE *Paravent in four sections*, 1899; colour lithograph, 150×200 (4 ft 11 ×6 ft 6^3/$_4$). R.-M. 47. Christie, Manson & Woods, London **198**
La Petite Blanchisseuse, 1896; colour lithograph, 30×19 (11^3/$_4$×7^1/$_2$). R.-M. 42. Bibliothèque Nationale, Paris *facing p.* **208**

BONNET, LOUIS-MARIN *The Charms of the Morning*, c. 1775. Colour print (imitation of pastel), 29×23.1 (11^3/$_8$×9^1/$_{16}$). H. 298. Kunstsammlung der Veste Coburg, Coburg *facing p.* **112**

BOSSE, ABRAHAM *The Engravers*, 1642; etching and engraving, 25.7×32.9 (10^1/$_8$× 13). Bl. 356. British Museum, London **8**
Printing a line engraving, 1642; etching and engraving, 25.9×31.7 (10^3/$_{16}$×12^1/$_2$). Bl. 205. British Museum, London **5**

BRAQUE, GEORGES *Fox*, 1911; etching, 54.5×37.5 (21^1/$_2$×14^3/$_4$). H.5. Bibliothèque Nationale, Paris **123**

BRESDIN, RODOLPHE *The Comedy of Death*, 1843; lithograph, 15×24 (5^7/$_8$×9^1/$_2$). B. 44. Paul Prouté Collection, Paris **192**
The Holy Family, 1855; lithograph, 56.5×44.5 (22^1/$_4$×17^1/$_2$) B. 53. Paul Prouté Collection, Paris **193**

BRUEGEL, PIETER THE ELDER *A Man of War, seen from behind at an angle*, 1564-5 (Th. Galle excud.); engraving and etching, 25 × 28.7 (9⁷/₈ × 11⁵/₁₆). B. 101. Sotheby's, London **103**
The Rabbit Hunt, 1566; engraving and etching, 21.8 × 29 (8⁹/₁₆ × 11³/₈). B.1. Rijksprentenkabinet, Rijksmuseum, Amsterdam **144**

BURGKMAIR, HANS *The Emperor Maximilian on horseback*, 1508; colour woodcut, 32.3 × 22.7 (12³/₄ × 8¹⁵/₁₆). B. 32. Kupferstichkabinett, Staatliche Museen, Berlin **11**

BUYTEWECH, WILLEM *Landscape*, c. 1615; etching, 8.8 × 12.8 (3¹/₂ × 5¹/₁₆). H. 40, I/III. Sotheby's, London **144**

CALLOT, JACQUES *The Fair at Gondreville*, 1624; etching, 18.2 × 33.3 (7¹/₈ × 13¹/₈). L. 561, I/IV. British Museum, London **106**
The Organ Grinder, from the *Beggars*, 1622; etching. L.480 **250**
The Temptation of St Anthony (second plate, detail), 1634; etching, 36 × 33.3 (14³/₈ × 13¹/₈). L. 1416, I-II/V. British Museum, London **107**

CAMPAGNOLA, GIULIO *Christ and the Woman of Samaria*, c. 1505, engraving, 13 × 18.6 (5¹/₈ × 7⁵/₁₆). H. 11, I/II. Albertina, Vienna **23**
Nude in a Landscape, c. 1505; engraving, 12 × 17 (4³/₄ × 6¹¹/₁₆). H. 13. Cabinet Rothschild, Louvre, Paris **265**

CANALETTO (ANTONIO CANAL) *Imaginary View of Venice*, c. 1743; etching, 29.9 × 43.5 (11³/₄ × 17¹/₈). P.-G. 12, I/II, undivided plate. Christie, Manson & Woods, London **146**
La Piera del Bando V. (enezia), c. 1743; etching, 14.3 × 21 (5⁵/₈ × 8¹/₄). P.-G. 17. Private collection **92**
La Preson. V. (enezia), c. 1743; etching, 14.3 × 21 (5⁵/₈ × 8¹/₄). P.-G. 14. Private collection **93**
Town on a Riverbank, c. 1743; etching, 29.9 × 43 (11³/₄ × 16⁷/₈). P.-G. 9, I/II. Private collection **48**

CARPI, UGO DA *Diogenes*, c. 1520-30; chiaroscuro woodcut, 48 × 34.8 (18⁷/₈ × 13³/₄). B. 10. Rijksprentenkabinet, Rijksmuseum, Amsterdam *facing p.* **80**

CASTIGLIONE, GIOVANNI BENEDETTO (GRECHETTO) *Old Man with a Long Beard*, c. 1650; etching, 17 × 13.8 (6¹¹/₁₆ × 5⁷/₁₆). B. 50. Rijksprentenkabinet, Rijksmuseum, Amsterdam **23**

CHAGALL, MARC *Chanticleer and the Fox*, from the *Fables of La Fontaine*, c. 1928; etching, 32.5 × 25 (12³/₄ × 9⁷/₈). Private collection **125**
The House at Peskowatik, from *Mein Leben*, 1923; etching, 21 × 18 (8¹/₄ × 7¹/₁₆). Private collection **125**

CLAUDE LORRAIN (CLAUDE GELLÉE) *Leaving for the Fields*, c. 1640; etching, 12.5 × 17.5 (4¹⁵/₁₆ × 6⁷/₈). R.-D. 16, I/IV. Paul Prouté Collection, Paris **108**

COROT, JEAN-BAPTISTE-CAMILLE *Willows and White Poplars*, 1871; lithograph, 25.8 × 39.3 (10¹/₈ × 15¹/₂). D. 30. Paul Prouté Collection, Paris **26**

CRANACH, LUCAS THE ELDER *St George and the Dragon*, c. 1510; woodcut, 15 × 12.4 (5¹⁵/₁₆ × 4⁷/₈). B. 64. Cabinet Rothschild, Louvre, Paris **244**
The Temptation of St Anthony, 1506; woodcut, 40.8 × 27.9 (16¹/₈ × 11). B. 56. Sotheby's, London **68**

DAUMIER, HONORÉ *A Demosthenic Oration*, from *Gens de Justice*, 1847; lithograph, 19 × 25.5 (7¹/₂ × 10¹/₁₆). D. 1379. Private collection **190**
Landscape Painters at Work, 1862; lithograph, 20.7 × 26.8 (8¹/₁₆ × 10⁹/₁₆). D. 3251. Private collection **190**

DEBUCOURT, PHILIBERT-LOUIS *Promenade publique*, 1792; colour aquatint, 63.5 × 45.5 (25 × 17⁷/₈). F. 33. Widener Collection, National Gallery of Art, Washington, D.C. **277**

DEGAS, EDGAR *Chanteuse de café-concert, c.* 1875; etching, 25.2 × 19.2 ($9^7/_8$ × $7^1/_2$). D.53, I/II. Paul Prouté Collection, Paris **237**
Self-portrait, 1855; etching, 23.1 × 14.3 ($9^1/_8$ × $5^5/_8$). D.1, III/V. Joseph Brooks Fair Collection, Art Institute of Chicago *Frontispiece*
La Sortie du bain, petite planche, 1890; lithograph, 22.1 × 24.5 ($8^3/_4$ × $9^5/_8$). D. 63. Private collection **168**

DELACROIX, EUGÈNE *Lion from the Atlas Mountains,* 1829; lithograph, 33.1 × 46.6 (13 × $18^3/_8$). D. 79, III/IV. Paul Prouté Collection, Paris **229**
Royal Tiger, 1829; lithograph, 32.6 × 46.5 ($12^7/_8$ × $18^1/_4$). D. 80, II/IV. Paul Prouté Collection, Paris **229**

DELLA BELLA, STEFANO Plate from *Paysages divers,* 1643; etching, 11.2 × 25.8 ($4^3/_8$ × $10^3/_{16}$). V. 758. Private collection **106**
Sultana, 1650; etching, 9.8 × 7.5 ($3^7/_8$ × $2^{15}/_{16}$). V. 188. Private collection **255**

DÜRER, ALBRECHT *Adam and Eve,* 1504; engraving, 25.2 × 19.4 ($9^7/_8$ × $7^5/_8$). M.1, B.1, IIa/III (H. IV/V). British Museum, London **179**
The Annunciation, c. 1510, from the *Small Passion* of 1511; woodcut, 12.8 × 9.9 (5 × $3^7/_8$). B. 19. Detail of dove, in original (above) and Mommard copy (below) **77**
Cardinal Albrecht of Brandenburg (The Small Cardinal), detail, 1519; engraving, 14.8 × 9.6 ($5^3/_4$ × $3^3/_4$). B. 102. **177**
Coat of Arms of Death (Shield with a Skull), c. 1503; engraving, 22 × 16 ($8^5/_8$ × $6^5/_{16}$). M. 98 A/D (B. 101). Rijksprentenkabinet, Rijksmuseum, Amsterdam **176**
The Four Horsemen of the Apocalypse, c. 1497; woodcut before the text, 39.2 × 28.2 ($15^1/_2$ × $11^1/_8$). M. 167, B. 64. Private collection **101**
Galloping Rider (The Small Courier), c. 1496; engraving, 11 × 7.8 ($4^3/_8$ × $3^1/_{16}$). M. 79 A/E, B.80. Sotheby's, London **128**
The Knight, Death and the Devil, 1513; engraving, 24.6 × 19 ($9^{11}/_{16}$ × $7^1/_2$). M. 74 B/G, B. 98. Christie, Manson & Woods, London **59**
Lion lying down, 1521; silverpoint drawing, about 12 × 17 ($4^3/_4$ × $6^{11}/_{16}$). W. 781. Albertina, Vienna *facing p.* **64**
Madonna with a Pear, 1511; engraving, 15.8 × 10.6 ($6^3/_{16}$ × $4^3/_{16}$). M. 33 B/C, B. 41. Private collection **128**
Willibald Pirckheimer, 1524; engraving, 18.2 × 11.5 ($7^3/_{16}$ × $4^1/_2$) M. 103, B. 106, Ib/II. Kupferstichkabinett, Staatliche Museen, Berlin **177**
St Eustace, c. 1501; engraving, 35.9 × 26.2 ($14^1/_8$ × $10^5/_{16}$). M. 60 B-C/K, B. 57. Sotheby's, London **46**
St Jerome by a Pollard Willow, 1512; drypoint, 21 × 18.3 ($8^1/_4$ × $7^3/_{16}$). M. 58, B.59, II/III. Rijksprentenkabinet, Rijksmuseum, Amsterdam **21**
St Jerome in a Cave, 1512; woodcut, 16.4 × 11.7 ($6^7/_{16}$ × $4^5/_8$). M. 229, B. 113. Ia/II, left; and Ic/II (Museum of Fine Arts, Boston, Harvey D. Parker Collection), right **102**
St Jerome in Penitence, c. 1496; engraving, 32.4 × 22.8 ($12^3/_4$ × 9). Detail reversed to show watermark. M. 57 B/G, B. 61. Private collection **45, 129**
St Jerome in his Study, 1514; engraving, 24.7 × 18.8 ($9^3/_4$ × $7^3/_8$). M. 59, B-C/F, B.60. Private collection **98**
Standard Bearer, c. 1500; engraving, 11.6 × 7.2 ($4^9/_{16}$ × $2^{13}/_{16}$). M. 92 A/C, B. 87. Rijksprentenkabinet, Rijksmuseum, Amsterdam **128**

DUVET, JEAN *Christ on a White Horse,* from the Apocalypse, *c.* 1550; engraving, 30.3 × 21.2 ($11^7/_8$ × $8^5/_{16}$). R.-D. 23, 45. Sotheby's, London **155**

ENSOR, JAMES *The Cathedral,* 1896; etching, 24.6 × 19 ($9^{11}/_{16}$ × $7^1/_2$). Cr. 7bis. Private collection **282**

FATTORI, GIOVANNI *Tuscan Landscape, c.* 1890; etching, 17.5 × 32.8 ($6^7/_8$ × $12^7/_8$). Uffizi, Florence **203**

FEININGER, LYONEL *Lüneburg,* 1924; woodcut, 24.5 × 40.6 ($9^5/_8$ × 16). Private collection **238**

FERRARESE MASTER OF THE TAROCCHI, *Talia XVI*, from 'Apollo and the Muses', *c.* 1465; engraving, 18×10 (7¹/₁₆×3¹⁵/₁₆). H.E.I 16a. British Museum, London
218

Poesia XXVII, from 'The Arts and Sciences', *c.* 1465; engraving, 18×10 (7¹/₁₆×3¹⁵/₁₆). H.E.I 27a. British Museum, London **218**

FRAGONARD, HONORÉ *The Family of Satyrs, c.* 1761-4; etching, 13.4×20.4 (5³/₈×8). W.4, II. Kupferstichkabinett, Staatliche Museen, Berlin **277**

GAUGUIN, PAUL *Manao Tupapau (Elle pense au revenant), c.* 1892; wood engraving, 20.3×36.2 (8×14¹/₄). G. 19, II, 20. Bibliothèque Nationale, Paris **238**
Nave Nave Fenua (Terre délicieuse), c. 1894; wood engraving, coloured, 34.5×20.5 (13⁵/₈×8¹/₁₆). G. 29. Paul Prouté Collection, Paris **118**

GÉRICAULT, THÉODORE *The Flemish Farrier*, 1821; lithograph, 22.7×31.5 (8¹⁵/₁₆×12⁷/₁₆). Bibliothèque Nationale, Paris **189**

GHISI, GIORGIO *'The Dream of Raphael'*, 1561; engraving, 38×54 (15×21¹/₄). B. 67. Rijksprentenkabinet, Rijksmuseum, Amsterdam **18**

GOLTZIUS, HENDRIK *Arcadian Landscape, c.* 1595; colour woodcut, 17.9×24 (7¹/₁₆×9⁷/₁₆). B. 241. Rijksprentenkabinet, Rijksmuseum, Amsterdam
facing p. **96**

GOYA, FRANCISCO *Blind Man with a Guitar, c.* 1778; etching, 39.5×57 (15¹/₂×22¹/₂). H. 20. British Museum, London **147**
The Colossus, c. 1815; mezzotint, 28.5×21 (11³/₁₆×8¹/₄). H. 29, II. Bibliothèque Nationale, Paris **147**
The Divided Ring (Plaza partida), from the *Toros de Burdeos*, 1825; lithograph, 30×41 (11¹³/₁₆×16¹/₈). H. 286. Lessing Julius Rosenwald Collection, National Gallery of Art, Washington, D.C. **266**
The Famous American, Mariano Ceballos, from the *Toros de Burdeos*, 1825; lithograph, 30.5×40 (12×15³/₄). H. 283. Lessing Julius Rosenwald Collection, National Gallery of Art, Washington, D.C. **267**
Landscape with Buildings and Trees, before 1810; etching and aquatint, 16.5×28.5 (6¹/₂×11¹/₈). H. 23, experimental proof. Biblioteca Nacional, Madrid **148**
Landscape with a Waterfall, before 1810; etching and aquatint, 15.6×28.5 (6¹/₈×11¹/₈). H. 23, experimental proof. Biblioteca Nacional, Madrid **149**
Ni por esas, from the *Desastres de la Guerra, c.* 1810-20; etching, pencil, drypoint and engraving, 16×21 (6⁵/₁₆×8¹/₄). H.131. Gabinetto delle Stampe, Milan **166**
Ruega por ella, from the *Caprichos, c.* 1797; etching, drypoint and engraving, 20.5×15 (8¹/₁₆×5¹⁵/₁₆). H. 66, 1st edition. Private collection **186**

HARUNOBU, SUZUKI *Girls reading a Poem, c.* 1750; colour woodcut, 24×19.5 (9⁷/₁₆×7¹¹/₁₆). British Museum, London **14**

HECKEL, ERICH *Self-portrait*, 1919; colour woodcut, 46×32.7 (28¹/₈×12⁷/₈). D.318, III. Baltimore Museum of Art, Baltimore, Maryland, Blanche Adler Foundation **120**

HELLEU, PAUL *Marcel Proust on his Death-bed*, 1922; drypoint, 33.7×54.5 (13¹/₄×21¹/₂). Sotheby's, London **280**

HOGARTH, WILLIAM *Beer Street, c.* 1740; etching and engraving, 38.7×32.3 (15¹/₄×12³/₄). British Museum, London **276**

HOLBEIN, HANS THE YOUNGER *Death and the Prince*, from the *Dance of Death, c.* 1523-6; woodcut **8**

HOWITT, SAMUEL *Pheasant Shooting*, from *Orme's British Field Sports, c.* 1804, publ. 1807-8; coloured aquatint, 30.5×44.5 (12×17¹/₂). Sotheby's, London **114**

Kirchner, Ernst Ludwig *Little Mountain Boy in the Sirocco*, 1919; woodcut, 58 × 37 (22$^7/_8$ × 14$^5/_8$). Kupferstichkabinett, Staatliche Museen, Berlin **121**
Portrait of Dr Grisebach, 1917; woodcut, 33.8 × 28.5 (13$^1/_4$ × 11$^3/_{16}$). Kupferstichkabinett, Staatliche Kunstsammlungen, Dresden (photo Deutsche Fotothek, Dresden) **120**

Klee, Paul *The Tightrope Walker*, 1923; colour lithograph, 75 × 63 (29$^1/_2$ × 24$^3/_4$). Staatliche Graphische Sammlung, Munich **123**

Lucas van Leyden *The Milkmaid*, 1510; engraving, 11.5 × 15.5 (4$^1/_2$ × 6$^1/_8$). B. 158. British Museum, London **103**
Portrait of the Emperor Maximilian, c. 1518; pen and brush drawing, 25.5 × 18.2 (10$^1/_{16}$ × 7$^3/_{16}$). Fondation Custodia (coll. F. Lugt), Institut Néerlandais, Paris **216**
Portrait of the Emperor Maximilian, 1520; engraving, 26.1 × 19.7 (10$^3/_8$ × 7$^3/_4$). B. 172. Rijksprentenkabinet, Rijksmuseum, Amsterdam **216**
St George freeing the Princess, 1508; engraving, 16.3 × 11.6 (6$^3/_8$ × 4$^1/_2$). B. 121. P. & D. Colnaghi, London **82**
Susanna and the Two Elders, 1508; engraving, 19.7 × 14.6 (7$^3/_4$ × 5$^3/_4$). B. 33. British Museum, London **102**

Manet, Edouard *The Cats' Rendezvous*, 1868; lithograph, 43.6 × 33.5 (17$^1/_8$ × 13$^1/_4$). Paul Prouté Collection, Paris **191**
The Races, 1864; lithograph, 36.5 × 51 (14$^3/_8$ × 20$^1/_8$). G. 72, I/II. Bibliothèque Nationale, Paris **227**

Mantegna, Andrea *The Battle of the Sea Gods* (left part of the frieze), 1493; engraving, 27.8 × 41.2 (10$^{15}/_{16}$ × 16$^1/_4$). H. 5. Rijksprentenkabinet, Rijksmuseum, Amsterdam **58**
The Risen Christ between St Andrew and St Longinus, c. 1500; engraving, 43.8 × 34 (17$^1/_4$ × 13$^3/_8$). H. 7. Rijksprentenkabinet, Rijksmuseum, Amsterdam **86**
Virgin and Child, c. 1450-70; engraving, 34.5 × 26 (13$^5/_8$ × 10$^1/_4$). H. 1, I/II (before the halo). British Museum, London **87**

Mantegna, School of (Zoan Andrea ?) *Silenus with Putti*, c. 1490-1500; engraving, 16.3 × 23.6 (6$^7/_{16}$ × 9$^5/_{16}$). H. 24a. Rijksprentenkabinet, Rijksmuseum, Amsterdam **98**

Master E.S. *The Letter M*, c. 1464-7; engraving, 14.4 × 18.2 (5$^{11}/_{16}$ × 7$^3/_{16}$). L. 294. Sotheby's, London **141**
The Virgin praying, half-length, 1467; engraving, 14.6 × 12 (5$^3/_4$ × 4$^{11}/_{16}$). L. 60 British Museum, London **141**
Two Men, from the Large Playing Cards, 1463; engraving, 12.8 × 8.7 (5$^1/_{16}$ × 3$^3/_8$). L. 241. Pinacoteca Nazionale, Bologna **64**

Master I. A. M. of Zwolle *The Adoration of the Magi*, c. 1485-90; engraving, 35.3 × 24 (13$^7/_8$ × 9$^7/_{16}$). L. 1. Paul Prouté Collection, Paris **65**
St George and the Dragon, c. 1485-90; engraving, 20.6 × 14 (8$^1/_8$ × 5$^1/_2$). L. 17, detail. Rijksprentenkabinet, Rijksmuseum, Amsterdam **66**

Master P. M. *Women bathing*, c. 1485; engraving, 19.6 × 16.3 (7$^3/_4$ × 6$^7/_{16}$). L. 2709a. Sotheby's, London **143**

Master P. W. *The Columbine Foot-soldier*, c. 1500; engraved playing card **63**

Master W. A. *Bishop's Crosier* (upper part), c. 1470; engraving, 34.5 × 19.3 (13$^5/_8$ × 7$^9/_{16}$). L. 49. Albertina, Vienna **141**

Master of the Housebook *Christ bearing the Cross*, c. 1480; engraving and drypoint, 12.8 × 19.3 (5$^1/_{16}$ × 7$^5/_8$). L. 13. Rijksprentenkabinet, Rijksmuseum, Amsterdam **19**
The Idolatry of Solomon, c. 1480; engraving, diam. 15.5 (16$^1/_8$). L. 85. Rijksprentenkabinet, Rijksmuseum, Amsterdam **140**

The Young Man and Death, c. 1480; engraving, 16.7×10.7 (6⁵/₈×4³/₁₆). L. 53. Rijksprentenkabinet, Rijksmuseum, Amsterdam **140**

MASTER OF THE PLAYING CARDS *King of the Wild Men*, c. 1450; engraving, 13.3×9 (5¹/₄×3⁹/₁₆). L. 58. Kupferstichkabinett, Staatliche Museen, Berlin **64**

MASTER OF THE RAVENNA LAST SUPPER *The Last Supper*, c. 1470; woodcut incunabulum, coloured, 28×20.2 (11×7¹⁵/₁₆). Schr. 1233. Biblioteca Classense, Ravenna **31**

MATISSE, HENRI *Nu au canapé*, 1922; lithograph, 49.3×40 (19³/₈×15³/₄). Sotheby's, London **241**
Odalisque with a Bowl of Fruit, 1925; lithograph, 26.8×19 (10⁹/₁₆×7¹/₂). Christie, Manson & Woods, London **240**

MECKENEM, ISRAHEL VAN *The Artist with his Wife Ida*, c. 1485-90; engraving, 13.2×17.8 (5³/₁₆×7). L. 1, I-II/III. British Museum, London **217**
Coat of arms with a boy doing a somersault, c. 1485-90; engraving, 14.5×11.8 (5¹¹/₁₆×4⁵/₈). L. 521. Sotheby's, London **78**

MERYON, CHARLES *L'Abside de Notre-Dame*, 1854; etching, 16.5×30 (6¹/₂×11¹³/₁₆). D.-W. 38, IV/VIII. Private collection **115**
La Morgue, 1854; etching, 21.3×19 (8³/₈×7¹/₂). D.-W. 36, II/VII. Bibliothèque Nationale, Paris **224**
Le Stryge, 1853; etching, 16.9×13 (6⁵/₈×5¹/₈). D.-W. 23, IV/VIII. Paul Prouté Collection, Paris **225**

MILLET, JEAN-FRANÇOIS *La Grande Bergère*, 1862; etching, 31×22.8 (12³/₁₆×9). Bibliothèque Nationale, Paris **226**

MONTAGNA, BENEDETTO *The Holy Family in a Landscape*, c. 1520-40; engraving, 15.8×21.6 (6¹/₄×8¹/₂). B. 8. Kupferstichkabinett, Staatliche Kunstsammlungen, Dresden (photo Deutsche Fotothek, Dresden) **19**

MORANDI, GIORGIO *Large Still-life with Coffee Pot*, 1933; etching, 29.6×39 (17³/₈×15³/₈). V. 99, II. Private collection **124**
Still-life with Five Objects, 1956; etching, 14×19.9 (5¹/₂×7¹³/₁₆). V. 116, III. Private collection **204**
The Three Houses of the Campiaro at Grizzana, 1929; etching, 24.8×29.9 (9³/₄×11³/₄). V. 59. Private collection **135**

MUNCH, EDVARD *Girl in a Nightdress at a Window*, 1894; drypoint, 20.5×14.3 (8¹/₁₆×5⁵/₈). Sch. 5, II/V. C. G. Boerner, Düsseldorf **236**
Madonna, 1902; colour lithograph, 82×58.8 (32¹/₄×23¹/₈). Sch. 33, A b 2. Staatliche Graphische Sammlung, Munich *facing p.* **264**
Moonlight, 1896; colour woodcut, 46×55.5 (18¹/₈×21⁷/₈). Sch. 81, c 1. Staatliche Graphische Sammlung, Munich *facing p.* **240**
The Sick Girl, 1896; colour lithograph, 42.1×56.5 (16⁵/₈×22¹/₄). Sch. 59a. Sotheby's, London **236**
Sin, 1901; colour lithograph, 69.5×39.5 (27³/₈×15¹/₂). Sch. 142. Rijksprentenkabinet, Rijksmuseum, Amsterdam *facing p.* **256**
Vampire, 1902; lithograph and colour woodcut, 37×55 (14⁵/₈×21⁵/₈). Sch. 34b, II. Folkwang Museum, Essen **119**

NANTEUIL, ROBERT *Louis XIV*, 1664; engraving, 39×30.4 (15³/₈×12). R.-D. 152-2, II. Bibliothèque Nationale, Paris **275**

NOLDE, EMIL *Danish Girl*, 1913; colour lithograph, 68×56 (26³/₄×22). Sch. 58. Sotheby's, London **122**
Young Couple, 1913; colour lithograph, 62×51 (24³/₈×20¹/₈). Sch. 82, 52C. Kupferstichkabinett, Staatliche Museen, Berlin **201**

OSTADE, ADRIAEN VAN *The Mountebank*, 1648; etching, 20.6×28.1 (8¹/₈×11¹/₁₆). G. 43, V/IX. C. G. Boerner, Düsseldorf **109**

PARMIGIANINO (FRANCESCO MAZZOLA) *The Entombment, c.* 1530; etching, 31.5 × 23.9 (12³/₈ × 9³/₈). Rijksprentenkabinet, Rijksmuseum, Amsterdam **20**

PICASSO, PABLO *Le Bain*, from *The Acrobats*, 1905; drypoint, 34.4 × 28.9 (13¹/₂ × 11³/₈). G.14b. Private collection **136**
Bust of a Woman after Cranach, 1958; colour linocut, 65 × 53.5 (25⁵/₈ × 21¹/₈). Bibliothèque Nationale, Paris *facing p.* **272**
Le Repas frugal, from *The Acrobats*, 1904; etching, 20.6 × 28.1 (8¹/₈ × 11¹/₁₆). G. 2, II. Private collection **205**
Salomé, from *The Acrobats*, 1905; drypoint, 40 × 34.8 (15³/₄ × 13³/₄). G. 17b. Private collection **137**
The Sculptor modelling, on the right two of his works, from *Le Chef-d'œuvre inconnu*, 1927; etching, 19.3 × 27.8 (7⁵/₈ × 10¹⁵/₁₆). G. 127b. Private collection **70**
The Wasp, from *Buffon*, 1941-2; sugar aquatint. Bl. 351, I. Private collection **28**

PIRANESI, GIOVANNI BATTISTA *Massive Doorway surmounted by a wide circular opening*, pl. IX of the *Carceri*, before 1750; etching, 55 × 44.5 (21⁵/₈ × 17¹/₂). H. IX, trial proof. Private collection **91**
Portrait of the artist: suggested design for his tomb, 1778; pen and brush drawing, 24 × 27 (9⁷/₁₆ × 10⁵/₈). Baltimore Museum of Art, Baltimore, Maryland, Robert Gilmor Collection (on permanent loan from the Peabody Institute) **259**
View of the Baths of Titus, detail, 1775; etching, whole print 48 × 70 (18⁷/₈ × 27¹/₂). H. 123, I/III. Private collection **185**
View of the Campo Vaccino, 1772; etching, 45.5 × 70 (17⁷/₈ × 27¹/₂). H. 100, I/IV. **49**
View of Paestum, 1778; etching, 49.5 × 65.2 (19¹/₂ × 25⁵/₈). H. 585, trial proof. Museum of Fine Arts, Boston **52**

PISSARRO, CAMILLE *Portrait of Paul Cézanne*, 1874; etching, 27 × 21.3 (10⁵/₈ × 8³/₈). D. 13. Paul Prouté Collection, Paris **235**

POLLAIUOLO, ANTONIO *The Battle of the Nudes, c.* 1470; engraving, 40 × 61 (15³/₄ × 24). H. 1: British Museum, London **84**

POLLAIUOLO, SCHOOL OF *Hercules and the Giants, c.* 1500; engraving, 40 × 59.5 (15³/₄ × 23³/₈). H. 2. British Museum, London **85**

RAIMONDI, MARCANTONIO *Portrait of Pietro Aretino, c.* 1510; engraving, 16.5 × 13.5 (6¹/₂ × 5⁵/₁₆). B. 38. P. & D. Colnaghi, London **219**

REDON, ODILON *Centaure visant les nues*, 1895; lithograph, 31.4 × 24 (12³/₈ × 9⁷/₁₆). M. 133. Sotheby's, London **196**
The Reader, 1892; lithograph, 31 × 23.6 (12³/₁₆ × 9⁵/₁₆). M. 119. Sotheby's, London **197**
Tree, 1892; lithograph, 48 × 32 (18⁷/₈ × 12⁹/₁₆). M. 120. Private collection **196**

REMBRANDT HARMENSZ. VAN RIJN *Abraham and Isaac*, 1645; etching: details of early and late impressions **95**
The Agony in the Garden, c. 1657; etching and drypoint, 11.1 × 8.4 (4⁵/₈ × 3¹/₄). B. 75. (1) British Museum, London; (2) private collection **133**
The Blindness of Tobit: Large Plate, 1651; etching, 16.1 × 12.9 (6³/₈ × 5¹/₈). B. 42, I/II. Rijksprentenkabinet, Rijksmuseum, Amsterdam **112**
Ephraim Bueno, detail, 1647; etching, drypoint and engraving, 24.1 × 17.7 (9¹/₂ × 7). B. 278, II. Private collection **132**
Christ healing the Sick (The Hundred Guilder Print), c. 1649; etching, drypoint and engraving, 27.8 × 38.8 (11 × 15⁵/₈). B. 74, I/II. British Museum, London **75**
Christ preaching (La Petite Tombe), c. 1652; etching, drypoint and engraving, 15.5 × 20.7 (6¹/₈ × 8¹/₈). B. 67. Sotheby's, London **130**
Clump of Trees with a Vista, 1652; drypoint, 15.6 × 21.1 (6¹/₈ × 8⁵/₁₆). B. 222, I/II. Rijksprentenkabinet, Rijksmuseum, Amsterdam **145**
Clump of Trees with a Vista, 1652; drypoint, 12.4 × 21.1 (4⁷/₈ × 8⁵/₁₆—plate cut?). B. 222, II. Christie, Manson & Woods, London **145**

Ecce Homo (horizontal), 1655; drypoint, 38.3×45.5 (14×18). B.76, I/VIII, entire print and detail. British Museum, London **57**

Thomas Jacobsz. Haaringh, detail, *c.* 1655; drypoint and etching, 19.5×15 (7¹¹/₁₆×5⁷/₈). B. 275, II. Rijksprentenkabinet, Rijksmuseum, Amsterdam **213**

Hundred Guilder Print see *Christ healing the Sick*

Joseph relating his Dreams (details), 1638; etching, 10.8×8.2 (4¹/₄×3¹/₄). B. 37, II and III **112**

Jupiter and Antiope: Large Plate, 1659; etching, engraving and drypoint, 13.8×20.5 (5⁷/₁₆×8¹/₁₆). B. 203, I/II. Rijksprentenkabinet, Rijksmuseum, Amsterdam **40**

La Petite Tombe see *Christ preaching*

Polander standing with his stick: profile to right, 1631; etching. B. 142 **81**

The Presentation in the Temple, in the dark manner, 1654; etching, drypoint and engraving, 21×16.2 (8¹/₈×6³/₈). B. 50. British Museum, London **167**

Rembrandt drawing at a Window, 1648; etching, drypoint and engraving, 16×13 (6¹/₈×5). B. 22, I/V. Rijksprentenkabinet, Rijksmuseum, Amsterdam **161**

Rembrandt leaning on a Stone Sill, 1639; etching, 20.8×17.1 (18¹/₈×6³/₈). B. 21. Rijksprentenkabinet, Rijksmuseum, Amsterdam **152**

Rembrandt in a Painter's Smock, *c.* 1655; pen and brush drawing, 20.3×13.4 (8×5¹/₄). B. 1171. Rembrandthuis, Amsterdam **181**

St Francis beneath a Tree, Praying, 1657; drypoint and etching, 18×24.4 (7¹/₁₆×9⁵/₈). B. 107, (1) I/II: Pierpont Morgan Library, New York; (2) II: Cabinet Rothschild, Louvre, Paris **73**

Arnold Tholinx, *c.* 1656; etching, drypoint and engraving, 19.5×14.9 (7¹³/₁₆×5⁷/₈). B. 284, I/II. Cabinet Rothschild, Louvre, Paris **72**

The Three Crosses, drypoint and engraving, 38.5×45 (15¹/₄×17³/₄). B. 78. (1) I/V, 1653: Rijksprentenkabinet, Rijksmuseum, Amsterdam; (2) IV/V, c. 1660: Museum of Fine Arts, Boston, Harvey D. Parker Collection **54, 55, 56**

The Three Trees, 1643; etching, drypoint and engraving, 21.3×27.9 (8¹/₄×11). B. 212. Kupferstichkabinett, Staatliche Kunstsammlungen, Dresden (photo Deutsche Fotothek, Dresden) **243**

The Windmill, 1641; etching, 14.5×20.8 (5³/₄×8¹/₄). B. 233. Sotheby's, London **113**

RIBERA, JUSEPE *Bacchus*, 1628; etching, 27.4×35.5 (10¹³/₁₆×14). B. 13, I. Rijksprentenkabinet, Rijksmuseum, Amsterdam **69**

ROUAULT, GEORGES *Qui ne se grime pas?*, from the *Miserere*, 1923; aquatint, 56.5×42.8 (22¹/₄×16⁷/₈). M. 8. Private collection **25**

RUISDAEL, JACOB VAN *Landscape with Trees and Houses on a Riverbank*, 1646; etching, 20.6×28.1 (8¹/₈×11¹/₁₆). D. 7, II/III. Rijksprentenkabinet, Rijksmuseum, Amsterdam **88**

PRINCE RUPERT (RUPRECHT VON DER PFALZ) *The Grand Executioner*, 1658; mezzotint, 63×44.4 (24³/₄×17¹/₂). A. 97.6. British Museum, London **22**

SCHONGAUER, MARTIN *The Censer*, *c.* 1475-80; engraving, 29.1×21.2 (11⁷/₁₆×8³/₈). Kupferstichkabinett, Staatliche Museen, Berlin **97**

Christ bearing the Cross (large plate), *c.* 1475-85; engraving, 28.6×43.1 (11¹/₄×17). L. 9. Albertina, Vienna **110**

Virgin in a Courtyard, *c.* 1475-85; engraving, 16.6×19 (6¹/₂×7¹/₂). Kupferstichkabinett, Staatliche Museen, Berlin **278**

SEGHERS, HERCULES *The Larch*, *c.* 1620; etching, 16.9×9.8 (6⁵/₈×3³/₄). Sp. 37. Rijksprentenkabinet, Rijksmuseum, Amsterdam **255**

Mountainous Landscape with Plateau, *c.* 1620; aquatint and drypoint, 13.4×19.4 (5¹/₄×7⁵/₈). Sp. 17 (variant not described). Rijksprentenkabinet, Rijksmuseum, Amsterdam *facing p.* **96**

Mountainous Landscape with a Track, *c.* 1620; combined techniques, 16.4×23.8 (6⁷/₁₆×9³/₈). Sp. 25B. Rijksprentenkabinet, Rijksmuseum, Amsterdam **27**

The Three Books, *c.* 1620; etching, 9.3×20.5 (3⁵/₈×8¹/₁₆). Rijksprentenkabinet, Rijksmuseum, Amsterdam **255**

TIEPOLO, GIOVANNI BATTISTA *The Adoration of the Magi, c.* 1755; etching, 43.1 × 28.6 (17 × 11^1/$_4$). V. 1, I/IV. Private collection **61**
Boy seated, leaning against an urn, c. 1740; etching, 14 × 18 (5^1/$_2$ × 7^1/$_{16}$). V. 3. Private collection **88**
Young Man standing and Old Man seated with a Monkey, c. 1750-65; etching, 23.1 × 17.8 (9^1/$_{16}$ × 1). V. 30, I/II. Private collection **90**

TIEPOLO, GIOVANNI DOMENICO *The Holy Family passing under an arch, c.* 1750-55; etching, 18.5 × 24.5 (7^1/$_4$ × 9^5/$_8$). V. 7, II. Private collection **209**
Old Man in a Cap, looking right, c. 1750-55; etching, 15.7 × 11.6 (6^3/$_{16}$ × 4^9/$_{16}$). V. 143, trial proof. Sotheby's, London **90**
Punchinello on a Swing, c. 1790; pen and brush drawing, about 29 × 41 (11^1/$_2$ × 16). Private collection **261**

TOULOUSE-LAUTREC, HENRI DE *Elsa the Viennese,* 1897; colour lithograph, 58 × 40.5 (22^7/$_8$ × 16). A. 3. Bibliothèque Nationale, Paris *facing p.* **176**
The Englishman at the Moulin Rouge, 1892; colour lithograph, 53 × 37.5 (20^7/$_8$ × 14^3/$_4$). A. 188. Bibliothèque Nationale, Paris *facing p.* **160**
La Grande Loge, 1897; colour lithograph, 51 × 39.8 (20^1/$_8$ × 15^5/$_8$). A. 229. Bibliothèque Nationale, Paris *facing p.* **144**
Réjane and Galipaux (in *Madame Sans Gêne*), 1894; colour lithograph, 38.8 × 23.1 (15^1/$_4$ × 9^1/$_{16}$). Bibliothèque Nationale, Paris **232**

UTAMARO, KITAGAWA *Utamaro painting a Screen in a Green House, c.* 1800; colour woodcut, 37 × 25 (14^5/$_8$ × 9^7/$_8$). British Museum, London **14**

VAN DYCK, ANTHONY *Erasmus of Rotterdam, c.* 1635; etching, 24.8 × 15.9 (9^3/$_4$ × 6^1/$_4$). M.-H. 5, I/V. Rijksprentenkabinet, Rijksmuseum, Amsterdam **210**
Frans Snyders, from the *Iconography,* published in 1645; etching. M.-H. 11, II/VII: forgery **80**

VAN GOGH, VINCENT *Dr Gachet (Man with a Pipe),* 1890; etching, 18 × 15 (7^1/$_{16}$ × 5^7/$_8$). Bibliothèque Nationale, Paris **202**

VICO, ENEA *The Rhinoceros,* 1640; engraving, 26.5 × 36.4 (10^7/$_{16}$ × 14^3/$_8$). B. 305, 47. Sotheby's, London **32**

VILLON, JACQUES *Renée de trois-quarts,* 1911; drypoint, 53.8 × 45.5 (21^1/$_8$ × 17^7/$_8$). Baltimore Museum of Art, Baltimore, Maryland **252**

VUILLARD, EDOUARD *La Cuisinière,* 1889; colour lithograph, 35 × 28 (13^3/$_4$ × 11). R.-M. 42. Bibliothèque Nationale, Paris *facing p.* **224**

WHISTLER, JAMES ABBOTT McNEILL *Nocturne Palaces,* 1879; etching, 28 × 19 (11 × 7^1/$_2$). K. 202, III/IV. Private collection **194**
Ponte del Piovan, 1879; etching, 22.5 × 15 (8^3/$_4$ × 5^7/$_8$). K. 209, II/VI. Kupferstichkabinett, Staatliche Museen, Berlin **195**
La Riva I, 1879; etching, 20 × 28.5 (7^7/$_8$ × 11^1/$_4$). K. 192, II/III. Kupferstichkabinett, Staatliche Museen, Berlin **195**

ZORN, ANDERS *The Toast,* 1893; etching, 32 × 26.5 (12^5/$_8$ × 10^7/$_{16}$). D. 80, IV. Kupferstichkabinett, Staatliche Kunstsammlungen, Dresden (photo Deutsche Fotothek, Dresden) **280**

Index of names

Adam, Robert 188
Aldegrever, Heinrich 105
Alken, Henry 116n., 242
Altdorfer, Albrecht 9, 104, 223n., 239
Amman, Jost 39
Andrea del Sarto 259
Andreä, Hieronymus 8, 223n.
Angiolini, Luigi 221, 223n., 224
Anonymous Master from Cologne 9
Arenberg, Dukes of 268
Astley, Sir Edward 208, 213, 233, 253, 264
Audubon, John James 247
Augustus III of Saxony 184
Aumale see Orléans
Aylesford, Heneage Finch, 5th Earl of 215, 216n., 230, 253, 264, 268

Baillie, William 49
Baldini, Baccio 207, 223, 224
Baldinucci, Filippo 180-82
Baldung Grien, Hans 9, 104, 222, 235, 260, 264
Barbari, Jacopo de' 63-4, 104, 228, 251, 264
Barnard, John 60, 72, 74, 136, 214, 216, 230, 233, 250, 253, 274
Barocci, Federico 104
Bartolomeo, Fra 258, 260
Bartolozzi, Francesco 21
Bartsch, Adam 3n., 157, 162
Basan, Pierre-François 53, 99n., 111
Bateman, Viscount 109
Baudelaire, Charles 200, 202
Bellange, Jacques 211, 224-5, 244, 253, 283

Bellini, Giovanni 258
Benedikt, Henri Harper 251
Berchem, Nicolaes 53n.
Bewick, Thomas 9
Bierens de Haan, Justus 265
Birckenstock, Johann Melchior von 222
Blake, William 12, 32, 117, 199, 225, 234, 248, 260, 268
Boldini, Giovanni 284
Bone, Muirhead 55, 234, 248
Bonnard, Pierre 116, 204, 234, 242, 248
Bonnet, Louis-Marin 21
Boon, Karel G. 111, 134n., 161-2
Bottari, Giovanni 209
Bracquemond, Félix 228, 284
Brandenburg, Cardinal Albrecht of 100, 177, 178
Braque, Georges 3, 123, 248
Bresdin, R. 248
Bretherton, James 79
Briquet, C. M. 43, 45
Bruegel, Pieter the Elder 105, 142, 143, 146, 223, 266
Buccleuch, Walter Francis, 5th Duke of 71, 230, 264, 268
Buckingham, Duke of 60, 220, 233, 253, 283
Buhot, Félix 228, 284
Burgkmair, Hans 9, 222, 250, 264
Burty, Philippe 227
Buytewech, Willem 148

Callot, Jacques 26, 47, 48, 108-9, 148, 211, 214, 216, 217, 244, 256, 283

Camerarius, Joachim 175
Campagnola, Giulio 21, 222, 223, 224, 238, 250, 264
Canaletto (Antonio Canal) 3, 44, 49, 93, 94, 114-15, 150, 152, 199, 220, 223, 224, 228, 231, 244, 253, 255, 258, 260
Carderera, Valentin 198
Carew, Paul 71
Carpi, Ugo da 104
Carriera, Rosalba 209
Castiglione, Giovanni Benedetto (Grechetto) 32
Catherine II of Russia 258
Caylus, Anne-Claude, Comte de 209
Cézanne, Paul 200, 234, 248
Chagall, Marc 4, 70, 117, 123, 126, 206, 248
Charles I of England 257
Charles IV of Spain 192
Charles V, Emperor 178, 180
Christina of Sweden 257
Claude Lorrain 105, 212, 220, 228, 259, 260
Claussin, Ignace-Joseph de 71-2, 81, 222
Clement XIII, Pope 188
Cock, Hieronymus 105, 143
Cognacq, Gabriel 243
Colbert, Jean-Baptiste 208, 257
Collius, Jacques 221, 242
Corot, Jean-Baptiste-Camille 29, 200, 228, 248
Correr, Count Teodoro 261
Cranach, Lucas the Elder 9, 100, 131, 219, 264
Crespi, Giuseppe Maria 209
Crespi, Luigi 209
Crozat, Pierre 209, 257-8, 260
Curtis, Atherton 212n., 250

Daumier, Honoré 26, 115, 150, 196, 200-202, 227, 233, 243, 248
David-Weill, David 254
Davidsohn, Paul 235
de Bruijn, Isaac 265-6, 268
Debucourt, Philibert-Louis 117, 228, 239
Degas, Edgar 32, 55, 64, 150, 169, 200, 228, 233, 248
de Groot, Hofstede 163, 183, 184
de Haan, Pieter 53, 109, 163
Delacroix, Eugène 228
Della Bella, Stefano 108, 211, 214, 244, 258, 283
Delteil, Loÿs 116, 158, 233
Demarteau, Gilles 21
Dodgson, Campbell 157, 240n.
Downe, Richard Dawnay, 10th Viscount 242, 253
Dujardin, Karel 105
Dunoyer de Segonzac, André 123, 242

Durazzo, Marquis Jacopo 222, 223n.
Dürer, Albrecht 3, 8, 14, 17, 43, 48, 58, 64, 77-9, 83, 97, 99, 100, 131, 132, 159, 160, 175-8, 180, 186, 208, 211, 214, 215, 219, 220-24, 228, 230, 231, 235, 238, 239, 242, 244, 247, 250, 251, 253, 254, 258-60, 262, 264, 265, 273, 283
Dusart, Cornelis 53n.
Dutuit, Eugène 79, 264
Duvet, Jean 220, 251

Eeles, Adrian 148, 254
Elsheimer, Adam 53n.
Ensor, James 248, 284
Erasmus 175, 180
Esdaile, William 220, 259, 260, 264
Eugene of Savoy 157, 184, 209, 216
Evelyn, John 182

Fairfax Murray, C. 264
Ferrarese Master of the *Tarocchi* 63
Finiguerra, Maso 15, 218
Firmin-Didot, Ambroise 134n., 222, 253, 264
Firmin-Didot, publisher 44
Fischer, Sebald 178
Forain, Jean-Louis 284
Fouquet, Jean 260, 264
Frederick Augustus II of Saxony 239, 240
Fries, Count Moriz von 219, 221, 242

Galichon, Emil 222
Gauguin, Paul 8, 32, 122, 150, 203, 234, 242, 248
Gauguin, Pola 150n.
Geisberg, Max 157, 158n.
Gerbeau, Jules 228
Gersaint, Edmé-François 134n., 157, 162, 214n.
Gerstenberg, Otto 268
Giorgione 257
Giotto 258
Godby, Alexander John 60n., 242
Goncourt, Edmond and Jules de 227, 228
Gow, Leonard 149, 242, 253
Goya, Francisco 20, 26, 34, 50, 77, 117, 150, 159, 163-4, 167, 189-99, 225, 227, 228, 231, 233, 234, 244, 248, 251, 254, 264
Graf, Urs 12, 17
Grechetto *see* Castiglione
Griffith, John 242
Guardi, Francesco 261-2
Guercino (Giovanni Francesco Barbieri) 181-2
Guérin, Marcel 233

Hachette, André-Jean 243, 250
Haden, Sir Francis Seymour 64, 71, 202, 227, 228

Hagens, Count Franz von 238, 242
Harunobu, Suzuki 9
Harris, Tomás 163-4
Hawkins, John Heawood 220, 230, 253
Hayter, Sir William 12, 24n.
Hazard, Nicolas-Auguste 233
Helleu, Paul 284
Henriet, Israël 48, 108
Heseltine, John Postle 260, 264
Heucher, Johann Heinrich 184
Hind, Arthur M. 45, 96, 115, 158, 163, 187
Hiroshige, Utagawa 116
Hodges, Charles Howard 242
Hokusai, Katsushika 116
Holbein, Hans the Younger 8, 260
Holford, Sir Robert Stayner 230, 242, 250, 265
Hollar, Wenzel 184, 214, 220, 283
Hopfer, Daniel 17
Houbraken, Arnold 136
Houbraken, Jacobus 212-13
Hubert, Alfred 230, 260, 264

Irwin, Theodor 264

Jabach, Everhard 257, 258
Janinet, François 20, 117
Josi, Christian 215, 218

Kalle, Friedrich 222, 283
Keynes, Sir Geoffrey 199
Kirchner, Ernst Ludwig 8, 122, 123n., 126, 206, 248
Klee, Paul 248
Klinger, Max 228, 284

Laffon, Emil 234
Langlois, François 209
Lanna, Baron Adalbert von 268
Lawrence, Thomas 259, 264
Le Blon, Jakob Christof 21
Legrand, Jacques-Guillaume 188
Legros, Alphonse 227, 228, 284
Lehrs, Max 45, 157, 158
Leonardo da Vinci 207, 216, 259, 260
Le Prince, Jean-Baptiste 20
Leyden, Baron Cornelis van 212
Liebermann, Max 184
Liechtenstein collection 158n.
Linnell, John 199, 260, 261n.
Louis XIV 208
Lucas van Leyden 17, 81, 99, 100, 178, 184, 186, 208, 211, 214, 215, 217, 219, 220, 222, 228, 247, 266, 283
Lugt, Frits 71, 74, 111, 149n., 162, 163, 206, 207, 214, 230, 253, 260, 266-8
Luther, Martin 175, 180
Lützelberger, Hans 8

Manet, Edouard 115, 150, 196, 228, 233, 248, 254
Mantegna, Andrea 30, 58, 83, 89, 95-6, 152, 208, 220, 222, 223, 228, 235, 239, 264
Marcantonio see Raimondi
Margadale of Islay, Lord 254
Margaret of Austria 180
Mariette, Claude-Augustin 134, 251
Mariette, Pierre I 208, 211n.
Mariette, Pierre II 71, 74, 211n.
Mariette, Pierre-Jean 157, 207n., 208-11, 213, 221, 242, 258, 283
Marolles, Michel de 208, 257
Masaccio 258
Master E. S. 64, 78, 139, 142, 157n., 220, 223, 239, 247, 264
Master I. A. M. of Zwolle 63, 230
Master LCz 222
Master P. M. 142, 247, 254
Master P. P. 219
Master P. W. 157n.
Master of the Amsterdam Cabinet see Master of the Housebook
Master of the Berlin Passion 63
Master of the Caduceus see Barbari
Master of the Crayfish 240
Master of the Gardens of Love 63
Master of the Housebook 15, 63, 78, 139
Master of the Playing Cards 63
Master of the Prophets and Sibyls 30, 207, 220
Master of the Vienna Passion 63
Master of the Year 1446 see Master E. S.
Matisse, Henri 234, 242, 248, 254
Maximilian I, Emperor 178
McBey, James 234
Meckenem, Israhel van 51, 63, 78, 220, 223, 238, 264
Meder, J. 47, 99, 130-32, 159-60
Medici, Cardinal Leopoldo de' 257
Melanchthon, Philip 175, 176, 177
Mellon, Andrew 239
Memling, Hans 97
Meryon, Charles 64, 115, 150, 200, 227, 228, 234, 248, 284
Michelangelo 258, 259, 260
Millet, Jean-François 227, 228, 233, 234, 248
Miró, Joan 4
Mocetto, Girolamo 222, 223
Morandi, Giorgio 33n., 70, 126, 138, 172, 206, 231, 242, 249
Morgan, John Pierpont 136, 230, 264-5
Morghen, Raffaello 220, 222, 283
Munch, Edvard 27, 66, 70, 122, 123n., 124-6, 150, 169-72, 206, 231, 233, 234, 242, 249, 254, 268

Nanteuil, Robert 274
Negker, Jost de 9

Niel, Jules 227
Nolde, Emil 122, 123n., 206, 249
Norblin, Jean-Pierre 134
Northwick, Sir John Rushout, 2nd Earl of 142, 240, 253
Nowell-Usticke, G. W. 111, 114, 149n., 253

Oppenheimer, Henry 260
Orléans, H.-E.-P.-L. d', duc d'Aumale 264
Ortelius, Abraham 211, 221, 238, 242, 265
Ostade, Adriaen van 47, 109-11, 211, 221, 228, 266
Ottley, William Young 219
'Otto prints' 32, 223

Paar, Prince Karl von 220
Parmigianino (Francesco Mazzola) 9, 17, 92n., 104, 259
Pepys, Samuel 183
Picart, Bernard 109
Picasso, Pablo 20, 55, 66, 69-70, 84n., 117, 123, 126, 138, 150, 151n., 157, 164, 206, 231, 233, 234, 242, 243, 249, 254, 268, 284
Piranesi, Francesco 50, 164, 188
Piranesi, Giovanni Battista 41, 42, 44, 45n., 51, 93, 115, 152, 164, 186-9, 199, 211-12, 231, 244, 265
Pirckheimer, Willibald 176-7, 223
Pisanello 260, 267
Pissarro, Camille 234, 249
Ploos van Amstel, Cornelis 214-15, 264
Pollaiuolo, Antonio 89, 220, 223, 224, 239, 240, 258
Pond, Arthur 208, 213, 214

Raimondi, Marcantonio 3, 49n., 78, 175, 178, 184, 207-9, 214, 215, 216, 219-22 passim, 228, 230, 231, 251, 264
Raphael 178, 207, 211, 239, 257-60
Redon, Odilon 116, 204, 234, 249
Rembrandt 3, 17, 27, 41, 49-50, 51, 53, 60, 64, 71-2, 74-83, 84n., 109, 111, 112, 114, 132-7, 139, 149, 152, 157, 158, 160-67 passim, 180-86, 198, 208, 211-18, 220, 221, 224, 230, 231, 233, 235, 238-40, 242-54 passim, 258-66 passim, 268n., 274, 284
Renoir, Auguste 116
Resch, Wolfgang 8
Robert, Louis 40
Robert-Dunesnil, A.-P.-F. 220, 224
Roche, Odilon 74n.
Rodin, Auguste 74n., 228
Roger-Marx, Claude 4, 228
Rosa, Salvator 105
Rosenwald, Lessing Julius 238, 268
Rothschild, Baron Edmond de 15, 134n., 223, 230, 253, 260, 263, 264, 265

Rouault, Georges 20, 27, 206, 249, 284
Röver, Valerius 214-15, 264
Rubens, Peter Paul 211, 220, 239
Rubieri, Giacomo 207
Rudge, E. 74, 152n., 230-33, 263
Rufo, Don Antonio 181-2, 183
Ruisdael, Jacob van 89, 220
Rupert, Prince (Ruprecht von der Pfalz) 15

Saint-Yves 242
Sandrart, Joachim von 182
Santarelli, Emilio 223n.
Schiavone (Andrea Meldolla) 15
Schliefer, Gustav 123
Schlösser, Carl 222, 238
Schocken, G. 142n., 251, 253
Schongauer, Martin 51, 64, 78, 97, 219, 220, 222, 228, 239, 240, 247, 250, 251, 264, 283
Seasongood, Edwin Alfred 89n., 243, 250
Seghers, Hercules 27, 139, 148, 151n., 219, 250, 274, 284
Senefelder, Alois 26
Siegen, Ludwig von 15
Signac, Paul 116
Silvestre, Israël 48, 108
Six, Jan 71, 184, 212, 221, 230, 238, 242
Six, Willem 212
Smith, Adam 212, 273
Spencer-Churchill, Edward George 240
Spranger, Bartholomeus 99
Steinlen, Théophile-Alexandre 228
Stinnes, Heinrich 234
Stoffels, Hendrickje 111
Stoss, Veit 219
Sträter, August 228, 235, 264
Strölin, Alfred 115, 250
Sykes, Sir Mark Masterman 218

Tarocchi, Ferrarese Master of the see Ferrarese
Theobald, Henry 71, 228, 283
Thomas, Henri-Jean 243
Tiepolo, Giovanni Battista 60, 92, 138, 199, 211, 223, 224, 231, 244, 258, 260, 261
Tiepolo, Giovanni Domenico 92, 199, 211, 223, 224, 244, 260-62
Tiepolo, Lorenzo 92, 199
Titian 207, 211
Toulouse-Lautrec, Henri de 26, 116, 204, 206, 228, 233, 234, 243, 249, 254

Vanderbilt, George W. 264
Van Dyck, Sir Anthony 47, 80, 214, 220, 228
Van Gogh, Vincent 204

Vasari, Giorgio 175, 257, 258
Verstolk van Soelen, Baron Jan Gijsbert 72, 220-22, 230, 238, 242, 254, 260, 264
Villon, Jacques 123, 172, 242
Vivant-Denon, Dominique 217, 230
Vliet, Jan van 53n.
Vollard, Ambroise 164, 203-6
Vuillard, Edouard 204, 206, 242, 249

Wartenburg, Count L. Yorck von 239
Watelet, Claude Henri 53, 134, 162
Waterloo, Anthonie 105
Watteau, Antoine 208
Weisbach, Valentin 230, 250, 264
Weisbach, Werner 250, 264
Wheatley, Francis 242

Whistler, James Abbott McNeill 64, 115, 150, 202-3, 228, 234, 249, 254, 284
White, Christopher 53n., 161-2
Wierix, Jan 79, 81
Willshire, W. H. 142
Wilson, Thomas 219, 220
Woodburn, Samuel 217, 218, 230, 259, 264

Zanetti, Antonio Maria 92n., 209, 216, 217, 230
Zinser, Richard 233
Zoomer, Jan Pietersz. 162, 184, 215, 216, 230
Zorn, Anders 227, 228, 233, 234, 249, 284